D0845593

Playing the Changes

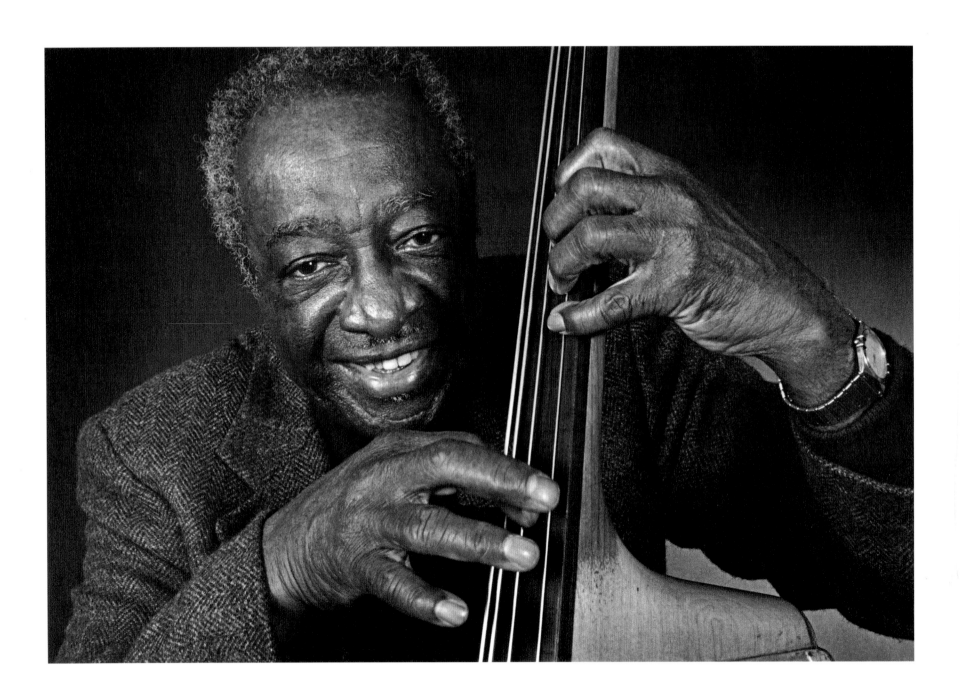

Playing the Changes

MILT HINTON'S LIFE
IN STORIES AND PHOTOGRAPHS

Milt Hinton, David G. Berger, and Holly Maxson

Foreword by Clint Eastwood

Preface by Dan Morgenstern

VANDERBILT UNIVERSITY PRESS • NASHVILLE

Frontispiece: Milt Hinton, Philadelphia, 1992. Photo by
Robert Asman © the Milton J. Hinton Photographic Collection.

Printed on acid-free paper.
Cover design by Gore Studio, Inc.
Text design by Dariel Mayer

Printed in China

Library of Congress Cataloging-in-Publication Data

Hinton, Milt.
Playing the changes : Milt Hinton's life in stories and
photographs / Milt Hinton, David G. Berger, and Holly
Maxson ; foreword by Clint Eastwood ; preface by Dan
Morgenstern.
 –1st ed.
 p. cm.
Rev. and enl. ed. of: Bass line. 1988.
Includes discography (p.), filmography (p.), bibliographical
references (p.), and index.
 ISBN 978-0-8265-1574-2 (cloth : alk. paper)
 1. Hinton, Milt. 2. Jazz musicians--United States--
Biography. I. Berger, David G. (David Garett), 1941-
II. Maxson, Holly. III. Hinton, Milt. Bass line. IV. Title.
ML418.H5A3 2008
787.5'165092--dc22
[B] 2007030389

Contents

Foreword

By Clint Eastwood

Milt Hinton is a unique figure in jazz. As a bass player, he spans seven decades of the music's history. Starting out with Cab Calloway in 1936, he soon became one of jazz's essential sidemen, performing on what are now classic recordings with the likes of Benny Goodman, Lionel Hampton, Coleman Hawkins, Billie Holiday, and Ben Webster. And with some help from Jackie Gleason, he became one of the first black musicians to integrate the recording studios in the early '50s, backing up legends like Frank Sinatra, Bing Crosby, and Barbra Streisand.

What also makes Milt Hinton's life so wonderful is his photographic work. He got a camera in the late '30s and began shooting his fellow musicians and the places he traveled. What he recorded provides valuable insights into why jazz is one of America's great art forms.

I was deeply touched when my son Kyle, a jazz bassist, was asked to perform at a concert celebrating Milt's ninetieth birthday at the JVC Festival in 2000. Having Kyle play in a bass chorus with some of jazz's finest musicians made me proud and reaffirmed my passion for the music.

Milt Hinton's body of work has inspired and guided me in my musical journey, and I think this book will provide a similar experience for all who have loved jazz as I have throughout my life.

April 2007

Preface

By Dan Morgenstern

Milt Hinton is an extraordinary man, and this is an extraordinary book. It engages the reader on a multiplicity of levels—and not just because its author has created both words and pictures.

On one level, it is the story of an exemplary American life, a tale of overcoming, telling us that talent combined with character, motivation, and tenacity can conquer adversity. On another level, it is a remarkable history of the great American music called jazz, told from the special perspective of a man who made some of that history in the course of a unique career spanning its most productive years—half a century and then some of music-making. It is also a slice of revealing personal and social Afro-American history, keenly observed. And to all this is added a selection of prime Hinton photographs, a kind of visual counterpoint to the words.

Though one hesitates to indulge in amateur psychology, it's possible that a musician's choice of instrument bears some relationship to his character. Hinton's choice was the bass, an instrument which (at least at the time of his choice) played a supportive role in jazz. Though he occasionally got a chance to show that he could shine in the spotlight—in fact, he was among the very first to prove that the bass could

play a solo role—Hinton chose to become a member of the rhythm section, the functional, unglamorous, workhorse heartbeat of the jazz ensemble. A good bassist knows how to make the soloists sound better, and thus must be someone who can sublimate his ego for the cause.

A good bassist must also be a good listener, able to discern the weaknesses as well as the strengths of the players he is there to support—in sum, a team player. It's plausible, I think, that this professional perspective also became a personal point of view. In any case, Milt Hinton is a man who knows how to listen well, a man who observes and remembers, and who is compassionate.

Such traits also mark a good historian and a good storyteller, and Hinton is both. Most musicians aren't very interested in the history of their music, though the present generation may be the first exception to that rule, which may tell us something about what has happened to jazz in recent years. When Hinton was a young man, most of his contemporaries were out to show that they could outdo their elders, while he respected experience and learned from it. (In this, he resembles the young Louis Armstrong.) At the same time, he was receptive

to new ideas, and eventually became an innovator himself.

And, as we learn from this book, he was never satisfied with his playing and constantly sought to improve it, studying with classical teachers and learning from gifted newcomers like Oscar Pettiford and Jimmy Blanton. (Speaking of encounters with other bassists, Milt's little tale about being challenged by the rambunctious young Charles Mingus is one of many gems to be found in the book.)

To call Milt Hinton a historian is not stretching the term. He may not always have been conscious of this role, but his ability to listen, to ask key questions, and to remember well was there almost from the start. Later his awareness of the importance of the past and the need to preserve it manifested itself in various effective ways. He invited such elders as Eubie Blake, who had not yet been discovered by the jazz press and public, and Perry Bradford to his home and interviewed them on tape, bringing them together for the first time in decades so they could spur each other's memory.

When the National Endowment for the Arts' jazz program got well under way, Milt served as a panelist and panel co-chairman (with this writer, who came to respect him even more from that experience) and played an important role in strengthening its oral history project, to which he later contributed a number of marvelous interviews demonstrating his skill, tact, and knowledge in no uncertain terms. (He is too modest to tell us much about these accomplishments, but they should be acknowledged.)

This sense of history, I think, also led to Milt's taking up photography, still another way of documenting and preserving the past for the present and future. Again, he tells us too little about how he came to excel at this pursuit, but even the earliest photos reproduced here demonstrate his talent for composition within the frame, his skills as an observer, and his perfect sense of timing—the latter a gift surely akin to his mastery of jazz rhythm. All

this might well be the envy of many a professional lensman. Some pros, of course, eventually gained the confidence of their jazz subjects and were able to make them feel relaxed, but very few were privy to so many informal shooting opportunities as Milt, who manifests a trait rare to photographers—discretion. Even when he took those lovely shots of his sleeping colleagues on buses and trains, he never took unfair advantage of them, and his heartrending studies of Billie Holiday nearing the end of her life are devoid of intrusiveness and cruelty.

By the same token, he knows how to tell stories without pulling his punches but never aims below the belt. We learn a lot, but nothing we don't need to know. In this, Milt differs markedly from certain writers on jazz who love to tell stories, true or not, out of school. Perhaps they should take up the bass!

Milt tells us just enough because he tells it true, without fancy embellishments and editorial comments. Thus his brief encounter with a lynching during his Mississippi boyhood, told so starkly, and purely in terms of what he saw and felt as a young child, is the more horrifying and effective for its economy of expression.

Throughout, the narrator's voice has this ring of truth, the texture of life itself. He has a real writer's ability to make a widely varied assortment of characters come alive for the reader. What a cast it is! Family members, friends, lovers, preachers, madams, numbers runners, gangsters (we get a fleeting glimpse of Al Capone himself), stooges, agents, managers, gamblers, the great and the small—even Jack Kennedy—appear in these pages. We come to know Milt's grandmother, from whom he learned the values that would guide him, and whom he called "Mama"; his somewhat remote, elusive mother; the two aunts with whom he was raised; and the uncles who made it possible for Milt and the four ladies to move to Chicago, and whose ways of supporting themselves (while always extending a helping hand) are often funny and always instructive. We are deeply

moved (again by the narrator's straightforward, undramatized telling) by Milt's first encounter with his father, at age 30, and by his immediate, unjudgmental acceptance of the man who'd abandoned him in infancy. And we learn just how much Mona, Milt's second wife, contributed to the fulfillment of her husband's human and professional potential.

But best of all for those of us vitally interested in jazz, we meet and come to know more than we knew about a host of musicians, famous and not so famous: Tiny Parham, all 400 pounds of him; Eddie South, perhaps the greatest of jazz violinists (who would have been lost to jazz if it had then been possible for a black musician to embark on a classical career); Chu Berry and Ben Webster, giants of the tenor saxophone; Dizzy Gillespie, young and brash; Cab Calloway, brilliant entertainer and complex man; Louis Armstrong, true king of jazz and incredibly hard worker; John Kirby, perhaps less of a bassist than his reputation leads us to believe; Benny Goodman, an enigma, and many more. Among them, the almost unknown singer Ann Robinson vividly stands out—hilarious and tragic, squandering her gifts, emblematic of so many unsung victims of the so-called music business, her fate an antidote to the romanticization of the "jazz life.

You had to be tough to survive; we learn that from this book. Yet there was, at least in retrospect, a certain heroic aura to life on the road, and certainly much that is comic. There are great stories here about eating and cooking—cabbage smells in Akron, for instance—and about the boarding houses and "hotels" where touring black musicians had to stay. Jerry, the gigantic and blasé Cincinnati rat, lingers in a reader's memory. What we also have here is a detailed description of the inner workings of a big jazz band, a unique mobile community with its own caste system, morés, and rules. Milt's fifteen years on the road with Cab Calloway bring forth insights (and anecdotes) that instruct and entertain. We learn, for example, that the valets were as essential as the

instrumental stars—perhaps more so. This is jazz history of a different kind than textbooks give us, and it is essential reading.

The book also has much to tell us about life in the New York recording studios—a world as vanished as that of the road bands of the Swing Era. Milt's climb to the very top of this highly competitive, structured, and exclusive substratum of the music world was a truly remarkable achievement about which he is characteristically modest. Certainly he is right to stress dependability and musical flexibility as reasons for his success, but others were also reliable and could read and play anything put in front of them with little time for rehearsing. Milts becoming the first black musician to break into this charmed circle was due to more—exceptional ability and equally uncommon strength of character also loomed large. And while he hints at it, we should stress that he opened the door for others.

What helped him too was a sense of humor and a sense of his own worth, as well as patience and perseverance. These traits are revealed throughout this fascinating narrative. Milt is utterly frank about his own mistakes and mishaps, and thus displays a true sense of humor—not the ability to make others laugh, but the capacity to laugh at oneself, and a much rarer gift than generally assumed. In subtle ways, this gift contributes to making this one of the most honest autobiographies I've read.

Hand in hand with this goes Milt's righteousness. He is a tolerant man, but he cannot stand deviousness, and, being an honest man, he has always stood up for his own rights and for others' as well. Such unfashionable virtues as self-respect and respect for others have contributed greatly to Milt Hinton's success in life and music—combined, of course, with exceptional talent and a willingness to face professional challenges.

What Milt says about a colleague and friend he much admired, the late trombonist Quentin "Butter" Jackson, also applies to himself:

Musically, his mind was always working. He could hear everything that was happening when the band played. . . . I don't know of any better sideman. . . . By the end of his life, he'd played with just about everyone . . . and when you look back on his career you realize that his greatness came from an ability to adapt to the changes happening in music through his lifetime.

I'm sure Milt would not want me to omit mention of his collaborator and close friend, David G. Berger, whom I can pay no greater compliment than stating what is true: his good hand in the making of this book is invisible, and what we hear is Milt's own voice. Like Milt, he is the ideal sideman who makes the soloist shine.

This is an essential book. One hopes it will be read by all young jazz musicians, and that they will learn the lessons it teaches about music and life. Congratulations, Judge—and thanks for letting me take this chorus.

Newark, New Jersey
December 1987

This Preface was originally written as the Foreword for *Bass Line: The Stories and Photographs of Milt Hinton,* published in 1988.

From Milt Hinton

I celebrated my ninetieth birthday several weeks ago, and it seems like the right time to look back and mention some of the people who made a real difference in my life. I've reread what I wrote when *Bass Line* was finished and I realize that some of what I said still applies and should be repeated.

One day in 1956, a fifteen-year-old kid named David Berger called and asked me if I'd give him bass lessons. He said he'd studied for about a year but was interested in learning more about playing jazz. Back in those days, I was so busy in the studios I didn't have enough time to brush my teeth. But he seemed so eager and motivated, I just couldn't bring myself to say no.

He came out to the house on a Saturday morning about a week later. I asked him to play for me and he sounded terrible. But fortunately he had a good sense of time, which is something you can't teach. So, for about a year I worked on developing his ear, teaching him fingering and bowing technique, and showing him how to use chords to build a bass line.

We liked one another right from the start, and we both knew it. We enjoyed being together so much that we'd spend practically every Saturday at my place and I'd take him on record dates whenever I could. He

quickly became part of our family and we got to know his folks too.

David and I remained close even after he went off to college. I was pleased when he decided to study sociology because I always felt he had talent in that area. And when he did research on musicians in graduate school it seemed logical. I've always been very proud to know I played a part in shaping his career.

David was the one who first took an active interest in my photographs. It was back in the early '60s when he sat in my basement and started organizing my negatives and contact sheets and having me identify where and when a picture had been taken, and who was in the shot.

We made a good deal of progress over the years, but things really changed when Holly Maxson came on the scene in 1979. Back in those days she was a professional photographer who had a great eye. She knew her way around a darkroom and she was a very good printer. But most important, whenever we looked at photos together, which we've been doing pretty regularly for twenty years, we always agreed on what was good.

Because of David's and Holly's efforts, there have been exhibits of my photos across the country and

overseas. That means thousands of people have had a chance to see my pictures, which is the most important thing to me.

A couple of years after *Bass Line* was published, and based on the reactions we got to it, I knew that someday we'd want to bring it up to date. We were finding new pictures and I was getting more recognition as a senior member of the jazz community. So in 1997, ten years after *Bass Line* was finished, we started working on a new book and it's been a labor of love.

We enjoy each other's company and we're all concerned about preserving an important part of the past. The photographs and stories are mine, but this book belongs to David and Holly just as much. I couldn't possibly tell the difference between their contributions and mine. The book is what it is because of them, and it wouldn't have happened if David hadn't called me for bass lessons more than forty years ago. Mona sums up my feelings for him in one line: "If Milton had had a son, he couldn't have asked for anything more."

When I look back at where I've come from, I still can't believe how things have turned out—what I've experienced in almost nine decades on this earth, and how lucky I've been. I often think about the people who shaped my life. Unfortunately, there isn't enough room to include everyone—just like there aren't enough pages to show everyone's photograph.

Still, there are categories of people and some specific individuals I have to mention—my family from Mississippi and Chicago and Mona's family from Sandusky, Ohio, my early music teachers, and the musicians whose talents and friendship have had a long-lasting influence on me—from my working days in Chicago, to the years I spent with Cab Calloway, to my time in the New York City studios.

I am grateful to the students I've taught, especially Jay D'Amico, Kevin Norton, and Mike Walters, because I've learned as much from them as they've learned from me; and to all the magnificent bass players in jazz and classical music who inspired and challenged me throughout my career

I'm thankful to a few non-musicians who've spent their lives supporting jazz and jazz musicians in many different ways—George Avakian, Ahmet Ertegun, Reverend John Garcia Gensel, Dick and Maddie Gibson, Nat Hentoff, John Hammond, Konrad Nowakowski, Hank O'Neal, George and Joyce Wein, Irwin Wolf, and Hans Zurbruegg.

Bob Asman, the artist who has been printing my photographs for almost twenty years, is another kind of master who deserves my gratitude, as does Dan Morgenstern, a wonderful writer and a longtime friend.

I've lived in the same neighborhood for over fifty years and I've had wonderful and supportive relationships with longtime neighbors and their children including Cynthia Bolling, Dan Bolling, Ola and Boston Chance, Gloria and DeWitt Doswell, Barbara Duncan, Donya Kato, Nina and Ursula Lovell, Edna and Albert Maxwell, Arlene, Chuck and Ronnie Maxwell, Lucille Phillips, and Harold Squires. The St. Albans Congregational Church has provided our family with spiritual guidance for decades. And in recent years, the gardeners and swimmers (Leon Dillinger, Al Fields, and my instructor, Austin Lewis) at the Roy Wilkins Center have kept me in good physical shape.

Last of all, I want to acknowledge my immediate family—Mona, who has been my partner, my supporter, and my salvation for more than sixty years; our daughter, Charlotte, and her husband, Bill Morgan; and everyone's pride and joy, our grandchild, Inez Mona.

St. Albans, New York
July 2000

Playing the Changes

Prologue: Vicksburg

In Vicksburg, Mississippi, 1910 was a magical year— I was born at home on June 23rd at four in the morning.

My mother, Hilda Gertrude Robinson, and my father, Milton Dixon Hinton, never did get along. They stayed together only three months after I was born and I didn't meet my father until I was about thirty.

I knew both my grandmothers, but my two grand- fathers were dead long before I was born. Since my mother's mother, Hettie Lettie Carter Robinson, lived with us while I was growing up, I knew her best. I called her "Mama" and I called my mother "Titter." They tell me it happened because Mama always called my mother "Sister," and when I was first learning to talk, "Titter" was as close as I could get.

Anyway, Mama had been a slave on Joe Davis's plantation in Vicksburg when she was very young. Later on she married and had thirteen children, and Titter was her eleventh. Mama's husband died five months before their last child, Matt, was born, so she had to raise all those kids by herself.

I really don't know that much about my father's folks—the Hinton side of the family. My mother's people never talked about them, probably because my father ran off and because the two grandmothers didn't get along. I think it had to do with a fight in their church congregation.

I'm not sure about the accuracy of my knowledge concerning this side of the family, but from what I've been able to piece together, my father was born in Monrovia, Africa. In fact, he had one of those tribal marks on his forehead, so he might have actually been a tribesman in his younger days.

Evidently, a missionary group was responsible for bringing him to this country with his mother, two brothers, and a sister. I don't know when this took place or whether they all came together or what ever happened to his father.

At the time I was born, his mother was living in Vicksburg, but I'm not sure if she raised her children there. I know he had a sister Lucy living in Memphis, which is where he went after he left my mother. And I've heard his brothers, James and John, were tough guys who'd run off when they were young and hadn't been heard from again.

So the Hintons weren't slave descendants at all. And that's probably the reason why my father's mother, Huldy Hinton, seemed so different to me from my mother's people.

From my birth until I left Mississippi when I was

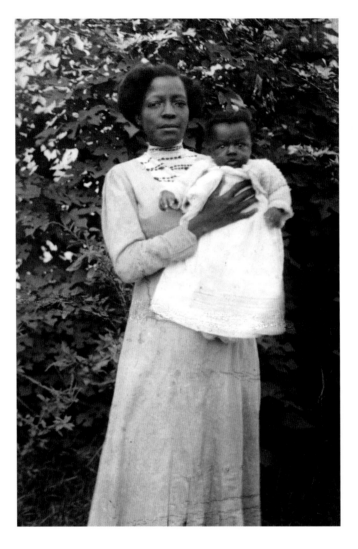

Hilda Gertrude Robinson
("Titter," Milt's mother) and
Milton John Hinton ("Milt"),
Vicksburg, Mississippi,
c. 1911

nine, I lived in Vicksburg with my mother, two of her sisters—my aunts Pearl and Alberta—and Mama. So three of Mama's children were living under one roof and two others—my uncles Bob and Matt—were still alive at the time I was born. Uncle Matt lived somewhere else in town, but Uncle Bob had gone up to Chicago a couple of months after I was born. My mother never did have any more children and my aunts never had kids.

So there I was, the only boy in a house full of women—Mama, Titter, and my two aunts.

The aunt closest to my age was Alberta, who everyone but me called "Sister." I called her "Sissy." My other aunt, Pearl, was about five years older than Titter. Long before I was born, she'd been married to Steve McKinzie. I only knew a couple of things about him. He had a red complexion and a nasty temper, and he'd had a fight one night and drowned in the river.

Vicksburg was built on a hillside rising up from the banks of the Mississippi River. White people lived at the top and the blacks lived down in what was called "the Valley."

My family rented a place on First North Street, almost at the bottom of the Valley. It had two rooms and a kitchen and was built on stilts so water could pass underneath if there was flooding. All around us—First, Second, and Third North Streets—were rows of these kinds of shacks built right next to each other. There was a Methodist church and a Baptist church near us, and I can still see the little neighborhood grocery store where we traded. It was a block or so farther down in the Valley, almost at the bayou.

The store was run by a black man people called Buck. When I was five or six, Mama used to send me down there to buy food—a nickel's worth of potatoes and greens, maybe a dime's worth of salt pork. She always gave me special instructions like, "Tell 'em to lagniappe you an onion." In those days, if you bought a couple of things in a small grocery, the owner would usually throw in something extra. Mama must've figured if she was going to get something for nothing she might as well try to get exactly what she needed. I never had to take money with me. Buck kept a little record book, and every week Mama or Titter would go down and pay him what we owed. He was very kind. I remember he'd give me a piece of candy just about every time I went in.

Almost all the people in our little community were poor. But I can remember one black man who stood out because he had some money. His name was Randolph. He was very fair—what they used to call octoroon. Evidently, he liked my mother. She was less

than twenty when I was an infant and she was very pretty and didn't have a husband. Anyway, he spent some time hanging around our house and I got to know him a little.

Randolph ran a saloon downtown that was for white people only. Blacks could take an empty pitcher to a little window in the back and get it filled with beer, but they couldn't go inside and get served. Everyone in the neighborhood knew him and knew he had money. He lived a couple of blocks from us, near the bayou and Buck's store.

Titter took me to his place once. It was much larger and nicer inside than all the other houses around. He sat me down on his front porch and showed me a picture album of his family. It was a real thrill because I'd never been out on a screen porch or looked at photographs like that before. I saw lots of shots of his family dressed up in beautiful clothes. Most of the people were fair-skinned like Randolph. They looked white, but somehow I knew they really weren't.

With all those children and no husband, Mama always had to work. When her children were much younger, she did full-time cooking for a family named Baer. They were one of the few Jewish families in Vicksburg and they owned a small department store. From what I heard, they never paid her much money, but like most other black domestics she found a way to play the system. She'd always order more food for them than they could possibly use and then take the extra home for our family.

At some point, the Baers let Mama set up a little stand at the side of their store. She was only there early in the morning when people were on the way to work. She sold coffee and two buttered biscuits for a nickel. But she stopped before I was born. Evidently, it was too tiring to bake biscuits every night, sell them the next morning, and then go to a cleaning and cooking job all day.

I also heard stories about how her two sons, my uncles Bob and Matt, used to bring money home when they were kids. Actually, they were pretty clever about it. They'd go down to the railroad depot with a couple of empty burlap sacks and stay all day. Every time a train passed through the yard, they'd make ugly faces at the white engineer and fireman. These guys would yell, "Nigger bastards!" and throw small pieces of coal at the kids. Of course, they hardly ever got hit, and by the end of the day they each took a sack filled with coal into town and sold it.

Other days they'd go down to the bayou hunting for turtles that came up from the Gulf. If they caught one, they'd try to sell it to a hotel or restaurant downtown.

When her kids got old enough to get their own domestic jobs, Mama stopped working for the Baers altogether and started taking in washing and ironing. She was still doing the same thing when I was young, because I can remember the black cauldron out back of our house that she washed in. She built a fire under that big pot and punched it with an old broom handle until it was just the right temperature for the clothes.

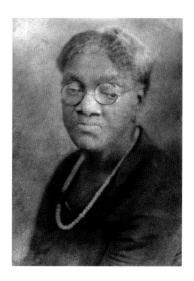

Hettie Lettie Carter Robinson ("Mama," Milt's maternal grandmother), Chicago, c. 1930

My two aunts worked as regular domestics doing cooking and cleaning. Until he left for Chicago, my Uncle Bob had a porter job in a barbershop and my Uncle Matt also worked there before he got a job as a chauffeur.

Titter was the only one of Mama's children who never did domestic work. Her brothers and sisters helped her go to school and also take piano lessons from a lady in town. Mama had managed to get a piano and I remember her telling me years later how she'd started paying fifty cents a week on it when Titter was a little girl.

When she was still a teenager, Titter started working for Reverend Edward Perry Jones, who was the minister of the Mt. Heron Baptist Church, where we belonged. She was a jack-of-all-trades. She helped his wife take care of their three boys—Ed, George, and McKissack. She did secretarial work for a little church newspaper he had. She even played the piano for the choir. But she was never asked to do cleaning or washing and that was very important to her.

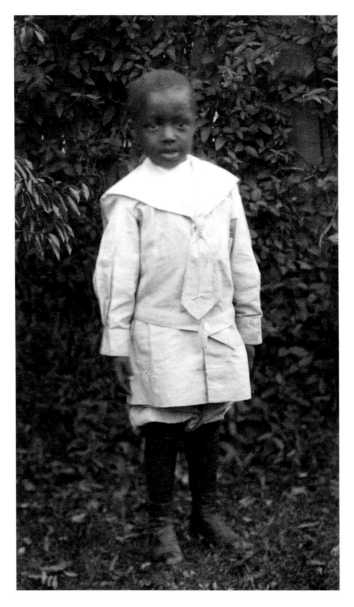

Milt, Vicksburg, Mississippi, 1913

school. He made my mother a teacher and I had to go there for a while. It was kind of a kindergarten where you would learn reading and writing.

I also went to regular public school in Vicksburg. I don't think I learned very much there because a few years later, when we moved to Chicago, they put me back a couple of grades. What I remember best is stopping on the way to school and buying a can of condensed milk for a nickel. I'd take it into the classroom, put a hole in the can, and set it under my desk. I kept a wooden clothespin in my drawer and I'd stick it in the can and let the milk absorb into the wood. Then I'd suck it until the sweet taste was gone, dip it back in the can, and start over again. I had it worked out so the little can lasted all day.

Starting when I was about four or five, I'd be taken to my other grandmother's, Huldy Hinton's, to spend a few days. She lived on the outskirts of town—away from the main part—where there weren't as many houses and it was much more rural. Mama or Titter would take me there. We'd go over a hill and as we went down toward the bottom, you'd come to a curve in the road and that's where she lived.

The place was pretty small but fixed up in a real cute way. I don't think my father's mother had a great deal of money, but she certainly lived better than we did. She had a front yard surrounded by a white picket fence with a big pecan tree growing in the middle. I can still see the little swinging gate where Mama or Titter would leave me. They'd never go to the door and exchange pleasantries, probably because of the conflicts which had taken place between the families.

Inside, you walked into a living-room area that had a bedroom on each side. Then, toward the rear, there were two steps going down into the kitchen. Right off the kitchen was a shed built over a brook which ran behind the house. The shed was cool inside. My grandmother stored flowers in there to keep them fresh. And she kept her milk cool by putting a big crock of it right into the running water.

She had a beautiful garden out back with lots of

I can still remember times when she would take me along with her to their house and how McKissack, who was a couple of years older, would pull me around in his little red wagon.

A few years after she began working there, some kind of fighting between different church groups took place and Reverend Jones decided to set up his own

flowers in bloom all the time. There were grapevines climbing up the sides and on top of the shed over the brook. When the grapes were ripe they were luscious. Another fruit she had, called maypop, came from a fairly large tree. I remember spending a lot of time looking for the ripe ones. If they were good, they were soft and pulpy and tasted something like a persimmon. But if they weren't just right, they tasted like alum and dried out your mouth for hours.

There was a church on one side of the house, a couple of hundred feet away. Evidently, the church leased some land from my grandmother and did some farming on it. Corn grew in the fields behind the house, and it looked to me like it went on for miles.

Grandmother Hinton was very different from Mama. She ate other kinds of food. She put molasses on her rice instead of sugar and drank tea instead of coffee. She also used strange spices to flavor things. Looking back, I think her cooking probably had a strong African influence.

I can still smell the smoke from her corncob pipe. Even her clothes were different. She wore Mother Hubbard–type dresses that came down to the floor. In fact, years later, that kind of dress had a lot to do with the way she died. She was living alone in the same house, and while she was sweeping and burning leaves, her long dress caught fire. From what I understand, there was no one around to put it out and she was burned very badly. I was working in Chicago when it happened. I heard she was in the hospital and in bad shape, but I never got a chance to go down and see her.

The conflict in our family really caused a lot of problems for all of us. It's one of those sad things that's stuck with me all my life.

As might be expected, I never knew any white kids in Vicksburg. But at a fairly young age I did have some experiences with a few white grownups.

I was four or five when I started picking up and delivering laundry for Mama. I still remember her telling me how I should always go to the back door and see the maid. When I was six, I got my first job working

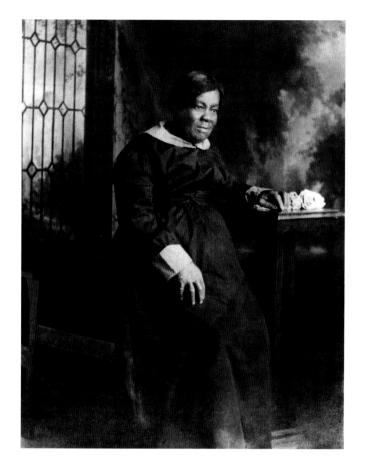

Huldy Hinton (Milt's paternal grandmother), Vicksburg, Mississippi, 1925

for a white lady named Mrs. Currant. She lived a few blocks up the hill and Mama took in her washing and ironing. Every two or three days I had to walk to a little dairy, get a pail filled with milk, and carry it over to her house. I think she paid me ten cents a week for two or three trips.

I also saw white guys come around to our house selling all kinds of goods. In those days, from what I understand, black people in Vicksburg weren't allowed to try on clothes in regular stores. So there was a need for this type of door-to-door service. These men would call Mama "Auntie," and they used that word almost every time they spoke to her—"Good morning, Auntie," "Fine day, Auntie," "I got something real nice for you today, Auntie," "Is Auntie interested in

some calico?" "How many children do you have now, Auntie?" They were always very condescending.

I'm sure their prices were ridiculously high and, just like the piano Mama had gotten, everything was always paid for on time, which made it even worse. Of course, Mama's credit was good, just like most black people's in the South. These folks knew they had to pay up because there was really no other choice for them.

The same kind of thing happened with life insurance. A guy would come around and sell you a policy, then collect on it every week or two. In fact, in the mid '70s we found out that my mother, who was living in Chicago at the time, was still paying fifteen cents a week on a policy she'd taken out in Vicksburg more than sixty years before—and the total value of the death benefit was only three hundred dollars. I guess when black people migrated north, these door-to-door guys wanted to keep a good thing going, so they just tagged along behind them.

One of the clearest memories of my childhood in Vicksburg is the lynching I saw when I was seven or eight.

At the time, my Uncle Matt was working as a chauffeur for a rich white man named Ham Watts who lived in a nearby town. There were only a few cars in Mississippi in 1918, so Uncle Matt really had a good job, and he knew it. Whenever he got a few minutes alone with the car, he drove over to our place. He always kept it polished and everyone would come out to get a close look. I can still see my uncle standing in front, next to the hood, all dressed up in his uniform and cap. He was so proud, just as if that car belonged to him.

Uncle Matt was named after his father, who died before he was born. Mama always said he learned to drive cars so well because he took after his namesake in looks and ability. Her husband had been kind of a chauffeur too—what they called a "hackman." When slavery ended, he'd gotten a team of horses and a wagon rig and hired out his services to rich white people in town.

Anyway, one night when he was alone, Uncle Matt had an accident with the car. Evidently, there was something in the middle of the road, and when he swerved to clear it, the car turned over. His leg was badly cut and broken and they put him in the county hospital in Vicksburg. In fact, it was so bad that for a while they thought they'd have to amputate.

Late one afternoon my Aunt Sissy took me to visit him. The colored ward in the hospital was one long smoky room filled with about a hundred patients and visitors. It was very hot and the noise was unbelievable.

The two of us left the hospital and started walking home just as it was getting dark. It was unusual for me to be out after dark, especially in the white part of town, and that's probably one reason I recall so much about that day.

We were on a main thoroughfare called Clay Street about a block or so from First North, where we'd turn right to go downhill into our neighborhood. That's when I saw a big crowd gathered on a corner up ahead of us. As we got closer we heard a lot of noise—screaming, hooting, loud explosions like firecrackers. From where we were and what I could see and hear, there was an awful lot of excitement going on. I tried to run ahead, but Aunt Sissy grabbed my arm and held me back. She was only fifteen or sixteen, but she must've had a good idea about what was really happening. I didn't, so I just kept pulling until I dragged her halfway down the next block, real close to the crowd.

Suddenly, I could see what was going on. There was a bonfire, and fifty or sixty white men were drinking out of whiskey jugs, dancing, cursing, and looking up toward a tree over their heads. And in this big tree I saw a figure shaped like a person hanging from a long wire cable attached to a branch. I was so stunned it took me a couple of seconds to realize it wasn't a scarecrow or a stuffed doll, but a real human, a black man, hanging up there. He was barefoot and didn't

have a shirt on, just pants tied around the waist with a piece of rope. He was covered with blood and must've been dead for a while. But that didn't seem to matter to the men in the street, who kept shooting their guns up at the dangling body.

Aunt Sissy pulled me down some narrow alleys between stores, trying to find a back way home. I kept trying to slow her down, turning back to look every few seconds. I couldn't believe my eyes.

The last thing I saw was a couple of men dragging over a gasoline drum and putting it under the hanging body. Then someone else threw a torch at the can and the place lit up like it was daytime. More than seventy years have passed, but I'll never forget that blaze and watching that body shrivel up like a piece of bacon while the crowd cheered. There was a horrible smell all over. No matter how far away we got, the stink was still there.

Aunt Sissy and I finally worked our way back to the house, and Mama was overjoyed to see us. She'd been terribly worried but afraid to go out looking. I guess every black person in Vicksburg knew what was going on that night—black men especially. Many of them would disappear for a few days after a lynching.

The next day at breakfast I heard Mama talking to some neighbors about what had happened the night before. Apparently, a white lady said she saw a black man peeping through her window while she was getting dressed, and she described what he looked like. Somebody had some hounds and took them searching all over town. At the railroad station the dogs barked at a black man who was waiting for a train. That was enough. They grabbed this poor man, tied him to a car, dragged him through town, and then strung him up. The mob had gotten so drunk and crazy that one of them shot another in the head by accident.

After breakfast, Aunt Sissy walked with me to school. To get there we had to go right by the corner where the crowd had been. Now it looked as if nothing had ever happened there. Clay Street was quiet. People were opening their stores or walking to work. There was one thing very noticeable though—the big

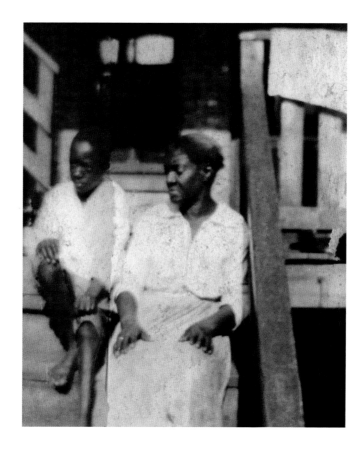

Milt and Mama, Vicksburg, Mississippi, c. 1918

tree they'd used to hang the man was gone. All that remained of it was a short stump. The blood-red paint on it was still dripping.

My Uncle Bob was the first one in our family to leave Vicksburg. He went up to Chicago in 1910, a couple of months after I was born.

Throughout my childhood, and even when I was in my teens, I heard long stories about how people got themselves out of Mississippi. In fact, I'm familiar with so many details, there are times when I feel like a lot of it actually happened to me.

Evidently, the man who really convinced many Vicksburg people to get out was Reverend Jones. His sermons in church had one theme—if you want a

It worked this way. In those days, barbershops in a small town like Vicksburg provided different kinds of services. You could get a haircut and shave of course, but since only a few very rich folks had indoor plumbing, you could go there for a bath too. So part of the barber shop was made up of little stalls, and each one had a tub inside.

The barbers were white, just like the customers, but all the porters were black. They made sure the tubs were clean and the water was hot. They'd get you soap, towels, a shaving mug, a sharp razor—things like that. Naturally, they shined shoes too.

People usually came in for a bath at the end of the week—either Saturday or Sunday. Since the barbers didn't work on Sundays, the porters were left to run the bath house alone. That's when they made their under-the-table money. It was pretty simple because there was no supervision and no way of accounting. On Monday mornings they just told the boss he had fewer bath customers than the number who had really shown up, and then they divvied up and pocketed the difference.

This kind of thing wasn't considered stealing or cheating. For black people back in those days, playing the system was simply a matter of survival.

Anyway, when Uncle Bob had put together about fifty extra dollars from the Sunday business, he knew he'd be heading up north soon.

From what I was always told, he picked Chicago because a couple of friends were already there. Word had gotten back about how jobs were plentiful and living conditions were good. Evidently, back in those days you could earn between fifteen and twenty-five dollars a week working in the stockyards, and even more being a bellhop or waiter in one of the big fancy hotels or restaurants. I guess Uncle Bob figured he already knew something about dealing in services, and that made Chicago sound like the best place in the world.

In 1910 it wasn't easy for a black man to leave Vicksburg by train. Uncle Bob couldn't just go down to the railroad station and buy a ticket for Chicago.

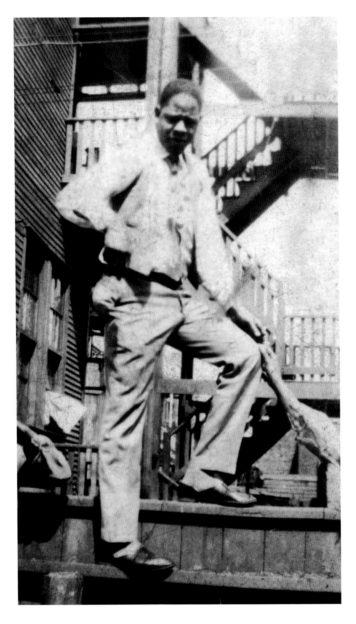

Robert Robinson ("Uncle Bob"), Chicago, c. 1920

better life, leave town as soon as you can. From what I understand, my Uncle Bob listened for a while and then took the advice.

Before he left he worked as a porter in a barber-shop. Actually he was doing pretty well there, because he'd learned to play the system at a fairly young age.

He might be asked about where he worked and whether he had his boss's permission to leave town. Like many other black men, my uncle learned a way to beat the system so he could get out of town.

He had a friend in Memphis write a fake letter and address it to him. It said something about how his sick Aunt Minnie was up in Memphis and how her last wish was to see her only nephew, Bob, before she died. It was signed by someone who pretended to be a cousin living with Aunt Minnie.

Uncle Bob took this phony letter to the barbershop and asked if he could go up to Memphis for a few days. The boss felt bad about the situation and wrote out a note saying Uncle Bob had his permission to buy a roundtrip ticket to Memphis.

The next evening Uncle Bob was on the train. When he arrived in Memphis, he cashed in the unused return trip and bought a one-way to Chicago. He never returned to Vicksburg.

A few weeks after arriving in Chicago, Uncle Bob got a job as a bellhop in one of the good downtown hotels. The city was booming in those days. More and more big businesses from the East were opening branch offices in Chicago. It had the giant stockyards, one of the largest railroad depots, and lots of conventions because of the city's central location. These things kept the big hotels filled, and that meant good money for all the people who worked in them. My uncle said he could make as much as fifty dollars a day in tips, which was rare for a black man in the North in those times, and certainly unheard of in Mississippi.

Actually, he didn't make his real money carrying bags and delivering messages. That came from illegal kinds of things like putting out-of-town guys in touch with expensive whores and selling liquor by the bottle after hours when everything was closed. He told me the demand got so great, he and some of the guys he worked with began making bathtub gin in the hotel basement and selling it for five bucks a pint.

From what I understand, just as soon as Uncle Bob started making money, he sent some of it back to Vicksburg. This was the typical pattern for black people. I remember times when I was a child seeing Mama open up a sealed envelope and take out a wad of newspaper wrapped around five or six ten-dollar bills.

Unfortunately, the money stopped when Uncle Bob got drafted into World War I. That's one reason it took our family a few years longer to leave Mississippi.

Uncle Matt joined the Navy in Vicksburg right around the same time. As it turned out, he contracted a serious illness and ended up sailing halfway around the world lying in the infirmary. When his ship finally got back to the States, he was discharged and sent home to Mississippi.

After Uncle Bob got his discharge, he found another good job in Chicago and started sending money to Vicksburg again. Within a year he had enough put away to be able to send for his brother. As might be expected, getting established in Chicago was easier for Uncle Matt than it had been for Uncle Bob. There was a job waiting for him and an apartment set up for the two of them to share.

From what I understand, the plan was for the two of them to take some time to save more money, then set up another apartment and send for Titter and Aunt Pearl. But the move took place three or four months ahead of schedule because some important white people in Vicksburg found out Reverend Jones was telling his congregation to move north. They made sure he understood that he'd better get out of town as quickly as possible. And when he and his family left for Chicago a couple of days later, he took Titter and Aunt Pearl along.

Somehow my uncles managed to adjust to their sisters' early arrival. They fixed up their apartment so the four of them could live comfortably for a short time. Of course, Titter had a ready-made job with the Joneses, and it wasn't long before they found something for Aunt Pearl.

For a while, Mama, Sissy, and I were the only ones left in Vicksburg. But just as soon as my uncles were

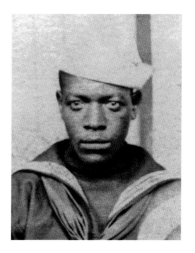

Matthew Robinson ("Uncle Matt"), Vicksburg, Mississippi, c. 1917

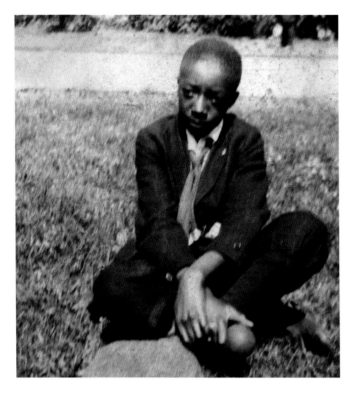

Milt, Vicksburg, Mississippi,
c. 1919

It was pouring that morning. A man with a horse and wagon was supposed to pick us up and drive us down to the railroad station. But the rain slowed him down so bad, by the time we got to the station, the train had already left.

There we were, standing in the station soaking wet, with all our baggage piled up around us. Titter had sent down a new suit and hat for me to wear on the trip, and the cardboard inside the bill got so wet that the whole thing had crinkled up. Sissy was crying. She wanted to get to Chicago more than anything. I was pretty disappointed too, but for a different reason. I'd been looking forward to getting on the train so I could eat the food our neighbors had packed for the ride— fried chicken, deviled eggs, cornbread, cakes—special things we didn't eat every day.

Somehow one of our neighbors found out we were stranded and sent another cart down to bring us over to their place. That's where we stayed and dried out until evening. Then we went back down to the station and got the six o'clock train to Chicago.

This was my first time on a train. We were in the black coach, of course, and it was crowded and un- believably dirty. It smelled like rotten food and it was noisy. It was hard to fall asleep and the trip seemed like it went on for days.

We got to Chicago sometime late the next day, and my mother and my aunt and uncles were right there to meet us. It was October or November, and it was pretty cold in Chicago. My mother had brought a coat to the station for me and put it on me the moment we arrived. Then we all got into a taxicab and went to my new home.

able to set up places for themselves, which left room for us at Titter and Aunt Pearl's, we headed north too. I was only nine, but I'll never forget that day.

We got up before dawn and Mama was trying to do everything. She'd sold off our piano and people came to pick it up. Neighbors stopped by and she gave them pots and pans and whatever else was too heavy to take with us. It was the last minute and I can still hear Sissy yelling, "Come on, Mama, please, Mama, get the stuff together."

1
Coming Up in Chicago

The first place we lived was at 36th and Vincennes Avenue, right in the middle of the Southside. It was a row house like all the others on the block, and it had been divided into two apartments, one upstairs, one downstairs. We had the upstairs with the use of the downstairs kitchen. The place was owned by Miss Jenny Lawes, a lovely black lady, and her sister. They lived downstairs and Miss Jenny, the older one, looked after the building, which she kept up beautifully.

The houses on our block and in the neighborhood didn't look like anything I'd ever seen in Vicksburg. For the first time, I saw black people at all different economic levels. A block from our house was the Vincennes Hotel, one of the fanciest black places in Chicago. I'd walk around there and see black men and women dressed up just like the fanciest white people I'd seen in Vicksburg. That's when I first realized that being black didn't always mean you had to be poor.

Reverend Jones lived in our neighborhood, but the new church he'd started in Evanston was too far for us to travel. So we joined the Ebenezer Baptist Church, which was at 35th and Dearborn, a few blocks from where the White Sox still play baseball. I went there with Mama every Sunday. As she got older, the arthritis in her knees gave her more trouble, and when she walked she could fall suddenly. I had to watch her pretty closely. My two aunts and my mother usually went along with us, but my uncles were always too busy with their lady friends to ever get near the place.

Besides the church, there was another kind of neighborhood group that people joined. It was made up of folks who'd come to Chicago from Vicksburg, and it was called the Vicksburg Emergency Club. They'd have one meeting a month in a church community center or some place like that, and I think the dues were a quarter a month. They'd sit around eating and talking about the old days in Mississippi and what was happening in Chicago. Many of their children knew each other and some of them even worked together.

Looking back on it, I believe that these kinds of hometown ties helped our people adjust to Chicago. It's exactly the same way people who came to America from other countries were tied together because of the place they originally came from.

I can still remember one situation which is a good example of this kind of support. Mama had a friend from Vicksburg who died pretty soon after she moved to Chicago with her husband, a guy they called Pappy.

The man was enormous. He must've weighed more than three hundred pounds and he worked in the stockyards. After his wife died, Pappy didn't have any relatives in Chicago, so once or twice a week he'd come and eat at our place. I can still see him sitting at the table eating most of the ham he'd brought for dinner. He had a couple of big scars on his hands and arms where he'd had accidents with his meat hook. He worked in the curing department and the salt had bleached his hands white. Being a child, I'd never seen anything like this, and I would stare at his hands until Mama took me aside and scolded me.

My uncles had moved out of the apartment a couple of weeks before we arrived. Naturally, living with their mother and sisters didn't give them the kind of freedom they needed. I can imagine how exciting Chicago must've been for them in the early '20s. You could earn a decent living and you had a kind of freedom that didn't exist for blacks in the South. They could do just about anything they wanted, and after a while, each one got his own place.

Every Sunday morning, after Sunday school, I was sent over to my uncles to collect money to help with Mama's expenses for the next week. They both lived pretty close by and I always looked forward to going there. It was one of the real highlights of my week. And since each one was always shacked up with a good-looking young lady, it was also my first experience with anything having to do with sex.

It didn't matter if I was at Uncle Bob's or Uncle Matt's place, the scene was always pretty much the same. Whichever uncle it was would come to the door in his pajamas and take me back to the bedroom. We'd have to go back there because that's where they kept their money.

The woman who was there was usually still in bed and I'd be introduced to her. They were really marvelous-looking and my uncles treated them well. I'd almost always get a candy bar or a couple of cookies and these ladies would make a big fuss over me, saying something like, "Milton, you're a fine-looking boy. Just wait 'til you get a little older—the girls are gonna love you."

Then my uncle would reach under his pillow and get out his billfold. He'd hand me a five-dollar bill and say, "Son, this is for food." Then he'd hand me another five and tell me, "This is for Mama to buy some clothes. You tell her that." And then he'd say, "This dollar's for you, but don't tell anybody I gave it to you, understand?" My uncles knew that if my mother was a little short that week and knew I had a dollar, she'd take it from me.

Later on, as I got older and my uncles got more successful, they'd give me a little more spending money. They'd usually ask me if I had a girl, and after I stood there for a couple of seconds looking real embarrassed, I'd hear something like, "Take this extra dollar and go to a show this afternoon."

Even though I was living with four women, I never felt like I was missing a father. My uncles were available and willing to give me just about whatever kind of support I needed.

Titter did get married again, sometime in the middle '20s. The man's name was Andrew Downs but everybody except me called him Manny. I called him Mr. Manny. He didn't have a regular job, but he got some type of payment from the Army every month. After they got married, he moved into our apartment and he and Titter took over a bedroom for themselves. No one moved out, we just put a bed into one of the other rooms. I remember Titter once went out and bought some new furniture with one of Mr. Manny's Army checks.

They weren't together more than a couple of years before Titter put Mr. Manny out. She was always very hard on him. She ordered him around and she seemed to take advantage of the little money he had. But he was kind to me. He was mechanically inclined, good with his hands, and always willing to explain how things worked.

Everything went downhill for him after he left our place. He became a very heavy drinker and his health

suffered because of it. I always tried to keep in contact with him. In fact, years later when I was on the road with Cab Calloway and we played Chicago, I looked him up and tried to help out in whatever way I could.

In those early days in Chicago we needed all the money we could get to run our house. Titter didn't want to commute to Reverend Jones's church in Evanston, so she got a job as a gift wrapper in Rothchild's Department Store, which didn't pay much. Aunt Pearl had a similar kind of job. At first Sissy couldn't find work, but after a while she got something that was low paying too. And since Mama had bad knees, she stayed home and took care of the cooking and the other chores.

Mama was the matriarch, but for some reason Titter was the one who did the budgeting for the house. There was a real system to it. Everyone in the house who worked paid twenty cents a day for food. Then on payday they'd each put in another two dollars to pay for meat and the staples—potatoes, flour, lard, sugar—which we'd buy every Saturday. Even though my uncles only came for dinner on Sundays, they made those weekly contributions I picked up Sunday mornings.

Each day before they went off to work, Titter and my aunts would put their twenty cents on top of our big dresser for Mama to buy whatever food she needed that day. Mama did the real shopping on Saturdays, and I would do the small shopping every day. She'd send me for ten cents' worth of mustard greens, a nickel's worth of onions, fifteen cents' worth of neck bones—that sort of thing. We always used a little neighborhood grocery which was owned by a black lady named Miss Dandy.

Somehow every few weeks Mama managed to stash away money in a big old trunk she kept in her closet. She'd tie bills in handkerchiefs and stick them in different parts of the trunk, just in case somebody really needed something.

I'll never forget the time she helped me out. Titter had been walking around the house complaining

Titter with Milt's aunts, Pearl McKinzie ("Aunt Pearl") and Alberta Robinson ("Aunt Sissy"), Chicago, c. 1922

about my wanting to join the Boy Scouts and how she couldn't afford to pay for the uniform. Mama let her carry on for what seemed like a couple of days. Then finally she decided to take some action. "Sister, how much is that uniform?" she asked my mother.

"I don't know, because I can't buy it for him," Titter answered.

"Well, go ask that boy what it costs," she told her.

A few seconds passed and nothing happened. Then Mama called across the room to me, "Boy, come here! How much does that uniform cost?"

I told her the pants, shirt, stockings, and cap cost $9.75. She went into her closet, opened her trunk, fumbled around for a couple of minutes, and took out one of those knotted handkerchiefs. Her eyes were pretty bad, so after she unknotted it, she handed two bills to Titter and said, "Here, count this and see how much is there." My mother told her there were

Milt, Chicago, c. 1922

two twenties. "Take one of them and get that boy his uniform."

A couple of days after we arrived in Chicago, Mama took me over to the Doolittle Grammar School at 36th and Cottage Grove, a block or two from where we lived. It was a beautiful red brick building with a large playground surrounding it—I'd never seen a school like that in Mississippi. They gave me some kind of test so they could put me in the right grade. I'd just finished fifth grade in Vicksburg, so I cried when I found out I'd have to go back and repeat three grades at Doolittle. That's how different the education was for blacks in the North and South in those days.

Almost all the pupils at Doolittle were black, just like the neighborhood. The only white kids I'd see in school or on the streets were the children of some local shopkeepers who lived over their stores.

I can't recall any kind of bad racial problems when I was a kid. There was one time though, when a bunch of us were running through a dry goods store and knocked over a manikin. The white shop owner grabbed two of us and called us "little nigger bastards." It wasn't serious, but it really hurt my feelings.

As a kid, it seemed to me that the attitudes of my parents' generation were much more negative toward whites than ours. There was distrust and an awful lot of fear. I know my mother tried to teach me this from the time I was very small. I remember hearing negative things about whites even when we lived in Mississippi—people like the clothing salesman who sold door-to-door, or the insurance man and piano guy who came around collecting money every week.

When I was growing up in Chicago, there was a real difference between light- and dark-skinned blacks. Part of it was a social thing—light complected people seemed to feel they were better or higher class than other blacks. Back in those days, the advertising companies always used light-skinned models to sell their products, and even though nobody ever said it out loud, the message given to blacks was pretty clear—you'll get ahead in the world if you look as white as you can. There was also the economic side to it. When I was a kid, all the black professional people I saw were light-skinned.

Ever since blacks have been in this country, their women have had white men's babies. It's also pretty well known that over the years, a lot of Southern white men have had two families—a white one and a black one. I'm sure if you went back and looked at the family backgrounds of some of the really successful light-skinned people, you'd probably find a rich white male ancestor who started it all. Many times these men took care of their mulatto children by giving them a start in life, like a good education, which could lead to a decent job. When these children were at school, or later when they worked, it was natural for them to be surrounded by people from the same kind of background and very likely they would marry one of them. Their children had the same physical characteristics, plus all the other advantages that education and a good job bring about.

I also heard stories from my mother about mixing that went on in the South with a much different class of people. She used to talk about one little settlement in Vicksburg, down near the train tracks, where all the men were white railroad workers and the women they lived with were black.

In fact, my mother had a friend who lived down

there with one of these guys and they had two or three children. This woman used to sneak over to our part of town to see my mother. None of the men wanted their women associating with other black people in town, and the same thing went for their kids. Naturally, whites wouldn't have anything to do with them, so they developed their own small community. My mother said they even had a little school just for their own people.

From a social and financial standpoint, these white men didn't have very much, and the women they lived with didn't seem any different from the rest of the blacks in town. The way my mother put it, though, the children in that community grew up thinking they were better than other black kids. So even though they didn't have all the advantages that mulattos from rich families did, they still had something important. For one, they lived better than most blacks in Vicksburg. It's also likely they grew up with a more positive attitude about themselves. And most important, since a lot of them were light-skinned, they had a better chance of getting a good job, especially when they moved up north.

Getting back to my grammar school in Chicago, we had black and white teachers at Doolittle. One of my favorites was a guy named Lucas who ran the playground. I also got very friendly with a boy in my class named Ralph Metcalfe. Later on, he became an Olympic champion and then a congressman, and we kept up our friendship through the years.

I stayed at Doolittle until I finished the sixth grade. Since I'd been left back a couple of years in school I was almost fourteen.

During this time, we lived in four or five different places. We stayed at 36th and Vincennes for about two years. After that, we sublet two different places on Rhodes Avenue, where we shared a kitchen and a bathroom with another family. Then in 1923 we moved to 3836 Rhodes, which was the first apartment that was all ours.

When I look back on it all now, I realize how difficult it must have been for rural people to adjust to a place like Chicago—and do it almost overnight. I was a kid, and like most kids I could handle change pretty easily. The cold weather, the thousands of people, the strange neighborhoods—all that never bothered me.

As best I can recall, the first time I heard music I loved was in Vicksburg. In warm weather they had people called troubadours—groups of musicians who went around playing from house-to-house late at night. They played very softly, maybe because it was so late. There was usually a singer who played guitar, a string bass, a clarinet, and maybe even a jug. I remember the sound of a bowed bass, which was really prominent in those groups. I guess they didn't use a tuba because it would have been too loud.

I used to wake up in the middle of the night to the sound of that kind of music. Everybody in the neighborhood would be standing out on front porches watching and listening. After the group finished a few tunes, people would throw them pennies and then they'd move on.

Titter taught piano and played for the church choir, so there was always music in our house. Even in Vicksburg we had that piano, which was pretty unusual for those days.

I heard a great deal of church music when I was in Mississippi, but I also remember hearing ragtime and some songs from World War I. In fact, a couple of years ago I was working someplace with Dick Hyman, a great piano player who's very interested in musicology and music history. He told me he'd just found a beautiful old song from the early part of the century and he played a couple of bars. I recognized it immediately. It was one of those songs I'd heard as a kid in Vicksburg. My Aunt Sissy had sung it in a church play and I could still sing part of it—something like, "I don't care how mean you are to me, Daddy. Don't leave me, Daddy. I know the reason why you're leaving."

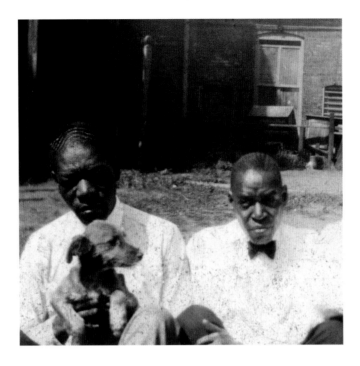

Uncle Bob and Uncle Matt,
Chicago, 1922

My Aunt Pearl sang in church choirs for most of her life. She knew all the religious songs and some of the classics too. Titter accompanied her on the piano, but she didn't have as strong a voice, so she sang the alto harmony parts. There were always people singing at our house after dinner on Sunday or after choir practice. And I'm sure this kind of thing went on at our place because we had the piano.

Once we got established in Chicago, we got a studio upright. It had a piano roll in it and when you closed the cover you could pat your feet and play it.

Some of my earliest memories of music in Chicago involve my Uncle Matt. He was crazy about Louis Armstrong, but he loved piano more than any other instrument. He never had a chance to study, but he learned to play some songs by ear. It seemed to come naturally to him and probably had something to do with his great mathematical abilities. He was a tall, lithe guy, with big beautiful hands and very long fingers, so his body was well suited for piano.

Every Sunday, the minute Uncle Matt arrived for dinner, he'd head straight for the piano. And while the women were cooking and setting the table, he'd play and sing for maybe an hour.

"Hear me, why you keep fooling, little coquette," he'd sing. "Coquette" was one of his favorite tunes.

There'd always be a cigarette hanging from his lips like Fats Waller. He didn't know more than three or four numbers and couldn't tell one note from another, but when you watched, you knew it was pure joy for him.

During the early '20s when I was growing up, the Southside was unbelievable from a musical standpoint. It probably had to do with the fact that during this period there were three times as many blacks in Chicago as in New York. I once heard that by the mid '20s, there were eight hundred thousand blacks, which made up about a quarter of the city's population. It likely happened because there were more new jobs available in Chicago, and since it's much more centrally located than New York, it was easier to get to from the South by railroad.

The size of the black population also meant the Southside had three times as many theaters and nightclubs as New York. The Vendome and the Grand Theatre were in my neighborhood, and they had pit bands with strings, tympani, and great trumpet players. There were ballrooms and nightclubs. During the early '20s, all the action seemed to be centered around South State Street between 26th and 35th. There were places like the Royal Gardens, a big club called the Entertainer's, and places like the Elite Club and the Panama and Dreamland Cafés. By the middle '20s, blacks had moved farther south and the club scene shifted along with them. There was the Sunset Cafe, the Apex, and the Plantation Café, all located around 35th and Calumet.

Starting from the time I came to Chicago in 1919, I'd spend my Sunday afternoons seeing a live show and a silent movie at one of the theaters. Dave Peyton had the orchestra at the Grand Theatre with musi-

cians like Oscar Lowe on sax, a trumpet player named Raymond Whitsett, and Jimmy Bell on violin. I liked Erskine Tate's Orchestra at the Vendome much better. I think he had that job for about ten years and at one time or another he must've brought in every good musician around Chicago. I'd see Teddy Weatherford playing piano, the great clarinet player Barney Bigard, and a percussionist named Jimmy Bertrand. I remember we'd sit there in amazement when he'd play the melody to a blues called "My Daddy Rocks Me" on tympani. Evidently, in those days he was about the only black guy around who could play all the percussion instruments, and I've heard he's the one who taught Lionel Hampton about xylophone.

Louis Armstrong was also in the pit. I can still see him standing up right next to Erskine Tate for the finale. He always brought the house down. And then they'd show the movie.

I always paid particular attention to violin players in those orchestras, probably because it was the instrument Titter always wanted me to play. She had high hopes for me, and I think even when I was a little kid, she truly believed I could make it as a legitimate musician. I saw violinists like Wright Smith, Clarence Black, and Charles Elgar dressed up in tuxedos and looking very dignified. These men were black and always looked very proud.

Then there was Eddie South, one of the stars and a marvellous violin soloist. I loved him from the start. He was my inspiration and my idol. Whenever I saw him, I knew what I wanted to be when I got older. I really worshipped him.

Every kid in our neighborhood was taking music lessons. Most girls seemed to take up piano, and the boys usually went for violin. I was pretty typical. For my birthday in 1923, Titter bought me a violin. It didn't come with a bow, so a friend of hers, Mrs. Bobo, got one for me. And the same day, my Aunt Pearl got me my first music book. She was the real talented one in our family and she always tried to encourage my musical pursuits. Unfortunately, the book

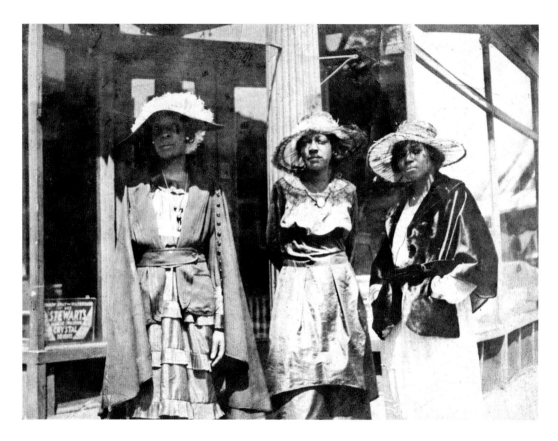

Aunt Pearl, Titter, and Aunt Sissy, Chicago, c. 1921

she found was so complicated I was never able to play it. Of course, it was the thought that mattered and I've never forgotten her gesture.

There were a couple of older boys in the neighborhood who'd been studying violin, and my mother gave one of them twenty-five cents to tune my new instrument. I remember him very well. His name was Quinn Wilson and later on we went to high school together.

James M. Jones, a man who lived across the hall from us, tried to show me something about music scales. Evidently, he'd been a songwriter when he was younger, but then had some kind of accident or sickness and lost a leg. I remember hearing how he had eyes for my mother, which is probably the real reason he took an interest in me. We didn't hit it off too well, so after one or two sessions our relationship ended.

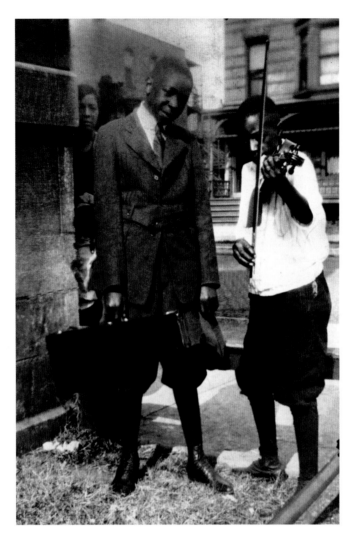

Ed Burke and Milt (Titter in background), Chicago, 1923

teach the basics. Lessons cost fifty cents and I'd take them in the back of his store.

I also went over to Hull House on Saturday mornings to take lessons. This is, of course, the famous community center on the Northside that was started by Jane Addams and is still active to this day. I didn't have a regular teacher, but lessons were so cheap it didn't matter. This is where I first got to know Benny Goodman and a few of his nine brothers and sisters. We were both in our early teens, and even though we studied different instruments, we'd spend time talking about music.

When I'd finished a couple of the simple violin books, maybe six months after I started playing, my mother switched my teacher. She found a black man named Mr. Woodford who lived in the neighborhood and was willing to come to our house and give me lessons for seventy-five cents an hour. I guess Titter figured the extra money was worth it, because each week she could sit and watch the lesson and then supervise my progress. I remember her asking Mr. Woodford exactly what I was supposed to practice, how long I should practice each exercise—those kinds of questions. Titter forced me to practice every day. Truthfully, I think she's the one who helped me create a kind of self-discipline which stuck with me through my entire life.

A couple of years later, when I got to be pretty good, she switched my teacher again. This time she picked Professor James Johnson. I guess she felt I was disciplined enough at this point, because she let me go to his house for lessons. He was about seventy years old, very serious, and he loved music. He'd studied all over the world and he had the degrees and certificates he'd gotten from Oberlin College and other places hanging on the walls. It reminded me of a doctor's office. I respected this man. He had a great mind for music and he really influenced my thinking during those early years.

For years I had a paper route in the neighborhood delivering the *Herald Examiner*. One day I found out

I took my first real violin lesson from a man named Joe Black. He was white and owned a little music store at 39th and Cottage Grove, a few blocks from where we lived. Mr. Black wasn't a trained teacher at all. He was really a merchant who sold music and played banjo. If you bought the latest songs from him, he'd spend a couple of minutes showing you how to play them. That's the way he sold a lot of his music. But he was a nice man, good with children, and he knew enough about different instruments to

that a new customer on 42nd and South Parkway was Eddie South's mother. Needless to say, I was very excited about this lady. She was tiny, kind of shy, and looked much too young to be his mother.

The first couple of times I was at her place collecting twenty cents for the week, I'd stand in the doorway trying to get a look at some of the photos of Eddie hanging on her walls. She must've noticed what I was doing, because after a couple of times, she asked me to come in and look around. She wanted to know if I was a musician and I told her I was studying violin. She told me about her son and how he was over in Europe playing in fancy places. Then, one time she said something I'll never forget: "If you keep concentrating on your studies, maybe one day you'll get to meet my son." Of course, I realize now that she was just being polite, but at that age, her words inspired me to work harder.

There was another person on my paper route who was involved with music and left an impression on me. His name was Mr. Hoskins and he lived in a little basement apartment. He did manual labor—shoveling coal from the street where the trucks had dumped it into the basement coal chutes that everybody had in those days. I can recall many warm nights when I'd see him sitting on the stoop in front of his place playing guitar and singing the blues. He was real country. His voice was nasal and the lyrics were always risqué. Sometimes he'd play his guitar with just a bottleneck in his left hand, which seemed to give him an electric kind of sound. I'd never heard singing or playing like that before and that sound stuck with me.

By 1925, my Uncle Matt had become a strong-arm guy for a black man from Vicksburg named Slim Thompson. The summer I turned sixteen, my uncle got me a job working in a cleaning and pressing place at the corner of 37th and State. It was owned by Pete Ford who was also from Vicksburg.

My job was to wait on customers in the front of

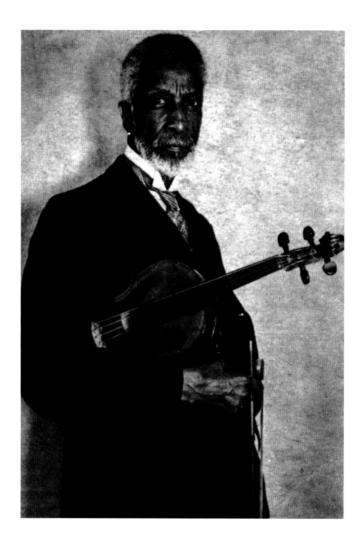

Professor James Johnson, Chicago, 1925

the place. If someone came in and wanted something cleaned, I was told to tell them the cleaner was on vacation and would be back in a week. But if somebody wanted a suit pressed, I was allowed to do it. They had a brand new Hoffman press which was pretty simple to operate. And I could keep the twenty-five-cent charge for myself.

After about a week, I figured out what was really going on in the place. There was a cleaning and pressing operation in the front, but the real action was in the back. Every few days they brought in vats of grain

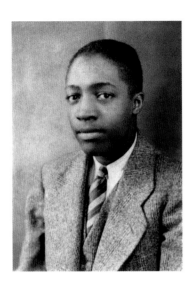

Milt, Chicago, c. 1926

alcohol, poured it into gallon cans, and stored it in cases. Then about twice a week there'd be a delivery of dozens of cases of regular government-bonded whiskey. Next, they opened the bottles and poured the whiskey into huge tubs, where they mixed it with the alcohol from the cans. Then they put the new mixture into pint bottles. Doing it this way, they could make three cases from the one good case they'd brought in.

I learned pretty quickly that Pete's place was tied into Al Capone's organization. Capone had opened a distilling factory at 37th and Wabash, in the middle of the Southside, and he'd arranged with Slim Thompson to handle the bottling and distribution for him.

Evidently, whenever Capone opened a new operation, he'd use neighborhood people. He built up trust in a local area very fast that way and it gave him plenty of new customers. So at Pete's, everyone was working for Slim, who was tied in with Capone.

Pete liked me and treated me right. Maybe it was because his people and mine knew each other from Vicksburg. He was a good-looking guy and built something like Babe Ruth—thin arms and legs and an enormous stomach. He was fair complected, but his mother was as black as a pair of patent-leather shoes. He loved her more than anything. He hadn't gotten married, so he bought her one of those beautiful big houses on the Southside. The two of them lived there together for years. Pete could eat more than anybody I knew. He used to send me out for sandwiches and he'd order five or six for himself. He'd tell me, "Better get two for yourself, 'cause you ain't gettin' none of mine," and he wasn't kidding. He could drink too. He'd open one of those pint bottles, lift it to his mouth, and drink it all in one gulp.

On Saturday mornings Capone would come by the place. There would always be a couple of dozen white policemen, wearing their regular uniforms, standing around on the curb right next to the side door. Capone would pull up in his long bullet-proof Marmon. He always wore one of those big hats on the side of his head, just like in the movies. The minute

the policemen saw him they'd line up, single file, like a theater line, and each one would wait to collect his weekly pay. I think sergeants got ten bucks and the regular patrolmen got five.

I saw Capone get real nasty a few times. I remember seeing him slap some policemen and I once saw him kick a porter in the behind. It was strange, though—whenever he hit somebody, just before he drove off, one of his lieutenants would hand the guy a twenty-dollar bill.

After I was working there about a month, I was given some more responsibilities. Every week a black guy who I heard was with the government came in with bond stamps which were on sheets about the size of the *New York Times.* I had to sit and cut the sheets into little strips so they'd fit over the caps of the bottles men were filling in a back room. From time to time, they'd also call me into the back to help them glue the strips and seal the bottles. When things were slow, Pete told me, I could still do pressing if I wanted.

A couple of weeks later they got me involved in delivery. By this time I was making ninety dollars a week, which was unheard of in those days. I bought some new clothes and spent a couple of bucks on food every day, which was a lot of money back then.

We sold most of our booze to flats all over the Southside. These were places that catered to men. You could drink, eat, have a woman, and get just about anything you wanted. There were fancy flats and cheaper ones, but they were all set up like apartments. There was a living room with a lot of food and booze around. It was pretty informal. You'd help yourself to whatever you wanted and the lady who ran the place kept track of what you'd taken. Of course, she also knew if you spent some time in a bedroom with one of her girls. And before you left, she'd tell you what you owed.

There was a phone in the back of Pete's so customers could call in their orders. We sold gallon cans of alcohol for eighteen dollars and pints for five apiece—that was wholesale. The customers who bought the

straight stuff usually made their own bathtub gin with it. I don't know what they'd resell pints for, or what homemade gin cost, but Uncle Matt once told me that we paid Capone six bucks a gallon, and we were getting three times that. So everybody involved made a hell of a lot of profit.

Pete had a couple of panel trucks with different signs mounted on the side. I remember one was "Ford Cleaning and Pressing" and another said something like "El Paso Cigars." But I never saw anything else in them except booze.

My job came to an abrupt end before the summer was over. Late one afternoon, Pete asked me to make a delivery with him. I didn't have a license, but my uncles had always let me drive whenever a car was around. Like most teenage boys, I loved cars, so whenever I went with Pete, I'd ask if I could drive. And most of the time he'd let me.

In those days everybody paid cash on delivery, so Pete always carried a lot of money around with him. He'd usually have a roll of tens and twenties, maybe fifteen hundred dollars' worth, in the pocket of his shirt.

This particular afternoon, we had to deliver to a flat at 46th and Drexel, way over west. Pete sat up front in the passenger seat next to me, eating and drinking all the way. But when we were only a couple of blocks from the place, a lady in a Nash came from nowhere and hit us in the side. The truck spun around, I went right through the front window, and Pete went out the side.

I don't think I ever lost consciousness. I remember being stretched out in the street and seeing Pete lying face down about ten feet away, looking like he was dead. There was so much alcohol on the pavement, it looked like it had just rained. I managed to crawl over to Pete and take the money out of his shirt pocket. Then I grabbed hold of something on the side of a parked car and pulled myself up. I knew I'd broken my leg and my right arm. And I saw the ring finger on my right hand was just hanging by a thin piece of skin.

But I was more upset about all the blood around my face. I was cut bad and wanted to get to a car mirror so I could look.

By this time a crowd had gathered and the area was blocked off. The first ambulance took Pete, and a couple of minutes later another one came and got me. For some reason we ended up in different hospitals.

I must've passed out in the ambulance, because the next thing I remember was my Uncle Matt standing next to me in the Emergency Room. Eddie Pappan, one of Capone's lieutenants I'd seen around Pete's, was there too. I had splints and gauze bandages all over and by this time the pain had really hit me. I was sobbing, but I managed to give my uncle the roll of bills I'd taken from Pete.

Two doctors came into the little cubicle where I was and talked to my uncle and Pappan. I could hear all of it. One of them said I had a broken leg and arm, and the other one added, "His finger's just hanging by a thread. We're gonna snip it off."

When I heard that, I went out of my head. I started yelling, "You don't touch my hand! You can't take my finger off!"

I could tell my uncle was getting real mad. He started speaking very slow and soft, which usually meant he was about to throw someone out a window. But before he could get himself worked up, Pappan turned to the doctors and said, "You don't take it off. You fix it!" It sounded like he was giving orders to a couple of henchmen. His voice wasn't loud, but his tone was so threatening it seemed to shake the walls of the little cubicle.

They spent hours working on my finger and finally got it back together. They did a pretty poor job, though—one bone goes the wrong way and another one's completely out of place. But eventually I was able to use it again, and I guess I have Eddie Pappan to thank for that.

The next day Titter came down to the hospital. This was the first time she'd heard about the kind of summer job I really had. Naturally, she was angry at my

uncle for months afterwards. She made him promise her that he'd break away from Slim immediately, which he did. Still, she never really trusted him the same way again.

I was in the hospital for weeks. Pete died a day or so after the accident, and a couple of weeks after that Slim was murdered. A lot of people said he was killed because of what had happened to us. It seemed that whenever something bad occurred, one of the bosses ended up dead.

The whole experience was sobering for me. I never had anything else to do with illegal booze, and to this day, I've never driven a car again.

By this time I was going to school at Wendell Phillips. Actually, I'd started there in junior high and went straight through high school in the same building.

Other than my experiences with music and musicians, I don't remember many things about Wendell Phillips. I know there were a lot of students involved in sports, especially basketball. In fact, we had a white coach named Harris who'd win the city championship just about every year.

There were some tough kids in our school. But back then, being tough meant something different than it does today. There was no dope and no boozing to speak of, but there was always a crap game going on in the boys' bathroom and guys would bet on making baskets in the gym. And there were always a couple of gangster types who'd try to take your money.

During my first couple of years I got picked on quite a bit. I was short, I wore glasses, and I always carried around a violin. With a name like Milton, it's no wonder they were after me so much.

It didn't take long for me to work out a way to fight back. I made a deal with a football player named Robert Rivers. He was huge, well over six feet, and weighed about 225. He was a terrible student, but in order to stay on the team he had to pass all his

courses. So I did his math homework, and in exchange he walked me back and forth to school every day. I think the arrangement worked out well for both of us.

People have talked about musicians coming out of other schools in Chicago, like Austin High, but we had some unbelievable talent at Wendell Phillips.

Quinn Wilson, the guy who tuned my first violin, was there. He was a couple of years ahead of me and I really looked up to him. He was a brilliant musician who played violin and piano and could also write beautiful songs. He was a captain in the ROTC, which was something I always wanted to be. Eventually he switched over to bass and worked with Earl Hines for a while. I think he would've gone much further in music if he hadn't gotten married and bogged down with children so early. But that's an old story with many guys I've known who could have been real stars.

Then there was Dan Burley, a wonderful skiffle piano player. I remember him playing whenever we'd have a party. He was the editor of the school paper and worked as the managing editor for the *Amsterdam News* later on.

Joe Marshall, the drummer, also went to Wendell Phillips. He eventually made it to New York and worked with Arthur Godfrey on radio and also did a slew of Broadway shows.

There were some good bass players, like Bill Anderson, Bob Marshall, and Jesse "Po" Simpkins. Bill made the transition from violin and ended up staying in Chicago, but Bob eventually settled in Seattle and Po moved out to San Francisco. Then a few years later John Levy came to Wendell Phillips. Of course, he went on to play with guys like Stuff Smith and George Shearing and eventually got into the business end of music in California.

Dorothy Donegan lived down the street from me and was playing good piano. I thought she was beautiful and for a couple of months I'd follow her home from school almost every day. I must've asked her to play duets with me dozens of times, but she'd always tell me to get lost. Years later, when I was busy in the

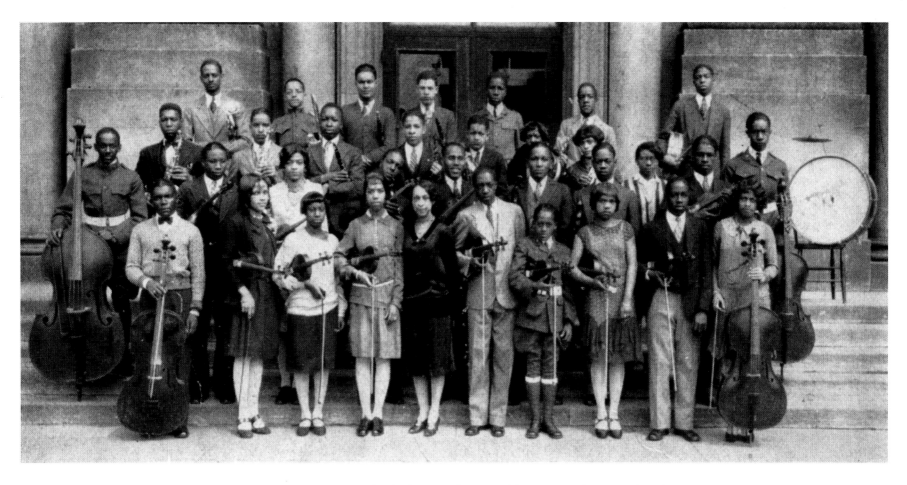

New York studios, I had my chance to get even. One day she called me for a record date and I told her to get lost. Until she passed, whenever I saw her, we'd laugh about it.

After a couple of years, some of the best musicians graduated and I had more seniority. Bill Lyle replaced Quinn Wilson as first chair in our symphony orchestra and when he graduated, it was finally my turn. Pretty soon I became president of the symphony. I was also made director of the booster orchestra, which played for dances and proms and during the intermissions at assemblies when they showed silent movies. I was getting to be one of the school's musical stars.

I never played any jazz during this time because both the symphony and booster orchestras played highbrow stuff. Music was written out and rehearsed and there was no ad-libbing or improvising whatsoever.

Our symphony was run by a black lady, Mildred Bryant Jones, who was the head of the Music Department. She also taught classes in theory and music history, which most of us took during our four years of high school. She was a tiny lady, but she had a way of scaring the hell out of the biggest guys. She wouldn't use a loud voice, just a certain kind of look which would make anyone obey.

Not only was Mrs. Jones interested in our musical education, but she was also very concerned about

Wendell Phillips High School Symphony Orchestra: Milt (*front row, sixth from left*) **and Mildred Bryant Jones** (*front row, fifth from left*), Chicago, 1929

giving us some practical knowledge. I think she really wanted us to be well-rounded. The orchestra played all the classics, and she'd always explain where the music came from and how it came to be written. She'd arrange trips for the orchestra, but before we went she'd talk to us about how we should act in public. She knew about our backgrounds and how we were lacking in this area and she wanted to be helpful. I remember how she'd sometimes stop right in the middle of a class or a rehearsal and talk about manners and what it meant to be polite. She even set up a dinner table once, just to show us the proper way to use dishes and silverware. She was concerned about giving us pride and dignity. Mrs. Jones didn't want us to embarrass ourselves or our community. Her lessons really stuck with me.

Wendell Phillips also had a great brass band that was part of the ROTC program and was run by Major N. Clark Smith. Evidently, he'd developed quite a reputation around the Midwest. He'd worked at a school in Kansas City and at Sumner, a black high school in St. Louis. Trumpet was his instrument, but he could also play woodwinds and violin.

By the time I got to know Major Smith, he was famous around Chicago. When I was a freshman, he talked about bringing Frederick Stock and the Chicago Symphony to our school. We joked about it for months. We were certain that those kinds of musicians couldn't possibly come out to a high school in the middle of the Black Belt. But one day they showed up for one of our regular assemblies, and they were absolutely amazing. It was the first time any of us had heard that kind of sound and it was truly inspiring.

I knew I wanted to be in the marching band right from the start. A couple of my best friends had already joined. There was George "Scoops" Carry, a great clarinet player who went with Earl Hines and then later on gave up music and became a lawyer. Scoville Browne was there on saxophone and Ed Burke played trombone. Ed Fant also played trombone, but he was always more interested in organizing things than in

playing music. And he was the kind of guy who could go to one class a week and end up with a good grade for the course.

You got a lot of prestige from playing in the band. The military uniforms were beautiful and you could work yourself up in rank. The band marched at football games, which meant you'd get the best seats—free. You also got to travel with the team when they played out-of-town games, and I can still remember seeing the gaslights in the streets when we went to St. Louis. Besides, everybody thought Major Smith was a great teacher. He rehearsed the band diligently. He was known to be a stickler for exactness and intonation, but you gained a tremendous amount from the whole experience.

Naturally, I couldn't make the band on violin, so I had to switch instruments. Ed Burke had switched from violin to trombone to get in. Ray Nance, who was a couple of years behind me, also played violin. In fact, after I graduated he became the first violinist in the school symphony.

Anyway, Ray and I changed to brass instruments right around the same time. For some reason I don't remember, Major Smith gave him a trumpet and I got something called a peck horn. It was used for playing oom-pah-pahs, which were supposed to be good for teaching you how to count. I think one reason Ray learned to play trumpet so well was because Major Smith played both violin and trumpet. He was able to show Ray how to make the transition and he always devoted a lot of time to him.

Right from the time I got the horn, I complained. After a very short time I was moved over to bass saxophone, but that didn't satisfy me either. I'd really gotten to like the low brass sound and I wanted to play tuba. But there was a problem—there were only two tubas in the band and both of them were taken. The two guys who played them were Hector Crozier, who was so enormous the tuba looked like a shirt collar around his neck, and Eddie Cole, Nat's older brother.

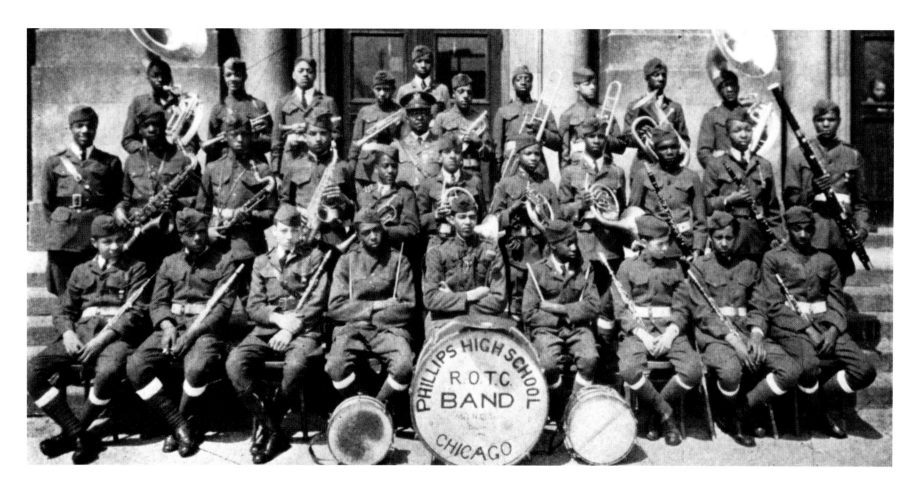

Nat was one of my mother's favorites because he played such beautiful piano, even when he was a kid. And she could always get him to come and perform at one of her church socials. In fact, all through the years, even after he died, she referred to him as "that dear Nathaniel."

All of us always thought Eddie was the real talent in the Cole family. He could sing, play piano and bass, write clever songs, and do just about anything musical. I remember how he'd perform at school, get up on the stage alone and do all his own material. He was brilliant at it.

Eddie left Chicago before any of us even finished school. He went to New York and got a job with Noble Sissle. They toured Europe and I remember Eddie coming back to visit, trying to impress everyone with his French and German. He'd been pretty successful over there and that gave him enough encouragement to form a band and take it out West. Nat was playing piano with him, and two other brothers, Isaac and Fred, were there too. But by the time they got to Dallas they'd gone bust. The group broke up, but Nat continued on to California, and of course everyone knows the end of that story.

A couple of years after that, Eddie formed another group called Three Loose Nuts. It was a comedy act where he played piano, sang, and danced, but they never made it big. Years later, after Nat got successful,

Wendell Phillips High School ROTC Marching Band: Milt with tuba (*back row, far left*) and Major N. Clark Smith (*second row, sixth from left*), Chicago, 1929

he tried to help Eddie by getting him some TV work out in Honolulu. That didn't work out either. Even with all that talent, he was always backstreet.

To get back to those high school years, when Eddie left school to go to New York, I got to move over to tuba. And the other tuba chair opened up a couple of weeks later after an incredible scene between Hector Crozier and Major Smith which I've never forgotten.

Major Smith always used a drumstick to conduct our rehearsals. On this particular day, Hector was playing so bad that after yelling at him four or five times, out of desperation Major Smith threw his drumstick in Hector's direction. It bounced off the side of Hector's horn, but before it hit the floor Hector had his tuba off and had thrown it at Major Smith. Needless to say, that brought a sudden end to Hector's high school music career.

By the time I graduated from Wendell Phillips, I was one of the three or four officers in the band. That meant I got to wear a Sam Brown belt that went around my waist and across my chest. When I left, John Levy had just become an officer, and I saved him the price of a belt by giving him mine.

There was another brass band outside of school we all joined. It was sponsored by the *Chicago Defender* newspaper and was also directed by Major Smith. Being in it gave you a lot of prestige. The uniforms were very distinctive and you'd get to march in parades all around Chicago—which meant free food and plenty of girls. Lionel Hampton was one of the drummers in that band. So was Hayes Alvis, the bass player who eventually worked with Earl Hines and Duke Ellington. Neither one of these guys wanted me in there because I was younger and pretty small and I still wore short pants. They didn't want Nat Cole either because he was even younger than me. But I fought with them about it. I knew I could read music better because I played violin and was accustomed to the notes. Major Smith knew it too and he always wanted the best guys.

So I went in on tuba and Nat played a drum, even though he'd played tuned bells in the school band.

I also made the All City Orchestra, which was made up of the best musicians from the twenty-three Chicago high schools—both black and white. Most kids had to wait until they were seniors to get in, but I made it for three years straight and got bronze, silver, and gold medals. Actually, the first two years I played violin, but by the third year I'd made the switch over to bass.

We'd get together once a week for most of the year. We also got to watch Chicago Symphony rehearsals whenever we wanted. Then, in June, we'd be rehearsed by Frederick Stock and play a concert downtown in Orchestra Hall with department heads from different high schools conducting.

In 1925 our family rented a beautiful place at 4143 Vincennes, in a neighborhood which had been all white a short time before. We belonged to the Ebenezer Baptist Church, which had been at 35th and Dearborn for years. But after the Southside grew, the church moved into a synagogue it bought at 45th and Vincennes. I still have a mental picture of Reverend Thomas—tall, fair-skinned, with long white hair, looking like the Lord himself—standing up in front of the two Stars of David which had been carved in the stone pulpit by the former owners.

Because I was the one in the family who usually looked after Mama, and religion played such a big part in her life, I had to spend a lot of time in church. And like most teenagers, I found the whole scene very boring. But Mama seemed to recognize the problem and she was pretty understanding about it. Even though she'd sit in the first or second row, she let me stay up in the balcony, which was usually empty, and I could read or talk to my friends.

There was one experience I'll never forget. Shortly after the church moved to the new building, Reverend Thomas died and a new minister was hired. After a couple of months, members of the congregation began complaining about him, accusing him of using church funds for his personal benefit. The deacons investi-

gated and fired the minister. But he refused to leave, even after they'd hired a replacement.

The showdown came one Sunday when the deacons were escorting the new man down the aisle to the pulpit and the old minister refused to step down. There was shouting and fists started flying. It was good I was there, because by the time the real violence began, I'd already swung over the front rail of the balcony, jumped down about eight or nine feet to the first floor, and was moving Mama to safety.

During this time, I'd still spend some of my Sunday afternoons in the theaters, but by now I was going to different places.

Blacks had become much more visible in all parts of Chicago. For years the wealthiest families—like the Swifts and Armours—had their mansions on Grand Boulevard. But as blacks started moving south, these big houses were sold to rich blacks like Madam Malone and Madam Walker, the two ladies who'd made their fortunes in hair and skin products for black women. In fact, in 1926 Grand Boulevard was officially renamed South Parkway.

Now more and more blacks were going downtown to shop during the day and for entertainment at night. Naturally, this got many whites upset. So pretty soon some new establishments opened right in the heart of the Black Belt to serve local people.

In 1926, the Metropolitan Theatre at 46th and South Parkway put in a new orchestra and opened its doors to blacks for the first time. The orchestra leader was Sammy Stewart and he had some great players with him. I remember seeing Bob Shoffner, a wonderful trumpet player, and Jimmy Bertrand, who'd been the drummer at the Vendome a few years before. But by this time he had an even bigger set of tympani.

In late 1927 and early 1928, a complex of buildings opened at 47th and South Parkway that was something like a modern shopping center. I remember playing ball in the hole they were digging for the foundation a couple of years earlier. There was the South Center Department Store, a five-and-ten, a drugstore,

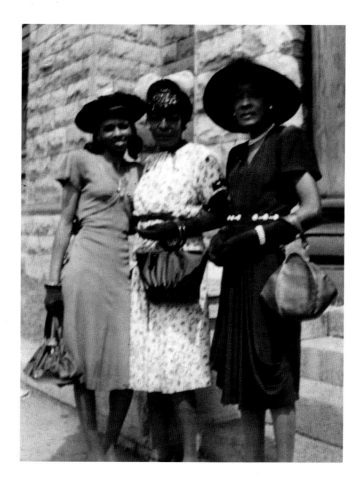

a Chinese restaurant called the Chu Chin Chow, and the Savoy Ballroom. But the centerpiece was the Regal Theatre, which was as big and plush as any downtown place.

Dave Peyton, who I used to see at the Grand Theatre, led the pit orchestra, which had at least twenty-two pieces. Reuben Reeves was one of the trumpet players, Jerome Pasquall was on sax, and for a while the drummer was Jasper Taylor, a real ladies' man. One time there was quite a scene when one of Taylor's jealous girlfriends, who was sitting in the audience, took a shot at him right in the middle of a show.

Aunt Sissy, Titter, and Aunt Pearl in front of the Ebenezer Baptist Church, Chicago, c. 1928

I loved to see Peyton because he used to play long overtures at the beginning of every show. There was always some kind of special lighting, and sometimes a chorus of singers or dancers would suddenly appear on the stage. These were real production numbers. For a long time Fess Williams, who was brought in from New York, conducted the stage band, the Royal Flush Orchestra. He was a flashy entertainer who wore white rhinestone suits and spoke very hip. He'd wave both hands in a strange kind of way when he conducted. He also played clarinet, and people thought of him as the black Ted Lewis. Percy Venable choreographed the regular dancers, the Regalettes, and there were always plenty of guest acts who sang and danced.

I can still remember seeing Duke's band at the Regal. He'd play there a couple of times a year and the shows he put on were unbelievable. I went whenever I could. I wanted to hear the stars like Johnny Hodges, of course, but I also wanted to see if I could get to know some of the guys in the band. After a while, a couple of the stagehands let me hang around the dressing rooms and walk just about anywhere backstage.

The guy I really looked up to was Duke's bass player, Wellman Braud. He was a very dignified New Orleans gentleman—an impeccable dresser—who seemed to be more high-class than the other guys in the band.

I sought him out. I'd try to be around whenever I got the chance, and if I saw him warming up just before a show, I'd get as close as possible so I could watch every one of his moves. I was always hoping he'd start a conversation—maybe even teach me something new. But he never did. He was quiet and seemed to keep to himself most of the time. He'd always greet me, smile, and act polite, but it never went further than that. Maybe he thought the way I was behaving was a little crazy—I'll never know.

I can still see the band on the stage dressed in white tails, and the set of drums Sonny Greer had in those days. I don't think there's ever been anything like it. In the back, behind him, there was a huge set of chimes, a vibraphone off to one side, and two or three tympani covered with rhinestones somewhere in between. Everything was custom-made and bright white, like the Arabian Nights. I don't know whether he could really play all those instruments, but he looked regal, sitting up there in the clouds behind the band. And I'll never forget how he played "Ring Dem Bells," moving around his instruments and reaching for the chimes.

During this whole period I learned a lot about music from listening to the radio. We couldn't afford an Atwater Kent, but we had a crystal set. I'd get a good crystal and stick the earphone into one of Mama's cut-glass bowls so we could all hear at the same time. The Chicago bands broadcast live at night, so I heard the greats like Earl Hines, Fletcher Henderson, Hugh Swift, Coon-Sanders, and Ted Lewis.

The Ritz Hotel and the Grand Terrace were right next-door to each other at 39th and South Parkway, and I'd stop and poke around just about every day on my way home from Wendell Phillips, which was at 39th and Prairie. There were always plenty of musicians around the Ritz. Many guys from the big out-of-town bands stayed there when they played Chicago, and I guess some musicians lived there permanently. It was like the President Hotel used to be in New York, filled with musicians, arrangers, copyists, and so forth. The Grand Terrace was pretty new and there were always all kinds of things going on there. I remember Fletcher Henderson's and Earl Hines's appearances more than anything else.

No matter which place I was in, I'd try to find a singer practicing or one of the big bands rehearsing. If I recognized one of the well-known musicians, I'd look for a chance to introduce myself.

Naturally, being exposed to this scene made me want a career in music even more.

2
My Career Begins

Looking back, I think the reason I finally made the switch to bass had to do with what was going on in the entertainment business in the late '20s.

I'm no expert, but it seems to me that the introduction of sound movies was the thing that really changed the industry. First there was the Jolson movie in 1927, and it was quickly followed by a couple of other talkies. Once they could put music in the movie itself, there was no reason to have live music in the theater where it was being shown. So after the first talkies came out, it wasn't long before the pit orchestras I'd grown up with began to disappear.

Talkies didn't really affect clubs which were still booming, and quite a few of the musicians who lost theater jobs began to work in them. But a theater gig was just about the only job around for a black string player. So when that work dried up, these guys were completely left out. I saw this firsthand. Dozens of violin players in my neighborhood were suddenly unemployed. But guys who played brass and reed instruments always seemed to be in demand.

Ed Burke is a good example. We were close friends ever since we were kids in Chicago. We lived in the same neighborhood, we went to Wendell Phillips together, and our families were so tight we grew up calling each other "play brother."

Burke was quite a character. And even though it's been about seventy-five years, I still remember an incident that happened in high school. There was an old black couple in the neighborhood who owned a little corner grocery store and paid Burke thirty-five cents a night to mop up. He knew these people kept their money in the bottom of a big flour barrel in the back room, and he also knew they were pretty forgetful and didn't keep good records. So every night before he left, he'd reach down in the barrel and pull up a couple of coins or a bill or two. He was always afraid of getting caught, so he never looked at what he got. He'd just keep it in his fist until he could slip it into one of the garbage cans. Then he'd wait until he was all finished mopping, and when he went to put out the cans on the street, he'd take the money out.

Well, one night when he got outside and checked the money he'd put in the can, he found two twenties. Evidently, he got scared to death. He didn't want to be seen with so much money, but he didn't want to return it either. I guess he figured since these old people didn't know what they had, they couldn't possibly miss it. So he went to a local bank and rented a safe deposit box to store the cash.

He must've forgotten about the box or didn't know how to renew the rental, and at the end of the year

Ed Burke with Milt's dog,
Sparky, Chicago, c. 1939

the bank sent a rental notice to his house. He wasn't home and his aunt got curious and opened the letter. After a lot of yelling and screaming, she marched him down to the bank and made him take out every last cent and return it to the couple. It was quite a scene and we laughed about it for years.

Sometime in his last year of high school, Burke switched from violin to trombone and got work immediately. It didn't take him long to get a steady job playing at the Cotton Club that Al Capone had opened in Cicero. This was about 1927. Walter Barnes, a clarinet player from Vicksburg, was the leader and he called the band the Royal Creolians. I always thought that name was funny, because as far as I knew no one in the band was from New Orleans. Lawrence Thomas was the trumpet player, Irby Gage was on clarinet, they had a good drummer named Bill Winston, and Lucky Millinder did all the choreography. The job paid seventy-five dollars a week and a short time after Burke got it, he quit high school.

At the time, I was in my sophomore year and still

had my neighborhood paper route. Having had to repeat a few grades when we came to Chicago, I was seventeen, a year or two older than my classmates. Anyway, there was one early morning scene involving Burke which seemed to be a big turning point in my musical career.

I always began delivering my papers about 4:15 in the morning. Around 4:00, a big newspaper truck would roll up to our house, and when the driver's helper dropped my bundle off the rear, the bang usually woke me up. I'd get dressed quickly, sling my canvas sack with papers in it over my shoulder, and walk my route.

I had a little dog named Spark Plug who went with me. I had good strength in both my left and right arms, so I'd walk down the middle of the street and throw papers on the right side of the block with my right arm, and on the left side with my left. Most of the houses were three stories high and had one apartment on a floor, and each apartment had a little balcony facing the street. Hitting the first floor was no problem, but after a while I got good enough so I could land a paper on the second- and third-floor balconies almost all the time.

When I delivered to buildings which had a couple of apartments on each floor, I had to go inside and drop a paper in front of each customer's doorway. I'd go into a building with Sparky and he'd run up four or five flights of stairs to the top floor. If there was a drunk sleeping in a hallway or a quarrel going on in one of the apartments, he'd make a lot of noise to warn me. When that happened, I'd just drop my papers on the first floor and leave as quickly as possible. Sparky was an amazing dog.

One morning just as I started out, a car came slowly down the street and somebody yelled, "Hey, Sporty," – my nickname in those days – "Get a horn!" It was Burke. He was on the way home from the Cotton Club and he was driving a brand new Ford with a set of flashy disk wheels.

Of course he stopped and showed me the car and told me how well everything was going for

him. It wasn't a malicious thing at all. He just wanted to see me making it as a musician too. A couple of weeks later, he even bought me a trombone and tried to teach me a few of the basics, but I never felt good about the instrument.

Seeing Burke early that morning really did it for me. I think it had to do with the humiliation I felt out there on the street carrying my papers. I knew I was as good a musician, but there he was in a new car making seventy-five dollars a week when I couldn't even make ten. At that point, I was sure I had no future on violin. Eddie South might've survived sound movies, but he'd always been a star and had to be one of the rare exceptions.

I decided that morning I'd have to make the shift to bass. I knew I wasn't good enough to make it on tuba, and besides, I'd always felt more comfortable with string instruments. I figured it couldn't be that difficult, because Quinn Wilson and a couple of other violin players I knew had already made the change. They were getting steady work too. The softer sound of a bass seemed to be replacing the harsher tone of the tuba, which had come out of the New Orleans parade-type bands. Also, big bands could absorb a tuba sound, but by this time there weren't many big bands left. So bass was getting pretty popular in clubs and smaller dance bands. In fact, there didn't seem to be enough bass players around to do the work.

At first, Quinn and Major Smith showed me a little about bass, but I really ended up teaching myself. It didn't take long to get used to the heavier strings. I started with a French bow, which is more like violin, so it felt comfortable. I bought a copy of the Simandl exercise book, but that didn't help me until much later when I got some formal training. I think I learned bass quickly because I seem to have the same mathematical abilities my Uncle Matt had. With me, they just showed up in a different way.

I learned how to convert from treble clef to bass clef. That let me figure out a system for playing bass by relating it to violin, which I knew much better. I realized that the strings on a bass and violin are reversed.

The bass strings are G-D-A-E, but on a violin, they're E-A-D-G. This means fourths become fifths when they're inverted. It's no big deal to someone who knows music, but the discovery was really helpful to me. I knew how to keep time and I knew how to read music, so once I worked out the relationship between the two instruments, I could convert from one to the other without actually reading. I was doing it all visually. If I saw a note on the fourth line of the bass clef, I'd play it with my fourth finger; if a note was in the third space, I'd use my second finger; if there was a flat, I'd play it with my first finger, and so on. For months I didn't know the names of the notes I was playing because the bass clef was so unfamiliar. But I'd mastered a system which worked, and no one really seemed to care if I could read the way you're supposed to.

For a while I played a bass that belonged to the high school, but I wasn't allowed to take it out of the building. As I got more involved, I decided I had to get my own instrument, so one day I went downtown to the Chicago Musical Instrument Company to buy one.

All they had was a brand-new bass—a flatback, built like a cigar box—and they wanted $175 for it. I only had $25 in my pocket and since I was still a minor, they wouldn't give me credit. So they took the $25 as a down payment and sent me home with some papers for my mother to fill out. That night she signed the forms and early the next morning I went down and picked up the bass.

I didn't use that bass very much. It was terrible sounding, and besides, I was able to get another instrument a few months later. But I kept it in Chicago for years, even after I joined Cab Calloway and was living in New York. I figured if the guys didn't let me make it, I'd always have something to play when I got back home. Eventually it just died. It had been leaning against a wall in my mother's apartment for so long the glue dried out and it collapsed.

I got my second bass as a result of playing in the All City Orchestra. It was my last year with them and

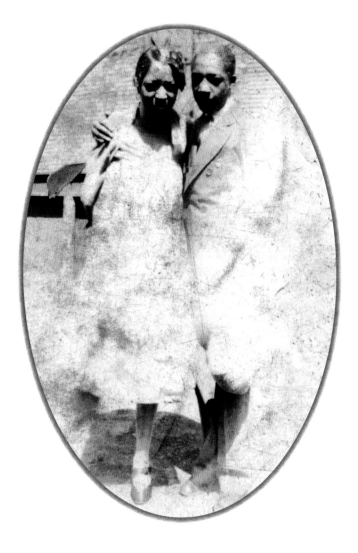

Titter and Milt, Chicago, c. 1928

a large room which had nothing else in it but basses, maybe fifteen or twenty. "Okay, try them out. See what you like," he said and left us.

We had a ball going from instrument to instrument—plucking, bowing, playing parts together, soloing. I remember the great acoustics in that room.

Mr. Lytton came back about half an hour later. He went around the room and asked each of us if we'd found a bass we liked. When we had all nodded that we had, he said, "The bass you picked is yours for as long as you play bass. If you ever decide to give up playing, bring it back to where you got it."

I never saw Mr. Lytton again, and I never saw any of the other bass players either. To this day I have that bass. It's a Tyrolean three-quarter bass viola which was made about a hundred and sixty years ago. It's a fine instrument which I used until I stopped playing.

I've never sold an instrument, but I've lent basses to musicians who were getting started in the business. I think the first was John Levy, who borrowed one right after he finished Wendell Phillips, a few years behind me. It gave him a chance to work and save some money so he could put down a deposit on his own instrument. Over the years, I must've done the same thing for a couple of dozen guys.

I truly think the reason I never sold a bass has to do with a philosophy I developed about music almost as soon as I began playing. I was an only child who grew up living with four women. Aunt Pearl was the most musical of them and always encouraged me to get involved. She was the one who bought me the lesson books and the sheet music.

Sissy was the one with the soul. She treated me more like a child than anyone else did—maybe because we were closer in age. On Christmas or my birthday, when the others gave me clothes and practical things, she'd bake me a big cake and buy some kind of small game or toy. I can still remember the steam engine she gave me one Christmas. It was one of those working models where kerosene heated up water and made a whistle blow. I must've kept it for ten years.

by that time I'd made it playing bass. Looking back, the whole story is amazing.

Our annual concert at Orchestra Hall had just ended and we were backstage packing up our instruments. There were eight bass players—six guys and two girls. A distinguished-looking man came over to us and introduced himself as Henry C. Lytton. He said he owned the Hub department store downtown and played bass with a businessmen's orchestra. He told us about his love for the instrument and then invited us to come down to his office a couple of days later.

We all gathered at his place and he took us into

To be honest, I had a young mother who acted more like a bossy older sister than anything else. She never seemed to spend a lot of time with me while I was growing up. I remember her complaining about being tired all the time, and maybe that's the reason she had such a short temper. All it ever took was my doing something stupid, the way most kids do, and she'd bawl me out or use the backside of her hand on me.

I don't ever remember a time when my mother took me in her arms and made me feel like I was her darling. Mama was the one who did that. She fed me and dressed me and made sure I got the proper kind of Christian education. She was my guiding angel and she showed me she loved me in all kinds of ways. Mama's the one person who's always had a special place in my heart.

But music came to mean more to me than anything else. I started playing the violin at thirteen and from that point on, whenever something bad happened, I'd go off alone and play my music. It became my religion. It was my salvation and it sustained me.

I was very young when I decided that as long as I treated music well, it had to do the same thing for me. I knew I'd never give it up no matter what the hardships. And I never did. I've always had close relationships with my instruments. My basses are like my children. They'll be with me forever.

When I was eighteen or nineteen, I played my first paying job at the Forum Hall at 43rd and Calumet. I'm not sure who I worked with, but I know it was a dance and we got paid according to how many tickets were sold.

It's difficult enough getting a bass to a job, but since I was still playing tuba, I took a streetcar over to the place carrying both instruments. I knew we'd finish late, so I arranged to have one of the guys drive me home and I told him I'd pay him twenty cents. When I got back that night, my mother was waiting up for me. She asked how much I made, and when I told her thirty-five cents, she just about hit the roof. I guess she figured that when you took off a nickel for the streetcar and twenty cents for the ride home, I'd worked four or five hours for a dime. Of course, she was only looking at it in financial terms. It didn't make any difference to me. I loved to play and the experience taught me a great deal.

A little while later I joined the union, figuring it was a good way to get some work. Back then, there were two locals in Chicago. Local 208 controlled the work on the Southside and was for black musicians, and Local 10 had the downtown and Northside jobs and was for whites. I guess 208 wanted new members because in those days they'd let you pay dues in installments. As I remember, it cost twenty dollars to join. You could put five down and pay the balance within a year.

Once I filed my application, I spent my free time at the local, which was a small building at 39th and State. The second floor had a bar and a pool table and a separate room for playing cards. The third floor was a big open space they used as a rehearsal hall. Different leaders would bring in their musicians to try out new arrangements or to see how a new guy sounded with their band. I'd hang around watching and listening, always hoping somebody would ask me to sit in. I saw Bill Johnson play bass up there. He was one of the giants who'd brought Joe Oliver to Chicago to work in his band about ten years earlier. And he was also one of the few people I knew who lived to be a hundred.

After hanging around a few months, I got to know Walter Wright. He was an older, dignified gentleman who was a great bass player. From what I heard, he wasn't the easiest man in the world to get along with so most guys stopped using him. By the time I got to know him, he was running the poker and pool concession at the union. A lot of gambling always went on up there—nickel-and-dime poker, craps, those sorts of things. Mr. Wright was kind to me, maybe because I sought him out. In those days I was eager to learn anything I could about bass, and I always found him helpful.

Staying around the union didn't help get me jobs immediately. But since bass was getting much more popular around this period, it was only a matter of time before leaders ran out of other possibilities and had to use me. That's exactly what happened. I got my first job because Hugh Swift's bass player got sick a couple of hours before a job. Hughie sent someone down to the union to find a replacement and I was the only guy around who wasn't working that night.

It was a Friday and I still had my paper job. I was making $9.75 a week delivering papers, and I got $19 for that one night's work. I couldn't believe it. By the time I got home it was four in the morning and I had just enough time to change and start my route.

About two weeks later Hughie called me and gave me two more nights. I felt honored, but I was scared to death. At this point my mother told me I had to choose between music and my paper route. She said I couldn't do both and keep up my schoolwork, which was the most important thing. Looking back, it was one of the toughest decisions I've ever had to make. Even though music jobs paid well, I was really taking a chance on being able to work steady. The $9.75 a week from delivering papers was guaranteed. Besides, on Christmas Day I'd get a buck from almost every one of my 261 customers.

Well, I took a chance and made a change in my career. It was because I was in love with music and how it made me feel. And ever since then, I've always said I only had two jobs in my life—delivering papers and playing music.

Hughie's band played freelance jobs, but he also had steady work at the Jeffrey Tavern a few nights a week. I never worked there with him, but I know the place catered to high-class white people. It was a sweet band which played society-type ballroom dance music—no jazz. All the parts were written out, but it was real simple stuff. Hughie played trumpet and there were always about eight or nine other musicians in the band, worlds older than me. One of the guys I still remember played a huge bass drum and he was terrible. He had something to do with the police department,

which was probably the reason he was there. Bill Samuels is the only other musician I recall by name. He was a trumpet player who lived in my neighborhood and at one time had been one of my newspaper customers.

Within a month or two I began getting other jobs too, but the pay wasn't always up to what Hughie offered. I played dances sponsored by the union at a big place called Warwick Hall at 47th and Vincennes. I think we'd each get three or four dollars for the night.

I recall one particular situation that happened late in the afternoon on New Year's Eve. Even though this is always the busiest night of the year for musicians, I didn't have a gig, and I was down at the union hanging around the bar feeling sorry for myself. After a while, some guy I'd never seen before walked in, went up to Mr. Wright, and asked, "Walter, you wanna work tonight?"

I'll never forget the way he answered. He said, "You haven't called me all this year or last, so there ain't no sense in callin' me now." Then he pointed me out to the man and told him I was available. I ended up getting hired.

Mr. Wright was that kind of man. If you wanted him, you took him just the way he was. He refused to take crap from anybody. It was one of the few times I've seen a guy stick to his principles and turn down a job. I've always admired him for that, and I remember hoping that someday I'd get to the point where I could afford to turn down something.

During this period, a bunch of musicians I knew from high school and from the neighborhood would rehearse at my house because we had a piano. Mama would fix a big pot of stew, and guys like Ed Fant, Scoville Browne, Scoops Carry, Ed Burke, Richard Barnet, and Willie Randall would come over in the morning and stay all day. We'd buy arrangements they called "stocks" and play them until we'd memorized all the parts.

I remember one of my early freelance jobs in particular because it was the first chance I had to play with some very well known musicians. It was a party

in the ballroom of the new Jesse Binga Bank at 35th and State. Dave Peyton was the leader and Freddie Keppard played trumpet. Needless to say, having grown up watching these stars perform on stage, I was thrilled to actually work with them. As it turned out, Freddie was pretty sick that day and since he lived near me, I ended up taking him home in a cab.

Several months before I graduated from high school, a few of my teachers who thought I should have more formal training in music got me to apply to Crane Junior College. I was accepted, but there was a problem—even though Crane was public, it still cost more than we could afford.

For a while, it looked as if college would be out of the question, but then an amazing thing happened. Mr. and Mrs. Floyd, the people who owned our building at 41st and Vincennes, said they'd help me out. I still remember Mrs. Floyd telling me, "You go over there and register and you find out what your books cost and then you come back here with the bill." I did, and she paid the whole thing. I couldn't believe it, and it was years before I understood their reasons.

The Floyds had struggled to pull themselves up from the bottom. They'd both worked for years to save enough to make a little down payment on these apartments. There were six attached buildings on Vincennes—4141, 4143, 4145, 4147, 4149, and 4151—and each one had three apartments. They lived in one unit and rented out all the others.

Evidently, when they took over, the place needed work. But by 1925 when we moved in, they'd turned it around. Mr. Floyd got involved in local politics, and it was Mrs. Floyd who ran around doing everything from papering the walls to putting out trash. She kept the place beautiful.

We had a whole floor to ourselves—three bedrooms, a large kitchen, even a back porch. It cost us a hundred a month, which was a great deal of money in those days.

All through the years we lived there, Mrs. Floyd had gotten to be friendly with Mama, Titter, and my aunts, and she really seemed to like me too. She had a son, Tommy, just about my age, who lived in Manhattan with her sister. I'm not sure why he was there, but I know he attended DeWitt Clinton High School. Anyway, every summer he would come out to visit for a couple of months, and Mrs. Floyd always insisted the two of us spend time together. Maybe she thought I'd be a good influence. Whatever the reason, she always wanted us to be close. And after a couple of visits, we did develop a friendship. Tommy eventually settled out in California, and whenever I got out that way, I'd make sure to contact him.

I guess the Floyds believed in our family enough that when an opportunity came, they decided to take a chance on me and contribute to my education. Chicago was like that in those days. There was a real feeling of community among black people. And it was somehow understood that if you had a little extra, you'd try to help people who were trying to help themselves.

Just about all the people I grew up with in Chicago came from small towns in Mississippi. This background seemed to tie them together. They shared in the struggle to get ahead. If a person got sick, friends would be over with all kinds of food, and I still remember delivering Mama's soup to houses all over the neighborhood. People trusted each other so much that a lot of the time they'd go out and leave their doors unlocked.

Looking back at the whole Chicago scene in those days, about the only divisiveness I ever saw among blacks had to do with skin color. In fact, I can still remember an experience I had when I was growing up.

I must've been in my early teens and there was an organization around called the National Association of Negro Musicians. As the name says, it was all black. The people who belonged were concerned about church music or the classics. They were choir singers, directors, concert artists, and so forth. There was no jazz at all. At some point, this organization started a junior division for kids who played and shared the

same kinds of interests in music. Since Titter worked with the choir at our church and always wanted me to be a classical violinist, it was natural for her to encourage me to join.

The first meeting I attended took place on a Sunday afternoon. When I got there, I could see that the kids already knew each other. Most of them played either piano or violin, and I guess if things had been different, we could have shared our interest in music. But none of them gave me a chance. I didn't get welcomed or introduced by anyone. In fact, nobody said a word to me all afternoon.

It didn't take long before I realized what was going on. Except for me, everyone in the place was very light skinned, and being dark made me stand out in this group.

I went home and told Titter all about it. I said my feelings were hurt so bad I'd never go back. But she wasn't about to let me get off that easy. She told me, "You don't go by no color. Those children are no better than you. You're going back next week and that's all there is to it."

She frightened me so much I did go back. And after I went to a few more meetings, the other kids started talking to me. But it was never real friendly and I always felt a separation which couldn't be overcome.

I also saw a few situations where a couple of people in a family were so light complected they could pass themselves off as white. Even if you had the physical traits, I'm sure the choice to pass was very difficult. It meant breaking off all ties with any friends or family members who were known to be part of the black community. I even know a few cases where children didn't come to their mother's funeral because they were afraid word would get out about their true identity.

Willie Randall, a musician I grew up with in Chicago, was very light complected. He and his sisters all had the features to pass, but for some reason they always lived with blacks. On the other hand, there was another guy I knew, a saxophone player named Henry Allen, who decided to live in the white world. It was actually pretty simple for him—a white Mickey Mouse band offered him a job and he left town for good.

I ran into him at least ten years later. He was working for Shep Fields and I was with Cab Calloway, playing a theater in Detroit. We were onstage one night and I looked down and saw him sitting in the front row. After a while, I caught his eye and we smiled to each other. At the end of the show when everyone was taking their bows, I waved to him and pointed to the rear of the theater. It was pretty clear I was signalling for him to meet me backstage. I waited, but he never showed.

Getting back to my education, Crane Junior College was on the northwest side of Chicago and I'd take the el back and forth every day with Scoops Carry and Hector Crozier, who I'd known from the marching band at Wendell Phillips. The ride took about an hour, and we used to do our assignments on the way home from school. The train would bump and jerk and we'd have a competition going on. We'd each write out a part and see if the others could count and sing it.

Crane was almost all white. Except for the time I spent in the All City Orchestra during high school, this was really the first time I was with whites on an everyday basis. Of course, when we weren't in class, most of the black kids hung out together, but I don't remember any racial incidents happening while I was there.

Musically, the training was strictly classical. I played bass in their symphony orchestra and eventually I got to play tuba in the brass band. There were only two tubas, the same way it had been at Wendell Phillips, so I had to wait for one of the guys to graduate. I can't remember the names of any of the musicians at Crane, but I know there were some damn good ones there.

Most of my courses were in music—theory, harmony, history, those kinds of things – and we were required to take some regular academics too. I took English courses and some advanced math. I had belonged to the Math Club in high school and it was always my strongest subject. I'd taken a little Spanish

at Wendell Phillips, but I took Italian at Crane. I seem to have some natural talent for foreign languages, so I did pretty well.

During the time I was at Crane, I continued working as a musician. The money got better and better, but sometimes it was difficult to stay awake during early morning classes. I guess, compared to most other students, the few guys who were working like I was were in good shape financially. I still remember many times when Scoops and I would take a couple of girls out to a fancy steak restaurant for lunch instead of using the school cafeteria.

I got my first steady job in the spring of 1930, about three or four months after I graduated from high school in January and had just started Crane. The leader was Tiny Parham, a piano player who must've weighed four hundred pounds. We had Delbert Bright, sort of an Earl Bostic-type saxophone player, and Freddie Williams, who sang and played guitar and banjo. Freddie had a short leg, so he wore a built-up shoe. Then there was Jimmy McHendrick on drums, and I played tuba.

All these guys were older than me, and they always teased me about my age. McHendrick was the oldest, but he didn't look it. He was short and brown, had jagged teeth, and spoke with a slight lisp. He'd already played with some name bands in New York, so he was the most musically experienced. He was a real showman who did all sorts of flashy tricks. In fact, a few years later, people talked about how much Lionel Hampton's style of drumming had been influenced by McHendrick.

We worked at a place in a white neighborhood on the Northside called the Merry Gardens. They'd have name dance bands like Wayne King and we'd play for twenty minutes when they took their intermission break. We weren't expected to play dance music, just entertain.

Tiny was masterful at it. He was a good piano player, but he knew how to use his physical appearance to clown and get laughs. There was one trick where he'd turn the piano so his back faced the audience. Sometimes when we played a fast tune, he'd make it look like he was swimming. Watching a short, four-hundred-pound guy act this way was pretty amusing, and he knew it.

About a month later, Tiny asked me to play with him for the summer. He had a gig in Collins Park, on the outskirts of Baltimore. All the other guys were going, the pay was good, and it was steady work, so I took it. By this time, Tiny only wanted bass, so I didn't bother taking my tuba on the trip.

This was my first time away from home for more than a few days and my first shot at having some real freedom. We played a couple of shows a night in a covered pavilion in an amusement park. I think it was the first time I became aware of performing for an audience and being a showman. I'd spin the bass around, dance with it, and hold it under my arm like a banjo. The people loved it, and the more reaction I got, the more I developed my own routines.

I don't recall what we got paid, but I know we got free rooms in a hotel and a couple of meals a day. I managed to send my mother twenty-five dollars a week. I still remember the food because it was the first time I ever had fresh saltwater fish. There were no planes in those days, so you couldn't get it in Chicago. We'd eat freshwater fish, of course, but the seafood was always smoked or salted. I fell in love with oysters and crab cakes and I ate plenty of fresh mackerel, which was a different color and very different tasting than the salted fish we'd have back home on Sunday mornings.

As might be expected, my fondest memories of that summer have to do with a girl I met. Her name was Helen Johnson and she was my first real adult romance.

Helen was a little plump but very beautiful. When I met her she was hanging out with an older guy who turned out to be the local numbers runner. That didn't seem to matter to her because we became very close. A couple of times a week, she would bring me lunch in

a large straw basket and we'd go off somewhere to a pond or a park and have a picnic lunch. It was beautiful and she taught me an awful lot.

McHendrick, the oldest and wisest in the band, thought something underhanded was going on. He watched Helen closely for a few weeks and he also checked out her boyfriend. He told me she was probably carrying money for him in that big basket. Freddie Williams guessed the same thing. In fact, both of them always gave me ideas about how to get things from Helen. They'd tell me to empty out the basket when she wasn't looking, or they'd suggest that I tell her I needed things, like a new watch. I never took their advice, but one time I did look in the basket and McHendrick was right. It was filled with small bills.

I ran into Helen again about four or five years later. I was home in Chicago, still living at my mother's place on Vincennes. I remember it was late afternoon and I was practicing when someone knocked on the door. It was a chauffeur and he was looking for me. He told me that Helen was staying at the Grand Hotel and wanted me to join her. Of course I went, and that was really the last intimate time we had together. She had married her old boyfriend, who'd gone legit and become a successful businessman.

A few years later we saw each other in Pittsburgh. At that point I was with Cab, and Helen came by the Stanley Theater where we were playing and took me on a tour of the city in her limousine. But now we were just good friends.

Getting back to the summer I worked with Tiny's band, when the gig ended, we went back to the Merry Gardens in Chicago and did some local radio broadcasts from there. And then in November of 1930, I recorded with Tiny. It was my first time in a studio.

Tiny may not have wanted me to take a tuba to the summer gig, but he asked me to play it on the record. That was seventy years ago, and I thought I'd left that part of my past behind. But now it's out on an album. I don't know why, but when I played tuba I was always loud, and it comes across that way on the record.

In fact, if you listen to "Down Yonder" a couple of times, you can hear my chops give out about halfway through. I was terrible.

Sometime after I started at Crane, I decided I needed to have more freedom. Rules and regulations at home weren't the problem. In fact, after I started earning money and making a contribution to the family, I could pretty much come and go as I pleased. Mama wasn't too crazy about what I was doing and Titter always wanted me to be a classical violinist or a choir director, but the money I was contributing helped them accept my choice of music.

The thing that really bothered me in terms of freedom had to do with my sexual activity. Now that I was working, I was meeting some nice young ladies who really liked hanging out with musicians. I didn't earn enough yet to make the hotel scene regularly, so I found two friends, Willie Randall and Henry Allen, who had the same problem. We decided to share the expenses on an apartment where we could take our female companions.

I don't remember what it cost, but we got a little place with one room, a separate kitchen, and a bath. We didn't want to take any of our things from home, because our families might ask questions, so we chipped in and bought towels and linens and we each got our own suit of pajamas.

Every weekend we'd stock up on supplies for the apartment. I think we kept more gin than anything else, but there were always things like crackers, nuts, and chips. Of course, each of us had to know when the place would be free, so we worked out a system where we could sign up and reserve time.

Henry didn't stay long. A couple of months after we took the place, he got offered the job with that traveling white band and disappeared quickly. After he left, Willie and I got Scoville Browne as a replacement.

In late 1930, I was working off and on with Tiny, but I took gigs with Freddie Williams, the guy who sang and played banjo and guitar with the band.

Freddie would get us hired as a duo, but we always got complaints about our playing.

After a couple of jobs I figured out what was going on. Freddie was so nervy that he'd promise anything just to get us hired. He'd say we played jazz, we did comedy—whatever he thought they were looking for. Naturally, when we'd show up and play what we always played, there was a lot of disappointment.

For a short time, I also worked at a new nightclub on the near Northside that was owned by Ralph Capone, Al's brother. I don't recall the name of the place, but Boyd Atkins, the well-known saxophonist, was the bandleader. Harry Dial played drums and my friend Willie Joseph, another sax player, worked there too. From what I understand, Ralph wanted to copy some of the things his brother had done at the Cotton Club in Cicero, but on a smaller scale. So we had about half the number of musicians and dancers.

What I remember most about the place is Lucky Millinder, who'd come in to choreograph the new shows. He was an unbelievably talented guy who spent years working for Percy Venable. I can still hear him calling out directions to us while we were playing: "Another eight, add two, go back to the last sixteen, tag two." He always seemed to know mathematically exactly what was needed to get the dancers and the music to finish at the same time. I've never seen anyone who was better at putting together dance and music, and from what I understand, that's the reason he finally became a bandleader.

Some weeknights I'd go out with Charles Levy, a neighborhood musician, and we'd try to hustle work. He played violin and he was a lot older. Actually, he was the one with the car, and he was always pushing me to do this kind of thing. He'd pick me up and we'd drive out to the roadhouses on the outskirts of Chicago. I remember the system we had. First we'd walk into a place and check it out. If there were customers and enough room for us to set up, we'd ask the owner for permission to play. Once we got the okay, we'd get our instruments from the car, unpack, drop a couple of quarters in a saucer, and put it out front for

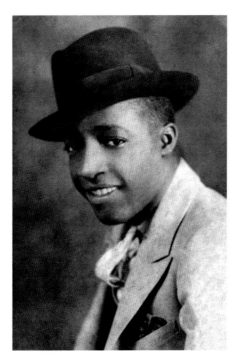

[Above] Milt, Chicago, c. 1929

[Below] Milt, Chicago, c. 1930

everyone to see. Then we'd ask customers what tunes they wanted to hear.

We might play five or six numbers, always keeping one eye on the saucer to see how business was going. If it looked like we'd made a couple of dollars, we'd keep on playing or take a break and then do another set. But if the plate was empty, we'd finish as quickly as possible, pack up, drive down the road to the next roadhouse, and start all over again.

I was earning good money from all of this freelance work, especially considering that this was the beginning of the Depression.

In the spring of 1931, I got offered a steady job with Jabbo at the Showboat on Clark Street, downtown. It was the last place Louis Armstrong worked before he left for New York.

The Showboat was one of those small basement-type rooms patronized by whites. Sam Beers was the owner. There were so many phones around that anybody walking in would immediately know the place doubled as a bookie joint during the day. Truthfully, the club and the guys who hung around there scared me. But the pay was sixty a week, which was too good to turn down.

Because of Louis, the club had developed a reputation as a trumpet room, so when he left, they decided they had to find a suitable replacement and the closest they could get was Jabbo Smith.

Altogether we had eight or nine pieces, and about half of us had been good friends for years. Cassino Simpson, who we called "Cass," played piano. At first, Floyd Campbell from St. Louis, who was much older than any of us, was the drummer and singer. He was handsome, dark skinned, heavyset, and he always had plenty of ladies chasing after him. For some reason I don't remember, he left after a couple of weeks. and when he did, a few of us made sure our friend Richard Barnet got the job.

Then there was John Thomas, a raucous-sounding trombone player who played like Tricky Sam Nanton.

Scoops Carry, Jerome Pasquall, and Scoville Browne all played reeds. We also had Ted Tinsley, a four-string-guitar player we called "Paducah" because he was from Kentucky. The minute we hit the bandstand at the beginning of the night, he'd doze off. But at four in the morning, just as we finished, he'd suddenly come alive. He'd sit up, eyes wide open, and yell out to all of us, "Where're we goin'?"

There were times when we'd go in to rehearse during the afternoon and get into our own little crap game just for fun. But after a while, a couple of the gangsters who hung around tried pushing their way into our game. I'll never forget one particular afternoon when I got involved. I didn't know the first thing about craps, but that day I ended up shooting. After a couple of rolls, I realized I must be winning because of the way the guys were reacting. Luckily, Scoville and Burke jumped in and bet for me. It all happened very quickly, and when it was over I'd won three hundred dollars. My biggest problem was what to do with the money. I couldn't tell Mama or Titter because then I'd have to explain about getting into the game. So I gave Scoville and Burke fifty dollars apiece for helping, and I took the other two hundred and hid it under a rug at home.

Many of the Showboat customers were gangsters and always great tippers. There was a dance floor, so if one of these guys wanted to dance to a special tune, he might put a few dollars up on the piano when he made his request. Everything went into a kitty, and on a good weekend night each of us could walk away with an extra five or six bucks.

After a while, my friends in the band asked me to pool tips with them so we could have our own parties. I agreed because these guys were my friends. I went to a couple of the parties but really didn't enjoy them. In those days I wasn't much of a drinker, but my share of the tips was going for food and booze and I wanted to get something for my money.

I'll never forget the last party they put on. They decided to save our tips for a week. They appointed one guy treasurer—I think it was Scoville—and he kept all

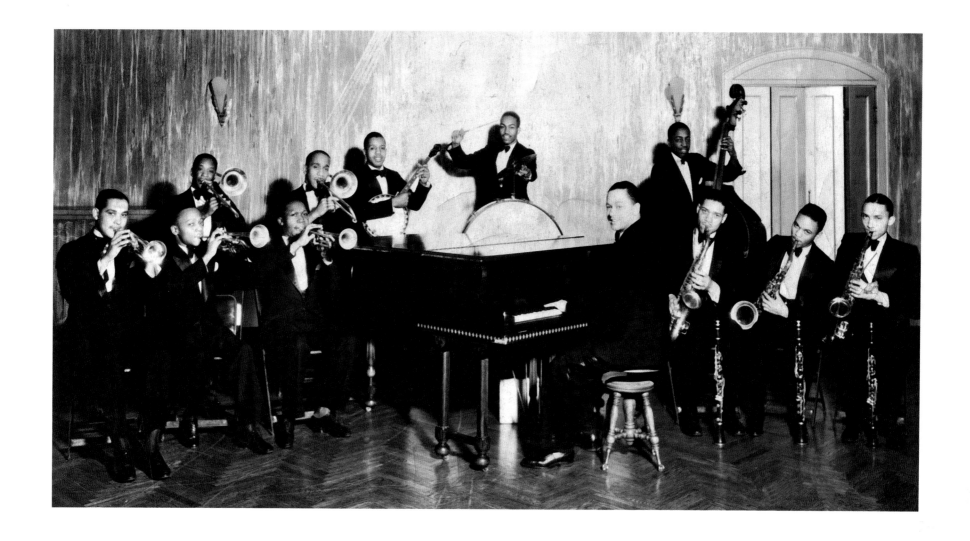

our shares from the beginning to the end of the week. When Thursday came around, one of the guys who knew all the vice spots on the Southside got in touch with a lady who had a big flat and ordered booze, food, and some girls for a party late Saturday night.

On Saturday we finished working about two, and by the time we got to this lady's place it must've been three. She had a couple of gallons of gin, chicken, greens, biscúits, potato salad, every possible kind of food. Then while we were drinking and eating, about a dozen beautiful girls walked in. A couple of minutes later they all had their clothes off and were doing a porno show on the living-room floor.

I don't know why, but I couldn't handle the whole scene. Maybe I was tired and the booze and food did me in. Or maybe it was all the porno stuff. I'm not sure. But when one of the girls who was playing with a pickle came over to me, I suddenly got very sick and barely made it to the bathroom.

All the guys were nice to me. They laid me down in one of the bedrooms to recuperate, and they put cold compresses on my head. I must've been there for

Cassino Simpson's band with Milt on bass, Chicago, c. 1931

about an hour. As soon as I stopped feeling dizzy, I got up and went home.

In addition to playing piano, Cass Simpson wrote most of the arrangements. He was a brilliant musician—one of the guys from that era I'll never forget. He was light complected and his face was scarred from smallpox. He always smoked a cigar when he played, and he'd let the ashes fall all around him. After he'd smoked it down to a little stub, he'd put the whole thing in his mouth, chew it for fifteen or twenty minutes, then spit out whatever was left. By the end of the night, the bandstand was filthy and smelled pretty foul.

We played what would probably be called New Orleans style. Cass actually wrote out parts so the reeds and brass could harmonize during solos. He also composed new tunes and for some reason always named them after soul food, like neckbones and rice, mustard greens and pig tails, cabbage and black eyes.

Cass was also an unbelievable piano player. He had Art Tatum's depth and Oscar Peterson's fire. I've really never heard anybody else play that way. But like a lot of geniuses, he had some serious mental problems, and I think all of us knew it, even back then. He was eventually committed to an asylum and died there at a very young age. I've heard that a jazz historian from Chicago once got into the place, taped him, and put out a limited-edition recording.

Jabbo played magnificently. He could play loud or soft. I can still see the mute he used—it was metal and looked like an old-fashioned doorknob. His tone and phrasing were different from Louis's, but he was just as exciting to hear. In those days, stories would go around about how Jabbo had tried to find Louis so he could challenge him. From what I understand, they actually had a couple of contests, and Jabbo gave him some stiff competition.

Some guys have problems with booze or drugs, but Jabbo's problem seemed to be women. He was a very handsome man and the ladies adored him. Evidently, it affected every aspect of his life. We'd start at ten every night, but Jabbo never showed up on time. His permanent house was in Milwaukee, but for this gig he'd gotten a room in a building on the Southside where a girl I knew also lived. Most of the time he wouldn't make it in for the first set, so when it ended at eleven, I'd get her on the phone and ask if she'd go over to Jabbo's and send him down. He'd usually be in bed and by the time he dressed and got to the club it would be midnight. Other times, we'd be on a break and he'd disappear for the next set or for the rest of the night.

Jabbo's punctuality became too much of a problem. I guess if you run a club and try and develop a steady following, you've got to know your star will be there most of the time. Jabbo was too undependable, and they let him go.

After that, Cass took over the band. We played some freelance jobs and around December of 1931, we were working a couple of nights a week at the Regal Theatre.

Walking bass hadn't come in yet. In fact, bass playing seemed to evolve pretty slowly. In my opinion, some of it was because the bass players around had switched from tuba and didn't know much about the techniques of playing string instruments. So at first the bass was given a percussive role, the same way tuba was used. Musically, it was kept simple. Everyone played the major note in a chord, period. Most things, including stock arrangements, were played in two-beat. So, for example, if you had an F chord, you played two F's to the bar. But sometimes on the last chorus the band might get hot and then you played four beats of the same note.

I was taking harmony courses at Crane, so I knew something about chord structure, but nobody had taught me anything about using music theory in a practical way. Just like all the others, I had to learn how to play on a chord by experimenting myself.

At some point during this time, I began playing the one and five notes in a chord. So if I had an F chord, I'd play F and C instead of all F's. A little later, I began using other notes in the chord too. It was all trial and error, and I got more daring as I went.

I figured out that my instrument had to identify a chord, so I always played the tonic as the first note. But I also realized that after the tonic, I could play a lot of other notes in the chord. So, for example, if I had an F chord I'd play an F first, follow it with an A and a C, and then maybe go to a D and put in the sixth. From a harmonic standpoint there are many acceptable notes, but I began to get a feeling for which combination sounded best, especially when I made the transition from one chord to the next. I was walking, but it took a long time before things flowed naturally. In fact, when I joined Cab a couple of years later, Ben Webster really taught me about connecting chords.

Whenever I took a solo in those days, I slapped. I think Bill Johnson was the first person I ever saw do it. Pops Foster and Wellman Braud slapped and so did Steve Brown, who I'd heard on Jean Goldkette's records. I guess, being younger than these guys, I wanted to outdo them.

One number we played called "Mama Don't Allow" featured every guy in the band. When it was my turn, I'd really put on a show. Johnson, Braud, Brown, and Pops were doing single slaps, but I got to the point where I could do double and even triple slaps. I also worked out a way to put the bass between my legs while I was playing, and I'd ride it like a horse across the stage.

When I graduated from Crane in January of 1932, I decided to go on to Northwestern University in Evanston. Looking back on it, I think my decision had a great deal to do with the guy who played tuba at Crane before I took over. I don't remember his name, but I idolized him. He was a great player and kind of an all-around performer. He'd gone on to Northwestern, so it seemed only natural for me to do the same. I recall going out there to some kind of spring music festival and I was very impressed with what I saw. That sealed it for me, and I registered for the spring semester.

I was working just about every night. I played the Indiana Theater on amateur night. Alberta Hunter was mistress of ceremonies and she also did some singing during the show. The crowd was filled with local kids who came to hear their friends perform, so they'd boo when Alberta spent too much time making introductions or singing an extra number. And sometimes we'd sit on the stage and boo right along with them. In fact, I can remember times when we'd lock the back door to keep Joe Williams out. He was just a kid and damn good, but we wanted to play our own things instead of backing up singers.

I also played with a guy named Johnny Long, who was something like the Lester Lanin of black high society. He got the exclusive work—cotillions, weddings, those sorts of things. For a while, we worked at Bacon's Casino at least two nights a week.

During the same period, I got hired by Erskine Tate to do one night a week at the Savoy Ballroom. In the old days, he'd had the band at the Vendome Theatre and later, he set up his own music school. At this point in his career he was still well known around Chicago, but he didn't have the same kind of fame he once did. Of course, that meant he couldn't demand the same kind of money either.

There was a union rule that required clubs to hire local guys whenever they brought in a name band from out of town. So when Andy Kirk, Earl Hines, or Fletcher Henderson came to the Savoy, Erskine Tate was brought in as the Sunday relief band to play during intermission.

Tate had always used a tuba, but when his tuba player quit, he decided to replace him with a string bass. He'd managed to get some good local musicians like Richard Barnet, Guy Kelly, Bob Shoffner, Scoville Browne, Ed Burke, and Jerome Pasquall. From what I heard later, he hired me because I was willing to work cheap.

The first time I rehearsed with the band was at the Savoy. The place was a one-story building and I came in through the main entrance on South Parkway. Of course I'd been there before, but never when the place was completely empty. So when I got inside, I was

overwhelmed by the size of the dance floor. All the guys were setting up on the stage at the other end of the building and it looked like they were two blocks away.

I lifted my bass and started walking toward them. As I got closer it was clear that some of the guys were staring in my direction, pointing, whispering and laughing. I remember trying to figure out what was going on as I made the long walk to the stage. The bass was still a pretty new instrument for dance bands and maybe that was funny to some people. Whatever it was, crossing the room that way made me the center of attention and it seemed to last forever.

When I finally got about fifteen feet from the stage, the drummer, Richard Barnet, yelled out, "Oh shit, here comes another nigger with a bass fiddle." They all broke up and the tremendous tension I was feeling suddenly ended. Of course, it also helped to have some friends in the band.

Erskine Tate was a tight guy which may have had something to do with the way his career was going in those days. The union set the scale at eighteen dollars a night and there was always a delegate around to see that we got our money. But Tate worked out a way to try to reduce his costs. After rehearsal on Monday nights, he'd take each guy aside and ask him for six dollars back. Fortunately, Richard Barnet tipped me off. He told me, "The first time he asks you for money back, tell him no, and he'll never ask again." Tate did ask, and the advice I got paid off.

Playing at the Savoy gave me the opportunity to meet some of the big names, like Coleman Hawkins, J. C. Higginbotham, and Mary Lou Williams. In fact, this was just about the time I first met Louis Armstrong. One afternoon, somebody took me over to a place at 37th and South Parkway where he was rehearsing. I'll never forget it—Zilner Randolph was going over arrangements and Louis was there sounding better than I'd ever heard him.

Then a couple of days before the spring semester began at Northwestern, I got two steady jobs. One

was at the Regal Theatre working for Ralph Cooper, and it paid sixty a week. By this time theaters like the Regal were suffering because of talkies and the general economic condition in the country. So instead of doing lavish production numbers with a big orchestra and dozens of dancers—the way they had in the past—now most of the entertainment in theaters was furnished by traveling vaudeville acts backed up by a small orchestra.

Ralph had been a singer and dancer around Chicago for years. He was very much like Cab in a way—much more a showman than a musician. He knew his own limitations, so he'd rely on his musicians to get him through. Kenneth Anderson was the piano player and he handled the musical direction. On trumpets we had a Cootie Williams squawking-type player named Tick Gray, Dolly Hutchinson, and a guy named Ray Hobson who I'll never forget. He'd sit in the pit with a straw sticking out of the top of a half-pint bottle of whiskey which he kept tucked away in the handkerchief pocket of his suit. Every ten minutes or so he'd lean forward, put the straw in his teeth, and take a little sip.

Jimmy Strong, who played like Lester Young, and Hutch Hutchinson, Dolly's husband, were in the sax section. John Thomas and Keg Johnson played trombone. The drummer was Jimmy McHendrick, who'd been in Tiny Parham's band with me a couple of years earlier.

The other steady gig I had was at a place called the Golden Lily on 55th near the el, and it paid forty a week. We'd start at eleven every night, so as soon as we finished our last show at the Regal, I'd head over and work there until three in the morning.

Even though I had these jobs, I still tried to make it at Northwestern. I figured I'd been able to work and still get my studying done when I was at Crane, but at Northwestern I couldn't make it beyond two or three months. I honestly don't remember too much about the school. I know I missed a lot of my classes and whenever I did make one of them, I usually had stayed up all night to do it.

I used to fall asleep in class all the time and never thought anyone noticed. But one day a professor asked me to come to his office after class. He questioned me about my absences and my drowsiness and I told him all about my work. He was shocked when I said I was making a hundred a week. After all, this was still the worst part of the Depression and practically no one was making anything like that. I'll never forget the advice he gave me:

> You will ruin your health by working in the evening and coming to school during the day. Your strength appears to be in your mastery of the bass. I would suggest that the time you have been devoting to classes here would be better spent if you were to leave the University and find a very accomplished private teacher who could help you with your playing. You are making a hundred dollars a week now and if you improve on your instrument, I am sure you will have no regrets.

I thanked him and started home to tell my mother what he'd said. I thought it all out riding back on the el, and by the time I got to the house I knew I was going to take his advice. I told Titter all about it, but all she said was, "I said that same thing to you a long time ago, but you only listen when other people tell you."

Eddie South had a very successful tour of Europe during the late '20s and early '30s. He played for high society—dukes and barons, the Rothschilds—and they all loved him. Even back in those days, jazz was big in Europe. The French seemed more enthusiastic than anybody else, maybe because they heard the French influence in the jazz coming from New Orleans.

Eddie had even taught himself how to speak Hungarian and managed to learn a couple of Hungarian songs. That may be why the Europeans called him the "black gypsy" and the "dark angel of the violin."

The way I've heard the story, in early 1932 one of the top people at the Music Corporation of America—MCA—saw Eddie in Europe, recognized how successful he was, and decided to book him back in the States. I guess MCA figured they could build a twelve-piece orchestra around him, get some high-class bookings, and really make him a star.

Apparently, Eddie told the people at MCA he wanted the best musicians in Chicago, and about a month before he was due back in the States, they got an agent named Sam Scolnick to get the right guys. I remember Scolnick. He had a twitch in his neck and a habit of carrying around a handful of change and jingling it all the time.

He put Charles Elgar, the great violinist who'd been Eddie's teacher, in charge of doing the actual

Everett Barksdale, Eddie South, and Milt, radio broadcast, Chicago, c. 1933

hiring. Elgar hired five or six more violinists, including Wright Smith. Many legitimate theaters had closed by this time, so the best string players were available.

Bob Shoffner was signed up to play trumpet along with two trombone players—John Thomas and my friend Ed Burke. Jimmy Bertrand was hired as the percussionist, and they got Ernie Marrero to play bongos and congas. I don't remember who recommended me for the job, but when they offered it, I jumped at the opportunity.

The idea was to put Eddie into a fancy hotel downtown and have him play beautiful, flowing kinds of music which the average person could really enjoy.

We each got a contract guaranteeing us forty weeks of work at seventy-five dollars a week. It was the early '30s and the going rate was about half that amount, so we were all pretty excited about the gig.

For three or four weeks we rehearsed every afternoon at the Chu Chin Chow restaurant next to the Regal. That meant I could still work evenings with Ralph Cooper and stay at the Golden Lily too. When we were just about finished learning the new arrangements, Eddie got back from Europe. He'd been traveling over there with a trio made up of Joe Spaulding on piano, Stanley Wilson on guitar, and Cliff King on clarinet.

Joe, whose real name was Antonia, was originally from Louisville. He was a grey haired guy and about fifty. He had a big scar across one side of his face from his nose down through his lip from a pretty serious car accident in Paris. He was an excellent pianist who could play just about anything, including the classics.

I never knew much about Stanley. He was a clean-cut, quiet guy who used a four-string guitar which seemed to limit the kinds of things he was able to play.

Cliff was short and had a nose that looked like an electric light bulb. He was a fantastic classical instrumentalist, but he enjoyed hamming it up too. I remember he'd take his clarinet apart while he played "Tiger Rag" and by the time he finished, he was just playing his mouthpiece. It's no wonder he billed himself as Cliff "Klarinet" King.

These guys started rehearsing with us, and Eddie began showing up too. He seemed to love the new arrangements and the way we made them sound.

For a while, someone else from one of the big hotels came by the Chu Chin Chow just about every day and listened to us rehearse. Even though everybody agreed we sounded wonderful, we didn't get work. From what I understand, some of the powerful people downtown decided it was too risky to put such a large black society orchestra into one of the fancy hotels.

MCA must've figured the whole thing was getting too expensive, because one day Scolnick came around offering to buy up our contracts for three hundred apiece. That was a hell of a lot of money in those days, so naturally everyone grabbed it. From what I heard later, Eddie had to use his own money to finance the deal, and with a band that big, it ended up costing him everything he'd made in Europe.

I was the only one who got treated differently. Instead of giving me the three hundred, Eddie gave me a steady job for seventy-five a week.

Although the downtown hotels weren't ready to accept Eddie with a big orchestra, there were plenty of clubs that wanted him with a smaller group. With me added, the trio which had backed him up in Europe became a quartet.

For months we worked the Rubaiyat on the near Northside. I don't remember who ran it, but Eddie Pappan was always around and people said the place belonged to Capone's organization.

It was a small dark room that seated about sixty-five. But it was very posh, and we always seemed to have a good crowd. Since we didn't have a drummer, I was the timekeeper—slapping, stomping, and doing whatever else I could to keep the tempo. We'd do tunes Eddie was known for like "Dancing on the Ceiling" and "After the Ball." Then we'd play classical pieces like "American in Paris" and "Rhapsody in Blue." We improvised most of the time, but when we did the symphonies, Joe Spaulding had the score. I'd look over his shoulder, trying to get my notes by reading from the music and watching his left hand.

The Rubaiyat was right behind the Chez Paris and around the corner from the College Inn. Some of the white musicians working at these places would come by on their break to hear us. Benny Goodman, Jack Teagarden, and Ben Pollack came around a couple of times a week, and Ben Bernie was also a regular. He'd often come in with his first saxophone player and arranger, Dick Stabile, and many times Dick brought his father, who played violin and loved to hear Eddie. Although I'd known Benny Goodman from childhood, this was one of my first opportunities to hang out with some of the other better-known white musicians.

In late June of 1932, Sam Scolnick booked Eddie into the Congress Hotel downtown to play for the Democratic Convention. A large number of the party big shots were staying there and I can still remember how thrilled I was to be able to see Al Smith, John Nance Garner, and Franklin Delano Roosevelt, who ended up being nominated. Some of the great movie stars of the day were there too.

Including Eddie, we still had five pieces, but by this time Everett Barksdale had replaced Stanley Wilson on guitar. They put us in the hotel lobby, about halfway up a twenty-foot rock garden which had a real waterfall. I know we sounded great, but I'm sure the noise from the lobby and the waterfall drowned us out. Truthfully, I'm not exactly sure why we were there. The job lasted about two weeks, a little longer than the convention, and it might be that hiring us was a way for the Democrats to give something back to a couple of their black politicians in Chicago.

I was still working with Eddie when he got a booking in Los Angeles in the fall of 1932, and he asked the four of us to join him. It was a four- or five-day train trip, but it turned out to be well worth it.

Back in those days, there was already a bunch of marvellous musicians on the Coast. Lionel Hampton was working for Les Hite, who had the band at the Cotton Club out there. And Buck Clayton had gone out from Kansas City. Word had gotten out we were coming, and when we pulled into the station, a little band Hamp had put together was there to greet us.

His wife, Gladys, was there too. She was sewing for one of the movie studios at that time and doing quite well. She knew Eddie and me from Chicago, and she immediately invited us over to the house.

We checked into a black hotel called the Dunbar on Central Avenue. It had a nice little club downstairs which was owned by Jack Johnson, the great prize fighter. The Champ liked to play bass, and a couple of times I saw him borrow an instrument and sit in with the small band that played there.

We were booked into the Ballyhoo, which was a very exclusive club on Sunset Boulevard. I remember we played a lot of tangos for a Latin dance team which had two boys and a girl. For a long time I thought that two of the dancers were Cesar Romero and Carmen Miranda, but my good friend Konrad Nowakowski tells me that Carmen Miranda didn't come to the States for the first time until the late '30s. Aside from tangos, we could play whatever we wanted.

The place was jammed all the time, and almost every night one or two of the big-time Hollywood musicians would come by to hear us. I remember seeing guys like Morris Stoloff and Alfred Newman. They loved Eddie. Sometimes I'd even see one or two people in the audience writing music on their starched shirt cuffs or scraps of paper.

When it was pretty clear we were going to be in California for more than two weeks, I left the Dunbar and found a room in a house owned by a lady named Maude Harris. The Dunbar was pretty expensive, but Mrs. Harris had a lovely place, close to work, and she only charged six dollars a week. Since she worked as a live-in for one of the big movie stars and was only around on weekends, I had the run of the place. I remember thinking how great it was to sleep in a bed with my initials on the headboard. It didn't seem to matter that the "M.H." really stood for Maude Harris.

I'd earned a hundred a week working several different jobs, but this was the first time I got that much from one gig. At the time they had rules in California saying that out-of-towners had to deposit a third of their pay with the union. I guess they figured if you

Milt with Lionel Hampton,
Los Angeles, c. 1948

the spring of '33. We each had a couple of thousand coming to us from the radio work we'd done and the money the union was holding.

We all took the long train ride back to Chicago and as I recall, I spent most of the summer working there. We played the Regal and we also made some records.

There was one gig I had that summer which I'll never forget. It was at the World's Fair and for an occasion blacks used to celebrate called "June Teenth"—for June 19th, the anniversary of the Emancipation Proclamation. Evidently, some of the sponsors decided to have an official June Teenth Day, and they got famous guests to perform, including Marian Anderson, Ethel Waters, Roland Hayes, and Paul Robeson. Then they put together a huge symphony made up of just about every black who could hold a bow, and brought Eubie Blake out to conduct. The whole thing was magnificent, and I was thrilled to work with these stars, even at a distance.

About fifty years later, I was playing a concert at Kennedy Center celebrating Eubie's one-hundredth birthday, and when it was over he told me, "You still look like you enjoy playing so much, you should pay them for the opportunity."

In the fall, we went to Detroit to play a fancy country club called the Blossom Heath, which was located on the outskirts of town and known for featuring violin music. Joe Venuti had recommended Eddie for the job. He and Eddie were very close friends and Joe had gotten Eddie work a couple of different times.

Joe always had a great sense of humor and was a practical joker. On this particular occasion, he'd finished his own engagement at the club a few nights before we arrived. And when we got there to play our first night, the headwaiter delivered a note from Joe. "Good luck," it said. "Hope you guys get out of here alive."

There's also an interesting story about Joe, Eddie, and Paul Whiteman's vocalist Bea Palmer. Joe and Bea spent some time working together in Whiteman's band, and after a while they got to be known for a couple of tunes that featured the two of them. When Joe left the band to go on his own, Bea really felt the

lost your job, you'd have something to fall back on and wouldn't have to go to anyone out there for help. So I'd get paid sixty-six dollars a week, and even after I took money out for room and board and everyday expenses, I was able to send plenty back home. We also got a couple of radio spots through one or two of the big-time guys who'd come by to hear Eddie at the club. In those days, everything was recorded on disk, so if there was any kind of mistake, we'd have to start from scratch.

I think we stayed in California more than six months. By the time we were ready to leave it was

loss. She insisted that Whiteman replace Joe with someone who could play the same kinds of things behind her. They tried a few guys, but she didn't like any of them. Then Joe convinced Bea that the only one who could do the job right was Eddie South. She went to Whiteman, but he refused to hire Eddie. Bea threatened to quit. A couple of days later they worked out a compromise. Eddie would join the band at the College Inn and play for Bea on four or five of her special tunes. But whenever he was onstage, he'd have to stand behind a screen. That way, the audience would just see a silhouette of a violinist playing and no one would know he was black.

I think our Detroit engagement was for two months, but after five or six weeks my mother called to tell me that Maude Osborne, a girl I knew from high school, was pregnant and telling everyone I was the father. I knew that was impossible. I'd seen her over the summer once or twice, but nothing ever happened between us. In fact, once when we went out for ice cream, she'd told me about a secret relationship she was having with a married guy I knew from high school.

I decided to call Maude from Detroit, but whenever I tried, she refused to speak to me. I talked to her mother a couple of times and explained that I wasn't the father. Nothing helped, and about two weeks later I got an official notice to appear in a Chicago domestic relations court. So I left Detroit and went home for a few days.

Just as soon as I got back, I went over to Maude's house and managed to see her. We were scheduled to go to court the next morning and I was pretty upset. I told her that even though we both knew I wasn't the father, I was willing to get married anyway. But that didn't seem to matter to her either.

The next morning, I was in court in front of a woman judge, which was pretty unusual in those days. Everyone from Maude's family and mine was in the courtroom. First Maude got up and told the judge she was pregnant and I was the father. When she finished, I told the judge I wasn't the father, but I was willing to get married because Maude was in trouble.

The judge said nothing would be decided until the baby was born, but as she began to write up the official decision, an amazing thing happened. Maude's mother walked over to the table where I was sitting with Titter. "You're a good boy, Milton," she said. "I know you didn't do this. The fact is my daughter's been fooling around with a married man and his wife's called me to say I should get her to stop."

When the judge heard this, she slammed her gavel down and dismissed the case. I got on the next train for Detroit.

When we finished our engagement in Detroit, we started playing the theater circuit. It was a tour arranged through one of the vaudeville bookers. We worked places I'd never heard of in Illinois, Ohio, and Pennsylvania. Then finally, in May of 1934, we made

Eubie Blake and Milt, Nice, France, c. 1978

it to New York. This was really the big time for me. But it's also a period when I had some difficulty.

Apparently, somebody had told Eddie that if he left the vaudeville circuit and stuck around New York for a while, he'd get much better jobs. He decided to take the advice and asked us to hang around too, promising to pick up the tab for our expenses just as soon as he got a booking. The other guys were older and more experienced than I was. They knew people in New York who could get them work and help them out with food and lodging, and I never heard anything from them while I was there. I worked hard to stretch my money. I guess I could have called my mother and asked her to send me the fare home, but I decided to tough it out. She wasn't in favor of my traveling anyway, and asking her for money would have shown her I couldn't make it playing jazz.

I had about a hundred dollars I'd saved from my salary. I was paying six dollars a week for a room up at the YMCA on 135th Street and I found some pretty cheap places nearby to eat. After a while I developed a routine. I usually tried to have only one meal a day, and I'd wait until about one in the afternoon to eat. I ate a lot of fish because I found one little greasy place that served a whole fish, four pieces of white bread, and some thick, gummy, fried potatoes for twenty cents. They also gave you a big bottle of soda for four cents. The meal wasn't very tasty, but it was filling.

Despite Eddie's promises, it was clear after a couple of weeks that another New York engagement wasn't going to happen soon. I knew I'd have to stretch my money even more, and I went out to get a cheaper place than the Y.

A few days later, I found a rooming house run by a couple named Collins. It was at the corner of 127th and 7th Avenue, right near the Apollo Theatre. In fact, a few of the guys staying there were musicians working at the Apollo. I think they were pretty down on their luck, though, because this place was very basic. Mr. Collins was a nice man and quite trusting. Many times he'd let boarders pay him at the end of the week,

after they got their paychecks. In those days that was unusual.

I had a cubbyhole no bigger than a walk-in closet on the first floor, and I got two meals a day along with the room. The food wasn't much, mostly starches—potatoes, rice, greens, cornbread—and a little meat. The whole thing cost me seven bucks a week, which was cheaper than the Y, considering that food was included. And even though Mrs. Collins didn't serve the best meals, it beat eating the same greasy fish once a day.

Two or three weeks later I was really broke. But when I was just about to call my mother for help, another woman rescued me.

There was a bar called the Alhambra at 126th and 7th Avenue where musicians and entertainers hung out. I spent quite a bit of time there, figuring if I got to know some of these people, I might get offered a gig. I never was, but I kept hanging out there anyway—I guess because I felt comfortable around show business people.

One night when I was there a young woman came in, walked up to the bar next to where I was standing, and asked me if I wanted a drink. Of course I accepted. She said her name was Ann Robinson and told me she was between shows, on an intermission break at the Cotton Club, where she was working with a dance act called The Three Rhythm Queens.

Ann wasn't good-looking at all, but she was a dancer and her body looked like it was carved out of alabaster. We were probably close to the same age, but when it came to experience, she was about a hundred years older than me. She was hip. The language she used, her expressions, were much hipper than anyone I'd ever met. To this day, I haven't figured out why she picked me up that night. Maybe it was because I looked like a young and honest type, very different from the guys she usually hung out with.

We talked for fifteen or twenty minutes. She asked me where I was from and what I was doing in New York. Then she put a couple of bucks on the bar, and as she turned and took a few steps toward the door,

she said, "I gotta go back and do the last show. If you got nothin' better to do, hang around here and wait for me."

She didn't wait for my answer—she just kept walking. But when she was halfway out the door, she called to the bartender, "Hey, Foster, this is on me. Give him anything he wants." And she was gone.

It was late and the meal I'd eaten had worn off. I was starving. So I asked Foster, "Does this mean I can have anything I want?" He nodded and I headed for the steam table.

About two hours later, Ann came back and picked me up in a cab. She lived on Sugar Hill in a fancy apartment building where the more successful black entertainers had their places. She acted so different from any woman I'd ever met that at first it scared me half to death. The minute we walked into her place, she took off every stitch of her clothes. I was shocked. I'd never seen a girl just walk around the room naked.

Then she lit a reefer and offered it to me. It didn't seem to bother her when I refused. She put on a record and started singing along with it, and a couple of minutes later the doorbell rang. A guy walked in and she introduced him to me. He sat down and they shared her joint. It was unbelievable. She was stark naked, but there we were, the three of us, just sitting around talking as if nothing unusual was going on.

About half an hour later the guy left, and the two of us spent a pretty wild night together. I had a good strong back in those days and the food I'd eaten a couple of hours earlier gave me extra stamina too.

I guess I passed the test, because after that first night Ann and I started hanging out together. She'd take me around to all the bars where musicians were. She always carried a big wallet, like a man, and when we'd get to one of those places she'd take it out and put it up on the bar in front of where I was sitting. She didn't want to embarrass me, so she'd always act as if the money was mine. She'd even tell me to buy drinks for some of the guys. She called me "Zee President," but I always felt she treated me more like a king.

After the engagement ended at the Cotton Club,

Ann Robinson, Village Vanguard nightclub, New York City, 1942 (© Charles Peterson)

Ann started working at a place called Monroe's Uptown House. She did a single act there—much less dancing and a lot more comedy and singing. She wrote clever hip lyrics to some of the standards and some original songs too. In fact, years later Nat Cole and a couple of other stars recorded a few of her tunes, but I don't think they ever made it to the charts.

I'd sit in Monroe's practically every night waiting for Ann to finish. There were always show business people from downtown in the audience. I think they came to places like that to get fresh material for their own acts. I heard that Martha Raye based some of her routines on Ann's material. Both were dancers and both had the widest mouths I've ever seen. Ann always

used her mouth in her comedy, and I guess after Martha Raye saw how Ann did it, she decided it could work for her too.

Ann was a night person, and once I started seeing her regularly, I became one. We'd go back to her place after the last show. I'd pay my dues of course, and then I'd go back over to the rooming house in time for some breakfast. I'd sleep until dinnertime, and after I ate, I'd hang out until it was time to meet Ann again.

Harlem was beautiful in those days. Everything on 7th Avenue was real sharp and very clean. Show business seemed to be thriving, and this was one of the meccas. It's true that a couple of black stars like Eubie Blake, Noble Sissle, and Will Vodery had made it big downtown, but plenty of whites came uptown to Harlem every night to see black performers. People have talked about white mobsters owning clubs in Harlem, but I saw many bars and nightclubs which were run by blacks. There were fantastic after-hours places catering to performers who started their day after the rest of the world had been sleeping for hours.

Aside from the nightspots, most businesses in Harlem appeared to be owned by whites. That surprised me. Up and down 7th Avenue, whites ran the fruit and vegetable stores, cleaners, variety stores, and groceries. The only black-owned establishments seemed to be barbershops and beauty parlors.

It was very different on the Southside of Chicago. Blacks owned all kinds of businesses there, which probably meant more neighborhood money stayed in the community. My background may have given me a bias, but I always felt that the people living in Chicago's Black Belt had a sense of community and were working with each other to make it. Harlem seemed more competitive. I got the sense that if you were going to succeed, you had to do it on your own.

I developed a pretty negative impression of New York during my stay. Maybe it had to do with my financial situation and my being from out of town. Whatever it was, I felt that practically everyone in Harlem was cold— completely the opposite from peo-

ple in Chicago. Even the musicians were different. We had giants in Chicago like Earl Hines, Jimmy Wade, and Louis. I'd met them and they were always pretty friendly. But the New York guys seemed standoffish, acting as though they were much better than everyone else.

In all the time I was in New York, only one guy gave me any encouragement. His name was Herman Autrey, and a little later he played trumpet with Fats Waller. He heard me practicing somewhere and told me, "Kid, you oughta stay in this city." I guess he thought I had potential, even though I didn't know it. Much later, after I'd made it, whenever we saw each other Autrey would say, "See, I told you so."

After at least a month in New York, Eddie finally got more work. I probably spent three weeks with Ann, but given the pace she set for me, it felt more like six months. I didn't see her again until I came back to New York with Cab a few years later. By then she was one of the stars in a *New Faces* show and doing most of her own material. She'd even made a record with James P. Johnson's band. We both had things going with other people, so we didn't see much of each other, but everything was friendly.

A couple of years after that, I was in New York walking in the Times Square area with my second wife Mona. Just as we passed the Brill Building, someone yelled, "Hey, Motherfucker!" and I stopped and turned toward the entrance. There was Ann, looking at me with a big smile. I introduced her to Mona and told her we'd just been married. I'll never forget how she looked Mona over from head to toe, then turned to me and said, "Yeah, she looks like she's good for you. That's just what you need, one of them schoolteacher bitches."

Mona wasn't a schoolteacher until years later—Ann was talking about how clean and straight she looked and how different she was. It was Ann's way of giving me her seal of approval. I think she really believed that someone like Mona would be good for me. After all, I had always been a lot squarer than the men Ann had known.

As we continued to walk, I told Mona about Ann and how she'd rescued me when I needed help the most. I said that if Ann ever asked for anything, I'd always feel obliged to try to repay her kindness.

I got the opportunity a few years later. I was on the road with Cab when I got a telegram from Ann. She was in Philadelphia with a show that had closed suddenly and she needed carfare back to New York. I handed the telegram to Mona, and within the hour she'd wired Ann a hundred dollars.

At one point in the mid '40s, Ann asked me to put a band together to accompany her on a couple of records. We made a few of her tunes, but I'm not sure they ever got released.

Unfortunately, sometime later, Ann started using heroin. I heard she'd stopped performing, but people still came around and bought her songs. I guess no one will ever know if she wrote any of the big hits. I'm sure she never kept track of copyrights and didn't care about getting credit as a composer. From what I understand, she was only interested in being paid cash on the spot, and everything she got went toward her habit.

I was down in Florida when I read she'd been murdered. It was a violent thing. She was found in an alley up in Harlem, behind her building, with her throat slashed. It must have been related to the whole drug scene.

Ann was one of the most talented people I've ever known, but drugs did the same thing to her that they've done to so many other creative minds, especially in jazz. It's so self-destructive and something I've never understood..

When I got back to Chicago, I decided to get married. I'm still not exactly sure why, but I have some ideas.

I never had a steady girlfriend the way most of my friends did. To be honest, back in my high school days I didn't want the responsibility. Besides, on weekend nights I always preferred hearing Duke or Fletcher or Jimmie Lunceford's band at the Regal, or playing a gig.

Even before I went on the road with Eddie, my friends were always teasing me about finding a steady girl. Looking back, I think they just wanted me to become part of their social scene, but I began to take the pressure seriously. In fact, while I was still in New York, I called Oby Allen, a girl I knew from high school, and told her I wanted to see her when I got back home.

Oby was training to be a nurse at Providence Hospital. She was a big girl, maybe 170 pounds, and back then I must've been about 50 pounds lighter. I asked her to marry me the first time we went out. We were at a dance in her residence hall and I acted purely on impulse. She said yes. Afterward, when we went home to tell our families, everyone hit the roof. They told us to wait awhile because we didn't really know each other. I remember her sister saying it wouldn't work because we were too different.

They say when you're young, you're dumb. If that's true, I was no exception. I've always been stubborn about certain things. Once I give my word and say I'll do something, I do it. So the more our families told us to wait, the faster I wanted to get married. And we did about a week later.

At first we lived at my family's place, and then we moved over to Oby's sister's apartment and rented a room. She never did finish nursing school. When I began to travel, she always wanted to go with me. But Oby hated show business and show-business people, so it was always a very uncomfortable scene for me. Her sister was right—our personalities were completely different. As time went on, things between us just got worse.

Over the next year, I did a few more vaudeville tours with Eddie. We even returned to New York two or three times, and one of the highlights was a gig we got at a brand-new nightclub just outside Manhattan. It was the summer of 1935, and I'll never forget it because it was the first time I got to spend some time with Bing Crosby.

Mr. and Mrs. Eddie South,
Chicago, c. 1933

The place was known as Ben Marden's Riviera. It was built on top of the Palisades overlooking the Hudson River, around Fort Lee on the Jersey side of the George Washington Bridge. I'm not sure if the bridge was finished by then, but I know we took a ferry from Manhattan to get to work every night.

Paul Whiteman's Orchestra was the featured group and we were the relief band. Whiteman had some excellent musicians. Frankie Trumbauer, the great saxophone player, was an officer in the Army Air Corps and used to fly a seaplane to work every night. He'd land on the Hudson and then walk to the club up a steep set of steps cut into the Palisades. Jack Teagarden and his brother Charlie were also there, and a piano player named Roy Bargy.

Bing had left the band years earlier and by this time had a big following. He was probably staying in New York City because he'd show up almost every night and hang out with the guys he knew in the band from the old days. But the tension between Bing and Whiteman was pretty obvious. Just about every time the band got ready to begin a set, Bing would stand in a visible spot and make faces at Whiteman up on stage. And it wasn't long before everyone in the place could sense what was going on.

When the tour ended in the fall, things slowed down again for Eddie. We played the Chez Paris in Chicago, but he never got good steady work again.

They say once you're a bandleader you can starve to death. The rest of us in the group could go our own way and get plenty of freelance calls because we were known as sidemen who'd work for a different price depending on the situation. But Eddie was a star, the only black violinist to survive the '20s, and no one would ever insult a star by asking him to work as a sideman or for a sideman's wages.

So Eddie would sit home for long stretches, practically broke and very down. I lived near him, and we seemed to have a special relationship. He called me "The Kid"—not Milt, or Milton, or Hinton, or Sporty, or Fump, like other people. He was a proud man, but there were many times when he needed money. He'd

ask me, "How much you make this week?" When I'd tell him, "Fifty bucks," he'd say, "Why don't you give me fifteen 'til Saturday night." A few times he'd get weekend work and would pay me back some of what he owed, but most of the time he didn't. I never cared because I truly loved him.

Eddie was a magnificent musician. He was very academic, he had amazing dexterity, and his intonation was excellent. He could do anything with a violin. He might play a difficult classical passage on one chorus and then swing harder than anyone on the next three. He demanded perfection from the musicians who worked for him, and most of the time he got it. Of course, he had some quirks—most brilliant people do. For instance, he'd never tell you what key he was going to play in and he'd never use standard keys. He'd call a tune like "Dinah," which everyone plays in A flat, but he'd play it in E. He didn't care what other people did—his first note was an E and he'd play it in E. If you missed it, he'd look up in the air and roll his eyes as if to say, "What's the matter with you?" You'd feel very embarrassed and from then on you'd probably pay much closer attention to what Eddie was doing.

Playing with him was one of the greatest challenges of my life. It was also about the best learning experience I ever had. As a teenager, I'd idolized him, and having the opportunity to know him, hear him, and study him closely was a dream come true.

Eddie's the one who first showed me what could really be done with a bow. And even though he didn't know my instrument, I give him the credit for the technique I eventually developed. I'm also very grateful for the opportunity I had to record with him in the early '30s. All the jazz violin players I've ever known rave about these records, and whenever I hear them, I'm still astounded by how great Eddie sounds. It's gratifying to know there's something there for future generations.

Once I spent an afternoon visiting Eddie at his place. Just before I left, he gave me a gift. He'd just gotten a new violin case and wanted me to have his old one. It wasn't much to look at. It was made of al-

ligator skin, but he'd used it so long it was practically worn out. None of that mattered, because when I opened it, I found a note written in longhand.

November 24, 1933
To Milton—

Retain this case as a remembrance. Countless are the miles it's traveled with me. I sincerely wish that your success equals the height of the miles I've carried it. This case has been with me for thousands of miles and I hope your career will carry you as far.

—Eddie South

It was the most meaningful thing he could have given me, and I've always felt it was his way of telling me about the special place I had in his life.

Around November of 1935, Zutty Singleton hired me to play at a new downtown club at State and Lake called the Three Deuces. Sam Beers, the guy who owned the Showboat where I'd worked with Jabbo a few years earlier, owned this place too.

The billing was "Art Tatum and the Zutty Singleton Quartet." Art played alone. We had Everett Barksdale, who I'd known from my days with Eddie, on guitar; Lee Collins on trumpet; Ted Cole, Cozy Cole's brother, on piano; and Zutty on drums, of course. We'd alternate with Art, except for the last number in the set when everyone played together.

The club had two floors, and we played downstairs. There was a bar upstairs and on breaks we'd usually hang out in one corner, playing pinochle with Art. He was nearly blind, so he used to put a big light behind him. He'd drop a card and we'd call whatever cards we were playing. It took me a while to get the hang of it, but once I did, the game ran smoothly.

The hours were long. We started at ten and finished at four. In fact, the place was known as an after-hours

hangout for local musicians and guys who were working in town. Zutty and Art on the same bill were a big drawing card, and the club filled up every night.

After a while guys began to sit in with us, usually during the last two sets. A few young unknowns like George Barnes played, but most were established people who stopped by after they finished their own gigs.

I remember when Fletcher was playing the Grand Terrace, some of his musicians came in. I think Chu Berry was first and a day or two later he brought Roy Eldridge, Buster Bailey, and Hilton Jefferson with him. They took turns playing with us, and the place went crazy.

Then there was the night John Kirby put in an appearance. He was working in Fletcher's band but already had a big name. Truthfully, I'd heard all the well-known bass players who were around in those days, and I knew I could outplay him. He was good on tuba, but his bass playing was mediocre. I'd run into him a couple of years earlier when I was just starting out, and he'd always acted pretty nasty.

This particular night, Chu and Roy were jamming with us and I was playing my can off. Of course, I got even stronger when I spotted Kirby in the room and nearly ripped the bass apart on my solos. When the tune ended, I caught his eye across the room, pointed to my bass, and motioned for him to come over and use it. He didn't show any emotion, he just shook his head from side to side. Some of the guys noticed what was going on, and soon they were yelling over to where he was sitting, trying to get him to play. A minute or two later he walked over, nodded to me, and took my bass.

The guys started a medium-tempo tune and Kirby began playing. I was standing several feet away and when he finished two choruses, he suddenly stopped, pushed the bass in my direction and with a real sour face said, "Here, man. I can't play this thing."

I felt like somebody had dropped a bomb. I knew how good my Tyrolean bass was, and I knew the truth —Kirby was using my bass as an excuse so he didn't

have to compete with me. But the place was packed, and there were plenty of famous musicians onstage and in the audience. Right or wrong, I felt very embarrassed, and after sixty-five years I still haven't forgotten.

All the guys in our band used reefer. For a while it seemed like the hip thing to do. Practically every time we had a break, a group of them would go back to the boiler room and light up. I didn't know anything about the stuff, but after a couple of days they asked me to try it and I still remember the night I did.

On our first break, three or four of us went back to the boiler room. They passed a joint around a few times and I had some. About ten minutes later, when we were back on the stand, someone asked me, "You get it?"

I answered, "No, I don't get it," and we played the set.

On the next break one of them told the others, "We gotta get Milt high." We went back to the boiler room again and they lit up another joint. This time they gave me instructions about "doin' it right" by "takin' it in and holdin' it in." I tried a few drags. I thought my lungs would burst and I started sneezing. They watched and laughed and told me to "keep smokin'." When I'd finished most of the joint myself, someone said, "He's got it now."

When I got back to the stand, I was scared. I got high all of a sudden, and I knew I couldn't handle it.

The band sounded magnificent. It was as if I was playing in the most heavenly place in the universe. Time slowed down so much it seemed to take three minutes to get from one note to the next. When I tried to speak, it felt like hours passed before the words came out. And it stayed that way all night.

When we finished at four, I was still stoned out of my mind. Somehow I managed to make it to the el and catch the right train, but when I got off at 43rd and walked over to South Parkway, I ran into serious problems. It was close to five and I was standing at the intersection, unable to cross the street. Each time the traffic signal changed, I'd step off the curb, then see what looked like dozens of headlights closing in on me, and I'd jump back on the sidewalk.

The headlights were probably ten or twelve blocks away—you could always see that far down South Parkway at night, especially when there wasn't any traffic. I'm sure the extension of time and space had distorted my judgment.

I stood on that corner until almost nine in the morning, too afraid to cross. And while I was waiting to regain control of my senses, I made a promise to the Lord: "If you let me come down this time, I'll never go up again."

I can't say I never tried reefer after that. But whenever I did, it was just to be sociable.

It was during the gig at the Three Deuces that Cab Calloway came through town and hired me. It was February 1936.

Al Morgan had been Cab's bass player. He was originally from New Orleans and quite an amazing man. He was tall, dark complected, and real handsome—he looked like he was chiseled out of ebony. He was a sharp dresser and was one of the first to wear huge houndstooth checks. He was quite gentlemanly, and he wasn't a boozer.

Needless to say, a guy like this had a big reputation with the ladies. They were crazy about Al, and he knew it. He had quite an ego. Whenever a girl gave him a program or a loose piece of paper to autograph, he'd sign it, tear off a stamp from a roll he carried in his pocket, lick the back, and paste it next to his name. The stamp was unusual—it was a picture of him.

There were always lots of rumors about the competition which went on between Al and Cab, and some people say it was the real reason he left the band.

I saw Al perform a couple of times when Cab played Chicago. He was always a showman and would stand up front where the audience could get a good look. Cab would take a bow, and as he walked off, Al

would spin his bass clockwise. A few seconds later, when Cab came back on again, he'd spin it the other way. It was all very flashy and very entertaining.

After these performances, I'd go backstage and hang out with my friend Keg Johnson, a trombone player who'd joined Cab's band. I never said too much to Al because I was pretty shy, but I'd stand around and watch him. He always had as many ladies backstage as Cab. I remember thinking, "God, he has it all. I wish I could be like that."

Here's how I got the job. In 1935, Cab went to California to make a movie called *The Singing Kid* with Al Jolson. When he left, Al Morgan was his bass player, but by the time they finished shooting, Al had quit and remained in California. From what I heard, he was so photogenic that some of the movie people told him they'd use him in other pictures if he stayed on the Coast. So he managed to join Les Hite's band, which had steady work at the Cotton Club out there, and that made him available.

Al's leaving took Cab by surprise. The movie was finished, and Cab was about to start working his way back east. Suddenly, he had no bass player.

At that point, Keg recommended me to Cab. Much later, I heard how Cab reacted to the suggestion. He told Keg, "Look, if I can get to New York, I'll get me a good bass player. But I got a lot of work to do before we get there. So when we hit Chicago, I'll drop by and hear this kid."

I'll never forget the night that Cab showed up at the Three Deuces.

As we walked back to the stand to begin the third set, somebody said, "Cab Calloway just walked in." I had no idea he was looking for a bass player or that I'd been recommended to him. I was curious about seeing him, so when I got up on the stand, I looked around the room and spotted him immediately. He had on a big coonskin coat and black derby and he looked sharp.

After our next set, Cab invited Zutty over to his table. From what Zutty told me later, the conversation went like this:

Cab told him, "Look, I like that kid bass player and Keg Johnson recommended him. I need a bass player right now."

Zutty answered, "You want him, you can have him." Just like that.

And then Cab said, "Yeah, I think I'd like to get him."

Zutty joined us on the stand and we played another set. At the next break, I went upstairs for a drink and some pinochle with Art. A few minutes later, Zutty took me to the side and told me, "Kid, you're gone."

"Gone where?" I asked.

"Cab asked me for you," he answered.

It was just like a baseball trade. Nobody ever asked me. That's the way it worked in those days.

I was pretty naive, so I asked Zutty, "Don't I have to give you notice or something?" I figured the union must have rules, and I didn't want to get in trouble.

Zutty put his face right up to mine, looked me in the eye, cocked his head, and said, "Boy, if you don't get your black ass outta here tonight, I'll kill you!"

A couple of years later, Zutty told me more about what had happened that night. When he had agreed to let me go, Cab thanked him profusely and told him, "Look, if you ever need anything, just get ahold of me."

So a couple of years later, when Zutty was in New York and down on his luck, he went to see Cab at the Cotton Club. They talked outside Cab's dressing room for a while. In the course of the conversation, Zutty reminded him about me and what he'd said back in Chicago. Cab told Zutty to wait while he got something from his dressing room, and several seconds later he came out and wished Zutty well. When the two of them shook hands, he slipped a bill into Zutty's palm, the way some people tip a headwaiter.

Zutty didn't look down. He just kept the folded bill in his hand and walked out of the club onto Broadway. When he finally looked, he couldn't believe what he saw—it was a five dollar bill.

Zutty and I laughed about the story for years.

Cab Calloway, c. 1936

The last couple of times I saw him, toward the end of his life, when things were going great for me in the studios, we'd shake hands and I'd slip him a couple of twenties. He'd look down at the bills and say, "Hey, man, that's not right." But I'd jump in with, "Look, I'm just trying to make up for Cab."

Getting back to that night at the Three Deuces–by the time Zutty told me what was happening, it was about two in the morning. The first thing I did was get to a phone so I could call my family to tell them the news. But just as I started talking to my mother, one of the guys from our band yelled, "We gotta go on now—Cab's gonna sing." I told her I'd call her back as soon as I could.

Cab sang for about half an hour and brought the house down. We played a few more numbers and then finished for the night. It was about four. As I was packing up my bass, I watched Cab saying his goodbyes. He put on his fur coat and derby, then turned toward me and said, "The train leaves at nine in the morning, LaSalle Street Station. Be there!"

I called my mother again and told her, "Get ahold of Oby. Tell her to get my stuff together and pack my bag. I'll be right home."

By the time I got to my mother's house, it was nearly six. Oby was there and she'd already packed my things. All I had was a little canvas case with one suit—a gabardine with cutouts around the arms—what they called a bi-swing. Of course, I didn't get any sleep. I took the suitcase and my bass and met Keg at the train about two hours later.

3
Cab

Keg and I got on the train and walked right into the private Pullman. I'd never seen the inside of a sleeper like that before. I certainly didn't leave Mississippi on one, and the trips I'd made with Eddie were never first-class.

Then I saw the guys in the band—all the giants just sitting around, relaxing, waiting for the train to pull out. Keg introduced me to most of them. I was so impressed and I can still name every one of the guys. Mouse Randolph, Doc Cheatham, and Lammar Wright were the trumpets. In addition to Keg, Claude Jones and DePriest Wheeler played trombone. Garvin Bushell, Foots Thomas, Andy Brown, and Ben Webster were in the reed section. Morris White was on guitar, Benny Payne played piano, and the drummer was Leroy Maxey.

Cab and Ben Webster had missed the train at LaSalle Station downtown. So they had to catch it at the 63rd Street stop, where they stumbled in, drunk as two hoot owls. I was sitting in the small anteroom next to the washroom talking to a couple of the guys when I first spotted them weaving down the aisle toward us. Just before they passed my seat, they stopped. I looked up. Ben's big eyes were blood red. He glanced down at me for a second, then turned to Cab and asked, "What is this?"

Cab nodded to me sitting there in my baggy gabardine suit and told him, "This is the new bass player."

Ben yelled, "The new what?"

Cab didn't answer. By this time, he was tugging at Ben's sleeve and within a couple of seconds they'd moved on.

I was devastated. This was my introduction to one of the greats, and he wouldn't even say hello. I remember thinking, "That's one guy I'll never like." As it turned out, I was never more wrong. Within a few weeks he and I had become good friends.

After a couple of hours I'd gotten to know my way around a little better.

In those days, Cab always had two cars reserved, a Pullman and a baggage car. The Pullman was divided into two sections—one for the band, one for Cab. The part for the band had about thirty upper and lower berths, some sitting areas, and a bathroom down at one end.

Cab's section was much fancier, with a drawing room, a couple of berths, a sitting room, and a private bathroom. The band ate meals in the dining car, but Cab had enough space to set up a good-sized dining table and have meals delivered to him.

Everyone kept his luggage in the baggage car, which was attached to the Pullman. Each guy had a

big H & M theatrical trunk that looks like the inside of a closet when it's opened. There's a set of five or six drawers on one side, and a place to hang about fifteen or twenty coats or pants on the other. But most of the car was taken up by Cab's green Lincoln convertible, which he took just about everywhere we went.

Later in the day there was a big scene about which berth I'd be using. The most desirable ones were lowers—especially toward the middle of the car where it was less bumpy. These went to the guys with the most seniority. Since Al Morgan had been one of them, he had lower seven, right in the middle.

It all started when Keg said he'd show me where I'd be sleeping and we walked down the car toward Al's old berth. When we got there, we found Mouse Randolph's bag sitting on the bed.

A couple of seconds later Mouse appeared out of nowhere and told me, "You're new—take upper seven."

Before I could say a word, Keg jumped in and answered in a real angry voice, "Look, man, Al had lower seven and he was the bass player. This is the new bass player who's takin' his place. So he's got lower seven."

Even though Keg hadn't been with the band for very long, he was known to be a militant man. He was a Texan who nobody fooled with or even kidded. In fact, he carried a couple of loaded pistols in his luggage—just in case. So when he used that firm tone of voice, Mouse must've known what it meant. He just picked up his bags and walked off. From that day on, lower seven was mine.

A little later, I got a message that Cab wanted to talk. I walked up to his private section in the front part of the car. It was beautiful. Everything was very plush—carpets, couches, lounge chairs. Absolutely high class.

We had a short conversation. I remember we were both standing, and he seemed completely sober— much different from when he'd gotten on the train with Ben early that morning.

All he said was, "Well, kid, I'll keep you on this trip 'til we get to New York. We get there and I'm gonna get me a real bass player."

"Okay," I answered. I accepted it. I wasn't even insulted—just glad to have a chance to play with that band.

Cab turned away, signalling that the conversation was over. I started walking back to the other end of the car, but when I got halfway there I realized I'd forgotten to ask about money. For a second, I thought about going back to see Cab, but I decided to see Keg instead.

Keg was sitting on his berth, next to mine. When I told him I hadn't asked Cab anything about money, he just said, "Everybody makes the same—a hundred a week and transportation—and you pay your expenses."

I flipped. A hundred dollars a week for a steady gig was unbelievable. I might've made that when I was with Eddie in California, but it was only for a short time. Besides, I'd just come from a job which paid thirty-five. So I was really in seventh heaven. Not only had I tripled my salary, but Cab worked fifty-two weeks a year, no layoffs.

That night we played a dance in Moline. It was early evening when the train pulled into town and I was sitting in the baggage car checking out the strings on my bass and adjusting the bridge. I was so wrapped up in what I was doing, it wasn't until a porter came by that I realized a half hour had passed since we'd stopped. By the time I got off the train, nobody was in sight. I panicked.

I waited for about fifteen minutes. Finally a local cabdriver, a black guy, pulled up to where I was standing, and I asked him if he'd seen any guys from the band. He said he'd just taken a bunch of them "up the hill to Mrs. Jones's place." I got in his car and told him, "Take me where you took them."

A few minutes later we pulled up in front of a row house. I asked the driver to wait while I checked things out.

A lady came to the door and opened it wide enough for me to look past her down a long hall to

Milt, c. 1936

a dining room, where some of the guys were sitting around eating. I was hungry too.

"Whatta you want?" she asked. I tried to explain I was with the band and needed a place to stay. She told me she had no more rooms, and she was very abrupt. Then-, just as she was about to close the door, one of the guys at the table asked, "Who is it, Mrs. Jones?" She turned toward him and answered in a different, polite kind of way, "A young man who says he's with the band. He wants a room, but I'm full."

"Tell him to go down the street. A couple of boys are stayin' down there," the same guy told her.

Mrs. Jones stepped outside and pointed to a house on the next corner. "That's Mrs. Harris's place. Try her." I got back in the cab and we drove over.

From the outside, the house looked fancier than Mrs. Jones's. I discovered later that it was used by the special senior guys in the band like Foots Thomas and Lammar Wright because the accommodations were more private and much nicer.

When Mrs. Harris opened the door, the smell of chicken came out and hit me in the face. I looked down the hall just like I'd done a few minutes earlier and there was the same scene—a couple of guys sitting and eating. I told her who I was and how I'd tried the house down the street. She asked me to wait and closed the door. At that point, I was really feeling weak from hunger and just about ready to give up.

A few seconds later, Foots opened the door and invited me in. I must've looked pretty pathetic because he seemed to take pity on me. He asked Mrs. Harris to find me "some kind of room." Then he invited me in to one of the best chicken dinners I've ever had.

The most important thing was that a couple of the big guys in the band were saying I could stick with them. In fact, from that day on, they always tried to look after me.

I wish the rest of the evening had turned out as well. But playing with the band for the first time was a pretty upsetting experience.

There'd never been a rehearsal for me, so that night's dance was the first time I ever worked with the band. Even though everybody else had written parts, there was no music for me. If there ever had been, it couldn't be found.

Another big problem was the way the band was set up. Al Morgan had been one of the featured musicians, so the bass was out front, about two feet from the piano. Then, stretched out towards the rear, were three levels of horns—trumpets on top, trombones in the middle, and reeds on the bottom.

If all that wasn't enough, I had to wear Al's uniform because there wasn't enough time to have a new one made or have his altered. He was about half a foot taller and fifty pounds heavier, so the sleeves on the jacket covered my fingertips and I had to overlap the waist of the trousers and pin up the cuffs. I looked like a little kid dressed up in his father's suit.

To really understand what happened later that night, it's important to know how we fixed our hair. The style in those days was a pompadour. You'd let the front grow, then work in some pomade and make one big wave right above your forehead. The grease held everything in place and also gave your hair a shiny, patent-leather look.

When we went out on the bandstand, the rhythm section started the first tune and everything seemed fine. But after a couple of choruses, the whole band hit and I really got shook. I'd never been put out in front of a band that large with such a strong brass section. When all those horns suddenly came in, I thought the wind was going to blow me over. It was a loud, powerful sound which made my teeth shake and would take me weeks to get used to.

The piano player, Benny Payne, saved my life that night. Since I had no music, I depended on instructions from him. He'd call out keys and the more difficult chord changes too. Of course, I also did what most bass players do when they're stuck—watch the piano player's left hand.

By the fourth or fifth tune I'd caught on pretty well. I have a good ear and I was following Benny's lead. I even saw some of the guys whispering to each other and pointing at me—nodding approval of my playing.

Cab probably noticed too, because a couple of tunes later he decided to find out what I could really do. He called "Reefer Man," and when the guys heard that, they all looked over in my direction. "That features you," Benny told me.

"What is it? How does it go?" I asked.

Benny gave me a rundown: "It starts in F. When he stomps off, you grab F and you keep playin' an F chord. It's yours alone until he brings the band in."

Seconds later, Cab counted it off, "One, two, one, two, three, four." I grabbed F, I squared F, I cubed F, I chromaticized F. I was scared to death and I was playing way over my head. I was fast—lightning fast—and all the guys watched me closely. They hadn't seen Al do anything like this.

Cab let it go on. Me, alone, chorus after chorus. And the guys kept encouraging him, yelling, "Go, go, let him go!"

My clothes were drenched. My jacket sleeves were so long it looked like I didn't have arms. Everything was flapping and flying around so much, I looked like Ichabod Crane.

Then my hair went. I felt the pomade melting on my head, running down the side of my face, and I could tell my hair was beginning to stand up straight like I got an electric shock. One by one the guys began to break up, and a chorus later Cab fell out too.

I played alone for what felt like an hour, but it was probably more like five or six minutes. Finally Cab yelled, "Now!" and the band hit.

The tune continued and there were two or three long solos. Then, at the end of one chorus, everyone stopped playing. But Benny shouted over to me, "Not you. Keep going! You got it alone again."

This time they put a spotlight on me. And because of the light, the audience couldn't see Benny come around from the piano and stand directly behind me. While I was playing he whispered, "The way this ends is you make like you've had it and fall back with the bass. I'll be right here to catch you."

I played two or three more choruses, then suddenly fell back and the stage went dark.

The audience loved it. I was a hit. More important, I knew I'd passed my musical initiation and gained the respect of the people who really mattered.

Cab's sister Blanche was a well-known entertainer back in the '20s, and she's the one who gave him his start.

Evidently, even as a kid hanging around his sister at the Sunset Cafe in Chicago, he'd learned how to take advantage of his good looks. Blanche got him a job as a relief drummer, and like a lot of drummers in those days, he began singing. His appearance helped make him popular and it wasn't long before he took over an existing band called the Missourians and re-named it after himself.

When Cab hired me, I was only the third or fourth guy who hadn't been with the original band. And after a while I began to realize the differences between the guys who'd been there from the start and the newer ones like me.

The musicians from the Missourians were accustomed to working the best theaters and clubs and making good money. They'd been doing it for years. For them, the band was a job, but it was also a social thing. They were concerned about dressing sharp and hanging out with good-looking ladies. That's exactly what they did, especially when we played big cities. They went out to the fanciest clubs, ate steak, and drank good whiskey. They might watch a floor show and applaud the musicians, but they didn't listen closely and would never think of sitting in. Eventually, many of the original guys got stale. Leroy Maxey, the drummer, for example, never listened enough to keep up. So when Gene Krupa's kind of drumming got popular, Leroy couldn't make it. He ended up getting replaced by Cozy Cole, who was a much more up-to-date player.

But the newer guys like Ben Webster were different. They wanted to experiment and grow musically. Their ears were wide open. They listened to the latest records and visited clubs and sat in wherever we traveled.

The Calloway rhythm section
(*clockwise from top right*):
Leroy Maxey, Milt, Benny
Payne, and Morris White,
c. 1937

Ben Webster storefront banner, Kansas City, c. 1937

Of course, Ben already had a great reputation. He'd joined Cab only a few months ahead of me, and he'd been with known bands like Fletcher Henderson and Andy Kirk. Back in those days, he loved to go jamming wherever we happened to be playing. We'd finish a performance with Cab, and Ben would change into something real sharp, grab his horn, and go out to a little club and sit in.

After I was with the band about three weeks, he started asking me to go with him. Ben always complained about bass players in local groups and he was eager to bring his own man. I can still remember, whenever we were about to go into a place, he'd use the same routine to make a grand entrance. The club would be dark, but the second he walked through the door, he'd light a cigarette. The glow of the match lit up his face just like a spotlight. Heads would turn and people saw the horn case. They knew Cab was in town, and they'd put two and two together. The whis-

pering would begin immediately: "Ben Webster's here." I think a lot of it was an ego thing for him.

After I'd gone jamming with Ben a couple of times, he started asking me to rehearse special things with him to use the next time we went out. Sometimes when we had a break between shows at a theater, he'd insist I go somewhere backstage and play with him. I was his practice man, like the guy who warms up the pitcher before the game starts. It really didn't matter to me how he looked at it, because I was playing duos, day after day, with one of the giants.

Some of the newer guys in the band spoke a hip language, the way a lot of jazz musicians always have. Ben was really the one who introduced me to it. He seemed to know the latest expressions and liked using them, especially when we were out of town in a club or restaurant, around strangers he thought were square. After a while it got to be a natural way of speaking for him and a group of other guys, including me.

A girl was a "soft," a guy was a "lane." "Pin" meant dig or look or see. A "short" was a car, an ugly girl was a "willowford." You could put words together and make sentences like, "Pin that soft on your right duke finalling from the short." That meant, "Look at the girl on your right getting out of the car."

There was also a vocabulary for counting money. A "rough" was a quarter, fifty cents was a "line." "Line two" was a dollar, "line four," two dollars, and so on. We called fifty dollars a "calf," and a hundred, a "cow." Ben might say, "Pin the frame on that lane. It's a possible calf and a cow." That meant, "Look at the suit that guy's wearing. It must've cost $150."

At one point in the '40s, some promoter tried to give Cab credit for inventing this language and published a thin wallet-sized booklet called the *Hepster's Dictionary* with Cab's name on it. But the fact is, no one person created the language. It was more a mixture of words and expressions many different people used. It changed over time. We might use a word so much we'd wear it out and it would disappear.

A bunch of us might hear a joke and make it part

of our language. I remember one time we were short a man for a night and we picked up a young sax player from Texas. He studied our music so hard his eyes almost popped out of his head. He looked at one part where the saxes had a section solo and he leaned over to the guy next to him and said, "It's gonna be hell goin' through here." For months after that, anytime we had a hard part to play, we'd use that same expression.

Our language was a kind of secret code. We could understand it, but the rest of the world couldn't, and using it made us feel different and maybe even better.

Of course, among black people, everybody seems to have a nickname. It's that way now and it was that way when I was young. Naturally, musicians are no exception.

Through the years, I've noticed how some guys seemed to be named for an animal they looked like. Cat Anderson really had a feline-looking face and people called Ben Webster "Frog" because of his bulging eyes. Guys got nicknames other ways too. We called Jonah Jones "Eggy" because of the shape of his head, and Panama Francis got his name from the type of hat he wore. Lester Young called everybody "Lady" and that's how Billie Holiday got to be called "Lady Day." She always called him "Zee President" and that got shortened to "Prez." Zutty was called "Face" because he'd call people "Black Face," "Beard Face," that sort of thing. People who know Lionel Hampton call him "Gates" because that's what he calls everybody.

I guess there's a story behind each musician's name, but I don't know all of them. I have no idea where "Bean" or "Rabbit" or "Sweet Pea" came from. I also know that there were a lot of guys who had names they didn't want their friends to call them. I never heard anyone who was a friend of Basie's call him "Count"—it was always "Bill" or "Basie."

When I was a kid they called me "Sporty." I don't know why—I wasn't that sharp a guy, but it stuck with me even after I joined Cab. When I'd been with the band for a couple of years, I got a new nickname which came from a joke I used to tell all the time. I'd

ask, "What's the lowest thing on earth?" and wait to get a few answers. Then I'd say, "Fump!"

"Fump, what's that?" everybody'd ask.

And I'd answer, "Whale shit at the bottom of the ocean!"

The joke sounds pretty corny today, but the name "Fump" stuck with me for at least a dozen years.

The next nickname I got also came from a joke I used to tell thirty years ago. It involved an old black guy in a courtroom. I don't even remember the story, but the punch line was, "Good morning, Judge." It

Milt, Cab Calloway bandstand, Dallas, c. 1937

Cab 67

wasn't long before my musician friends started calling me "Judge," which I'd like to think had to do with my age and status in jazz. But truthfully, it probably had more to do with my calling someone "Judge" when I couldn't think of his name.

I can usually date my friendships with people from the nickname someone calls me. Ed Burke and Scoville Browne, who knew me from my days in Chicago, called me Sporty, and the one or two guys who are still around from Cab's band still call me Fump. It actually helps me recognize and identify people, especially when I haven't seen them in years.

On that first road trip, we didn't hit any big town where I could get some new clothes. Besides, I didn't have money saved, so even if we'd found a good place, I couldn't have afforded much of anything. For months, my wardrobe was made up of the one gabardine suit I started out with. I must have looked pretty bad because one day I overheard Ben and Keg talking about me, saying, "We gotta get him some new clothes. We can't let them see him in New York like this. We gotta get him dressed before we go uptown."

A couple of weeks later, just before we got to New York, Keg came to me and asked if I had any money saved. When I said I had about four hundred dollars, he told me about the shopping plans he and Ben had made for me.

About an hour after we hit New York, I was in a downtown clothing store called Billy Taub's with the two of them. Even though they weren't more than a couple of years older, they were both treating me like a father would treat his little boy. They took turns holding up jackets, pants, shirts, ties, and asked each other, "How d'ya like this?" If they agreed on something, one of them gave it to a salesman and said, "Okay, put this with our things." They never consulted me, but I didn't care. Their interest and concern is what really counted. It was a beautiful gesture that I'll never forget.

We must've spent two hours in that store. By the time we finally left, I had two suits, three jackets, a half dozen shirts and ties, three pairs of shoes—even socks

and underwear. I walked out of the place wearing a beautiful green tweed jacket. I was looking real sharp and the two of them were beaming. Then the three of us headed uptown.

We had a week off before rehearsals started for our gig at the new Cotton Club which was about to open downtown. I spent most of the time in Harlem with Ben. I guess I didn't look too bad in my new clothes—at least he didn't seem to mind being seen with me. He took me with him everywhere, and since he knew just about everybody, I got a chance to meet some of the best musicians around.

During the same week I also got a place to live in Harlem. Mrs. Floyd, our landlady from Chicago, arranged all of it for me. She had a brother, Mr. Allan, who owned a good-sized house on West 113th Street. She'd contacted him a couple of weeks before I arrived and got him to agree to rent me a room. It wasn't a real rooming house. There were only a couple of other boarders, but the one I'll never forget was Maizie Wright. She was a tall, dark, older, single lady from Georgia who worked in a local laundry.

Just before we started rehearsing, Oby took a train in from Chicago, and when she arrived everything was set up for her. I'd enjoyed the break, but by the end of the week I was ready to work again.

Herman Stark, Owney Madden, and a couple of others had gotten hold of the Palais Royale at 49th and Broadway, where Paul Whiteman used to work, and made it into the new downtown Cotton Club. Cab got booked to open the place and everybody was concerned that it be the best. So each day we rehearsed for hours.

It was a big production called "Copper Colored Gal of Mine." Will Vodery, who wrote a lot of Florenz Ziegfeld's shows, did some of this one, and Clarence Robinson was the choreographer. It was a lavish show. The only difference between it and a regular Broadway musical was that the audience could eat and drink while they watched us. Otherwise, everything was just as fancy and probably just as expensive to put on.

The performers included Cab, Bill Robinson,

the Berry Brothers, the Nicholas Brothers, and Avis Andrews. They also had about three dozen of the most beautiful light-skinned girls in the world. Half of them, the showgirls, were very tall and the rest danced in the chorus line. There were also male dancers called the Cotton Club Boys. In fact, Cholly Atkins, who got well known later for doing rock 'n' roll choreography, was one of them.

Cab paid us full salary during the time we were re-hearsing. It was months, as I recall, because there were problems with construction and with changes in the show. The band would play in the area—Long Island, West Chester, Jersey—so Cab could pick up enough to cover expenses.

In the early fall, when the night of the dress re-hearsal finally came, I had a devastating experience.

Everybody involved with the show was real up-tight. Then, just before we were set to begin, the union

delegate from Local 802 walked in. At first it looked like a routine visit. He checked the contract, then walked around and asked each of us for our union card. Things changed the minute he saw my card was from 208 in Chicago.

He stared at it for a second and then threw it back at me, saying, "You can't work steady in this city without belonging to the New York local. You gotta process a transfer and that'll take six months."

I was shocked. I panicked. Before talking to Foots or Lammar or any of the senior guys, I immediately ran off to see Cab. I found him in a corner, pacing up and down, rehearsing his lyrics and dance steps. I could see how nervous he was, so I quickly told him about the union problem. He didn't seem to care. All he said was, "Go see Mr. Wright. He'll give you your money and the fare back to Chicago."

I didn't believe what I'd heard. I guess I expected more than that from Cab. I stood there with my head cocked, staring at him. Then he said, "Yeah, man, I ain't got time for this shit. I gotta get this song down for the opening tomorrow."

I went to Keg. He'd seen what had happened and had already tried talking to the union guy. Apparently, the local was really against anybody from out of town working in a brand-new club, especially when it was on Broadway, right in the middle of the city.

They immediately sent for Chick Webb's bass player, Elmer James, and he came down to the club about an hour later. Naturally, watching all of this and feeling completely helpless broke my heart.

Just as I was getting set to leave the club and head back uptown to start packing, Keg and Foots cornered me. They convinced me to hang around town for a couple of days while they tried to straighten it all out. I agreed, of course. There wasn't anything pressing for me in Chicago, anyway, so I had nothing to lose.

The show opened the next night and got rave reviews. A few days later, Cab had settled down and Keg, Foots, Lammar, and Ben went in to see him. Later they told me about the beautiful job they did on him, which went something like:

Look, man, you're a star, don't you know that? You're a big man. So you don't have to let no union tell ya' what to do. Shit, you're supposed to have anybody you want working for you. Why the hell d'ya let the union tell you to send that kid back home? You'll be on the air three times a week—you can't have no new guy. You got all these gangsters around you. You oughta know people who can straighten this shit out.

Cab told them, "Yeah, that's right. Nobody's gonna tell me what to do. Where's the kid? Tell him to come down here and see me."

A couple of hours later, I was in with Cab. Foots was there too because he was the assistant musical director. Cab told me, "You don't leave town. They say you can't work every night, but if you go downtown to the union and deposit your transfer, you can work two days a week."

Foots jumped in. He repeated everything Cab had said, just so there wouldn't be any misunderstandings. Then he added, "The new guy's really not makin' it like Milt. Milt knows the book. So we'll use Milt on the two nights we broadcast. That way we'll go on the air sounding great."

Cab agreed. I was to come in Wednesday and Friday nights and I'd still get my full hundred a week.

Most of the guys in the band had figured out how Cab's mind worked and they knew how to influence him. They realized that he wasn't musically adept enough to hear all the harmonics and really know what was going on. They also knew he depended on the musicians he hired. He trusted their ears. So if the important guys approved of a new man, it was good enough for Cab.

Elmer James played his heart out. After all, he was trying to get my job. But no matter what he did, the guys didn't give him any encouragement. They remained loyal to me. It's true I knew the book, but I don't think I sounded any better than him. What was more important to the band was the time we'd spent

on the road together. They liked me and thought of me as one of them.

So all the guys went to work convincing Cab about me. On the two nights I'd come to play, they'd make a fuss about everything I did. They'd nod approval during my solos and sometimes quietly applaud or yell out "Yeah!" or "Beautiful!" when I'd finish. This went on for weeks until the night they staged a grand finale.

It was a Wednesday. We were on the air playing a tune called "Nagasaki," which featured Keg on trombone. A chorus before his solo, Keg turned to me and whispered, "When we get to letter C, you take it."

Cab didn't know anything about the switch. "Nagasaki" was up-tempo, so he was out in front leading, with his baton waving and his hair flying. When we got to letter C, I started soloing instead of Keg. Cab looked confused for a second but recovered quickly and pointed the baton at me. The spotlight followed. There I was in all my glory, and when I finished, the audience gave me a loud round of applause.

That settled it for Cab. When I came in on Friday—two nights later—I passed his dressing room and overheard him talking to a couple of the guys about me. He was saying something like, "I'm gonna make a star out of him."

Within a week, more strings were pulled somewhere and my union transfer went through in three months instead of six. When I needed the money for initiation fees and union dues, Maizie Wright, the lady from my rooming house, insisted on giving it to me, no questions asked.

Elmer James left, and for the next sixteen years I was Cab's steady bass player.

Looking back, I often wonder whether Owney Madden or Herman Stark ever got involved in my union problem. Both of them were well-nknown gangsters. In fact, in Cab's book he describes how they were involved with him financially. Of course, the guys in the band knew what was going on. We'd always see gangsters hanging around the club, and even some of the celebrity customers would spend time with Madden and Stark and their associates. I remember

whenever George Raft came into the room we'd play "Sweet Georgia Brown." He'd get up and do a little dance routine for the audience, then take a seat at a table with a couple of these same people. It was all public.

Somehow Cab managed to keep the underworld away from the band itself, and I give him a lot of credit for that. There were times when I saw these guys wanting to jump in and straighten out one of the musicians. In fact, it happened to me after Chu Berry joined the band and we had a fight out in front of the Cotton Club. But Cab always stood his ground with them. He'd say, "Look, it's my band. I'll take care of it." In that sense, there was only one leader.

Working for Cab was probably one of the two best steady gigs around. The other was with Duke. Of course, they were very different kinds of jobs. Duke was a genius and his music was miles above everyone

Foots Thomas, backstage, New York City, c. 1940

Cab was the only bandleader who gave his guys a paid vacation. He was born on Christmas, so he refused to work for anybody on that day. No matter where we were in the country, he'd shut down from December 23rd until New Year's Eve. We'd leave with a week's salary plus a hundred-dollar cash gift and a ticket to New York, where most of us lived. For six or seven years, he'd also give us a ticket to Chicago because we had a steady New Year's Eve gig at the Hotel Sherman there. He wanted to be sure we'd have our transportation already paid, so we'd be back that night.

Cab never missed a payday either. Even in the last days of the band, when we'd get booked into smaller places like Youngstown or Scranton and practically no audience showed, he'd call New York and have them wire payroll money. He kept it all going for as long as he could.

All of us knew we had jobs that were worth keeping. We even had a saying about it: "Lay dead and get ahead. Wait for Thursday and don't make waves."

Milt, backstage, c. 1941

else's. One of the most amazing things about him was his ability to take young unknowns and turn them into stars almost overnight. He did it by studying all the aspects of their playing, and then writing material which featured them and emphasized all their strong points. But having so many stars in one band had its drawbacks. All those big egos seemed to cause competition, and there was always some kind of hostility going on.

We had only one star in our band—Cab. And he wasn't very interested in music. All he really ever wanted from us was solid accompaniment. But he paid better than Duke and he also seemed more concerned about developing discipline and making sure we had a positive image of ourselves.

When I joined the band in 1936, everyone got the same hundred a week, paid on Thursday. But later it changed and the longer you were with the band, the more you earned.

After the new Cotton Club opened, we played there every year. We'd introduce a fresh show and do it for six months. Then, when we left, Duke usually followed.

Our shows at the Cotton Club seemed to have the same kind of format, year after year. There were stars like Bill Robinson, Ethel Waters, and the Nicholas Brothers, who did their solos and performed with singers and dancers in big production numbers. There always seemed to be one with a jungle motif which had plenty of dancing with drum accompaniment and growling trombones. Cab conducted the band, which was always onstage accompanying all the performers. But he had his own numbers in the show, and when he was out front, Foots would conduct.

For a while these shows became known for the new dances they introduced. The dance always had a song that went along with it, like "Peckin" and "Scrontch." One year I spent time thinking up a new tune and

dance. I called it "Cle Hops" and showed it to Cab. He liked it enough to play it occasionally. I think Andy Gibson did the arrangement, and recently someone told me there's an aircheck recording of it around somewhere. I never got any royalties, but that didn't upset me. What really counted was that my composition was getting played and I was encouraged to try writing more.

Spending half your time at the Cotton Club and the other half on the road was an amazing way to divide up the year. It really gave you the best of both worlds. The guys with families could set up house and settle in for a while because they knew they'd be working in New York for a six-month stretch. In fact, many of us chose New York as a permanent place to live for just that reason.

But you weren't in one place year-round, and that was good too. After six months, the repetition of the show started getting to you. By the fourth or fifth month, most of the guys began feeling restless and stale on the job and even at home. But knowing it was only a matter of time before they'd be able to get some fresh air made anything seem all right.

When we'd go back on the road, it was the Cab Calloway show again. We'd have a girl singer like June Richmond or Mary Louise, a featured tap dancer, a comedian, and the Cotton Club Boys.

We'd start by playing theaters. The show would be about an hour and a half long and we'd do three or four a day. The tour usually began in a New York theater where the audience was different from the Cotton Club's, then moved to Newark, Philadelphia, Atlantic City, Baltimore, Washington, Pittsburgh, and so forth. It was always a full week in the big towns and a split week in smaller places like Akron or Youngstown. Playing Texas took a month.

Finally, at the end of three months, we'd have worked our way out to California. By this time things were so monotonous it was a relief to go into the Million Dollar Ballroom in L.A. and play dance music for a couple of weeks.

When we finished the Coast we'd start back. Only

Cozy Cole (*in background*), Hilton Jefferson, and band bus driver, Alabama, c. 1940

[Above] Cab's Lincoln convertible and the Calloway band bus, c. 1941

[Opposite page] Jonah Jones and Holmes (Cab's chauffeur) with the band bus, Little Rock, Arkansas, c. 1941

this time, we'd do one-night dances in much smaller and more rural places. Cab would stand in front of the band, leading with a baton and singing, of course, but we didn't have all the acts with us. One of the good things about working dances was the opportunity to play a greater variety of music. But since most of our guys were so used to playing tunes from the show, it took weeks before we'd be able to really let go.

Sometimes there were no railroads into these "water tanks" so we had to travel by bus, which was much harder on us. A bus isn't like a train. You're sitting practically all the time and on the bumpy country roads we traveled, it was difficult to read without getting nauseous. After a while, about the only thing left to do was wait for the next stop for food and beer.

Using the bus also meant we had to pay attention to finding bathrooms, which wasn't always easy in rural areas. Many times, we'd suddenly stop by the side of the road and one of the guys would rush out to a nearby field with a roll of toilet paper in his hand. We knew he had the runs so bad he just couldn't hold it any longer.

South of the Mason-Dixon Line, we avoided roadside stops whenever possible because we were always afraid we'd attract too much attention. To help solve the problem, we worked out a system for pissing out of a moving bus. If one of the guys had to relieve himself, he'd walk up to the front of the bus and yell, "Oil change!" That meant everyone on the right side had about ten seconds to make sure their windows were closed. Then the driver would open the passenger door and the guy could piss onto the roadway.

Most of the small towns didn't have a theater, just an armory or an auditorium. In the South, we often played outdoors at a pavilion or a fairground, and sometimes we'd even have to use a tobacco barn.

After weeks of this routine, everyone was exhausted, ready to get back to a more settled life in New York and begin rehearsals for a new Cotton Club show.

It didn't take long for me to change my feelings about New York. Only a few years earlier when I'd been stranded in Harlem, hanging out with Ann Robinson, feeling isolated, and waiting for Eddie

South to find work, I'd hated the place. But now, being in Cab's band, hanging out with the best entertainers in the world, and enjoying a different economic situation, I began to love the city.

What impressed me more than anything else was being able to experience the melting-pot aspects of New York. Rubbing elbows with people from every possible ethnic group is something my Mississippi ancestors could never have imagined. Things weren't that way in Chicago either. Blacks on the Southside may have been friendlier to each other than blacks in Harlem, but from my point of view, they never really mingled with anyone other than their own. New York was definitely different in that respect.

In Chicago during the '20s, if you were black and went to the Palace Theater, you sat up in the "buzzard's roost" and got an aerial view of the show. But in New York during that same period, Sissle and Blake had their own shows on Broadway, Will Vodery was writing for Ziegfeld, and except for a very few places which were owned by the underworld and screened their customers, blacks and whites ran around Harlem together to see top-notch entertainers. And it continued into the '30s, when Benny Goodman hired Teddy Wilson and Hamp, and all the clubs opened on 52nd Street.

I developed a real fondness for Harlem. I still remember how, when the weather was warm, some of us would walk from the Cotton Club at 48th and Broadway up to the places where we were staying in Harlem. We'd been playing in a smoke-filled room all night, so when four AM rolled around, we looked forward to getting some fresh air.

There were usually five or six of us. We'd head up toward Central Park West and then follow it north all the way to Harlem. There was a great bakery on 116th, and we'd stop there and pick up a couple of dozen donuts or some fresh rolls. Then we'd get a couple of quarts of milk, spread everything out on a park bench, and pass the food around. When we finished, we'd go our separate ways.

I usually stopped to pick up a newspaper at an af-

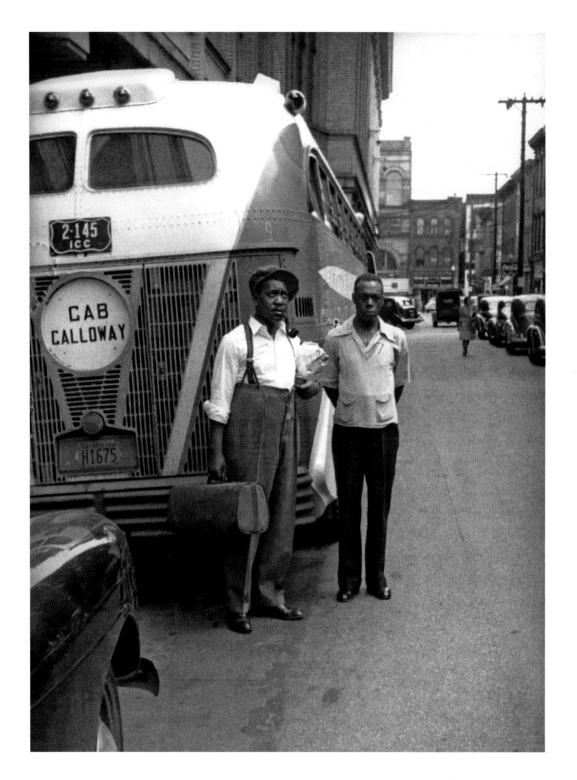

ter-hours bar at 115th and 7th. The place was owned by a guy named Jack Carter. He'd been a well-known drummer with Noble Sissle and had toured Europe with him.

Bars had to close at four, and when I got to the place, maybe five-thirty or six, the lights would be off. I'd knock and a few seconds later Carter would look through the little glass window in the door, then let me in. He was very smart about serving after hours. He always had two shots already poured for each of his regulars, so if anyone was ever watching through the front window, they wouldn't see him pour a drink after closing time. I'd spend about a half-hour talking music with some of the guys. Then I'd leave a dollar for the drinks, take a paper, and walk back to the place I was staying.

During the late '30s, jazz got big in New York, especially downtown on 52nd Street. A couple of us would spend our hour off between shows at the Cotton Club, and go over there whenever we could. Guys like Stuff Smith, Benny Carter, and Coleman Hawkins had small bands in different clubs, and Art Tatum was usually playing in one of them. It was a beautiful scene.

In 1936, Teddy Wilson and Lionel Hampton were working with Benny Goodman at the Pennsylvania Hotel. At some point, Cab went and saw that band a few times. He was so impressed with Gene Krupa, it wasn't long before he fired Leroy Maxey and hired Cozy Cole, who was flashy and could solo like Krupa. Cozy had been with Blanche Calloway earlier but left to do freelance work, and when Cab hired him he'd been playing on 52nd Street with Stuff Smith and Jonah Jones.

By this time, Teddy was popular enough to get his own record contract with Brunswick. Since he didn't have a regular band in those days, every time he made a record, he'd call on his old friends. They were good players and they'd recommend their friends too. I knew Teddy from Chicago, but he and Ben were from Texas and knew each other even better. So whenever

we were in town with Cab, Ben made sure I'd get the call.

Of course, it was Teddy's bands which accompanied Billie Holiday on some of her early records and, as it turned out, I was fortunate enough to be on a few of them too. It's interesting to look at the personnel on the sessions Teddy made in the middle '30s. As might be expected, there are guys from Benny's band, but you can pretty much tell if Duke or Cab was working in New York from the other people listed.

Even though Hamp was with Benny, he got his own contract with RCA. We knew each other from the early days, so whenever he had a session and I was in town, he'd call me. Benny's band had a schedule similar to ours, and on the long breaks some of us hung out together. Sometimes Hamp would come by the Cotton Club alone and pick up Cozy and me, and maybe one or two others. Then we'd run over and spend an hour on 52nd Street. Hamp was hot in those days and even though he was under contract, everybody wanted to record him.

I can still recall the night we were standing at a bar in one of the clubs and a strange guy came up to Hamp and told him, "Hey, I want you to do a record date for me tomorrow." Hamp answered immediately, "Okay, give me three hundred dollars." They talked a little about a time and place and the number of musicians Hamp would use, and then the guy gave him the money and walked out.

Hamp told Cozy and me we were going to do the date, but only if we drank three hundred dollars' worth of booze before we went back to work. He ordered about ten drinks, but there wasn't enough time to finish them. So we split the money three ways and got back just in time to do the second show. The next day we met in a studio and made a couple of sides.

I recorded with Hamp under similar circumstances several other times. Looking back on it, I think some of his greatest records were made in this last-minute way. Of course, a great deal had to do with his getting the best sidemen. I remember one date I did in 1939

[Top] Ben Webster, Harlem, New York City, c. 1941

[Bottom] Paul Webster and Milt, Harlem, New York City c. 1941

Cozy Cole and two friends, outside the Apollo Theatre, Harlem, New York City, c. 1939

where he used Chu, Ben Webster, Coleman Hawkins, and Benny Carter on reeds, Dizzy on trumpet, Clyde Hart on piano, Cozy on drums, and Charlie Christian on guitar. You couldn't ask for much more.

The records I did with Ethel Waters in the late '30s had the same calibre of musicians on them. And as the years passed and some of these guys got popular enough to have their own sessions, I'd sometimes get the call. By 1945, I'd played on records with leaders like Pete Brown, Foots, Jonah Jones, Chu, Coleman Hawkins, Buck Clayton, Emmett Berry, J. C. Heard, and Ike Quebec. I'd even made a couple of sides under my own name.

Cab had a contract with Vocallion and later Okeh, and he made a lot of records, but he really didn't like performing in the studio. His reputation came from clubs and radio– before records were big– where he was always playing to a live audience. He didn't want to listen when the record executives promised to make him great. He'd say, "I'm great already. I don't need records. Radio made me." In fact, whenever he had to make a record, it was always a traumatic scene.

In those early days, when Cab found out that Ben and I had made some records with Teddy, he got real upset. He called us in one day and laid it out: "I'm not gonna have my guys runnin' around makin' somebody else great." Ben just about blew his stack. He told Cab, "Man, whatta ya talkin' about? If you think I'm gonna sit here and die in your band, forget it." He actually threatened to quit.

The next night Cab got us together again. He must have thought things over, because all he said was, "I'm glad I've got the calibre of musicians in my band everybody else wants." The problem ended after that meeting, but four or five months later Ben left.

It was inevitable. There just wasn't enough for him to do musically. He always got a couple of eight-bar spots, but that just didn't give him enough room. Besides, by this time he was pretty well known from his records and from the sitting in he'd done at clubs all across the country. He had a built-in following and he knew it.

In early summer of 1937, Ben went to Cab and gave him notice. He told him that he wanted more opportunity to play jazz. I think he really wanted to go with Duke, who had a great band and was the only one paying close to what Cab paid. Cab told him he understood, and when he asked for someone who could be his replacement, Ben recommended Chu Berry. Cab called Chu immediately. He was with Fletcher's band at the Grand Terrace, but he was able to join us a couple of days later at the Palace Theatre in Cleveland, as I recall.

Chu was also a great soloist, but he dealt with the musical problem Ben had faced in a very different way. There's no doubt that musically he was the greatest thing that ever happened to the band. He's responsible for changing things around.

Chu must've been in his late twenties when he joined us, but he'd been around and always acted much more mature. Physically he was big, like a football player, and real outspoken but personable. He was a frugal man who'd save his money by putting large bills in the leaves of a Bible which he kept in his trunk. He had a close relationship with his family and he loved his hometown, Wheeling, West Virginia. He always wore sports clothes—sweaters and slacks—except when he went home. If we had a break for a couple of days, he'd put on a sharp suit, get some of the big bills out of his Bible, and go see his mother.

Chu was truly a musician's musician. You knew it by hearing him play or listening to him talk about music. He's the first one I knew who tuned a little sharp. It gave an edge to his sound which let him cut through the whole band and be heard. He'd also worked with almost everyone who counted. So he had our respect right from the start.

Cab liked Chu, even though Chu often told him exactly what was on his mind. That's the way he came to have an influence on our music. He began working on Cab just as soon as he joined the band. I remember the conversations they'd have. Chu would be calm about what he was saying, but he'd get it all out so Cab could think it over. Chu would say something

like, "You got good musicians in your band, but your music is stale. When you leave the stage, the band's got nothin' to play. Man, we can't 'hi-de-ho' if you ain't there."

He'd suggest that Cab get Fletcher Henderson, Don Redman, and Benny Carter to do some arrangements for us. Then he'd go on, "If you were to build you a good band, even if your hair fell out, you'd still make it."

This kind of nudging eventually got to Cab, and the next time we were in New York he hired Benny Carter to write four new arrangements for us. I remember how excited we were about getting some fresh material, and I think Cab sensed our mood. He wanted to participate and also show his leadership, so he decided he'd go over the new tunes. When Chu heard this, he went to Cab to convince him to bring in Benny Carter to rehearse us. He explained to him, "That way we'll get it right the first time and then you'll have it all the time."

Cab agreed to let Benny in for one rehearsal and the band sounded great. When we were finished, Cab came by to give his official approval, and everything seemed to be fine.

But a couple of weeks later when Cab got Benny's bill, he flipped. He was used to paying fifteen or twenty dollars for an arrangement, and Benny had charged a hundred apiece. Cab paid the four hundred but decided we'd all have to suffer for it. So from that time on, he refused to play any of those tunes, and whenever we asked about them, he'd just ignore us.

After a while, we worked out a way to get around Cab and play the arrangements anyway. We used them whenever we played dance music late at night and he'd left for the evening. Many times, just as soon as he was gone, Foots called one of the four numbers and we'd have a ball with it.

Chu also got us some better music to play by trading arrangements with other bands. I think he traded with Chick Webb more than anyone else because he knew him very well.

Chick was consumed by music. I'd always see him hanging around the Cotton Club talking about his band to anybody who would listen. I remember times I was with him when he got so excited about a new arrangement, he tried to sing all the parts.

Chu and Chick would talk music for hours and work out ways to make their trades. Trading was easy for Chick because he was a leader, but Chu had it harder. He knew Cab would never agree to swap, so he'd sneak out the parts, one by one, and have them copied by hand.

Once in a while, Cab would point to an arrangement we'd gotten and ask where it came from. Foots would usually give him a vague answer which wasn't the truth. But Cab never pushed. I don't think he really cared. After all, it didn't cost him anything.

Later on, Chu was also responsible for Cab's making records which featured guys in the band. It started about 1939, around the time the Cab Jivers was created. That was a quartet made up of Chu, Cozy, Danny Barker on guitar, and me. I think it was formed because someone in Cab's organization realized that each of us in the group had developed a reputation and a following. Of course, Benny Goodman was having great success featuring a quartet with Teddy, Hamp, and Gene.

I remember hearing Chu tell Cab, "Look, you're making records, but people like the band too. Why don't you make one side singing and one side featuring some of the guys?" Since Cab never really cared much about records, he just went along.

I think I was the first to be featured, on a tune I wrote called "Ebony Silhouette." Dizzy Gillespie did one called "Pickin' the Cabbage" that's a classic, and Tyree Glenn had a nice solo on "North of the Mohawk Trail." Hilton Jefferson had a feature on "Willow Weep for Me," and Chu himself soloed on "A Ghost of a Chance." Some instrumentals were made with a small group, but we used the whole band too. Cozy recorded "Ratamacue," "Crescendo in Drums," and "Paradiddle," and we did a tune called "Lonesome

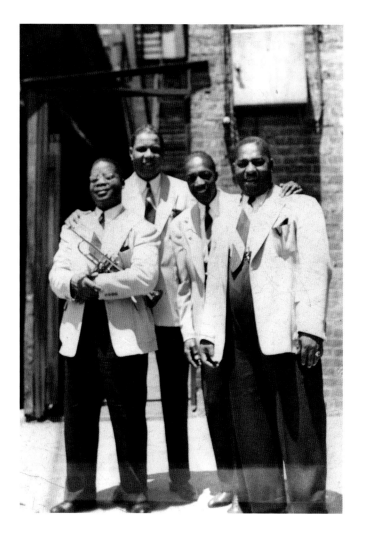

Nights" which featured the whole sax section. Later, I recorded another tune called "Pluckin' the Bass," and when Jonah Jones got into the band, we made "Jonah Joins the Cab."

In all the years I worked for Cab, I was out a total of two days. It was in 1939 when I went home to Chicago for my grandmother's funeral. We were at the Cotton Club and a Latin relief band was there with us. The bass player from the group subbed for me, playing the shows and the dance music. But

[Above] Lammar Wright, Benny Payne, Milt, and Chu Berry, Cleveland, 1938

[Opposite page] Cab Calloway with a winner of the *Cab Calloway Quizzicale* radio show, Florida, c. 1941

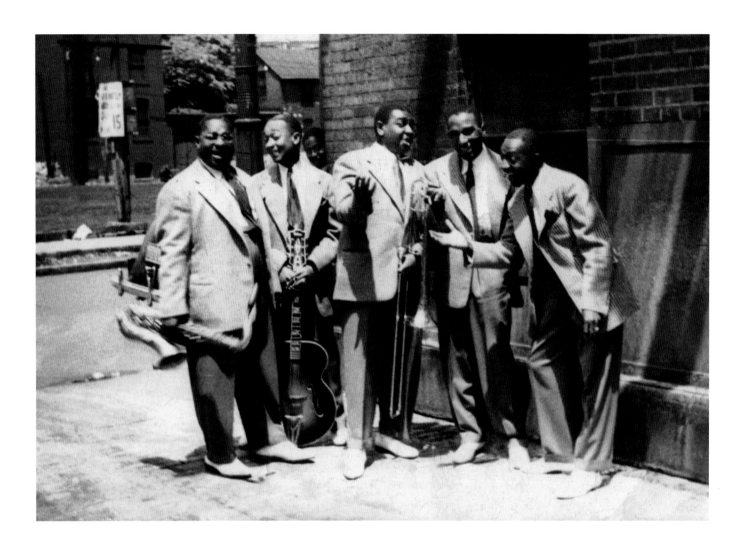

he also did the record session that which had been scheduled for the day I left. And as fate would have it, the tune they recorded was "Jumpin' Jive," one of Cab's best.

Like most other jazz-oriented guys in the band, I enjoyed the instrumental things most. I wasn't much of a "hi-de-ho" man, even though I knew that's what brought in the people and put bread on the table. If we weren't playing instrumentals and Cab was on-stage, I preferred it when he sang ballads.

I don't think the public ever realized just how good the musicianship was in the band. The guys in other bands knew, though. In fact, many of them felt sorry for us because we weren't ever fully utilized the way Duke or Fletcher used their men.

Looking back, it's clear to me that Chu really did change the band. He brought in better music and he raised the standards. He got us some recognition as musicians. Even within the limits Cab imposed, he managed to be an innovative player and many of us listened to him and followed his lead.

Chu and I were always very good friends and we

used to clown around a lot together. One night at the Cotton Club I decided to play a little joke on him that went too far.

I was walking through the kitchen on my way to the bandstand to do the second show and saw an enormous bin of uncooked brown rice. I'm not sure why I decided to stop and fill my tuxedo pockets with the rice, but it probably had something to do with the whiskey I'd drunk between shows.

I went back to the bandstand with the rest of the guys and the show began. Cab sang and then Bill Robinson came out and danced. But every time there was a rest in the music, I'd take a pinch of rice from my pocket, lean forward a couple of feet to where Chu was sitting, and drop it into the bell of his horn. After I did it a couple of times, I began hearing a faint tinkling sound coming from his direction every time he'd play. It was the rice hitting up against the sides of his sax. I started laughing and some of the other guys noticed and started laughing along.

The first few times I did it, Chu didn't move—he didn't even blink an eye. But by the fourth or fifth time, I could tell he was annoyed. While he was playing, he turned halfway around, tilted his horn to one side and said out of one corner of his mouth, "Don't do that anymore."

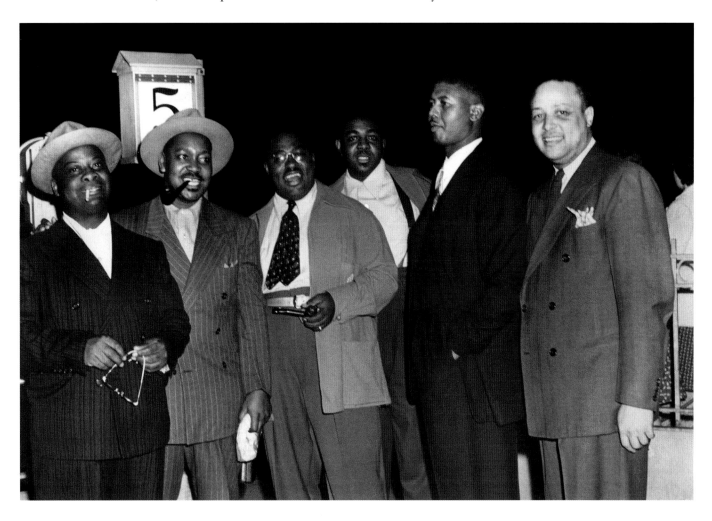

Lammar Wright, Jonah Jones, Chu Berry, Tyree Glenn, Foots Thomas, and Quentin "Butter" Jackson, c. 1941

But that didn't stop me. I was feeling no pain and, besides, I was getting a good reaction from all the guys. So the next time I had a two-bar rest, I leaned over and dropped another pinch in.

Chu turned toward me again, this time without the sax in his mouth, and said in a loud voice, "I'm telling you for the last time, don't do that anymore." I felt I'd been challenged. I waited for the chorus to end, then grabbed a handful of rice out of my pocket and threw the whole thing in his direction.

He dropped his horn into the rack, got up, and turned around to grab me. He was an ex–football player, big, not fat, but muscular and hard as nails. The second I saw his sax go down, I put my bass up against the wall and went through the back curtain. I stood to one side, and when he came through I grabbed the curtain and wrapped it all around his head. He was tangled up just long enough to give me a head start. I jumped down most of the steps and dashed out the backstage door. When I turned the corner onto Broadway, he was right behind me, so I began running uptown as fast as I could.

In those days I was thin, and I could run pretty fast. Chu was large, but once he got momentum up he was sailing. At 49th Street he must've been a half-block behind, but by 51st he was only about ten feet away.

I knew Chu would tear me up if he caught me and that fear kept me going for another block, right to where Birdland used to be on 52nd Street. That's where I ran out of steam, but Chu couldn't make it either. He'd stopped running about a quarter of a block behind me and was walking toward me very slowly. We were both completely exhausted. I just couldn't move my legs anymore, and when Chu reached me, I could see he was in the same condition. I'm sure he didn't have the strength to lift his arms even if he still wanted to hit me. We were both standing there in our band uniforms, panting. Finally Chu got up the energy to tell me, "Look, that's it, it's over, but don't ever do that again."

We slowly walked the four blocks back to the club and when we got there, Cab, Bill Robinson, and Herman Stark were waiting out front. I don't think either one of us ever got such a bawling out. We must've been fired at least six or seven times that night.

In 1939, Doc Cheatham, who'd been with Cab for years, was feeling ill and decided to give notice. By this time, when it came to finding replacements, Cab would go to Chu first. He knew everybody and was really on top of the music scene. Chu spent about a week looking around and then recommended a young kid named John Birks Gillespie, who everyone called Dizzy. Cab hired him.

We were at the Cotton Club when Diz joined us. He'd been playing with Teddy Hill's band and really had no reputation to speak of. Even back in those days, he was hanging out with Lorraine, who was in the chorus at the Apollo and later became his wife.

At first Diz didn't have a dime, so some of us helped him out whenever it was necessary. I remember giving him five bucks about a week after he joined the band so he could have his mouthpiece plated. It was so worn it was ruining his chops.

Diz's music was revolutionary. Even back then he was playing way ahead of the times. But only a couple of us who had our ears open listened. I knew he'd take music to a new place. So did Chu, Cozy, and a couple of the others.

Diz's biggest musical problem was that he'd try playing things he couldn't technically handle. I'd often hear him start a solo he just couldn't finish. Whenever that happened, some of the older guys would look over at him and make ugly faces. Cab usually showed the same kind of disgust and often scolded Diz at rehearsals or after a performance. He'd say things like, "Why in hell can't you play like everybody else? Why d'ya make all those mistakes and have all those funny sounds come outta your horn? Play it like the other guys do!"

Diz would sit quietly, with his head hung down.

[Opposite page] Dizzy Gillespie, Chu Berry, and Butter Jackson, Fox Theater, Detroit, c. 1940

He looked like a little school kid being scolded by the teacher.

When the weather was warm and we were playing the Cotton Club, Diz and I would try to get up to the roof between shows to work on our music. He'd take his horn and I'd somehow squeeze my bass through the narrow back passageways. Playing up there is how he and I became dear friends.

By this time, the Cab Jivers was going strong and I had a featured spot in the stage production. As one of the members, that meant I'd have a solo in every show. So during many of the intermissions when Diz and I would head for the roof, he'd help me with my solo for an upcoming performance.

He always wanted to change my way of walking chords, which was straight down the middle. Since I knew the tunes I'd be soloing on, he'd take them apart harmonically and give me flatted chords and very modern substitutions to use. Whenever I had trouble understanding, he'd demonstrate by playing the bass line on his horn, note for note.

The Cab Jivers always performed out in front of the band, and Diz would watch closely from his seat in the trumpet section toward the back of the stage. Each time I finished my solo, I'd turn around to get his reaction. If I had done well, he'd nod his head up and down or use two fingers to give me an okay sign. But if I'd screwed up, he'd make an ugly face.

One day, all of this came to a sudden end, and it was really due to the communication system we'd been using on stage.

It was summer and the band had gone up to do three Sunday shows at the State Theater in Hartford. A couple of days earlier at the Cotton Club, Diz and I had worked out a solo for me to play with the Cab Jivers on "Girl of My Dreams." I'd also practiced it with him backstage right before the first show.

When it came time for the Cab Jivers' feature, the four of us walked down to the front of the stage from our regular places on the bandstand. Then the back of the stage where the rest of the band was sitting was darkened, and a couple of spotlights were put on us.

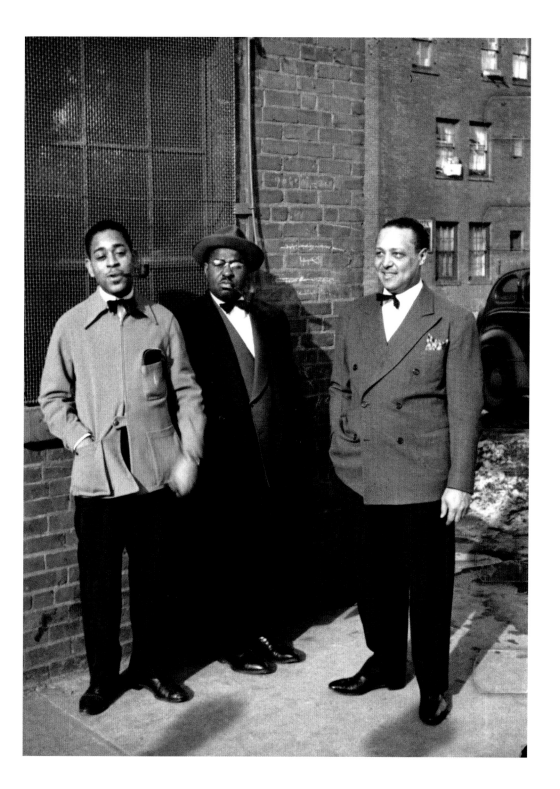

The "Cab Jivers," (*clockwise from upper left*): Milt, Cozy Cole, Danny Barker, and Chu Berry, c. 1940

We played a few tunes, but by the time we played "Girl of My Dreams" I'd forgotten everything Diz had showed me. I must have missed my solo by a mile. The tune ended and I turned around to get a reaction from Diz, who was sitting in the dark. He was holding his nose with one hand and waving at me with the other. It was clear what he was telling me—"You stink."

At the exact same moment, one of the guys up on the bandstand thumped a spitball and it landed right in the spotlight next to where Chu was standing.

Cab was watching the show from the wings. He saw Diz's gesture and he saw the wad of paper land. He never saw who threw it, but in Cab's eyes, Diz was always wrong, so he didn't have to study the situation any further.

When the show ended, most of the guys went back to the dressing rooms. The only ones left on stage were Benny Payne and Chu, who were talking off in a corner, and I was there packing up my bass. Cab must have stopped Diz in the wings at the end of the show because I could hear him yelling, "Well, you did it again! Those men were out there entertaining all those people and you're sittin' back there throwin' spitballs just like you're in school. What's wrong with you? Can't you do anything right?"

I couldn't see Diz but I knew he wasn't hanging his head. This time he was right. He always called Cab "Fess," and I could hear him saying over and over, "Fess, I didn't do it."

The two of them went at it for a while. It got louder and nastier. A minute or two later I decided to walk over to the wings where they were standing, just in case. When I stepped around the curtain I saw two ladies standing a couple of feet from Cab, who was still wearing his white stage outfit.

Cab was yelling, "You did it! I was looking right at you when you threw it!" But Diz wouldn't let it go. He was right and he had to prove his point. He moved closer to Cab and told him in a sharper tone, "You're just a damn liar for saying I did it."

Cab wasn't going to let one of his musicians call him a liar, especially in front of those two fine-looking

women. So he called Diz some more names and then threatened, "Now go on, get outta here before I slap you around."

That made it worse. Diz stood there, arms folded, looking like the Rock of Gibraltar, repeating, "You ain't gonna do nothin'."

Physically, Cab was a big man. He'd learned how to street fight growing up in Baltimore and he was fast. Suddenly his hand was in the air and he slapped Diz across the side of his face. A split second later, Diz had his Case knife out and was going for Cab. I was just a couple of feet away, so when Diz took a swing at Cab's stomach with his knife, I hit his hand and made him miss. Then Cab grabbed Diz around the wrist and tried to wrestle the knife away. Within seconds the big guys, Chu and Benny, had made it to where we were and quickly pulled them apart. Chu took Cab to his dressing room and Benny took Diz to the band room.

Charles "Cholly" Atkins,
Donald Mills, Avis Andrews,
Louis Brown, Dizzy Gillespie,
and Keg Johnson, backstage,
Earle Theater, Philadelphia,
c. 1939

About ten minutes later Cab came down to the band room, where we were all talking to Diz, trying to calm him down. Cab was still wearing his white suit, but one pant leg was covered with blood and he had a bandage around his wrist. He looked at Diz and told him, "Pack your horn and get outta here." Then he turned and left.

Before we knew it, Diz had gone out the stage door.

The cuts on Cab's thigh and wrist weren't very serious. In fact, he did the second and third shows without any problems. Afterward, we took the bus back to New York and Cab rode with us. The trip was quiet, like when someone dies and no one really knows what to say.

Whenever Cab rode the bus, he had the first seat, directly behind the driver. It was about two in the morning when we pulled up to the Theresa Hotel, which was our usual drop-off place. Cab was the first one off. And when he stepped down, there were Diz and Lorraine waiting to greet him. Diz looked at him and said, "Fess, I'm sorry." But Cab didn't say a word. He reached out and touched Diz's palm and kept walking.

About thirty years ago, I played at a reunion concert at Carnegie Hall for all the guys who'd worked for Cab over the years. Tyree, Cozy, Illinois Jacquet, Dizzy—just about everyone who was still living showed up. In the middle of the concert, before Dizzy was about to do a solo, he walked over to where I was standing onstage and said, "Listen, as soon as I finish my solo on the next tune, you go into a vamp and I'll grab the mike and start talking." Tyree, who was standing next to me, seemed to know what Dizzy was planning. "Man, don't get this whole thing started again. It's been dead and buried for years," he told Dizzy.

"Hey, it's gonna be beautiful. Don't worry," Diz said, and he turned and walked to the center of the stage.

When Dizzy finished his solo, I started the vamp, and Cozy followed immediately. Dizzy grabbed the mike and scatted for a minute or two. Then he signalled us to stop playing, turned around to the band, and asked loudly, "Who threw the spitball?" Evidently, he'd told everyone but me what to do, because they all got up and answered in unison, "Not me!"

I guess enough of the audience knew the story, because the place went wild. Cab came out front, took the mike, and said, "Diz, I know you didn't do it." The two of them embraced and the show went on.

That was the first time I ever heard Cab admit he knew it wasn't Dizzy. In fact, in his book which came out a few years after the reunion, he says I was the one who threw it. Mel Torme, who reviewed the book in the *New York Times*, said some pretty negative things about me for not admitting my guilt and for letting Dizzy take the rap. I was very upset about it and when I saw Mel in Nice four or five years later, I told him how I couldn't have thrown the spitball into the spotlight because I was standing in the same spotlight myself.

In his book, Diz was the first to publicly identify the true culprit. Of course, he'd always known, because the guy who did it was sitting with him in the trumpet section—Jonah Jones.

M y saddest memory from those years on the road was Chu Berry's untimely death in 1941.

We'd finished an engagement in Chicago and had a day off before traveling on to Youngstown for a one-nighter and then up to Buffalo and Canada. Lammar had just gotten delivery on a new car and wanted to take it part way to Canada. Chu had someone in Columbus he wanted to see, so he and Lammar agreed to share car expenses. They arranged to leave

Dizzy Gillespie, the Palace Theater, Cleveland, 1939

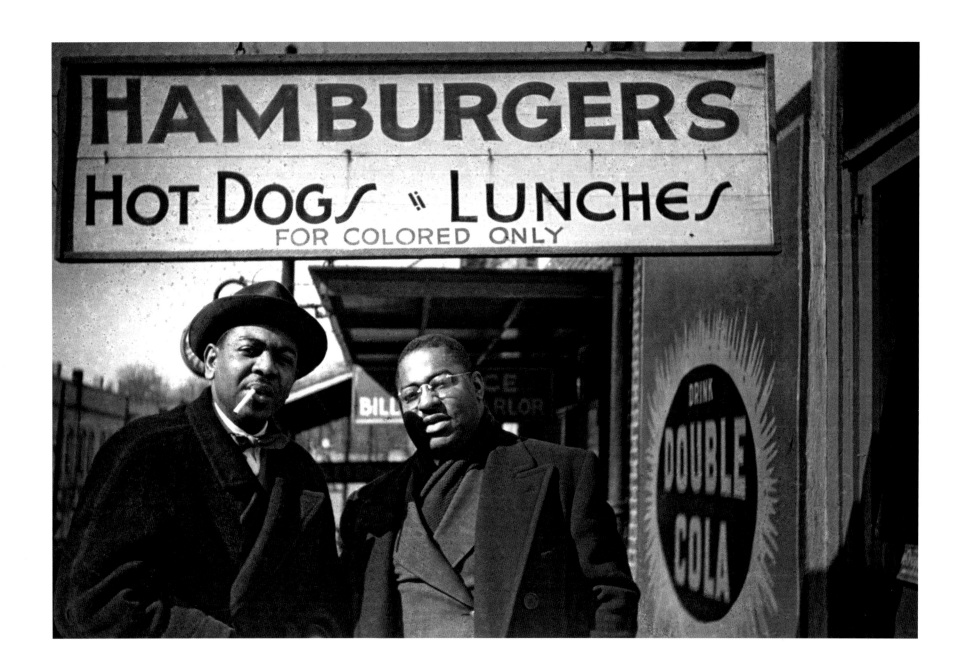

Tyree Glenn and Chu Berry, Fort Bragg, North Carolina, c. 1940

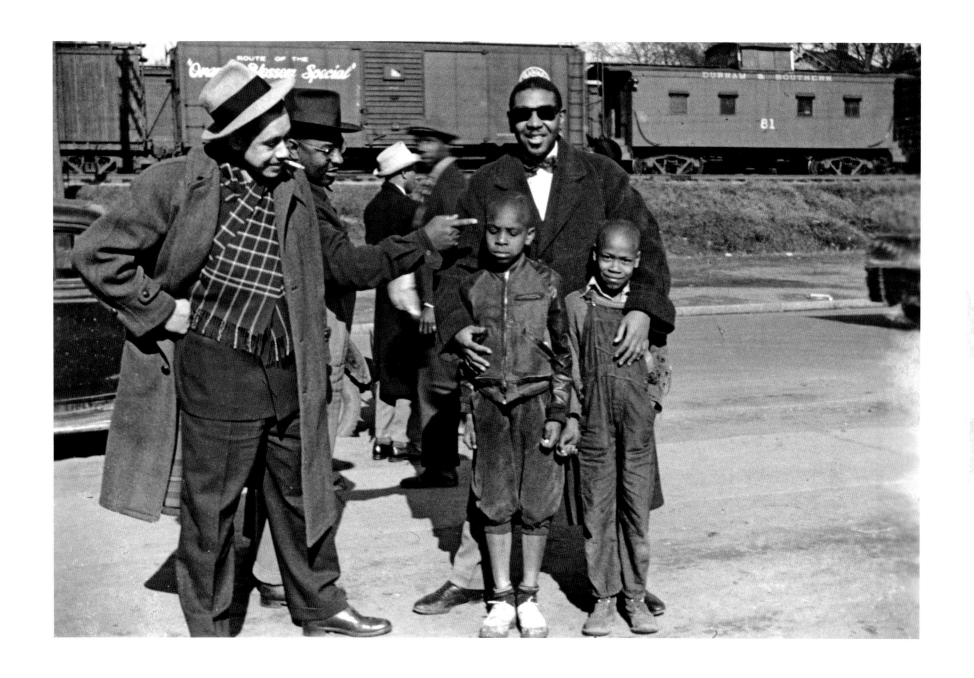

Cab Calloway, Chu Berry, and Tyree Glenn with friends, Durham, North Carolina, c. 1940

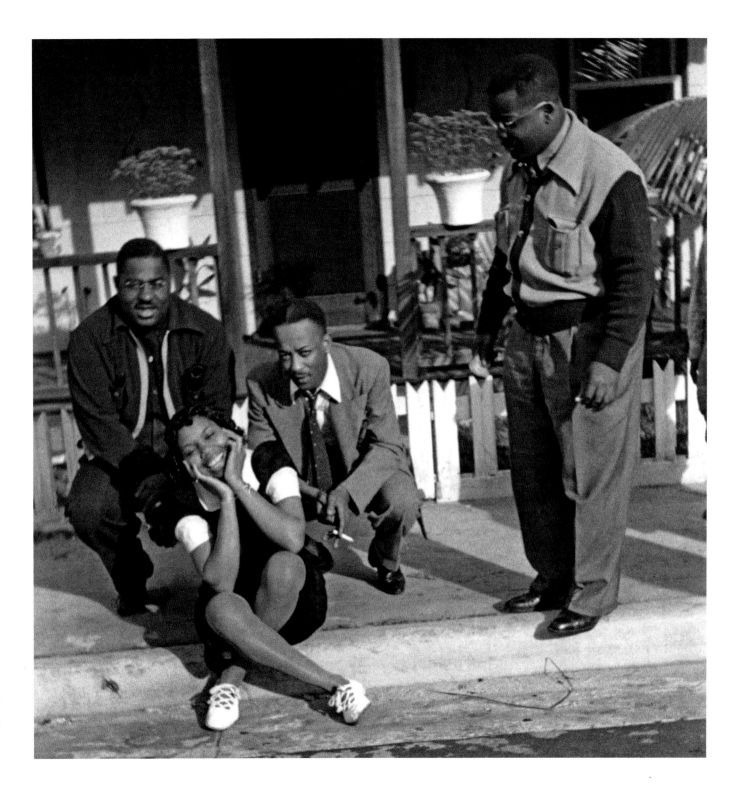

Chu Berry, unknown, Danny
Barker, and Lammar Wright,
Durham, North Carolina,
c. 1940

Chicago a day ahead of us, stop in Columbus, and meet the band in Youngstown. Then they planned to drive to Buffalo, where they'd meet us again. They were going to leave the car at the border and join us for the trip into Canada. We were using a bus for this tour because it was more convenient than the train.

We met in Youngstown and played the dance. Afterward, Chu and I were standing around talking while some stagehands and porters were breaking down the bandstand and loading the bus. A couple of minutes later, Lammar walked over and joined us. I remember him telling Chu that Andy Brown was going to join them for the car trip to Buffalo and that they'd be leaving immediately. As Lammar walked away, Chu said to me, "I'd just as soon get on the bus, but I paid to ride all the way to Buffalo, so I might as well go on."

In a little while the three of them got into the car. I guess Lammar was tired because I saw him stretch out across the back seat. When they left, Andy was driving and Chu was in the front passenger seat next to him.

Our bus pulled out about half an hour later. I was sitting up front, right behind the driver, and we were eating sandwiches and drinking beer. Ten or fifteen minutes later, we suddenly slowed down and the driver said, "Something's going on out there—looks like an accident." We stopped.

I left my seat and went up to the front window. It was pitch black and very difficult to see. There were no streetlights and no other cars in sight. A couple of seconds passed, and then a man who looked like Lammar crossed in front of our headlight beams about thirty feet away. I threw open the front door and got out and ran towards him.

It was Lammar and he was really shook up. His new car was pointing up in the air on one side of the road. Then I heard Chu's voice and I quickly found him about ten feet away. He was lying in the road with his skull opened up. I knew it was real bad. He was conscious and kept saying, "Find my change. I left my change around. Look for it."

I actually started looking around for his money.

I guess I was in shock too. I found his watch in the middle of the highway, even though the band was still on his wrist. I also came across five or six pieces of his pipe.

I don't know how much time passed before Eddie Barefield and I lifted Chu into the bus. We all drove to a hospital a couple of miles away. I remember waiting around there for hours. When we finally left, Chu wanted to get up and go with us. He was so out of it that a couple of orderlies had to hold him down. Even though Andy and Lammar had some minor cuts and bruises and a few broken teeth, they went with us.

We spent most of the day driving to Buffalo and played a dance that night. When we finished, Cab got us all together and announced that Chu had died several hours earlier.

Looking back, and given what happened, it's strange that Chu was always terrified of flying. I remember the first time Cab chartered a plane. We had to get from Philadelphia to Chicago in less than a day and flying was the only way to do it. All of us were excited about the trip except for Chu. In fact, he went to Cab and begged to be excused from the last two shows in Philadelphia so he could take a train and get to Chicago in time to meet us. I think Cab saw how real his fear was and let him do it.

Within a couple of days of Chu's death, Cab had to think about a replacement. At first he sent for a guy named Ted McRae. He'd been playing with Chick Webb and had done a lot of the things with Ella Fitzgerald and the band. He was a nice, sweet tenor player, but not a hard swinger like Chu. So we kept looking and came up with a guy named Skippy Williams. He wasn't strong enough either, and so Skinny Brown came in. It took a while, but we eventually got Illinois Jacquet, who probably came closest to Chu in terms of being a hot player. When he joined us, he'd already made "Flying Home" with Hamp, so he had a big following. But as far as I'm concerned, we never could find a real replacement. Chu Berry was a musical genius—one of a handful in the history of jazz.

Whenever I practiced, I tried to get ahold of something I couldn't play and attempt to really master it. I always chose a classical piece, because in those days, that was the most complicated kind of music around.

Some of the guys in the band used to put me down for practicing. They'd hear me bowing passages I couldn't play very well, and they thought I was ridiculous. I'd hear them say things like, "Look at him. He thinks somebody's gonna hire him to play that stuff, all them classical numbers."

I find that reading music is just like reading words—the more you do it, the more proficient you get. Years ago I got into a habit I still have: Whenever I see a piece of music, no matter what it is—a violin part, something for saxophone—whether it concerns me or not, I pick it up and start reading. It's really an exercise I've used to discipline myself.

Working with Cab for sixteen years could have made me stale. You play the same music over and over, and after a while you can do it in your sleep. Many guys liked it that way because it was easy. But when the band business got bad, they weren't prepared to do anything else. On the other hand, I was able to work on radio and TV and get all kinds of record dates. In a real way, practicing and discipline paid off.

I first went looking for a bass teacher after I dropped out of Northwestern. I figured if I wasn't going to have any more school training in music, I might as well get some privately.

I found a man named Paul Steinke who was German and had come to this country with his family when he was a child. They settled in Milwaukee, which always had a large number of Germans. When I first met him, he was still living there and playing bass in the symphony orchestra.

Every week I'd commute from Chicago to Milwaukee on a little trolley train called the Yellow Line. I think it cost a dollar round-trip and took about an hour to go each way. Paul would keep me at his house all day. He was very concerned about having discipline and the proper attitude when it came to

playing bass. And he'd always shout at me while I played: "Stand up straight, you're a man!" "Don't stoop!" "Raise that elbow!" It felt like he was giving me orders.

I must've seen Steinke regularly for more than a year before I started traveling with Eddie South and had to stop. But we always kept in contact. After I joined Cab and we'd play the Riverside in Milwaukee, I'd always make a point of seeing him. One of the breweries would send a keg of beer, a barrel of pretzels, and a couple of pounds of cheese to the theater every day, just for the band. I'd invite him to come down, and he'd spend the day hanging around with us backstage between shows, talking and drinking beer.

We grew much closer. I began to realize that underneath all the barking and shouting was a very kind man. One of my prized possessions is an old German bass book Paul gave me during one of his theater visits. It's a large, original, handwritten manuscript called *Contrabass und Posaunen-Schule* by Carl Berg, which has never been published as far as I know. The pages are frayed and very yellow, but it's got much more information in it than most other bass books I've ever seen.

The last time I saw Paul was in the early '70s. I was playing a concert in Milwaukee with Pearl Bailey and the local symphony orchestra, and I asked a couple of the bass players about him. One guy got him on the phone and then drove me out to his place. He must have been about ninety, but when he saw me he grabbed me and tried to lift me off my feet. We had a beautiful visit. He was getting ready to move to a smaller house because he and his wife didn't need the space anymore. Just before I left, he asked if I still had the Berg book. He was so pleased to hear I'd taken good care of it.

After I joined Cab, I continued studying on my own, but I never found I made real progress working that way. After six or eight months, in the course of my travels, I ran into a couple of people I respected who told me that if I found one of the great teachers, I could improve in a short period of time.

The more I thought about going to someone, the more scared I got. I guess I didn't want to find out how bad a bass player I really was. Finally I decided to try to arrange for lessons with a man named Dmitri Shmuklovsky who played with the Chicago Civic Opera and had a reputation as one of the finest teachers around. But setting things up wasn't easy.

Sometime after high school, while I was still living with my family in Chicago, I'd become friendly with a guy named Bob Kagan who was about my age. He used to hustle strings by going from theater to theater and club to club and trying to sell sets to all the fiddle players. In those days, his store was a big canvas bag which he always carried, and business wasn't very profitable. In fact, many times I'd take him to my house so Mama could fix him a good meal.

Over the next few years, things got better for both of us, and eventually Bob opened a music store in Chicago. He knew all the string players in town, so I figured he could be an intermediary and put me in touch with Shmuklovsky. Truthfully, I didn't want to contact Shmuklovsky myself. I wasn't sure how he felt about jazz and I had no idea how he'd react to having a black student. So on one of our month-long engagements at the Hotel Sherman, I decided to see Bob in person and talk to him about the problem.

His store was called Kagan and Gaines which was a beautiful place on Wabash. Bob couldn't have been nicer. After I explained what I wanted, and while I was standing in his office, he picked up the phone and called Shmuklovsky. Of course, I could only hear one end of the conversation, but I got a good idea about what was going on.

For the first few minutes everything seemed to run smoothly. But the tone appeared to change the second Bob said two words: "Cab Calloway." There was a pause and then Bob began trying to convince Shmuklovsky to take me. He mostly talked about our friendship and my strong desire to learn. Half of what he said was in Russian or Yiddish. After a few more minutes, Shmuklovsky apparently gave in. They agreed I'd pay fifteen dollars a lesson and have my

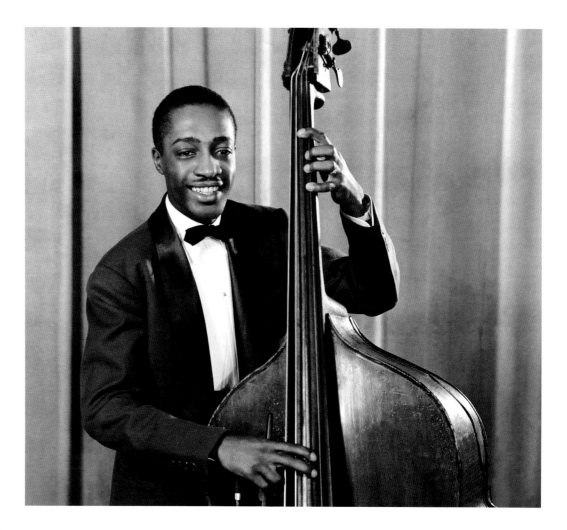

Milt, c. 1941

first one at Shmuklovsky's house at two the following Wednesday.

When I went to Shmuklovsky's place that day, he took me to his music room where he had a piano and his bass. He was big and gruff and he had a full beard. There was no small talk. His accent was thick and he was hard to understand. He told me to sit down and then asked me a difficult question: "What do you want from me? You're working with a band. You're making money. What can I do for you?"

I was nervous, but I managed to get out an answer:

"I want to learn as much as I can about bass. I want to know everything I can possibly know about my instrument." He looked at me closely. I think he was a little shocked by what I'd said.

"Stand up over there and play something for me," he ordered.

I must've sounded terrible because Shmuklovsky stood across the room shaking his head from side to side. But a few minutes later, he was on top of me correcting my bowing and demonstrating different kinds of fingerings.

The hour went by very quickly. When I realized we were ten minutes over, I reached into my pocket and pulled out the three fives to give him for the lesson. When he saw that he screamed, "I'm not through with you. I didn't ask you for any money yet."

About half an hour later he decided we were finished. "Now I'll take your money," he said. Then he went on to give me instructions about my next lesson:

> Your lesson is at two next Wednesday, but you come here at one o'clock. I like for my students to know each other. I have another student who will be here and he's in the same category as you. I want you to meet him and talk to him about the bass. You can share things with him.

I arrived early the next week and met Mike Rubin, the other student. We waited together in a little anteroom and talked about bass—what we knew and what we still needed to learn. After a while, Shmuklovsky called Mike in for his lesson and I waited for more than an hour until it was my turn. I didn't mind at all. There weren't many times in those days when I was completely alone. Waiting gave me a chance to think about my lesson—to mentally prepare myself for the challenge.

At the end of my third or fourth lesson, just before we were set to leave the Sherman and go back on the road, Shmuklovsky made it very clear about where we stood: "I will teach you everything I possibly can about the bass because you really want to learn it. But

you must promise one thing, that you will practice regularly when you're away."

His commitment sealed it for me. I promised, and I kept my word. After those first few lessons, every time I came through Chicago, I'd call and arrange to see him. Many times when I'd go back after five or six months, he'd ask me to play for him. After a while he'd shake his head and say, "You're falling into bad habits again." Then he'd point out my mistakes, one after another, and send me off with a set of exercises.

Over the years I got to meet some other Shmuklovsky students. They all called him "Old Stokey" and I started doing the same thing. Every time I'd see one of them, we'd talk about him.

When I won the Esquire Award in 1944, a couple of them brought him down to the presentation. There'd been an announcement in the Chicago papers that Leonard Feather was going to make the presentation at the Sherman, where we were playing. I was really surprised when I saw them all. I found out later that it was Stokey's first time in a cabaret and the first time he'd ever heard a live band like ours. Naturally, I was flattered because he'd gone out of his way to show me that he cared.

Shmuklovsky was a master teacher who was known for his fingering techniques. But he taught me much more than that. He wouldn't just tell you how to play something, he'd always give you reasons for doing it:

> Music is sound and people only hear it. So if I tell you to play with the second finger and you want to play with your first, play. People will never know the difference. I say play the third note with your second finger because, to me, it's the easiest way to get to the fourth note. Some people are different. If you can do it better with your teeth or your feet, it is your choice. Just as long as you can play it. There are other ways, but I think mine is the most sensible for you because your body's built that way.

He'd say the same kind of thing about bowing. He was very flexible. "I use a German bow, but I know many people who play with a French bow and sound better. Whatever fits you is right."

When I first knew him, I was using a French bow, which was a carryover from playing violin. After a while I switched because of my admiration for him. If the master used a German bow, I had to use one too.

In his late years Stokey moved to Florida and taught at the University of Miami. I ran into a couple of his students I'd known from the old days, and they told me he died in his nineties. Whenever I think about him now, I realize how strongly he affected my life.

The fifteen dollars a lesson wasn't important to Shmuklovsky. He never watched the clock and he always went over. You stayed until he was satisfied that you got what he wanted you to have. For him, passing on his skill and knowledge to the next generation was a solemn duty. It was a mission that went beyond his music. And looking back, I know his greatest gift was to teach me this strong sense of responsibility. It's the reason I've always tried to help young people. If someone wants to improve, if they have a sincere desire to learn, I've always tried to be there to give them whatever I can.

In 1937, I got an unbelievable bass through a man in New York named Jago Peternella, who had a shop upstairs in a brownstone on 52nd Street. I remember, at the time I got it, we were playing one of those long engagements at the new Cotton Club.

When we were in New York, I'd often go downtown to Peternella's place during the day. He had a bunch of basses in a little back room and I'd spend a couple of hours trying them out. There would usually be one or two other bass players who'd stop by and do the same thing, so we'd have a chance to discuss technique and share ideas.

But there were times when I'd spend most of a day just watching Peternella work. He'd sit in his large bay window, where the light was best, building or repairing one of his string instruments. The man was a real

artist and I learned a great deal from him. I think he liked me because he recognized my interest in his craft. In fact, at that time I actually thought about going into the repair end of it when I got too old to play.

One day in 1937 Peternella sat me down and said:

Notes on a bass spread the sound of the orchestra, make it sound bigger, give it depth. In your band, the bass is not like other instruments, which play many notes. You play only a few and they must be perfect—round and clear and beautiful. So the best

Barrie Kolstein working on one of Milt's basses, Baldwin, New York, c. 1985

bass player is the man with the best bass. And I have found the right one for you.

Back then, I believed in that philosophy of bass playing too. After all, there was no amplification to speak of, and guys like Ray Brown were still in knee pants. So I said I was interested in getting a better instrument, and he told me about a special one he'd just discovered over in Italy.

Apparently, a family in Milan he'd known for fifty years had a bass which had been with them for several generations. No one played it anymore and it was being kept in a cellar, where it could be destroyed by worms. Since these people needed money bad, I told

Peternella to negotiate with them and tell me what he thought was a fair price. They exchanged a few letters, and after the family decided to leave the price up to him, he told me I could have it for seventeen hundred dollars.

That was a tremendous amount of money in 1937. I was making a hundred a week and had managed to save about seven hundred. But that was all I had. Peternella liked me. I trusted him. I knew he'd found a good instrument for me, so I decided to try to borrow the additional money.

I went to Cab first and he agreed to lend me the thousand I needed, as long as I'd pay back fifty a week. I gave the seventeen hundred to Peternella and

about a month later the bass arrived. It had been taken apart and shipped over in pieces, which were separately wrapped. Peternella had to put it all back together in his shop.

The minute I saw it finished and played a few notes, I knew I'd bought a good bass. It's a seven-eighths size, much larger than the three-quarter one I'd been using. For a long time, I was under the impression that it was made in Italy about 1740 by Matteo Goffriller, so I did some research on him. He and Stradivarius had shops in the same section of town and knew each other. But for some reason, Goffriller didn't belong to the same guild. That meant that he couldn't get the rich commissions, just everyday work like making all the string instruments for a school or church.

The bass has a beautiful piece of curly maple on the back, which is very unusual. Curly maple is harder than regular maple and that makes it much better for throwing sound. It comes from trees growing on the perimeter of the forest, which are kept in constant motion by the wind. And it takes generations for them to grow large enough to be used. As I understand it, the reason it's unusual to find this wood in a bass has to do with economics. It made much more sense to use a large piece of curly maple to make eight or ten violins instead of just one bass.

I traveled with that bass for a long time. Unfortunately, it would get broken at least twice a year. Eventually, it developed a bad crack, and I had to take it to a repair shop in Buffalo where we were working. When the man who ran the place unwrapped it to look at the damage, he immediately recognized how good the bass was. He started ranting and raving at me about abusing the instrument. He even threatened to take it away from me unless I promised to treat it with more respect. Of course, he was right. And after that incident, I appreciated what I had much more and decided to be more careful with it.

More recently, a couple of bass makers told me that it's not a Goffriller, but probably a French bass which was made a little later. It really doesn't matter to me. I have a magnificent instrument with a beautiful sound and it served me very well throughout my career.

By the late '30s, my marriage to Oby was over, even though it was years before we actually got a divorce. Of course, everyone had tried to warn us about our incompatibilities before we got married. Being young, we thought we knew better, but it didn't take long before we recognized things had gone sour.

Since I was on the road half the year, it was easy for us to go our separate ways. But when we did see each other it would heat up pretty quickly. Looking back, I really can't put all the blame on either one of us. We both had strong personalities and hot tempers, and the chemistry just wasn't right. Physically, she was much bigger than me and that alone probably caused more ugly incidents than I care to remember.

Mama was over ninety when she passed. She'd lived a full life. There was no pain or suffering—she just died in her sleep.

I went to Chicago for the funeral and the night before, there was a real traditional wake. All the people from Mississippi came with food—hams, cakes, whatever their specialty happened to be. They would stay for a while and talk about the old days in Vicksburg.

Playing with Cab put the spotlight on me. I was dressed real sharp and I'd been living in New York for a couple of years. I guess, to the young ladies who were at the wake, I looked better than what they'd seen locally. At least I know a few of them were flirting with me for hours.

Toward the end of the night, when these ladies were leaving, I collected some names and phone numbers. My mother must've seen what was going on, and a couple of minutes later she had me alone and was giving me hell: "You come home to bury Mama, then spend all your time looking at girls." She was right. But she hadn't stopped me before I'd gotten the name of a beautiful girl who sang in my mother's choir. Her name was Mona Clayton.

small beauty school in St. Louis, but soon she was selling hair straighteners and other products. Eventually, she had beauty-supply stores and schools in different cities and she became one of the richest black women in America.

Long before I ever met Mona, I'd had some contact with Madame Malone. It was in '30 or '31. I was playing with Eddie South, and he took a trio to St. Louis to play at her school. She was a little wisp of a lady, very well dressed and always dignified. She seemed concerned about culture and refinement. I remember, she made her students go to chapel every morning before classes, and every afternoon she would hold a tea.

Her school was made up of four or five buildings. There were classrooms in one or two, there was a dormitory, and one building even had a little theater with a regular stage and about a hundred seats. She put us up in the dormitory and we stayed about a week. Every day after lunch and every night after dinner, we'd go down to the theater and play an hour-long concert. I can still see Madame Malone sitting in the same seat, right in the middle of the third or fourth row, surrounded by her students, loving every note we played.

By the time Mona went to school, Madame Malone had moved her headquarters to Chicago. She'd bought a block of buildings on South Parkway and set up an even bigger establishment than what I'd seen in St. Louis.

After about a year in school, Mona went back to Sandusky, passed the licensing exam, and started working with her sisters in their shop. Evidently, it didn't take long for her to recognize she was probably the worst beautician in the world. And when she did, she wrote to Madame Malone for advice. Somehow Madame Malone knew about Mona's talent with numbers and offered her a job as the company bookkeeper. Mona accepted and returned to Chicago as soon as possible.

Mona says just before she left Sandusky her mother told her, "The first thing you do is join a church out

Mona was in her early twenties when I met her. She'd finished high school back in Sandusky, Ohio, when she was sixteen. At that time, one of her sisters was living in Chicago and two others were running a beauty parlor back home. So the family decided to send Mona away to cosmetology school, figuring when she finished, she'd return home and work in her sisters' shop.

Mona went to Chicago and enrolled in the Poro Beauty School, which was run by Annie Malone, who was known as Madame Malone. She'd started with a

there. You've known the church all your life. There are a lot of devils in the world, but the ones you'll find in church are more likely nicer than what's on the street."

She took her mother's advice. A few weeks after arriving in Chicago, Mona joined a church, which happened to be the same one my family belonged to. Eventually, she became a singer in my mother's choir, and that's the reason she was at Mama's funeral. In fact, she knew just about everyone in my family, including my uncles, but since I was living in New York, I was the one exception.

Getting back to the time I first met Mona—a few weeks after Mama's funeral, I called her from New York. Long-distance phone calls were expensive in those days. In fact, phones were still pretty much of a luxury, so I guess when I called and we spoke for ten or fifteen minutes, she must've been impressed.

A couple of days later I called again. This time I told her we'd be playing Indianapolis in a week and I invited her to join me there for a weekend. She agreed.

The band arrived in Indianapolis on a Sunday. Mona would be coming to town the following Friday afternoon, which gave me time to get things ready. In those days, the hotel situation for blacks was terrible in Indianapolis. And when I saw my room, I knew it wasn't going to be right for us. So I spent a few days searching for a better place. Fortunately, I ran into some people I knew who rented rooms in their house and had a nice big one available. I moved in immediately.

That Friday morning I got up early and shopped for weekend provisions—chips, nuts, pretzels, fruit, and plenty of whiskey, of course. Then I went to work.

I'd told Mona on the phone I'd be playing one of the afternoon shows when her train came in and wouldn't be able to meet her. We'd agreed she'd take a cab to the theater and wait for me backstage.

When the show ended I met her in the wings. I remember how beautiful she looked, sitting in a corner, perched up on my bass trunk. We started talking about plans for the weekend—where we should go, what kind of food we should eat, that sort of thing.

Suddenly, from out of nowhere, my mother appeared on the scene. I was completely shocked, but Mona was worse off. She'd been caught by her choir teacher out of town with an older guy who just happened to be her teacher's son. She nearly died of embarrassment.

Evidently, I'd forgotten that I told Titter a month earlier that I was going to be playing in Indianapolis. She had some friends there and arranged to visit them for the weekend. She figured she'd surprise me and show up backstage. But as it turned out, she did much more than surprise me. She ruined my weekend.

Mona Clayton, Chicago, c. 1939

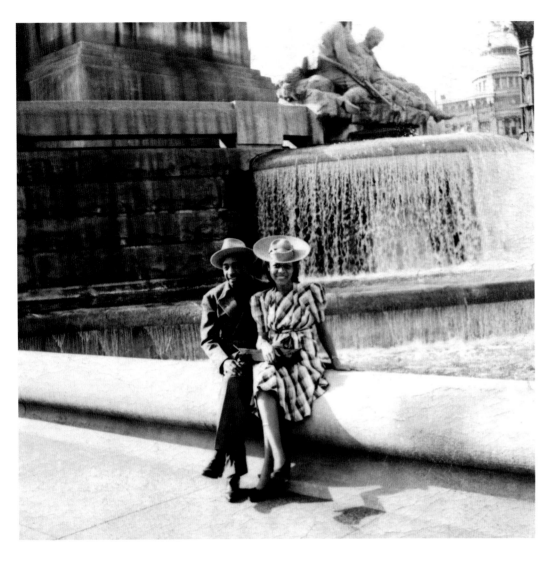

Milt and Mona Clayton,
Indianapolis, 1939

with musicians and stagehands around. Titter just began ranting and raving:

> I told you at Mama's funeral to leave these young girls alone, but you didn't listen. It seems like you're comin' to the end of one bad marriage, but that's not gonna teach you a lesson. You're startin' all over again and this time she's just a baby. You're not gonna spoil these girls, takin' them out of town to spend the night. They come from good families and you oughta be ashamed of yourself.

My mother tore me up that afternoon, but it didn't stop Mona and me from being together. I called her the next day and we laughed about what had happened. In fact, the whole scene with Titter probably brought us closer together.

Mona's family must've had some serious reservations about me. Her people had struggled through the Depression and managed to make a decent home for themselves. Then I appeared on the scene, a traveling jazz musician, ready to whisk their daughter away to places unknown.

Mona's parents were originally from a little town in Mississippi called Okolona. Her father's full name was Nebuchadnezzar Clayton, but people called him Neb, and her mother's name was Rhoda.

Mr. Clayton had started working for the railway at a young age and, even though he probably didn't earn much, compared to most Southern blacks he was pretty well off. Evidently, he was smart enough to know that the only way life could be better for him and his family was to leave the South. So about 1919, he took his wife and six small children—Henerine, Hert, Belle, Charlotte, Neb, and Dave—and headed north.

When the family got to Centralia, Illinois, they stopped long enough for Mrs. Clayton to give birth to Mona. Then they moved on to Sandusky, Ohio, right on the outskirts of Cleveland, where Mr. Clayton heard he could find work fixing boilers. That became their permanent home.

"Whatta ya doin' here?" she snapped at Mona. "You sneak off for the weekend and give me some made-up excuse about extra work for your job."

She ordered Mona to go to the station and get on the next train for Chicago. I tried to argue, but it was no use. I realized Mona really had no choice. We said a fast goodbye, kind of nodding to each other, and she was gone before I knew it.

I was next. It didn't matter that we were backstage

When they first arrived in Sandusky, they rented a small house, but within a couple of years they bought a place of their own. They really had to, because they'd had two more kids, Marylouise and Charles, which brought the total to nine—six girls and three boys.

The house they bought was on the east side, and they were about the only black family in the neighborhood. From what I've heard, back in those days, Sandusky had a very small black community on the south side, but most of the town was made up of whites.

During the last few years of the '20s, just as things seemed to be looking up for the Claytons, the Depression came and turned their world upside down. Mr. Clayton, like so many others, found himself without a job. But he never gave up. In fact, he was about the most industrious and enterprising man I've ever known. He made up his mind that he and his wife and their nine children would make it through the hard times without anyone's help, and they did.

He took any kind of odd job he could get, but most of the time he did plumbing, electrical, and car repairs for people in the community. He also made sure that the other members of his family made a contribution. To his way of thinking, every one of his children, girl or boy, was capable of doing the same kind of work. So if he needed help fixing a car and one of the girls was around, she'd be expected to crawl under it with him. Every one of the kids also learned how to wash, starch, and iron clothes so the family could earn money taking in laundry.

Mona says she began working regularly when she was ten and remembers her first job very well. She took care of a couple of children, but she also did their family's washing and ironing. She worked after school every day, all day Saturday, and after church on Sunday, and she earned three dollars a week.

There were times when things hit rock bottom. Mona still remembers how she and her brothers and sisters would have to divide an apple or an orange nine ways and how they'd somehow stretch a pound of hot dogs to feed eleven. She also talks about how

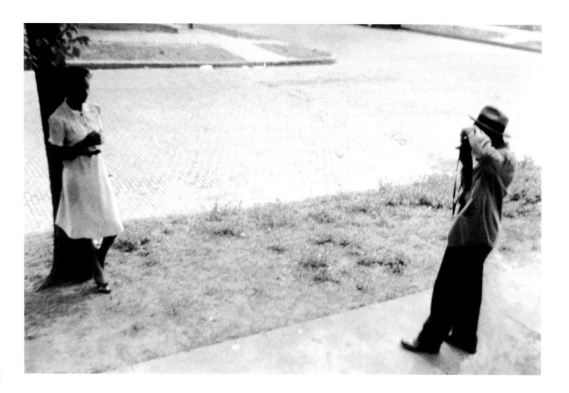

Milt and Mona, c. 1939

her father would cut up old automobile tires and use the tread to resole their shoes. It was unbelievable that he somehow managed to hold onto an old Ford so he could carry his tools and spare parts around to different jobs. Mona says he was so concerned about keeping it working that when the weather got very cold, he'd take out the engine at the end of the day and keep it in the house overnight.

Mona recalls one time her mother took the kids to a charity relief center and brought home canned food and used clothing. When her father saw what his wife had done, he gathered the family together and told them, "We'll have to do without anything we can't get on our own." Then he made sure they returned every morsel of food and every stitch of clothing.

The family made it through the Depression, and Mona's parents deserve all the credit in the world for that. Her father's organization and discipline allowed them to survive. He and his wife gave their children a

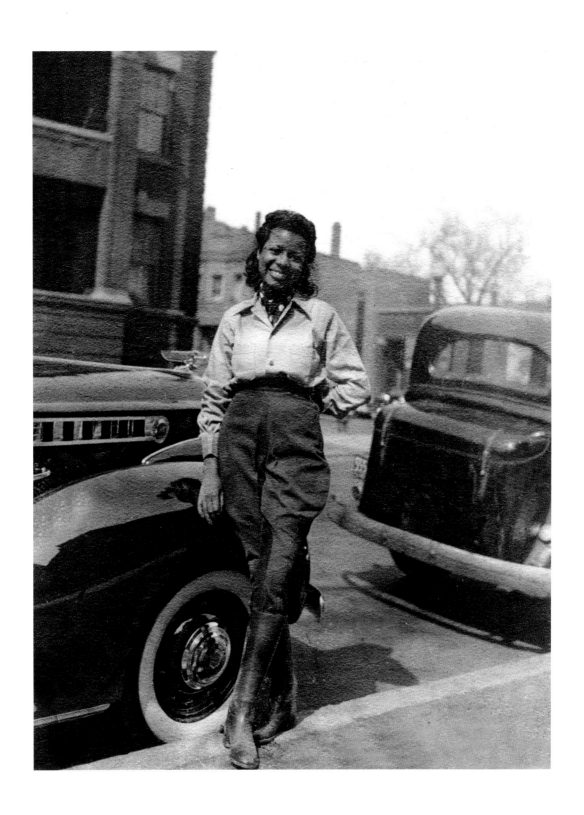

Mona Clayton, Chicago,
c. 1940

sense of responsibility and taught them priorities. They pushed each child to get as much education as possible. That included Belle, Mona's next-to-oldest sister, who had infantile paralysis and walked with braces on both legs. They made sure she graduated from high school and then finished business college.

Mr. Clayton died more than sixty years ago and Mrs. Clayton passed in the early '60s, but the strength and unity in their family is still going strong today.

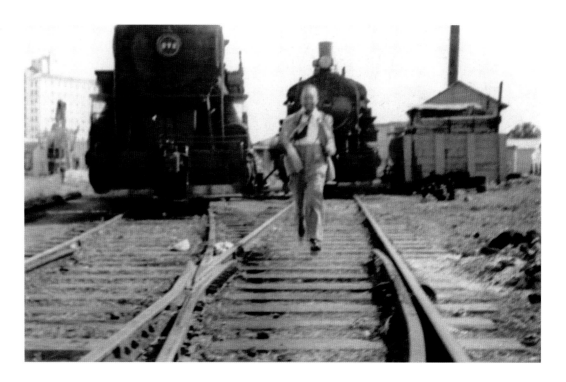

If I lived another ninety years, there still wouldn't be enough time to recount all the experiences I had on the road with Cab. Naturally, there are highlights which stand out in my memory and give a sense of what life was like during those sixteen years.

There was a system to traveling on the road. Most of the time we went by train and had our own two cars. If we were doing a string of one-nighters, we'd usually get on our Pullman at one or two AM after we finished our gig. Then sometime before dawn, our cars would get hooked to a regular through train and we'd be on our way to the town we were playing next.

The following day we'd be up by noon. We'd put on bathrobes and hang around our berths waiting for a turn in the bathroom. After each guy washed and shaved, he'd go to his big H & M trunk in the baggage car, take out a clean suit, go back to the Pullman, and get dressed. We would usually spend the rest of the afternoon in the dining car and then back in the Pullman hanging out, reading, talking, or playing cards.

The schedule was worked out so we'd get to our destination by early evening. About a half hour before arrival, one of the porters would come through and make the announcement. That was our signal to get ready. We'd change clothes again, wash, and fix our hair. That way, when the train pulled in everyone could get off looking fresh.

If we knew we'd be getting back on the train again after the gig that night, we might head for one of the bars and check out the local action. But if we were staying in town overnight, we'd check into our hotel or rooming house before we made the bar scene. Whenever this happened, we'd leave our big trunks on the baggage car, which was parked on a side track, and only take a small overnight bag with a fresh shirt, a change of underwear, and a toilet kit. Of course, it was different if we were playing a theater for a week or more. Our trunks would be delivered to us and we'd give up the two railroad cars.

No matter how long the engagement, we never had to handle much more than our overnight cases—not our uniforms, not even our instruments. Cab always had two valets—one for him, one for us. For a while, they were Rudolph Rivers and Harold Holder, and they were absolutely amazing guys. They knew all of us really well—our friends and enemies, our personal habits. If we were playing a theater, they'd make sure the guys who got along were put in the same dressing room. And whenever you got to your dressing room,

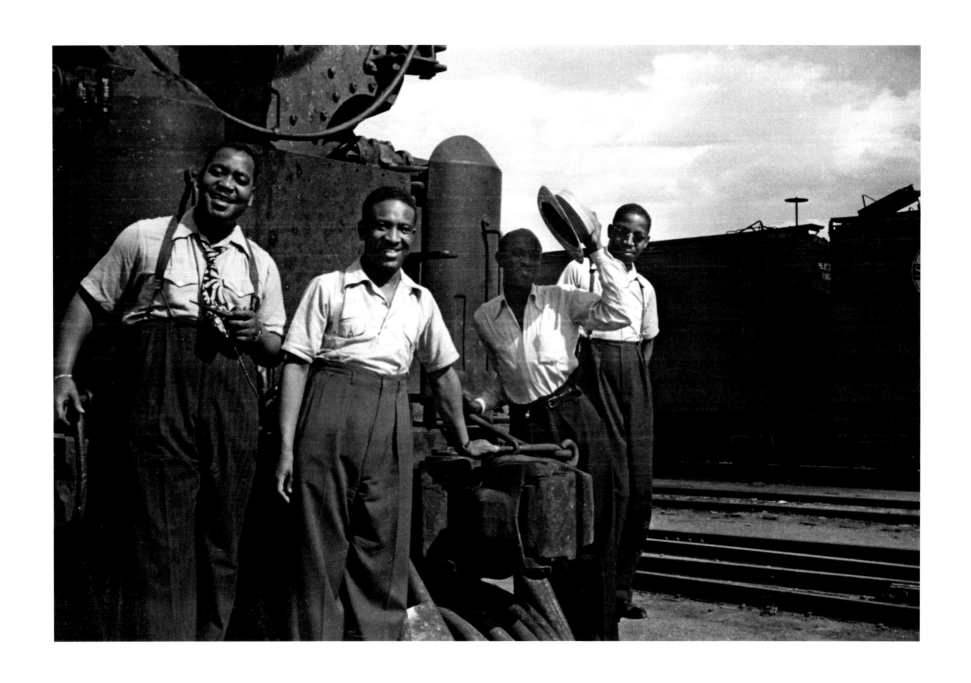

[Above] Jonah Jones, Andy Gibson, Shad Collins, and Hilton Jefferson, New Orleans, c. 1942

[Opposite page] Tyree Glenn, Butter Jackson, and Keg Johnson, Durham, North Carolina, c. 1940

you'd find your trunk open, dirty clothes sorted for the laundry, uniforms ready, even shirts and socks hung up, shoes shined—everything set, down to the last detail.

These valets also knew how to set up our bandstand. They'd unpack all the instruments, set up drums—they even knew how to put clarinets together and replace reeds. We could walk onto a job twenty minutes before starting time, change into our uniforms, and get on the bandstand.

Naturally there were no written rules for the guys in the band. But there was a set of dos and don'ts everybody understood. And all of them came down from Cab.

He led like no one else I've ever seen or heard about. Maybe he was making up for not being much of a musician. I don't know for sure. The fact is, he wasn't much older than the rest of us, but we all respected him a great deal. He'd give orders and you wouldn't be put off. The way he did it made you understand the position he was in.

Punctuality was extremely important. Cab had an expression about that: "I gotta be here—you better be here." He'd say that around us all the time and it stuck. Everybody knew this was a rule to be taken seriously—if you were late, you could get fired. In fact, that's what happened to one of our trombone players, Claude Jones.

I truly believe some of what we learned about behaving back in those days remained with us for life. The musicians who went on to become famous, like Jonah and Dizzy, always ran their own bands the way Cab ran his.

"Cleanliness is next to godliness." Cab believed that and got us to believe it too.

We had about six different stage uniforms. When we played theaters, we'd change after each show, and at real fancy places we'd even change during the intermission. He'd buy everything for us, including shirts, shoes, even socks. But it was strictly for the stage and couldn't ever be worn on the street.

We kept our own clothes up-to-date too. Nobody

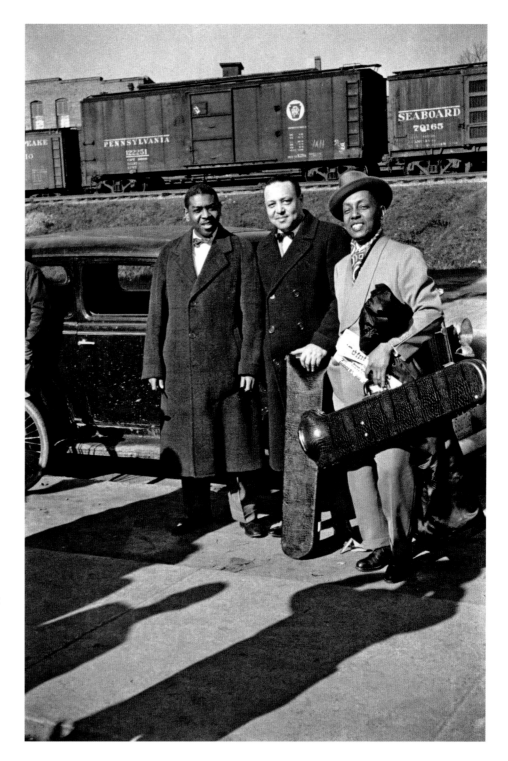

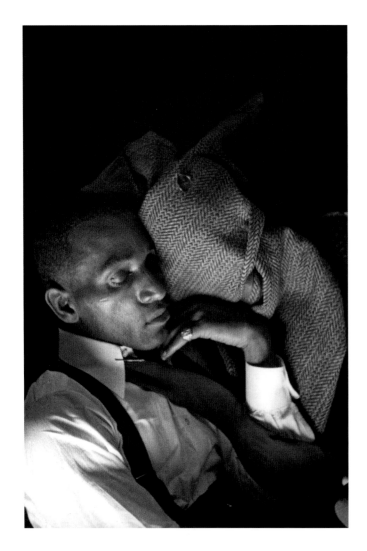

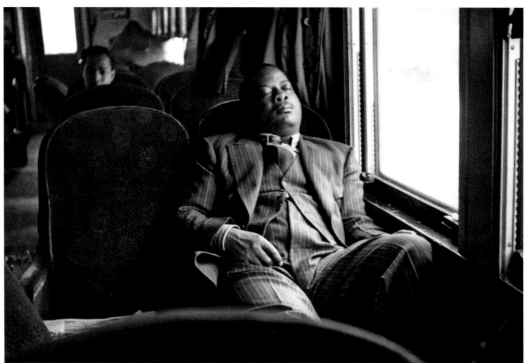

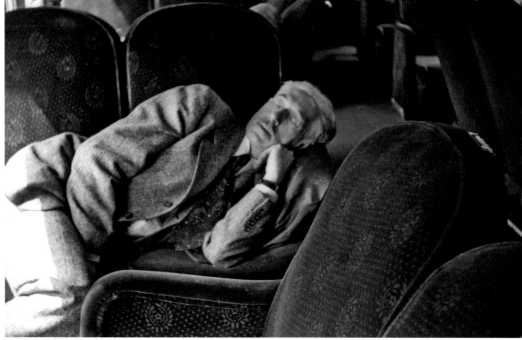

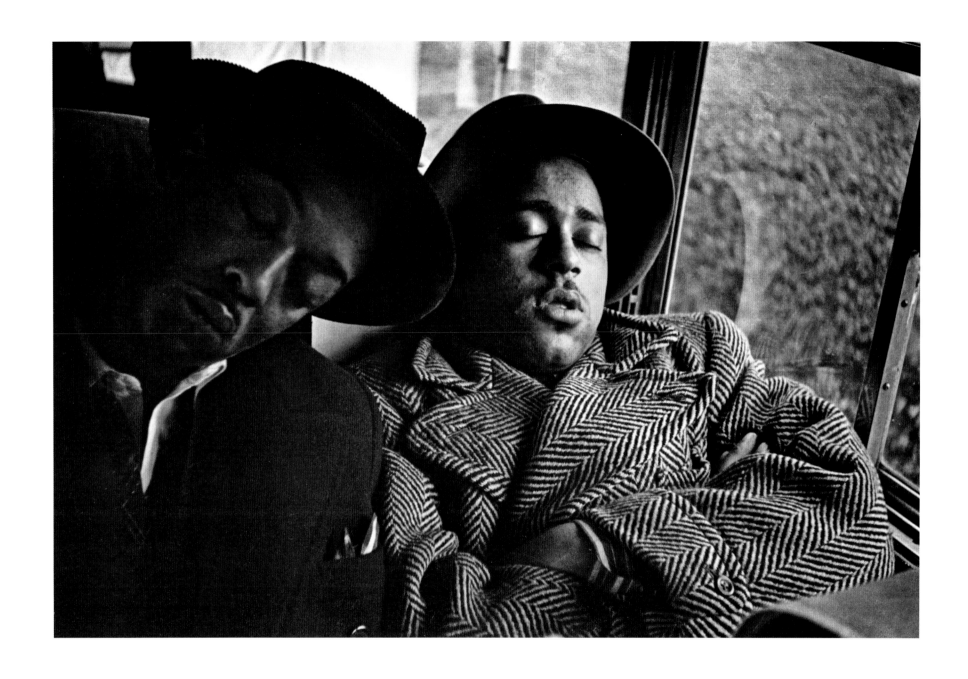

[Above] Danny Barker and Dizzy Gillespie, train, c. 1940

[Opposite page] *Clockwise from top left*: Cozy Cole, Lammar Wright, and Hugh Wright, train, c. 1940

Cozy Cole, Danny Barker, and Shad Collins, New Orleans, c. 1941

in the band was unkempt. Cab wouldn't allow it and neither would we. You were expected to keep yourself clean on- and offstage—clothes pressed, shoes shined, that kind of thing.

If a guy started to look a little ragged—maybe his undershirt or shorts had a hole—he'd probably get a friendly warning from one of the others. Somebody might tell him, "You better watch those holes, man, or the bat's gonna get you." And if he didn't get new underwear within a week, somebody else might walk up to him, put a finger in the hole of his undershirt, and ask, "Did you call me a son of a bitch?" He wouldn't wait for an answer. He'd just walk off with his finger still in the hole and tear the shirt off. Even if the guy got angry, he wouldn't fight back because the rest of us would be standing around laughing and he knew he was outnumbered.

If a guy wore a hat that didn't look too good— maybe it was greasy or frayed around the edges—a few of us might steal it and throw it in the trash. After a day or two the person who owned it would ask around, "Anybody seen my hat?" And, one by one, each of us would answer, "Maybe the bat got it."

Of course, the bat really represented the importance of being neat and clean. And when you think about how much time we spent together—in hotels, Pullmans, buses, dressing rooms, and restaurants—we probably needed something like the imaginary bat to keep us compatible.

Many of the established guys in the band, including me, were Masons. Cab joined too. Most of us had been initiated at the Pioneer Lodge No. 1, Prince Hall, in St. Paul, and every time we played there we'd try to spend some time at the lodge. If someone in the band had shown himself worthy and had a desire to join, one of us would recommend him and try to set up an initiation. But there were enough of us in the band to have our own meetings on the road. Sometimes backstage between shows, we'd have a short meeting and conduct readings. We'd always spend time with the guys who were newly initiated, trying to teach them

the real meaning of Masonry and how it could help them in daily life.

Being a Mason is a sacred thing. There's a lot of secrecy about it, so people don't talk about what's involved. It's really a system of morals based on the Bible. There are many signs and symbols which only Masons know, and if you don't belong, it's hard to understand.

I've always thought one major problem with Masonry has to do with race. There shouldn't be a separate black and white system, but there has been. It seems to contradict the whole philosophy of the organization. But ever since I've been a Mason, I've been able to fit my own beliefs about race into their framework. There's never really been a problem for me. I've tried to keep it simple. And I've never felt I had to accept someone just because he's a Mason. If a guy doesn't conduct himself in the proper manner—if he doesn't live up to the rules he pledged to obey—I just don't have anything to do with him.

I don't think Cab had any rules about booze or women. We were never abusive to people, ladies in particular, and we tried to avoid making scenes in the towns we played. Good common sense was very important and we always tried to use just that.

But there were unwritten rules about reefer. Cab was strongly opposed to it and constantly made his feelings clear. He'd say, "I don't care what you do when you get far away. But anybody uses reefer on the bandstand, backstage, on a bus, train, or in the vicinity of where we're working is fired. Don't ever use it anywhere around me."

We understood. He did songs about dope like "Reefer Man" and "Kickin' the Gong Around," and people probably thought he used it. Maybe he thought we were being watched by the government. We might have been, for all I know. In fact, sometimes it seemed like the local authorities were looking for any excuse to check us out.

Once in Memphis, somebody complained to the police that we'd jazzed up the "Star-Spangled Banner."

Jonah Jones and Butter
Jackson, Hotel Elgin,
Elgin, Illinois, c. 1942

Danny Barker, Springfield,
Illinois, c. 1945

Milt, unknown, Cab Calloway, and Keg Johnson, Masonic ceremony, Minneapolis, c. 1944

A couple of local police came to the theater to investigate. Actually, the guy who'd complained had confused our playing of John Philip Sousa's "Stars and Stripes Forever" with the national anthem. But that didn't stop the police from searching around backstage and asking all kinds of questions.

Of course, there were several guys who used reefer. Cab may not have known, but everyone else did, including the valets, who handled it beautifully. Whenever they'd assign dressing rooms, they'd always put the smokers as far away as possible from Cab. They'd also try to give them a room with a window to help with ventilation.

It was only reefer though. Except for one or two guys who joined the band later on, harder stuff was never a serious problem. I don't think anybody ever tried to push hard stuff on me. I remember one time I was on 52nd Street and a bass player I knew asked me to lend him three bucks so he could cop something for us to share. I said something like, "Me? You gotta be kidding," and went my own way.

Diz escaped that scene, which must have been difficult when he was hanging around with heavy users during the bebop era. But he'd always been a very strong guy and never wanted to depend on that stuff.

Ike Quebec, a great tenor player who joined Cab in the mid '40s, was one of the few hard-drug users in the band. He was unknown when he came with us, and even though he made some beautiful records, he died before his time and didn't get the recognition he deserved.

I have to admit I didn't know what was going on with Ike until much later. I was so naive. Up on the stand, night after night, I'd look over and see him with his eyes closed, and I'd think to myself, "This guy better cool it with the ladies. He's been up all night again." I was always amazed at how he'd be sound asleep and then suddenly come alive just in time to make his cue. It wasn't until much later that I learned the difference between sleeping and nodding off.

Stealing was never a problem in the band. You could leave just about anything you owned around and it would be safe. Occasionally, someone might take a few drinks out of your bottle, but usually you'd just forget about it. If it really got bad, you might hold up your near-empty bottle and announce, "Next time somebody takes a drink outta this, they'll be drinkin' my piss."

That actually happened once. One of the guys, I don't remember who, pissed in his bottle, stashed it in the wings, and went out on stage to do the show. A couple of minutes later we heard someone vomiting backstage. That incident seemed to end the problem forever.

There was another part to the discipline that existed in the band. We knew Cab wasn't our peer musically. He was an entertainer and a showman who didn't know about intonation from a technical standpoint. He had good ears, but he really couldn't rehearse a band. And he recognized it.

So at times, we'd hold our own rehearsals to work on new material. There was a great deal of pride in the band. We knew we had a reputation and we wanted to live up to it. But there was also another, more selfish reason for rehearsing—with the constant repetition of shows and one-nighters, playing new things kept us sane.

Over the years, the musical reputation of the band grew because of the guys who came in to replace the old-timers from the original Missourians. Quentin "Butter" Jackson's a good example. He was in the trombone section, but he could also play piano and bass and he had such a wonderful voice, Cab even let him sing a little. Musically, Butter's mind was always working. When the band played, he could hear everything. He knew everybody's part, so if a guy got sick at the last minute and couldn't make it, Butter would get up on the spot and play it.

He was never a star, but by the end of his life he'd played with just about everyone, from McKinney's Cotton Pickers, Fletcher, Duke, and Basie to Quincy Jones and the Thad Jones–Mel Lewis Orchestra. When I look back at his career, I can see that his greatness came from his ability to adapt to the changes occurring in music throughout his lifetime. I don't know of any better sideman, and there are plenty of other people who share my opinion.

Sometimes when we were on the road, the leaders of the sections would have their own rehearsals. The trumpets might get together in an empty theater room and go over their parts—breathing, phrasing, and so forth. The saxes would be in another room and the trombone section in a third place—all doing basically the same thing.

Cozy always practiced. Even between shows he'd find a place backstage or under the stage, get

his drum pad and a favorite pipe, and work out. I'd usually find a corner not too far from where he was set up and practice too. I'd do the exercises Stokey had given me and play passages from Simandl. After we'd played alone for a while, we'd work together. Sometimes we'd sing parts from one of my music books, but most of the time we'd work on rhythms and timing.

Frequently Cozy and I would practice between shows all day. We'd go to the theater early and take a fifth of whiskey. We'd start about ten AM and work until the first show. As soon as it ended, we'd get out of uniform, start in again, and practice until the next show. We'd go on that way until the late show ended. Then we'd head out for a big dinner.

Sometime during those years I bought a portable radio-phonograph to carry on the road. It could receive all the regular stations plus shortwave, and it also changed records. The machine was one of my prized possessions. It was built like a battleship. This was before vinyl, so it had a genuine leather case. It was supposed to be portable because there was

Ike Quebec, recording studio, New York City, c. 1961

between shows, I might put on all Duke, the next day all Fletcher, or Benny Goodman, or Bing Crosby, and I'd announce it on the bulletin board. This gave us an opportunity to really listen to what other bands were doing, how their sections and soloists sounded, and what their arrangements were like. It was a way for us to keep up with what was happening in the music world.

Guys were always playing cards for low stakes, just to pass time, and for a while it was okay to shoot craps, as long as everyone stayed out of trouble. But then an incident which involved me and Mona changed everything. It put an end to the crap game, but even more important, it changed my life around.

We were playing the Colonial Theater in Columbus, and Mona had come from Chicago to spend a few days with me. I was drinking in those days and acting pretty dumb. It was a Thursday and I'd just gotten paid. I had a couple of drinks, took my pay, and went with Mona up to the dressing room where the crap game was going on. Five minutes later I'd lost everything.

Mona watched but didn't say a word. Earlier in the day, I'd given her a couple of hundred bucks to hold for us to have a good time. But after I'd lost all my pay, I asked her for a hundred and she gave it to me. A few minutes later I'd lost that too.

At that point, I was embarrassed to ask Mona for more, and besides, I wanted her to have enough money to get back home. So I went downstairs, backstage, and found our road manager, Hugh Wright, a white man who was a retired lieutenant colonel.

"Give me some money," I demanded.

"Damn, son, I just paid you," he replied.

I raised my voice, "Damn that. I don't wanna hear that. Give me some money."

"I won't give you any more. You'll have to see Cab to get it." His voice was quiet, but he was still very firm about his position.

I took a shot or two from my flask and walked into Cab's dressing room. The show had just ended and he was almost undressed. Rudolph, his valet, was bend-

a handle on the side, but it probably weighed 150 pounds. I think I paid three hundred dollars for it, which was a tremendous amount of money in those days.

All the guys bought records of their favorite singers and bands, and we kept them in a storage box. Many times, I'd set up the phonograph backstage in a hallway between dressing rooms, and we'd put on a stack of records. It got to the point, after a while, where I'd take requests for certain performers. One afternoon

ing over him taking off his socks. I walked right up to Cab and started beating on his bare chest, screaming, "How long do I have to be in your band before I can get some money? I want some now."

Cab was much bigger than me. He grabbed my hands and held them down at my sides. He was looking down at me just as if I was a little kid having a temper tantrum. He shook his head from side to side and said to Rudolph, "Get him outta here before I kill him."

Rudolph pushed me back toward the entrance, but I was still yapping, "How long before I get my money? I want my money now. Well, how long?"

Halfway out the door, I could hear Cab say, "I don't care how much you get. I don't give a damn what you get. Get anything you like."

That's all I needed to hear.

I had another quick shot, went backstage, and found Mr. Wright again.

"Cab says I can have anything I want," I told him.

"Okay. If Cab says so, you can get it. How much you want?"

By this time I was really loaded and pretty mad. "I want a thousand. Gimme a thousand."

He reached in his pocket, peeled off ten one-hundred-dollar bills, and scribbled out an IOU on a scrap of paper. I signed, grabbed my money, and dashed back to the game.

I walked through the dressing room door yelling, "I shoot a hundred." But there was dead silence. I looked around the room. There was no game. Everyone's head was bowed. The place looked like a funeral parlor. The moment they saw me they began filing out, one by one, and a couple of seconds later I was there all alone.

Several days later a couple of the guys told me what had happened. At about the time I was getting money from Mr. Wright, Cab was at the game tearing into all of them. He told them something like this:

Now you all know Fump. He's a fool, especially when he's drinking. He's the worst gambler of all

Mona Hinton, New York City, c. 1948

of you. You know that because you've all won his money. This is making for a bad scene in the band. It's causing dissention. He ain't got sense enough to stop gambling, so I'm gonna stop it. Anybody gambles with Milt Hinton from now on is fired. As of tonight, the crap game is over for him.

When Mona found me sitting alone in the dressing room, I must've looked pretty pathetic. We walked back to the hotel without saying a word. Then when

we got to the room, she talked while she packed her bags:

I'm gonna see you, Milton. You're a nice guy and you play well. People like to hear you and you like to play for them. You work hard for your money and you're entitled to it. But I couldn't live that way. It would torture me to see you go through your hard-earned money like that.

We argued for a while. I was really in love with her. She was the only real happiness I'd ever known and I didn't want to lose her. Her bags were on the floor next to the door and I said, "Look, just give me one more chance."

But her answer came back the same way: "No. You're too nice a guy. You should have everything you want, but you don't have anything. I couldn't live that way. I wasn't raised to go out and spend money foolishly. But it's yours, you earned it, you're entitled to spend it the way you want."

Finally, I asked, "Mona, would you try if I let you handle the money?"

"I don't think you could do that, Milton, because your life has been so different from mine."

I pleaded until she agreed to give it a chance.

From that day on, I really made an effort to shape up. I cut back on my drinking and I stopped gambling completely. The two of us became even closer. We couldn't see enough of each other and a lot of times we'd travel most of a day just to be able to spend an hour or two with one another. We were madly in love.

There were exceptions, but we usually got over-charged by the local hotel owners and the people who ran the rooming houses. All of them were black, but that didn't matter. They knew we couldn't stay in the bigger places, so like the typical white store owner in the black ghetto, these folks made some profit from the segregation system. It really didn't matter that we were all the same color.

Most people charged three or four dollars a night for a room in their house without meals. The colored hotels got as much as five or six dollars. They were terrible too. The linens wouldn't be changed and there were bedbugs and roaches everywhere.

We all resented this kind of treatment. I disliked it more than being denied service in white places, because black people were the ones doing it. Besides, white bands were staying in nicer hotels that charged the same or less than we were paying.

Bandleaders like Cab and Duke didn't experience the same kind of scene. Many times they'd get invited to stay with one of the rich black families in a town. And when they did use a hotel or rooming house, somebody always seemed to come up with a fancier place for them.

Just about all the rooming houses we used were run by strong women who didn't mind cooking. They knew how to fix food for a lot of people and do it cheap. There'd always be plenty of green vegetables—turnips, mustards, collards, things like that. These ladies would cook a stockpot full and throw in two or three ham hocks to flavor it. There were always plenty of mashed potatoes, some kind of beans, and cornbread or biscuits. There'd be chicken or meat, usually pork chops or meatloaf, and it was always covered in gravy. The whole meal would cost us fifty or sixty cents. The food was well seasoned, tasted good, and it was filling.

In the bigger cities, some of the rooming-house owners actually made their living on musicians. They might have our band stay for a week. Then when we left, Duke or Chick or Fletcher might come into town, and their guys would use the same rooms. So a couple of these places got to be fairly well known among the musicians from the various bands.

In Atlanta there was a lady called Mom Sutton who ran a restaurant in her house. You could get a room there or just go to eat. I remember her big dining room very well. There were six or seven large round tables at one end and an open kitchen with three big stoves at the other, where you'd see her

cooking. Mom always kept a bottle of gin on top of one stove, and every fifteen or twenty minutes she'd reach for it.

In the summer months, it would get hot as hell in Mom's place. You'd see her standing over the stoves and the sweat would pour down from everywhere. But the gin bottle was still there. And whenever she'd stop to take a swig, she'd say, "You gotta fight fire with fire!"

Mom might've been loaded by the time she'd finished cooking, but her meals were always a picture to see and taste. She had a young girl do the serving, and everything was put in individual dishes. Nothing was for the whole table. If she had peas, there'd be a separate small dish for each person. The same thing for the greens, mashed potatoes, and biscuits. Everything she served was delicious, but her dishwashing bills must have been unbelievable.

Mother Havelow's big brownstone in Philadelphia was another well-known place for musicians to stay. She lived pretty close to New York and always seemed to be involved in society happenings there. She was a small lady—very proper and very concerned about the social status of her customers.

She had about eight rooms to rent. But even though all the guys wanted to stay there, she'd only take the top musicians. She chose you based on your seniority in the band and your reputation. Second-floor rooms were better than third- or fourth-floor rooms because you didn't have to share a bathroom with as many guys. After I was with Cab for a few years, Lammar and Foots got me into the house. And after another six or seven years, I finally made it to the second floor.

The basement was where she had her kitchen and dining room and there was always activity down there. She served very good food, but there were also a few extra benefits. She was a pinochle lover and after every meal, she'd clear the table and sit down for a game. If you played with her, she served you free whiskey. Otherwise, she'd sell you a bottle if you wanted one. She'd also serve after-hours snacks, so when we'd get

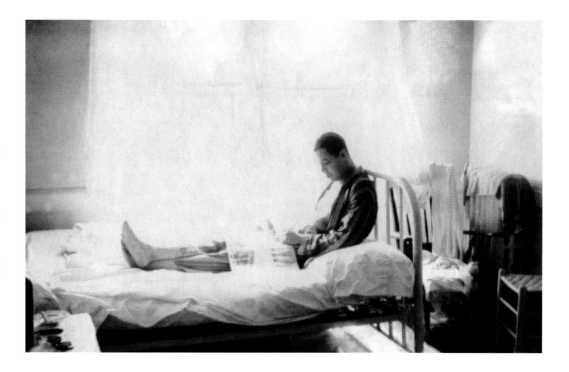

back after the late show, there'd be plenty to eat and drink.

Mother Havelow was really a kind lady. She'd even turn her head when you brought in a guest. You could do whatever you wanted all night just as long as you acted dignified about it.

In Cincinnati we'd usually stop at the Sterling Hotel. It was an old, wooden-framed, broken-down place owned by some black people who never took care of it. There was an addition on the back which had five or six rooms, and the only way to get to it was to go outside. One match would have done the place in. It was filthy.

There was a famous rat living at the Sterling. He was almost as big as a cat, and all the musicians knew him so well they named him Jerry. Most of the time, Jerry would walk along the walls of the lobby, but occasionally he'd pass you on the stairs. When that happened, you'd move to one side and let him go by. He wasn't afraid of anybody.

Unknown Calloway band member, rooming house, Philadelphia, c. 1944

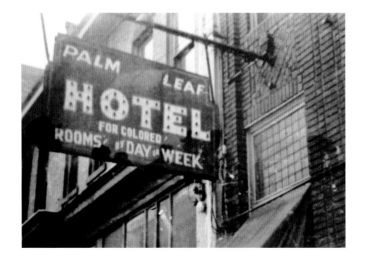

[Top] Palm Leaf Hotel,
Florida, c. 1944

[Bottom] Milt, rooming house,
Philadelphia, c. 1944

The Sterling also had a little cabaret on the first floor called the Cotton Club. It was a dump—just as rundown as the rest of the place. But the hotel always hired a good local band and we'd sometimes jam with these guys after we finished at the theater.

We used to eat around the corner from the Sterling at a place called Uncle Henry's which was named after the owner. He served an all-you-can-eat meal for fifty cents that was incredible.

I'll never forget the time Chu and Benny Carter, who was in town with another band, went there for dinner one night. Both of these guys were enormous. They walked in, paid their fifty cents apiece in advance, and sat down at a round table with three or four of us.

Uncle Henry always served the same way. He put large plates of different foods on the table and everyone helped themselves. But on this particular occasion, Ben and Chu were hungry, and long after the rest of us had finished eating, the two of them were just getting started. As soon as a fresh platter was put down for the table, they'd empty it onto their plates, finish quickly, and ask for more.

Finally, Uncle Henry came over to us, looked at Chu and Benny, and said, "Here's your fifty cents back. I'd like you to leave now and I hope you don't come back here no more. I'm losing lots of money on the two of you." We all laughed, but he was very serious about it.

Chu waited until our next visit to Cincinnati before going back. I'm not sure if Benny ever returned, but I know that the two of them never went in there together again.

We also played towns where there weren't any good, convenient places for us to eat. Many times, the theater we were working was downtown, and the nearby restaurants were too expensive or the management made us feel uncomfortable. That happened often enough that a group of us decided we'd do some of our own cooking.

It began with four guys—Foots, Lammar, Tyree, and me. When we started out, we'd only cook when

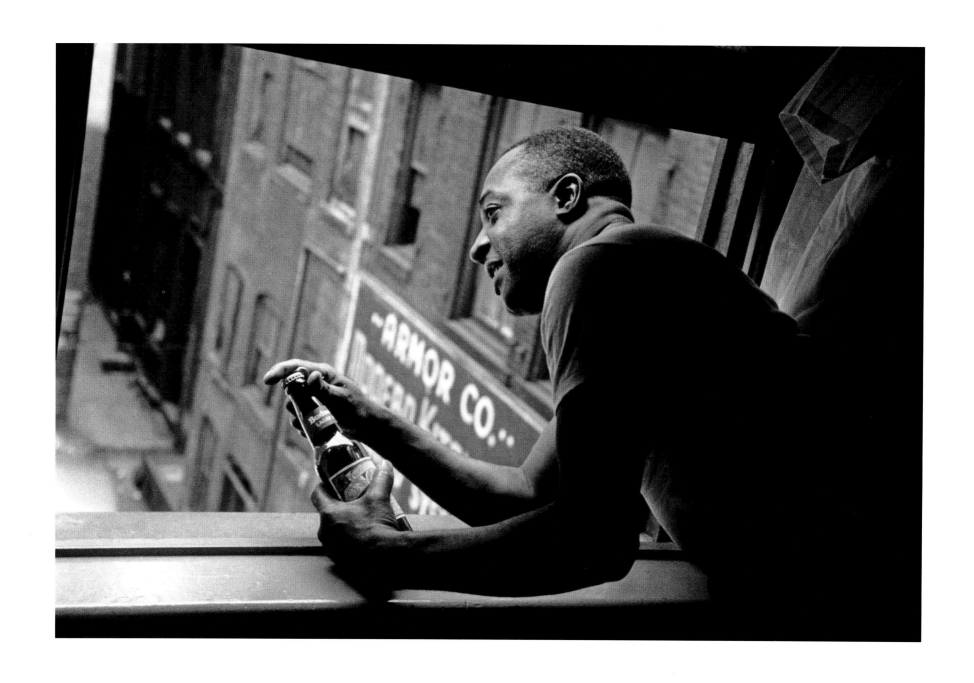

Milt, Pittsburgh, c. 1948

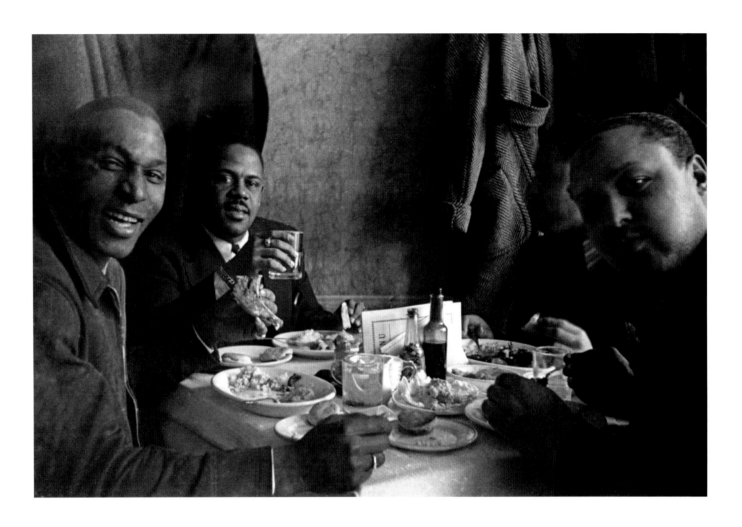

Cozy Cole, Mario Bauza, Dizzy Gillespie, and Butter Jackson, restaurant, Chicago, c. 1940

we couldn't find a good restaurant close by and the theater had a kitchen we could use. But soon we bought ourselves a fancy electric cooker with three compartments and two thermostats, and we got some good restaurant-type pots and pans. Then we had a carpenter build a beautiful custom trunk for all the equipment so we could take it on the road.

At first, the four of us took turns cooking for each other. When it was your cooking day, you had to shop for the food, prepare it, and clean up afterward. But it wasn't long before some of the other guys asked if they could join us. In fact, for a while we were cooking for most of the band, and sometimes even for Cab.

We made each guy buy his own tin plate and set of utensils. Then when we were ready to serve a meal, the guys would line up to get their food. We'd charge fifty cents apiece, but when Cab ate, we'd get a dollar fifty from him.

We never skimped on food. We always bought plenty of the best stuff. After a while some of us developed a particular specialty. I was a meatloaf man. I would make something called Millionaire's Meatloaf. I'd get plenty of ground steak, veal, and pork and mix it with green peppers and breadcrumbs. It was about two feet long and absolutely delicious.

Lammar was a chicken man. He used to fix some

concoction with chicken, spaghetti, and tomato sauce which was unbelievable. Foots had a couple of dishes he'd cook with flour batter. It was always good food, but he'd always make a terrible mess. We'd find food on the walls and ceiling wherever he cooked and we never could figure out how he did it.

Tyree teamed up with me, which meant we'd do two days in a row. He was a little lazy, so I'd do most of the cooking. But if I pushed him, he'd shop with me, and most of the time we'd clean up together.

I'll never forget the time when it was my day to cook, and we were playing a theater in Akron which had a beautiful kitchen on the top floor. I went up there early in the morning, a couple of hours before the first show. I wanted time to get out our pots and pans and set up so I could cook breakfast before the noon show and also start on dinner.

After an hour, I'd cooked a pound of bacon, made plenty of pancake batter, had the coffee brewing, and put the dinner roast in the oven.

When the guys drifted in, I started making my pancakes. And forty minutes later I was still cooking. Everyone was eating them just as fast as they came off the skillet. Ten minutes later the manager called, "Half an hour!" I got Foots to watch the stove while I ran downstairs and put on my uniform. By the time I got back, only Chu and Tyree, the ones with the biggest appetites, were left. The rest of the guys had gone off to dress.

When the manager called, "Fifteen minutes!" I left a few pancakes on the grill for myself and went out to the mirror in the hall so I could adjust my shirt and tie. A couple of minutes later I returned to the kitchen to eat. I was starved. I'd probably made more than a hundred pancakes but hadn't had a chance to help myself. When I reached the stove, the skillet was scraped clean. Chu and Tyree were chewing on toothpicks, grinning from ear to ear.

The manager called, "Five minutes!" I was feeling very weak. The batter was all gone, so I went to the refrigerator and grabbed the watermelon I'd bought for dessert that night. I cut off a large slice and ate it

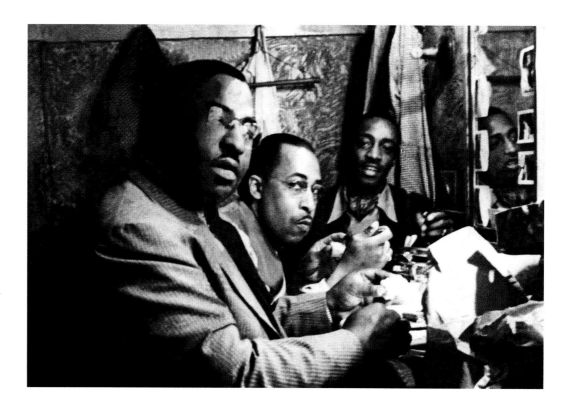

Chu Berry, Morris White, and Milt, backstage, c. 1938

quickly. I just wanted enough strength to get through the first show. I must have cussed Chu and Tyree for a week.

Another unforgettable cooking experience happened when we were playing a theater in Kansas City. It was my day to cook, but I had some friends in town who had invited me out for dinner after the second show. I tried to switch my day with someone else but I couldn't, so I bought plenty of cabbage, corn on the cob, and meat, and I set up my kitchen in one of the dressing rooms under the stage.

By the time the second show was about to start, I'd finished cooking and had the stove thermostat set so it would keep the food warm. Before we hit, I told the guys I was going out for dinner afterward but the food would be ready for them when they finished.

The second show began and for the first twenty minutes everything was fine. But things began to change during a big dance number when the smell of

cabbage started coming up through the stage floor-boards and out into the theater. Soon the odor was everywhere, and it wasn't long before we could see people in the audience sniffing the air.

When the show ended, the manager came back-stage and said, "Jesus, you guys got everybody walking out of the theater hungry. What's going on?" Before anyone answered, I had my coat on and was off to dinner with my friends.

In Louisville, a couple of us used to stay at Estelle Jones's place. We'd send her a card a week or so in advance and give our arrival and departure dates. Her rooms were okay, but her place was ideal because she had a beauty parlor out in front. That meant there was a constant flow of girls who we'd try to invite to our rooms for a drink.

One afternoon I almost got killed in that place. I was with Tyree, a couple of girls, and some local black guy. We were sitting around drinking and for some reason I had my camera out and was taking pictures of everyone in the room.

After I'd taken a couple of close-ups of this local guy and his lady, he suddenly turned towards me and yelled, "Man, whatta ya doin'?"

I told him I was just fooling around taking pictures, that it was a hobby of mine. But the more I tried to explain, the angrier he got: "You don't know this lady. This lady's got children in this town. Whatta ya think you are, a newspaperman? You don't know her. You put that picture in the paper, this lady's gonna be in big trouble."

By the time he finished, he was raving. I kept re-peating, "I don't mean anyone harm." But he was too worked up to hear me.

A couple of seconds later he pulled a knife. Thank God, Tyree jumped into it. He grabbed a Coke bottle and started yelling as he walked toward the guy. For a few seconds it looked like there'd be violence, but Tyree managed to prevent it. He turned and told me, "Open your camera and give him the film." I did. The guy grabbed the roll and left with his lady.

For years, Tyree and I would laugh about that after-noon in Louisville. If I had a camera around my neck, he'd point to it and say, "Remember, you don't wanna be too sly or too slick with that thing."

I always stayed in contact with the Joneses, the people my mother had worked for back in Vicksburg, and I'd see them frequently whenever we played Chicago. The story of what happened to that family is fascinating.

Reverend Jones made a name for himself after he moved his family from Vicksburg to Chicago. His church in Evanston was well known and at one point he was president of the National Baptist Convention, which was quite a prestigious position. He seemed pretty well off compared to most black people in Chicago. Like many black clergymen, he probably had a little money, but more important, he knew the right people. Consequently, the family always lived in nicer houses. His boys—Ed, George, and McKissack—went to better schools and got good jobs in the summer, usually doing service work on the railroad.

Sometime in the mid '20s, Reverend Jones died very suddenly and the boys went home to live with their mother. A while later she took the family savings and bought a couple of taxicabs, but by the beginning of the '30s, the boys had gotten involved in a numbers policy business on the Southside.

Years later, George told me how it started. Evidently, they had plenty of street contacts because of the cab business, but they had no bank to speak of. Once they put out the word about opening their new business, there was plenty of action. Luckily, for the first three or four days no one's number came in, and that gave them a chance to build up their reserves.

The thing that really helped their business grow happened a couple of weeks later. Someone hit big, and when the Joneses gave their writer the payoff money for his customer, the guy kept it and ran off. In those days, when you played the numbers, you got a receipt showing what you'd bet. When this customer didn't get his money, he went right to the Joneses and

complained. He probably expected to get an argument, but he didn't. The Joneses asked for his receipt, and when the numbers matched, they paid him right on the spot.

Evidently, that kind of thing was unusual in those days, but the Joneses were smart. They figured it might cost some money, but the publicity they'd get would be worth it. They were right. News traveled all over the Southside and pretty soon people were saying, "Play with the Jones boys. They'll pay off no matter what." A couple of weeks later, business was really booming.

The Joneses were also smart about how they organized their business. There was so much cash around, they realized they'd have a hard time running things unless they could trust the people who worked for them. Since there weren't enough of their own family to handle the important jobs, they did the next best thing and got old friends they'd known from Vicksburg. These people were dependable, honest, and eager to earn a good living.

My Uncle Matt was one of the guys they hired. They'd known just about everyone in our family for years, and they knew they could trust him completely. He was a perfect choice. He was the closest thing our family had to a gangster, and he was also fantastic with figures. In fact, his abilities got to be so well known, people were always testing him. They'd rattle off a long list of numbers, and a few seconds later he'd have the total. It was an amazing gift that he'd explain by saying, "I've been around crap games so long, it just comes naturally."

His memory for figures was also unbelievable. He could remember dozens of numbers for days at a time, and this, of course reduced the Joneses' need for keeping records. They made him the comptroller, the man in charge of collecting from the runners and totaling up the day's take, which was one of their most important jobs.

The Joneses changed their headquarters pretty regularly, but they always seemed to use small houses on one of the narrow back streets on the Southside. Over the years, I met Uncle Matt in two or three of these

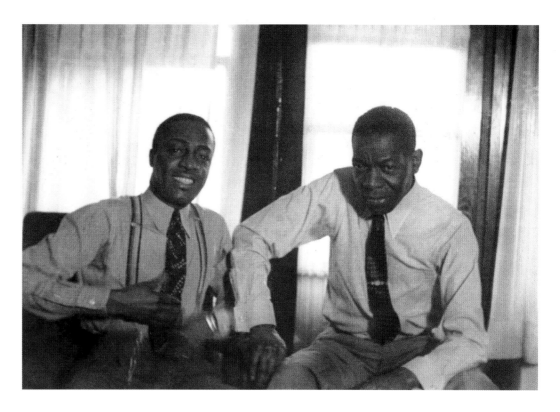

places and all of them seemed to be set up the same way. The first floor looked something like a crude bank with one teller's cage, where Uncle Matt would sit. The cage was built out of raw lumber with chicken wire nailed to it and there was only one narrow opening, directly in front of his seat. Then down in the basement, they had a couple of older ladies cooking and serving food and beer to the runners. There always seemed to be a bunch of these guys around waiting for their slips to be counted and for the day's drawing.

I don't know how many wheels the Joneses had altogether, but two I remember were called "Harlem" and "The Bronx." There were all different ways to bet—one, two, three numbers, and so forth—and the payoff changed depending on the kind of bet. The Joneses would collect a piece on each dollar's worth of business and the rest went to the writers and runners as commission. Uncle Matt got a couple of pennies

Milt and Uncle Matt, Chicago, c. 1939

Milt and Cozy Cole, Panther Room, Hotel Sherman, Chicago, 1941

on every dollar because of his position. That was high, considering how much was taken in, but it was always understood he'd use most of it to play his own numbers.

I still remember the day Uncle Matt hit big. There were numbers that stood for everything—man, woman, nose, head, left hand, right hand, sky, moon. As my uncle told it, earlier on this particular day, a black cat had wandered through the bank and he had played the numbers that stood for it.

The payoff was large. I still remember the size of the roll he won. Mama, Sissy, and Titter got five or six dresses each, and I got a suit and a pair of shoes. Knowing Uncle Matt, I'm sure he also spent a couple of hundred on his two favorite women. He was always a great spender, but this win gave him an excuse to do something special for our family.

Seeing all that money in the Joneses' bank and the roll of bills in my uncle's pocket really made me want to be a part of that scene. In fact, one time when I was in my middle twenties, I actually went to the Joneses and asked for a job.

To this day, I don't know whether Titter or Mama got to Uncle Matt, or if he did it on his own, but the Jones brothers turned me down cold. They closed the door on me like I'd never seen it closed before. Ed told me, "Man, you've studied music at school. You're earning a little money with bands around town. You gotta keep it up. You're the only thing clean that's come outta Mississippi in years."

They treated me like I was being groomed for a world championship. They saw I had a chance to make it through music and they wanted to encourage whatever abilities I had.

Evidently, the Jones boys were always able to take care of the police, so they weren't a big problem. But at one point, a few guys from the Chicago mob tried to move in on their operation and there was some violence.

The Joneses also managed to put money into legitimate businesses. They owned a lot of stock in one of the public utilities and they bought apartments and hotels, including the Bath House where I'd sometimes

stay. It was a high-class place where many black celebrities stayed when they visited Chicago. It was very expensive—way out of my league on the salary I was making. But the Joneses knew me and probably realized that when I came to town, I needed more freedom than I could get at my family's house. So they'd give me one of their own suites to use, free of charge. Then they'd parade me around the place telling everyone who I was. They were all very proud.

In the late '30s, the Joneses had some trouble with the income tax people. Ed made a deal with the government and agreed to go to jail in exchange for George and McKissack's freedom. He did a couple of years in a federal prison, but even while he was in, business went on as usual.

McKissack died in a freak car accident, and in the middle '40s Ed and George took the whole family and moved to Mexico, where they set up a legitimate textile business. Their mother and my mother stayed in contact for years and I'd hear stories about how the family was living like royalty—huge houses, dozens of servants, schools in Europe for their children. For a long time, I'd see George when he visited New York. Even though we were both senior citizens, he'd still pat me on the head and tell everyone how proud he was that I'd made it.

I n his own way, Cab was concerned about race. He didn't want to present black people in a stereotyped, Uncle Tom image, especially in the Deep South. So when we went down there he'd make sure to emphasize a high-class presentation. He'd take performers like Honi Coles, Avis Andrews, and the Mills Brothers with him, and he'd make sure everyone dressed and acted properly, both on and off the stage. In his own way, he emphasized the dignity of black people.

Of course, the music we played was completely different from what blacks usually heard. In most Southern towns there'd be a small radio station which played blues and catered to a black audience. The lyrics usually had sexual messages: "You got bad

Chu Berry and friend, Durham, North Carolina, c. 1940

Front row: Chu Berry, Rudolf Rivers, and Butter Jackson; *Back row*: Danny Barker, unknown,
Cozy Cole, Tyree Glenn, and Cliff (Cab Calloway's valet), railroad station, Atlanta, c. 1940

blood, mama, I think you need a shot,"; "Now my needle's in you, honey"—those kinds of lines. These stations always seemed to have a disc jockey named Sam. He'd read commercials and announce songs, period. He had absolutely no personality.

Southern black people seemed to be kept ignorant, poor, and fighting among themselves. But Cab was like a breath of fresh air. Lyrics like "She's tall, tan, and terrific" presented a different image of black women. Kathryn Perry singing "Don't Worry 'bout Me" to Bill Robinson was the same kind of thing. He's going north to seek his fortune and she's telling him not to worry, she'll be all right at home. It was beautiful to see and it also showed that black people could be dignified.

I don't think the white establishment in these towns appreciated what we were doing. They didn't want their black people to be exposed to our brand of entertainment, and they seemed to prefer it when we played a dance instead of a stage show.

We even heard about instances where whites in these towns would try to turn local blacks against us. They'd tell them how we thought we were smarter and better and how we'd steal their women if they weren't careful.

Cab knew what was happening, so whenever possible he took precautions to prevent trouble. In small towns, he'd always try to use the Pullman instead of local lodging. And when we used it, he'd remind us about the dangers of bringing girls back to the train and how we should always be on the lookout for jealous boyfriends.

If we knew we'd be using the Pullman, we'd sometimes pool our money for a party and give it to a couple of the porters before we went off to work. These guys were amazing. They'd go out, buy booze and food, get ice, and have everything ready for our return.

After we finished work, we'd come back with our female companions and the party would start. A few hours later word would spread through the car that we were about to leave. We'd send the girls home and within five or ten minutes our Pullman would be hooked up to a train and we'd be off to our next engagement.

I remember one night Cab had a lady in his section of the Pullman. We were having our own party, but we could hear the two of them carrying on. Apparently, she wanted to go, but Cab objected. He was loaded and when he got that way he could get pretty abusive. Finally we heard her tell him, "Listen, man, I go with the chief of police, and if you don't let me off right now, there'll be real trouble."

Cab knew the scene well enough to believe her. There were always some powerful whites in these Southern towns who had families on both sides of the color line. His tone changed immediately. We heard him apologizing over and over again as he walked her off the train and put her into a cab.

We played Atlanta for a couple of weeks one time, and Lammar and I decided to rent a little efficiency apartment. It was winter and cold as hell. The only heat we had was a fireplace, so we hired a local kid to get some coal and wood, sit in the place every night, and keep the fire going. That way when we'd get back after the last show, it would be comfortable. We always kept a couple of bottles around, just in case one of us ran into a girl at the theater and ended up inviting her back after the show.

When it came to ladies, the procedure we usually followed was to try and line things up during intermission. When the break came, we'd go out and mingle with the crowd, sign autographs, and look for possibilities. If a girl looked interesting, you'd invite her to meet you backstage after the performance. And if she showed up, you'd give her your address so she could come by later. That way, you'd avoid being seen leaving with her and protect the woman and yourself from local guys who might be watching and ready to start something. Even in a big city like Atlanta, we were careful. After all, it was still the South, where jealousy seemed to be common.

One night on this particular trip, I'd made a good contact with a girl. After the show I met her backstage and gave her my address, and then dashed back to the apartment so I could set things up before she arrived.

Later he told me what had happened. After the show he decided he wanted some companionship for the evening, so he hung around until he found a lady who was interested. He started walking back to our place with her, but about a block later some local guys started chasing him.

I guess word got around fast, because neither of our girls ever showed up. Lammar and I drank the rest of the booze and fell asleep in front of the fire.

After I'd been with the band five or six years, Mona joined me on the road. In fact, she was really the only woman who ever traveled with us regularly. That was because the guys quickly realized they could trust her. She didn't mind anybody else's business. They knew they could do what they wanted and she wouldn't spread the word back home.

Mona adapted to the traveling beautifully and became a tremendous help to all of us. This was particularly true when we were doing one-nighters in small towns and would arrive just before we were scheduled to perform. She became expert at finding food and getting us lodging when we needed it most.

Black or white, people seem to be less threatened by a stranger who's a woman, and I think that's one reason Mona was so successful. She'd go over to the black section of town and somehow find a lady who was willing to help. She'd explain how she was traveling with Cab's band and that the guys needed rooms for the night. These towns were too small to have a colored hotel or even a couple of big rooming houses, so the lady would either get on the phone herself or give Mona numbers to call to find neighborhood people who might rent a room or two.

Mona also had a knack for finding good food in these little places. She'd manage to get hold of a friendly lady who looked like she didn't mind working and ask:

If I go down to the store and get a dozen chickens, can I pay you to fix them for the boys? I'll help

Butter Jackson, Jonah Jones and railroad workers, New Orleans, c. 1941

But when I got to the place, I found the kid we'd hired had drunk up half our whiskey and passed out. The fire had burned down and it was freezing. I woke him up and sent him home. Then I started the fire again and put out the refreshments. By this time, forty-five minutes had passed and there was still no sign of the lady.

A few minutes later, I began to hear shouting outside on the street, off in the distance. When it got closer and louder, I knew it was Lammar and I ran out front to check it out. I saw him down the block, coming full speed toward our place, being chased by two black guys. I stepped back inside the front door but left it open. A couple of seconds later Lammar charged in and I quickly locked the door behind him.

you do the frying. Then we'll get someone to take it down to the dance hall so they can have something to eat at intermission.

Once she got the okay, she'd give the lady a generous amount of money.

Dances usually started at nine. At ten-thirty or eleven, when we took our intermission, Mona would appear with two or three young boys carrying big baskets filled with chicken. Most of the time it was still warm and we'd have bread or biscuits too. She'd go around and collect a dollar from each guy and then we'd go back to work. She was an angel. The guys in the band loved her for what she did.

By the time we got ready to leave one of these towns, Mona had made friends with the people who'd rented us rooms and done some of the cooking. She'd keep a list of names and addresses, so when we knew we'd be coming through town again, she could write and give them a chance to set things up for us.

When we played in New York, Mona and I usually stayed at the Cecil Hotel, above Minton's in Harlem.

Some musicians stayed at the Cecil because it was cheap and fairly clean. But there were also a lot of pimps and whores living there too. We always tried to get a little suite that was pretty basic. You came into a good-sized room that had a double bed and then, off to one side, there was another smaller room.

There wasn't much furniture and whatever they had looked like it was on its last legs. It was so depressing that the second or third time we used the hotel, Mona decided she'd have to make some improvements. She'd go to Blumstein's on 125th Street and get some paint and a few yards of cretonne, which was a real cheap fabric with big colorful flowers all over it. Then she'd paint a couple of the walls and hang the fabric around the bottom of the bare wall sink across from our bed. It wasn't much, but it helped. In fact, there were times when the wives or girlfriends of some of the other musicians staying at the hotel would see what Mona had done and actually be upset by it. They'd tell her things like, "You're crazy spending time on this place,

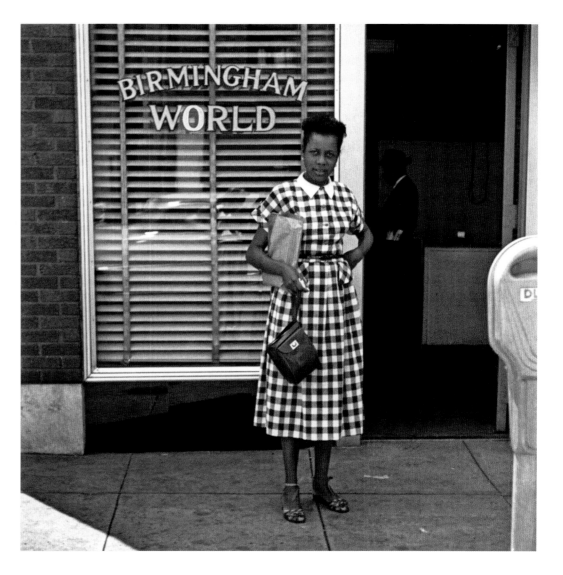

treating it like your home." And Mona would answer, "If I spend six weeks here, it is my home."

One time, the suite we had was right next to a transient room which got rented out at least once a day. Long before we got there, someone had put a hole about the size of a quarter through the wall between the rooms. For a while, whenever we'd hear noises coming from that room, we'd check out the action, and sometimes when friends visited our place they'd want to have a turn too.

Mona, Birmingham, Alabama, c. 1950

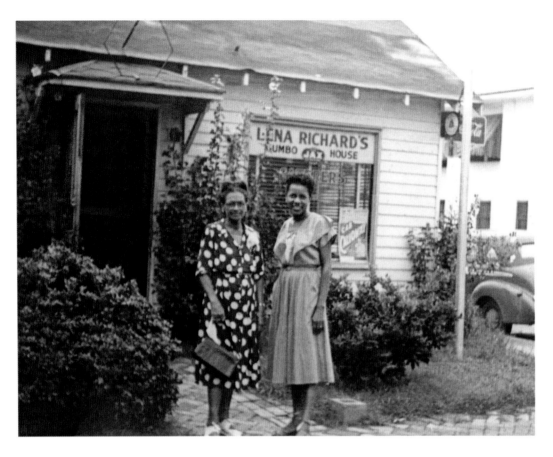

us and we were rolling around on the floor, laughing so hard it hurt. Two or three minutes must've passed before Mona's mother suddenly walked over to the peephole to have a look for herself. She didn't laugh like we did, but she stayed glued to that spot for the next five minutes, obviously enjoying the show.

One of the most memorable experiences I have from the Cecil was an episode that involved Mona and Ben Webster. By this time, he'd already left Duke's band and was playing in different clubs on 52nd Street.

People got to know we were staying at the hotel, and after a while there seemed to be a steady stream of visitors, just about any hour of the day or night. In those days Mona tried to get to bed early. But that never stopped guys from stopping by at two or three in the morning after they'd finished work. There were many times when a couple of us would sit around talking until dawn, and Mona somehow managed to sleep through it all.

Early one morning, Mona and I were awakened by loud banging in the hallway outside our room. When I opened the door, Ben was standing there. He had a tall, heavy-set prostitute with him and they were drunk. Before I could say anything, they were in the room, standing at the foot of the bed. By this time, Mona's eyes were open and Ben started making introductions: "This is Maizie. Baby, say hello to Mona."

Mona wanted no part of it, so she pulled the covers up over her head. Ben saw this and told her, "Hey, Maizie's a good girl. We're just trying to have some fun—don't spoil it." Mona lifted the covers and looked over at me.

Seeing her eyes and the expression on her face, I knew exactly what she was thinking: "Milton, for God's sake, please get them out of here."

We didn't have much of a conversation. Ben and Maizie weren't making very much sense. After ten minutes they left and walked up three flights to Ben's room on the fifth floor. A few minutes later Mona and I were sound asleep.

But we didn't have peace for very long. About five-

During this particular stay, Mona's mother decided to come and spend a couple of days with us. A few hours after she arrived, she saw us use the peephole and made it clear she didn't like it: "It's wrong spying on people. You should be ashamed of yourselves."

But a couple of days later things changed. I got home from work about two in the morning and while Mona, her mother, and I were sitting around eating, we began hearing loud groans from the room next door. Mona went over to the peephole and a second or two later burst out laughing. Then I took a look. I couldn't believe it—there was a man and a woman lying on the bed and she was carefully plaiting his pubic hair. I turned away from the wall, looked over to Mona who was being lectured by her mother, and the two of us broke up.

It was quite a scene. Mrs. Clayton was scolding

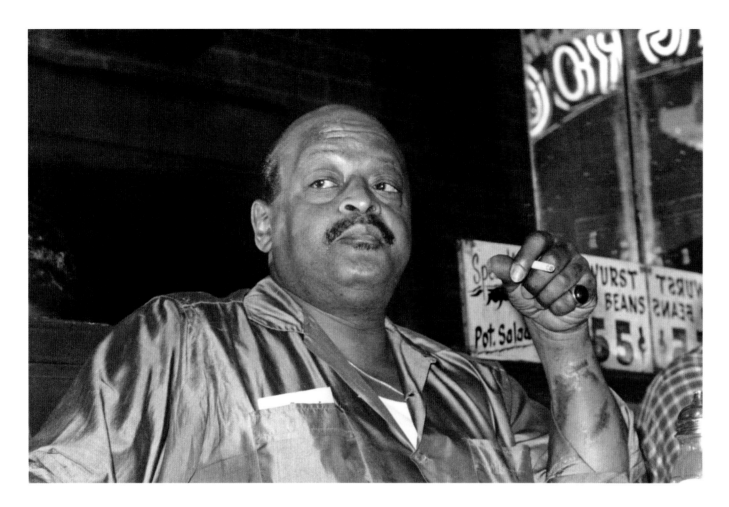

thirty we were awakened again by loud noises which seemed to be coming from the hallway upstairs. It sounded like the place was on fire.

A couple of seconds later, there was a knock at our door. As soon as I turned the lock, Ben pushed his way in and I could see Maizie out in the hallway. She had a big knife in her hand and was calling Ben every kind of mother imaginable. I pulled him farther into the room and quickly closed the door so she couldn't follow. Then he told us what was going on. When Maizie was about to leave his room, she couldn't find one of her shoes. She accused him of hiding it to stop her from going back on the street and then told him her pimp would kill her if she didn't bring in enough money.

Ben was beside himself. At that hour he didn't know what else to do but ask Mona for a pair of her shoes. Maizie must've been a foot taller and probably wore shoes twice Mona's size, but that didn't seem to matter. I think Mona would have done anything to have some peace and get back to sleep. She went to the closet, got a pair of shoes, and handed them to him.

I saw Ben the next afternoon and he apologized a couple of hundred times for what had happened. It seems that when he and Maizie came into the hotel the night before, she stumbled and broke her heel. Ben had given the bad shoe to the hotel porter to have the heel fixed. In their drunkenness they'd forgotten everything, and it was only later when the porter brought

Ben Webster, Beefsteak Charlie's, New York City, c. 1960

the fixed shoe to Ben that he remembered what had gone on.

Of course, on one level this episode was very funny, but when I look back on it, I recognize a sadness in it which I hadn't really seen before. Booze had already caught up to Ben when he was still a relatively young man. In many ways, the whole 52nd Street scene was probably responsible for destroying him, as well as some of the other top jazz players.

In Ben's case, "Cotton Tail" and some of the other things he'd done with Duke started getting him exposure and some name recognition. When that happened, one of the club owners on 52nd Street offered him twice what he was making with Duke to work with his own group. Money and ego were always very important to Ben, so he left.

Once he was out on his own, Ben ran into a problem. In Duke's band he was used to playing with a high-calibre rhythm section—Sonny Greer, Jimmy Blanton, and Duke himself. But on 52nd Street things were very different. An owner might give a star a high salary, but there was never enough left to pay for a good rhythm section. So, like so many other guys who went out on their own, Ben often worked with second-rate sidemen.

He struggled with it. At first he'd spend set after set showing them what he wanted, but after a while he realized it was hopeless. He'd even complain to the boss about the problem, but the answer was always the same—"Whatta ya want from me? I got a budget for music and most of it goes to pay you."

The rhythm section made Ben sound bad too. He couldn't get the same kind of sound he had on records, and he knew it. People would come to hear him do what he was known for, but they'd never hear it the way they remembered.

Booze was always a big part of the jazz club scene. Back then, things got so frustrating for Ben, the only way he could cope was to get loaded every night. Coleman Hawkins had the same experience. In my opinion, the economic situation and the environment had a great deal to do with destroying some of the musical giants years before their time.

Cab had a big following among both black and white people. He made some records, of course, but his real reputation came from the coast-to-coast radio broadcasts we did a couple of nights a week from the Cotton Club. Later, we had another radio show called *Cab Calloway's Quizzicale*. I was a regular member of the cast, but I didn't have a name. I had a number—"62 Jones." Tyree and Eddie Morton, the dancer, were also on the show. It was basically a musical quiz program where listeners called in and tried to win prizes. We'd do jokes and other kinds of dialogue, so there was a regular script and lines to read, the same as other radio shows in those days. With all that exposure, wherever we played in the country, people would come out just to see what Cab looked like.

I don't think we ever played for an all-black audience. We'd work plenty of segregated theaters where blacks had to sit up in the balcony We'd also play a lot of all-white dances, but I can remember others where they'd allow whites and blacks in, then divide the room in half. There'd be a rope from the center of the bandstand down the middle of the dance floor. Whites danced on one side, blacks on the other. Many times the band would end up on the white side of the room. It was as dumb as that.

Once at a dance in Jacksonville, they roped off an aisle so we could go to the bathroom at intermission. When the break came, we started walking toward the colored men's room and some of the white guys in the audience stood on each side of the aisle and leaned across the ropes trying to hit us. It was like a nightmare parade and we were the star attraction.

We also played some strange places in Texas. I can recall a one-nighter in a Longview roadhouse—Mattie's Palm Isle—which was beyond belief.

Apparently, for generations the people in this town had been small-time farmers, working the land and raising a few cows. They'd always had a lot of land, but it was barren and worthless. In fact, it was so bad that for years, cattle had gotten sick grazing on some of the ranges.

Everything suddenly changed when it was discovered that the town was sitting in the middle of a very

large oil field. In some places, oil was just oozing out of the ground, which is the reason cattle got sick so often.

Soon these people had leased their land to a few big oil companies. The money started flowing in and the town went wild. It wasn't long before Northern sharpies found out about the place and came in selling Palm Beach suits for five hundred dollars and gold watches for much more. These local people would buy whatever they were told rich people had in Houston or Dallas or up north. That's how we came to play there. Some of the townspeople had been told about the great black bands from New York and decided they had to have one play for them. Unfortunately, we got the job.

Our train pulled into town late one afternoon. Before we left the Pullman we put on fresh uniforms. Then a dozen big private cars picked us up and drove us about thirty miles out of town to a big wooden roadhouse. By the time we arrived it was pitch black, except for the lights in the place. It really was the middle of nowhere.

Inside, the roadhouse was rustic. The stage was shaky and much too small—maybe about the right size for four or five guys. Somehow our valets managed to set up our equipment and we squeezed onto the bandstand.

We began playing and soon the place was filled. Booze was everywhere and it didn't take long before most people were drunk. The more they drank, the louder they got and the more they seemed to want to fight.

Benny Payne was playing piano and I was standing right next to him. At some point during the evening, while we were in the middle of a number, a couple looking very loaded walked over to the piano. They watched Benny for a while and then the girl started talking to him. He ignored her, knowing what could happen if he let a conversation begin. But she wouldn't give up and she offered Benny a drink. He pretended not to hear, but after she asked two or three times he told her, "No, thank you," in a very polite way.

Hearing that, she yelled, "You mean you ain't gonna take a drink that's offered you, boy?"

Benny knew immediately he had to take the drink, regardless of the risks. He took the glass from her and finished it in one gulp. But just as soon as he put it down on the piano, the guy with her leaned over close to Benny and told him, "Nigger, you can't be takin' whiskey from my girl."

I was so terrified, I could barely move my fingers. I looked around the room for an escape route. But it wasn't necessary—at least at that moment—because seconds later, a fight broke out between a few of the locals on the other side of the room and it caught this guy's attention. He backed away from Benny, grabbed his girl's hand, and rushed over to check it out.

We kept playing. I felt relieved, but it didn't last long. A couple of minutes later I heard a commotion on the side of the stage and when I was able to get a clear view, I couldn't believe my eyes. Our road manager, Jack Boyd, a white man from Texas, was standing next to Cab shooing off five or six local guys. They were pushing and pulling, trying to hit Cab, and I could hear them shouting things like, "I'll give two hundred to hit the nigger." I didn't understand it then, but later I learned they had a town law about a fine you'd pay for assaulting blacks. That's what the two hundred dollars was about.

We tried to keep playing, but suddenly all hell broke loose. I couldn't believe the brawling. The place looked like one of those barroom scenes in an old Western movie—guys hitting each other with bottles, chairs, anything they could get hold of and swing.

We grabbed our instruments and rushed off the little stage, but there was no place to go. The windows were too small to climb through, and with all the fighting, we couldn't make it across the room to the door. So we huddled together against the wall next to the stage.

A few seconds later, the manager of the place came over and shouted, "I'll try and save you niggers, but this is gettin' outta hand." He pulled up a trapdoor a few feet away from us and we went down a ladder into a dirt cellar, one by one, carrying our instruments.

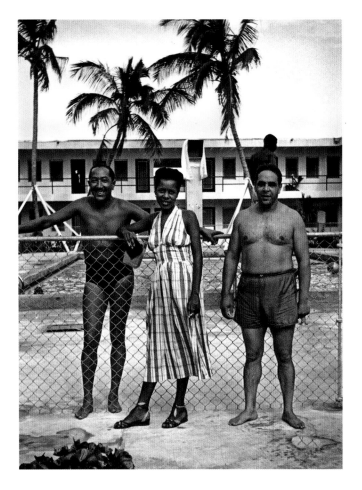

Doc Cheatham, Mona Hinton, and Butch Thompson, Sir John Motel, Miami, c. 1950

I recall some Jim Crow encounters in Miami during a trip in the late '40s. We were staying at a brand-new black motel called the Sir John. It was considered luxurious in those days because it had a pool and its own little nightclub. One night after we finished, five or six of us went to a club on the beach to hear some white friends from New York. Of course, we knew we wouldn't be served in the place, so we went in through a back door, figuring we'd be able to listen from the kitchen. It was late and the kitchen had been closed for hours, but that didn't stop the owner from chasing us out.

Several nights later, these same white friends showed up at our hotel's club. Just as we were about to start jamming, the police came and ordered our friends to leave. They just didn't want fraternizing between the races, no matter where it happened.

One of the strangest experiences I ever had with Jim Crow was in Omaha in the late '40s, and it involved Rudy Powell, a sax player in the band. Several years earlier he'd gotten involved with a black nationalist group and he carried a card identifying him as Musheed Karweem, a member of this particular sect. He'd grown a goatee and he wore a fez wherever he went.

On this particular occasion the band had traveled by bus from Chicago. We arrived about one AM and headed for the hotel we'd always used on the black side of town, but when we got there, we saw that the place had burned down.

None of us knew about any other lodging for blacks, and by this time it was so late, there wasn't even a cab driver around to ask. At that point, Mr. Wright figured we'd sleep on the bus, and he told our driver to park in front of the theater where we'd be playing the next day. None of us liked the idea. We'd been traveling all day and really wanted a good night's sleep.

Just as soon as we got to the theater, Rudy walked up to the front of the bus to talk to the driver. He pointed out a hotel sign down the street and asked

We must've spent a couple of hours down there listening to the stomping and the glass breaking and feeling the vibrations from the room above us. It felt like an eternity. Everyone was scared to death.

Then it all got quiet, and about a half hour later the manager opened the trapdoor and told us it was all over.

Cars were waiting for us outside. We drove back to the station, got back on our Pullman, and just as it started to get light, we pulled out of Longview.

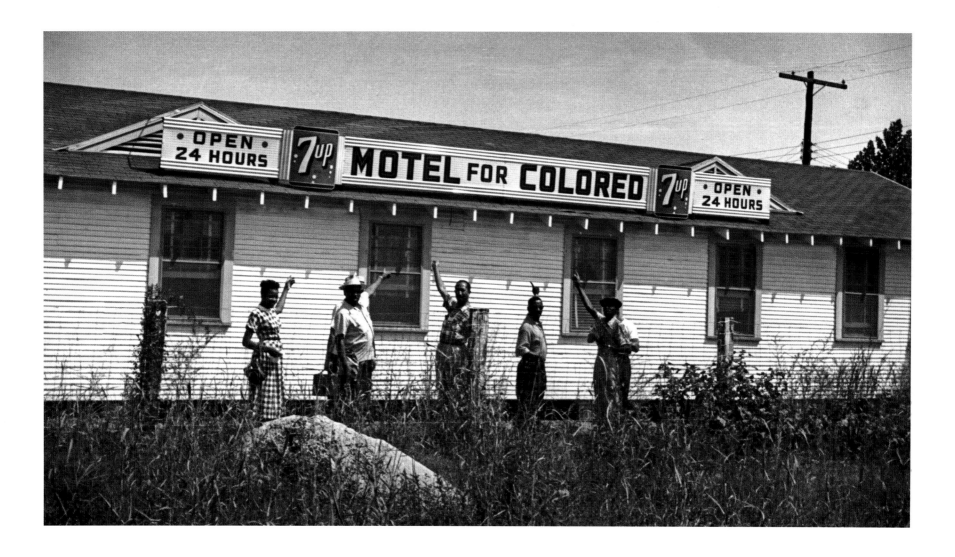

the guy if he'd take us there. A minute or two later, we were parked in front of a large, fancy-looking hotel. Rudy stood up in the aisle and told all of us to wait for him. Then he walked off the bus and into the hotel.

According to Rudy, the clerk on duty told him all the rooms were taken. That was the usual excuse in large Northern hotels. But Rudy demanded to see the manager, and after they argued back and forth, the manager finally appeared. The way Rudy told the story, the manager came to the front desk and told

him, "We're really not filled. The truth is our hotel doesn't serve colored."

Without hesitating, Rudy answered, "I'm not colored." Even though he was very dark, he was wearing his fez and he had a beard, which was unusual in those days. While he talked, he kept flashing his identification card. He said:

Call the State Department. I want to speak to someone at the State Department in Washington

Mona, Ike Quebec, Doc Cheatham, Mario Bauza, and Shad Collins, Georgia, c. 1950

Milton Dixon Hinton (Milt's father), Memphis, c. 1940

right now. I am a foreigner in your country. I am representing my country. You say you cannot serve me because you do not serve colored. I say I am not colored. Put me through to Washington, now. We must straighten this out immediately.

According to Rudy, the manager didn't know what to do. At first he said, "I'm very sorry, but we have a hotel policy." As Rudy got more insistent, the guy softened and finally gave in, saying, "I'm sorry, sir, we've made a mistake. We'll see to it that you get a room."

At that point, Rudy decided to push even further. "My brother countrymen are outside, and I must have rooms for all of them. I am the only one in the party who speaks your language. I will have to go out and explain what has happened."

Rudy returned to the bus, stood up in front, and told us what had happened. Then he said, "Look, you guys can't speak any English. Just follow me into the hotel and don't say a word."

A few minutes later, we were lined up in the lobby. Jonah Jones, Shad Collins, Kansas Fields—not one of us remotely close to looking white. Rudy stood up front next to the desk. Each time one of us stepped up to get our room assignment and a key, he would announce us with a long Arabic name and then sign the register.

The next morning he quietly came around to each of our rooms, collected the money, and paid the whole bill, just as if he was really the head of our party.

I saw Rudy do this same kind of thing on many other occasions. One time we were playing somewhere in the Deep South and Mr. Wright was eating alone in a bus depot restaurant. He turned around and there was Rudy sitting at a table with his fez on. Mr. Wright was scared to death. He didn't want any kind of confrontation, especially in those days. But Rudy had done it again. He'd flipped out his card and after a short argument with the waitress, he got served.

Rudy always knew exactly what he was doing. He was aware of the stupidity of segregation and figured out a way to play the system. And every time he pulled it off, he laughed about it. We all did—probably because these episodes told us something about how little thought people give to the way they behave. These rules are taught from childhood and they're followed because that's the way things are done. People just don't know there's another way.

My father and mother had split by the time I was three months old. Since my mother never kept in contact with him and no one ever talked about him, he was pretty much a mystery to me for a good part of my life.

He once stopped by our house in Vicksburg when I was about three or four and Mama was taking care of me. I always slept on a short wooden bench in the hallway. Mama had a special kind of pad she'd put down to make it soft, and there'd usually be an oil lamp burning when I went to bed.

I was half asleep when he came, but I still have a faint memory of feeling his rough beard against my cheek when he gave me a hug. I woke up the next morning and found a sack of marbles, some candy, and about fifty pennies on the floor next to me.

When Mama saw I was up and playing with those things, she told me, "Your daddy was here last night, boy, and you wouldn't wake up."

That was really the only memory I had of him until I was thirty and we finally got to meet face to face. And that's one of the most memorable experiences of my life.

It wasn't the kind of situation where I was totally surprised. I was with Cab and we were working at a theater in Memphis. A year or so before that, Mona had tracked down my father's sister, Lucy Woods, who was still living in Memphis. They'd written to each other a couple of times and Mona had told her the date I'd be coming to town. So even before we got to Memphis the word seemed to be out about my arrival. And when our train pulled into the Memphis station, a cabdriver who knew some of the guys told me, "Your

father's gonna be down to the theater to see you." I was really excited about it and I told all the guys too.

One night in the middle of the week, we were up onstage doing a show. Just as I finished a solo, Benny Payne leaned over to me and whispered, "Hey, did you see your dad yet?" When I shook my head, he nodded over toward the wings. I looked and there he was. It was like seeing myself in a mirror. I knew it was him immediately.

As soon as the show ended, I ran over and hugged and kissed him. Cozy, Chu, and some of the other guys stood around watching. They seemed to share my happiness.

I saw him just about every night for the rest of the week. We'd go out to a bar between shows or we'd have dinner after I finished for the night. I also got to see my Aunt Lucy Woods. She was a big fat lady who was a beautician and married to a chef. She had a real hoarse voice, the same as my father and just like me.

My father told me that after he split up with my mother, he remarried and had a bunch of kids. Apparently, back in his younger days he was a real lady's man, and that's what broke up his second marriage. In fact, my Aunt Lucy once told me, his second wife was so angry at him that when she found out his sister had moved into her neighborhood, she took all the children and moved away.

There've been many times when I've thought about the half sisters and brothers I must have somewhere in the world. And when I hear about someone named Hinton, I always try to find out about their family background.

My father never gave me a clear picture of what he'd been doing for most of his life. He knew about soil and sampling cotton. When he was younger, being a sampler was a very important job, particularly for a black man. Cotton bales were shipped through Memphis on the way to the North and he took samples and graded them, which determined the price.

He also said he'd gone back over to Africa for a while to work on a rubber plantation. Then he got involved in some kind of crime and had to leave sud-

denly. When he got back to the States, he spent some time in jail and had to work in the mines. That's where a rock fell on him and he lost a finger on his left hand.

When I spent time with my father during that week, other guys from the band were usually around and we never talked about anything serious. There was one instance, though, when he said a couple of things which really meant something to me.

It happened one night when we were sitting alone in a bar and both of us were pretty loaded. But to this day I remember what he said. We were in a booth and he looked at me across the table and told me, "You're doing great. You look wonderful and you have a good job. I never got along with your mother, but from what I see, she's done a fine job raising you."

I guess this was his way of saying he was proud of how I'd grown up. I think he also knew that, except for having his blood, he couldn't really take any credit for me. But that didn't matter to either one of us. I was so excited that I pulled him over to the nearest phone booth and called my mother in Chicago. When she answered, I handed the receiver to him but kept my head close so I could hear both sides of the conversation.

After they both said hello, my mother asked, "Who's this?"

"Milton," he said.

"Baby, you got a cold? You're hoarse," she told him.

"No, no, I don't have no cold. It's me. Milton," he said.

"Oh, for goodness' sake, it's you." Thirty years had gone by, but she was able to recognize his voice.

Then she asked him, "Where's my child?"

"He's right here standing next to me," he told her.

They exchanged pleasantries for another minute and then he handed me the phone.

They never communicated again after that, but I've always been thankful I had one opportunity to hear them talk to each other.

I saw my father again the next time we played Memphis. In fact, I got together with him, my Aunt Lucy, and some of Mona's family who were also living

About the only thing she left were some personal effects—family pictures, letters and papers, and souvenirs. There was a citation which had been given to my father for working on the atomic bomb project at Oak Ridge and there were some pictures of him and my aunt. I was very pleased to get those things. It's not a lot, but it gives me and my own family some sense of a part of our history.

All the bands changed during the war years. Many of the best sidemen got drafted and morale seemed to drop. Cab lost a lot of people, and the only replacements he could find were guys who couldn't be drafted. Many were inexperienced and undisciplined, musically and otherwise. They weren't used to playing good arrangements, and some just didn't know their own limitations. They'd replaced much more established guys and because of it, some figured they were ready for the big time. I still recall hearing Tommy Dorsey talking to Cab about these problems. He said jokingly, "After the war I don't think I'll hire anybody who's not older than forty-five."

My own story with the draft was pretty unusual. As soon as I got my draft notice, I went to Cab. I was a nervous wreck. I've always been nonviolent and the thought of shooting a gun turns my stomach. Besides, with me on the front lines, I know we would've lost for sure.

Back in those days, the Army did all the drafting, but when it came to musicians, the other branches of the service did plenty of active recruiting. They were all interested in having great bands, and it wasn't long before some real competition developed. If a good musician got drafted by the Army, he could go to the Navy or the Coast Guard and try to get a better deal. Sometimes it was even possible to negotiate with one branch to get into the specific band you wanted. Say, for example, a musician wanted to be stationed near his home and there happened to be an army post close by. He might let that post's band director know he'd been called up and what day he was going through

Milt and Lucy Hinton Woods ("Aunt Lucy"), Memphis, c. 1941

there. I made a couple of trips to Memphis after that and I even brought my daughter Charlotte with me and made arrangements through Aunt Lucy to meet him, but he never showed. I hadn't grown up with any kind of expectations about him, so I guess I couldn't feel hurt about anything he did.

Aunt Lucy wrote to us after my father died. She said he'd been doing gardening work for a family in Memphis and was sixty-six years old. A few years later Aunt Lucy died. She was a widow, so Mona and I went down to Memphis to bury her.

induction. The director would tell his commanding officer about it, and they'd send somebody down to the induction center to request this guy.

A couple of my friends suggested I go with the Coast Guard because I could get stationed in New York and keep working on the outside. But other people said I could get the best deal with the Marines, because their bands stayed in one place and were only used to play guys on and off ships.

I reported for my physical and came through a big induction center near Grand Central Station. They were giving written tests and physicals, and I waited for hours. Somehow the word must've gotten out about my induction, because I had two guys from the Marines, one from the Coast Guard, and a Navy man from Great Lakes following me around all day waiting for me to finish. Each one had a written request for my assignment to their unit.

I probably would've had some choice and been able to work out a good deal, but I never had to. I was rejected for physical reasons. I didn't pay much attention to the details. Maybe it was my answers to the questions about violence and fighting. I don't know. I certainly would have served my country if they'd taken me. In fact, I probably ended up playing more armed forces dances and shows with Cab than many of the guys who were taken in.

Aside from bad music and the low morale in bands during the war years, I only had one negative experience because I wasn't in the service. It happened in New York one night while I was with Cab working at the Strand Theatre. Benny Goodman had asked me to do a week with him in a small Greenwich Village club. Cab's last show ended at ten-thirty and Benny's gig started at eleven. The timing was tight, but I took it.

A couple of days before the gig started, I got more anxious about being able to make it from one place to the other on time. I figured I'd have half an hour to change clothes, take my bass, and go forty blocks downtown to the Village. But I knew all the shows broke about the same time and there was always a lot of traffic in the theater district which could slow me up.

After thinking it over, I worked out a plan to take care of the problem. I made arrangements with one of our valets to take my bass down to the club as soon as our last show ended. Without my bass, I could change into street clothes after the show and take the subway downtown, instead of worrying about finding a cab and fighting theater traffic.

On the first night of the gig, my plan started off working well. But as soon as I came out of the subway in the Village and began walking over to the club, things changed.

Two policemen were sitting in a parked car about twenty feet from the subway exit and just as I walked past, one of them leaned out the window and yelled over to me, "Hey, where're you goin'?" I'd been looking at my watch for the past half hour and knew I had less than five minutes to get to the club. Besides, I resented being stopped for no reason. So I did a real dumb thing—I talked back.

All it took was a couple of words from me: "Whatta ya mean, where am I going? This is New York—you don't stop people and ask where they're going."

Before I knew it, the two of them were out of the car breathing down my neck. "Okay, wise guy, where's your draft card?"

I reached into my pants pocket to get my wallet, but it wasn't there. I'd left it in my uniform back at the theater. And I immediately realized I had a problem.

I tried turning on the charm. "You see, officers, I'm a musician and I work for Mr. Cab Calloway. Right now, I'm on my way to play an engagement with Mr. Benny Goodman around the corner."

It was too late. They put me in the car and took me down to the local station house. I talked all during the ride: "Look, all you have to do is stop by and see Mr. Goodman. Ask him if I'm supposed to work with him tonight." They didn't even bother answering.

They put me in a holding cell with a drunk who kept throwing up. The stink was unbelievable. About twenty minutes later, I called over the sergeant who'd

Milt, Cedar Rapids, Iowa, 1941

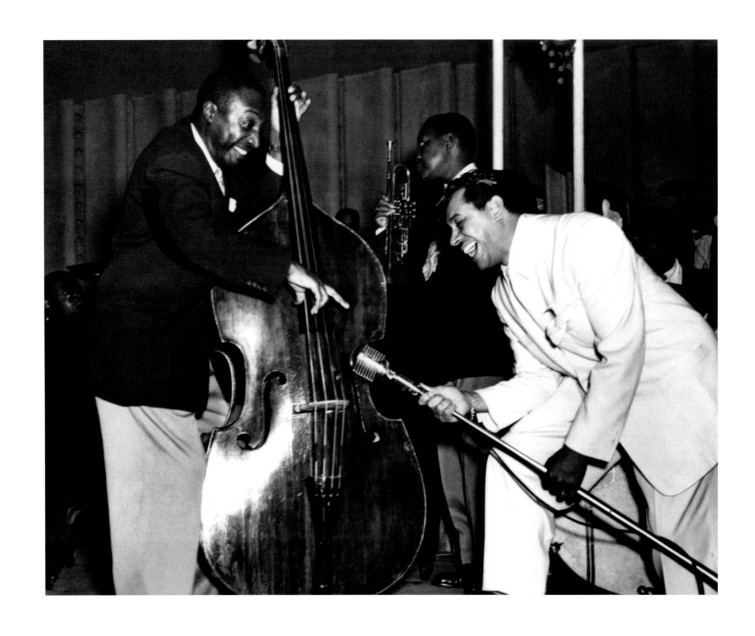

[Above] Milt, Jonah Jones, and Cab Calloway, Havana, 1951

[Opposite page] Scoville Browne, Jimmy Blanton, and Al Lucas outside the Braddock Hotel, New York City, c. 1940

put me in. I gave him a five-dollar bill and asked him to call Cab at the theater. He took the money and the phone number, but I never saw him again.

I was up all night. At six in the morning, another sergeant passed my cell and when I noticed his Masonic ring, I threw up a distress signal. He caught it immediately and came over. I told him what had happened—about the guys who brought me in and the money I gave to the other sergeant. He called Cab and about an hour later someone came down with my draft card and I got released.

It was early morning, but a guy was cleaning at the club and I was able to get my bass. Then I took a cab to the theater. Every part of me smelled, so as soon as I arrived I showered and put on my uniform. By then it was time to do the first show.

From that point on, I decided to take the bass myself. I figured that carrying my instrument was like walking with a big billboard announcing to everybody, "Look, I'm okay out here at this late hour. I'm only a musician."

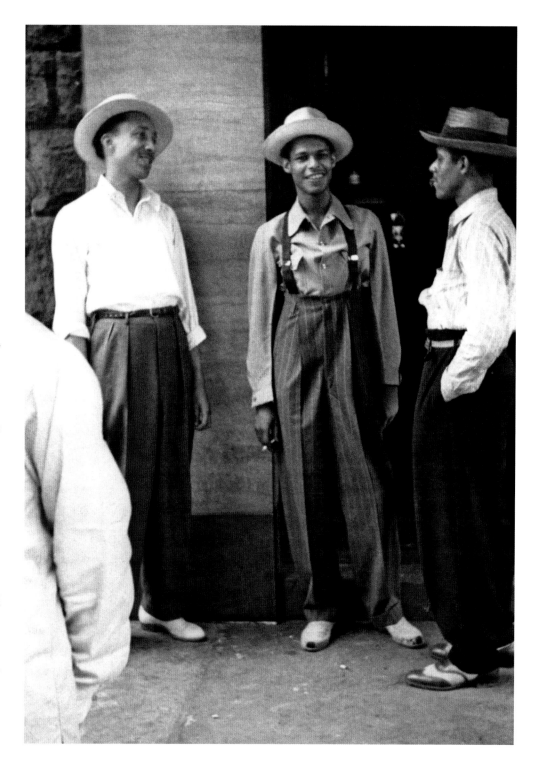

My reputation as a musician grew during my years with Cab. In the late '30s there weren't too many well-known bass players. Of course, there was Pops Foster. He'd played with Luis Russell's band and had always been well connected to the New Orleans scene. Even back in those days he was known as the senior senator of the bass. Then there was John Kirby, but he was much more a leader than a player.

Almost nobody playing jazz used a bow. But I knew violin, so I could do things they couldn't. It was the same for Jimmy Blanton. He was classically trained on violin exactly the same way.

I can still remember the first time I met him. I'd had some kind of conflict with Oby and I was stranded up in Harlem without a dime, trying to figure out how to get downtown and meet the band at Penn Station. Ben Webster was with Duke at the time, and I knew he was staying at the Braddock Hotel, so I went over to borrow some money from him.

When I couldn't find him, I decided to wait in the bar. After about an hour Ben came in with Blanton. I waved at him. He walked over to me and I explained the problem. He reached into his pocket and pulled out a couple of fives. He knew that wouldn't be enough, so he turned to Blanton who was standing at the bar about ten feet away and said, "Bear, come over here."

Blanton walked toward us. "Yeah, Frog, whatta ya want?"

"This is Fump. You got money?" Blanton nodded that he did.

"Well, you give Fump a cow and a calf and I'll cover it."

Blanton reached into his watch pocket and pulled out a roll of fifty-dollar bills, peeled off three, and handed them to me.

I must've seen Blanton a dozen times after that. In fact, I was with Cab in California when he got sick. It was late '41 or early '42. Duke had been playing L.A., but when it was time for the band to leave, Blanton was too sick to go. He'd contracted tuberculosis and was put in a sanitarium. I made a point of visiting whenever I could and we'd talk until he got too tired to go on. It was a sad situation. He was just a kid, twenty-three or twenty-four, and completely alone out there.

I met Oscar Pettiford in Minneapolis, which was his hometown. He came from a big family and most of them played music. The first time I saw him—I think it was 1939—was on one of our first trips to Minneapolis. In fact, it was the same time some of the guys joined the Masons in St. Paul. One night after work, a couple of us went to a little local club and he was playing. I couldn't believe my ears. He didn't appear to be schooled. Everything seemed to come to him naturally. His fingering was correct and when he soloed, it was like no one else I'd ever heard. He did everything right. I was so amazed that when the set ended I introduced myself and asked him to come down to the theater so he could meet some of the guys.

Pettiford showed up the next day and played with Benny Payne, Cozy, and a few others in a rehearsal room backstage. Even Cab came in to listen and after a few minutes said something about firing me and hiring him. He might have been serious, but we were packed and off to our next engagement before I could find out. Even back in those days, I knew it wouldn't be long before Pettiford was discovered. And I was right. Within a few months I began hearing his name mentioned everywhere.

After our first meeting we kept in touch. On the surface he appeared to be a very happy guy, but he always had a terrible drinking problem and it got out of hand regularly.

And there was another unbelievable bass player from Minneapolis, Adolphus Alsbrook, who I'd met in Chicago before I went with Cab. I first got to know him in the early '30s when I was working at the Savoy Ballroom with Erskine Tate. He was about seventeen and visiting Chicago to box in the Golden Gloves, which was being held at the Savoy.

I'll never forget the first night I saw him, I was on the bandstand and he spent the entire evening standing right in front of me, watching. He was a huge black man, well over six feet, so even with the elevation of the bandstand, his head came to my knees. All of this made me feel pretty uncomfortable.

When we finished for the night, he introduced himself. He told me he really admired my playing and asked if he could study with me. I was feeling pretty cocky, so I told him, "Sure, come over to my house tomorrow afternoon. I'll teach you."

He showed up the next day with his bass and a copy of Simandl's exercise book. I bowed a few passages and then asked him to play. He turned to one of the most difficult exercises in the back and went through it with ease. He was able to play in the thumb position like it was nothing. He was perfect. He read the music without any effort, the way someone reads a comic book.

He'd put me to shame. I felt I'd been set up. I was insulted, and I told him to leave my house immedi-

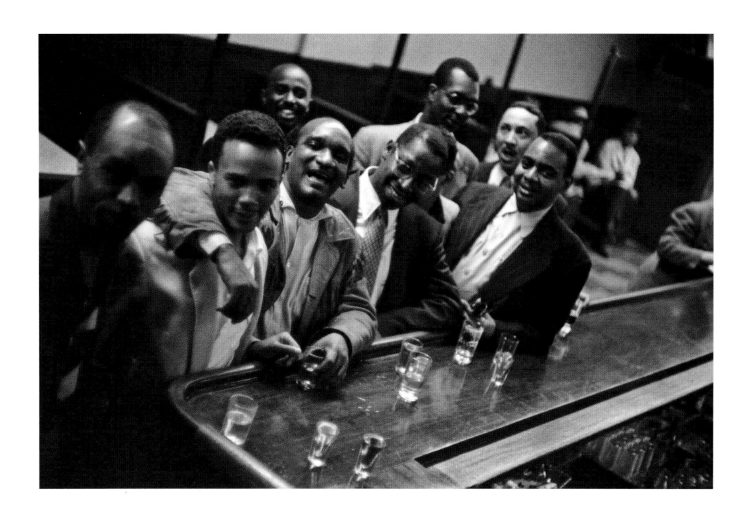

ately. But he was very apologetic. He said he knew music theoretically but wanted to learn how I played the things I did at the Savoy the night before. He was sincere, and I believed him. So for the next few days we hung out together—talking music and playing bass—until he had to go back to Minneapolis.

I kept in touch with Alsbrook and followed his career over the years. A lot of bass players I ran into across the country also knew about him. Everyone agreed his knowledge of bass and music in general was astounding. In a way, he became a legend. Guys told so many stories about him it became difficult to separate fact from fiction.

I heard he got a black belt in one of the martial arts, and for a while was a policeman in Minneapolis. At one point someone told me he was still playing bass but had also taken up the harp. I know there was a time when Duke wanted to hire him, but Alsbrook refused because he didn't want to travel. Then for a while he was in California arranging for television, and later I heard he moved to Seattle. About fifteen years ago, he called me on my birthday. At that point he was living in Vancouver.

I think I first met Slam Stewart in California. I was working with Cab and sometimes after we'd finish our last show, a couple of us would head for a popular

At bar: Kelly Martin, Quincy Jones, Oscar Pettiford, Hilton Jefferson, and Paul Webster; *Second row:* unknown, Bill Pemberton, and Scoville Browne, Beefsteak Charlie's, New York City, 1952

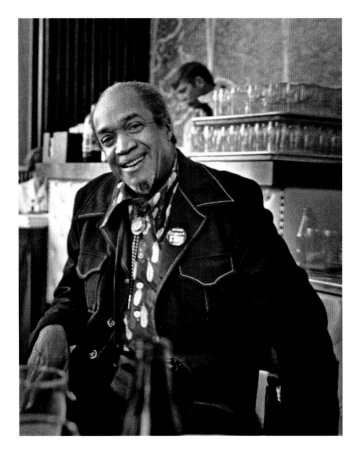

bass in the world—a step away from a cigar box—and make it sound beautiful. Slam didn't hold the bass like Major, and he used the tips of his fingers when he played. It was completely unorthodox, but he always played in tune. He was also able to use only two or three inches of bow and produce a symphony.

I knew Charlie Mingus from the time he was a kid in California. I'll never forget our first meeting. It was the early '40s and we were playing the Million Dollar Ballroom in L.A. One afternoon, after we'd finished a matinee, I was standing with a couple of guys backstage and I saw someone coming toward us carrying his bass. When he was a few feet away, he looked at me and said, "I've heard all about you. Let's play."

"Okay," I told him. "Let me get my bass."

A short time later, we were alone in a small room backstage, all set to go. Charlie had brought his Simandl and some other music and he told me he wanted to play first. He went through some intermediate exercises, then turned to me and said, "Now let me hear you."

By this time, I knew Simandl. I turned to the back and played one of the difficult passages. I was flawless, the same way Alsbrook had been when he played at my house in Chicago.

I can still see the look of amazement on Charlie's face. "Look," I told him, "musicians don't challenge each other. They learn from each other."

After that, things between us were fine. Even though we didn't see each other a great deal, I always felt we were good friends. He was eccentric as a musician and as a person. He was also brilliant. People called him explosive, but I never saw that part of him. Maybe he gave me a certain amount of respect because I was older.

I must've played four or five concerts with Charlie, including one at Town Hall in New York. I also made a couple of records with him. But what I remember most is Charlie at rehearsals. He knew he couldn't notate everything in music. No one can. So he'd say to a guy, "Here's how I put it down, but I want you to listen to the way I play it." He'd sit at the piano and

after-hours spot to hear Art Tatum. Slam would often show up too, and if there was a bass around we'd take turns playing with Art.

Slam and Major Holley both perfected a way of bowing and singing which always amazed me. People who heard them could tell the difference in their sound immediately. Slam had a sweet voice and he hummed what he bowed. But Major's voice was much deeper and rougher, which allowed him to hum an octave below what he was playing.

When you watched them, you could see the difference between their techniques. Major held the bass when he played, which made it hard for him to move up and down on the strings and he'd usually play a lot of notes in one register. He could also take the worst

play through the part. Then he'd have the guy play it until it was perfect.

I don't know why Charlie abused himself throughout his life. When he was in his early thirties, I'd see him get a whole head of cabbage from the steam table in Beefsteak Charlie's and then go back for more. Even in those days, I'd talk to him about his weight. He'd always tell me the same thing: "I know I'm wrong, but I can't help it."

To the day he died, it was the same story. Toward the end, I'd call him a couple of times a week. Every time we talked he'd say, "I didn't take care of myself. I just destroyed my body."

I n all my years with Cab, there were only two occasions when I seriously considered leaving. It wasn't because I went out looking for another job. It happened because people approached me.

Once it involved John Hammond. As far as I'm concerned, he's done more for American music than anyone else. I say American music rather than jazz, because John's influence extended beyond the jazz world. Everyone knew he came from a wealthy family, and I guess he could've been a playboy or spent his life giving away his money to charities like a lot of rich people do. But he was different. He spent his entire career going out and finding talented people who he felt needed exposure. Then he'd make sure they'd get presented to the public.

John was out front on the race issue at least twenty years before it became a fashionable thing. He was looking for talent, period. Skin color had nothing to do with it. Naturally, with his connections, he could get away with things most other people couldn't.

It's well known that John was responsible for introducing the public to people like Bessie Smith, Billie Holiday, Basie, and years later, Aretha Franklin, George Benson, Bruce Springsteen, and Bob Dylan. But there aren't too many people who know what he was doing behind the scenes in the early days. That's how he was involved with me.

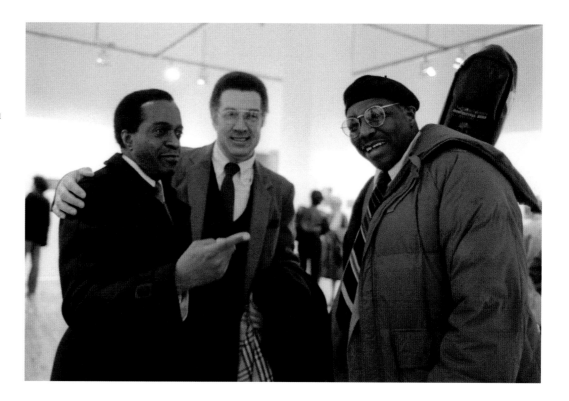

Jackie Williams, Kenny Burrell, and Major Holley, New York City, 1985

Back as early as 1942, he got interested in integrating the staff guys who did the radio shows at CBS. I think his original plan was to hire Johnny Hodges, Charlie Shavers, Cozy, me, and one or two others.

We were playing the Strand Theatre in New York when John came around one day. He wanted to discuss the situation with Cab and ask him about hiring Cozy and me. I know at first Cab agreed, because after John left, he called us to his dressing room. Cab described the radio work and asked if we were interested in doing it.

At that point, the idea of living in New York year-round and having new musical challenges was very exciting to both of us, and by the end of the conversation we'd worked out a plan to make the transition run smoothly for Cab. We agreed to do the next two weeks with him in Chicago and then leave for New York to join CBS. That way, he'd have time to look for replacements.

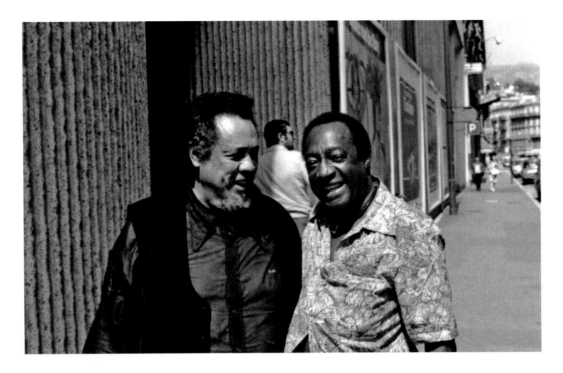

Charles Mingus and Milt,
Philadelphia, c. 1972

Cozy and I were flying high. We told everyone in Chicago we'd be working on network radio and how we'd be part of a very select group of musicians. Toward the end of the two weeks, we hung around waiting for the call from New York. But it never came.

When we finished in Chicago, we began a road trip west. The first three or four days, the two of us were so down it took all we had to make it through each show.

I never knew exactly what happened. The rumor was that some people in the Mills office were the ones responsible for the deal going bad. That office booked Cab and Duke and evidently they decided that it would be bad for business if some of the best guys left the bands.

A few weeks passed and then a compromise was worked out. In the end, Cab gave up only one guy, Cozy. I don't know who made that choice, but I think it went to Cozy instead of me because he had a bigger name at the time. Ben Webster and Charlie Shavers were also hired, but Johnny Hodges stayed with Duke.

The second time I thought about leaving Cab was in the mid '40s and involved a radio show in New York called *Casey—Crime Photographer*. Herman Chittison, a piano player, led a quartet with bass, drums, and guitar which played the background music for this program.

Everett Barksdale was the guitar player on the show. He and I knew each other from the old days in Chicago. In fact, I was the one who'd gotten him a job with Eddie South. So when there'd been some kind of problem with Chittison's bass player, Barksdale recommended me.

We were playing at a theater in Milwaukee, and I got a telegram offering three hundred a week to do the show. That was big money in those days, more than twice what I was making with Cab. I showed it around backstage to all the guys and they told me I had to take it. But by this time Cab and the band were like family and that's really the reason I hesitated.

Actually, it was my mother who made the decision for me. I took the commuter train into Chicago and met her in a restaurant on the Southside. I showed her the offer and told her the money was too good to turn down. But she wouldn't hear of it. She sat there shaking her head, telling me, "Money doesn't matter. Cab is family. You don't run out on family."

That afternoon I called Chittison in New York and turned down his offer.

I was thrilled beyond words when Mona told me she was pregnant. It was the summer of 1946. We were on the road someplace and I ran to tell Cab. He told me, "Man, your old lady's pregnant? So's mine. You have this one on me."

Mona decided to get her prenatal care at a hospital in the Bronx. She was still traveling with me, so whenever we were anywhere close to New York, she'd go in for a checkup.

Sometime during her third or fourth month she ran into some serious problems. I remember, it was our last day playing Baltimore before we headed west. She figured before we got further away from New York,

she'd take a morning train up, get her checkup, then come and meet me for dinner.

By the time she returned, she was really sick. It was far too much riding to do in one day and everyone around thought she was going to have a miscarriage.

I was scared and really didn't know where to turn. I wanted to take care of Mona, but I knew I'd have to go with the band the next day and leave her behind. My family was in Chicago and all her people were in Ohio, so it would take a couple of days before someone could get to Baltimore.

I went to see Cab and he came to my rescue. Baltimore was his hometown. His sister Bernice was living there and had some good connections. Within a few hours, we were put in contact with a doctor who got Mona admitted to a hospital immediately. The next day I was able to leave town knowing she was being well cared for.

Mona recovered within a day or two and the doctor gave her permission to make one more trip, to the place where the baby would be born. We talked by phone about where she should go. Even though we were spending more time in New York than anyplace else, we didn't have family there. We thought about Sandusky but decided against it because it would be too inconvenient to get to if I had a couple of days off. We finally chose Chicago. My family had plenty of room, the location was better, and it had great medical facilities.

A couple of days after we made our decision, Mona took the train out and moved into my mother's place. Of course I had to stay on the road, but I'd call at least once a day to see how things were going. Then, a few weeks before the baby was due, Mona's mother went out to Chicago to be with her. In the end, everything turned out fine. Our first and only child, Charlotte, was born on February 28, 1947.

A month later, while we were working in Chicago, Mona told me she wanted to pick up where we'd left off and go back on the road with me. We wanted to be together very badly because we'd really missed each other when she was in Chicago. The band was just

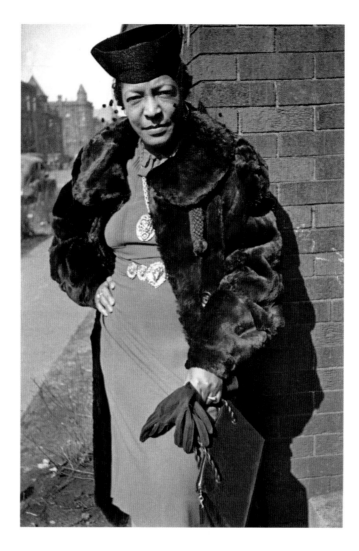

Titter, Chicago, c. 1945

about to start a road trip out to California, so Mona and I figured the three of us would give it a try.

It was quite a scene. Even though we had our own compartment, the train wasn't set up for traveling with a baby. I can still remember walking through ten or twelve cars in the middle of the night to get to the dining car so I could mix some formula and heat up a bottle. Most of the guys in the band would try to do what they could to help, but Paul Webster and Hilton Jefferson, who we called "Jeff," seemed to be around more than anyone else.

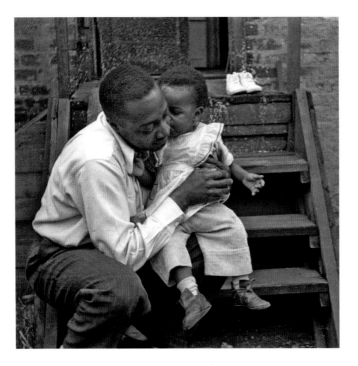

Milt with his daughter
Charlotte, Queens,
New York City, 1951

Mona wasn't fully recovered yet, so I spent many nights staying up with Charlotte. Also, whenever possible, I'd get off at a station stop and buy a couple of things I thought would make the trip more comfortable for her—a bag of ice, crackers, fruit – things like that.

I remember one time when we stopped in Cheyenne, Mona was feeling pretty sick and I got off to get her a bottle of Kaopectate. The places right around the station didn't have it and by the time I found a drugstore, I was two blocks from the station. I guess the guys had convinced the conductor to hold the train for me for a while, but by the time I made it back, it was pulling out of the station.

It must've looked like one of those scenes you see in the movies. For a few hundred yards I was running as fast as I could toward the last car, and a couple of the guys were standing out on the rear platform waving me on. Finally, I was able to grab someone's arm and two of them pulled me aboard.

It took about a week before we got to California. Since we were going to be working in L.A. for a while,

Mona and I got a room in a small boarding house. The lady who owned the place was very nice about the baby and Jeff got a room there so he could help us out.

I had expected that once we got settled, things would get better. Unfortunately, it didn't turn out that way. In fact, after a few days our problems got worse. Mona's health didn't improve at all. She slept a lot and whenever she was up, she had her hands full with Charlotte. Jeff and I would get back to the place after the last show, just in time for the two o'clock feeding. He'd warm the bottles while I changed the diapers.

It didn't take long before the problems began to affect me. Something happened that's never happened before or since—my body started twitching and I couldn't control it. It scared me so much that I found a doctor as quick as I could. He gave me a complete physical. He told me my nerves were shot. I was doing too much. There was no way I could work and take care of my wife and baby at the same time. He gave me pills to control the twitching, but he said it would most likely continue until we made some changes in the way we were living.

Mona got medical attention too. She found out that the sickness she'd been feeling ever since the birth had been caused by the doctors in Chicago, who didn't do a thorough job after the delivery. She had a D and C, and by the time we were ready to leave California, she was finally back to normal again.

Cab really helped during this difficult period. He didn't have to be reminded about what he'd said when Mona first got pregnant. One day, when things were really at their lowest, he took me aside and told me, "I said for you to have that baby on me. Now, you and Mona add up all your bills, put them down on a slip of paper, and give it to me."

We did it. I remember it all came to four hundred dollars. And just as soon as I gave him the total, he handed me the money, in cash. We really needed it at that point. I've never forgotten what he did, and I don't think he did either. Every time he saw Charlotte he'd say, "That's my child."

The three of us made the trip back east together. As usual, it took weeks because of all the one-nighters we did along the way. It wasn't easy, but things were much better than they'd been on the way out. Mona had regained her strength and Charlotte was a little older and calmer.

When we were about a week away from New York, we realized we'd never discussed where we'd be living in the city. We'd rented rooms and hotel suites before, but with a baby, there'd be cribs, playpens, all kinds of furniture. We needed a permanent place with a couple of rooms and a kitchen.

It didn't take us long to find out there was a housing shortage. A regular lease was impossible to get. So at first we tried to find a sublet. We heard about a lady who had a real crummy place on 144th near where we used to stay. She was willing to sublet, but only if we gave her two thousand dollars up front and double rent. We had about two thousand in savings and weren't about to give it all to her.

Then one afternoon a couple of days later, our luck changed. I was with Foots Thomas in one of the downtown bars where musicians hung out, and he ran into a Latin piano player he knew named Nicholas Rodriquez. The three of us had a few beers and ate the free lunch. Since my housing problem was the only thing on my mind, I told Rodriquez all about it. I still remember what he said. It was too good to be true and at first I didn't believe him:

> I can solve your problem. I have a small place, just a room with a little kitchen and bathroom, up on 126th and 8th. The day after tomorrow I'm going on the road with a U.S.O. tour, so I won't be using it for six months. Nobody's there. It's not much, but if you want it while I'm gone, it's yours.

I offered him money, but he refused. I insisted, and we finally agreed on twenty-five a month. And a couple of days later, we moved in.

Even in those days, 126th and 8th Avenue was a pretty bad neighborhood. I think there were more pimps and prostitutes around there than anywhere else

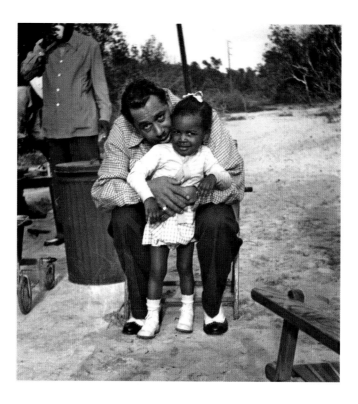

Cab Calloway and Charlotte, Florida, 1951

in the world. The apartment was on the second floor, over the Pasadena Bar, and like Rodriquez had told me, it was just one small room. He had left his furniture and clothes, so when we unloaded our suitcases and all the things for the baby, it was hard to find an empty spot to stand. Living there was unforgettable.

Rodriquez didn't have a phone so we ordered one, but before it was connected, an incredible scene happened one day after we'd been there about a week. It was around midnight and someone started banging on the door and woke us up. Charlotte started crying of course, and Mona lifted her out of the crib. I was pretty nervous, but I went to check out the noise anyway. It turned out to be a lady who lived upstairs on the fourth floor. Evidently, a couple of Mona's sisters in Sandusky were so worried about her, they'd convinced the telephone company to give them a number for anyone who lived at our address.

Right from the moment I first saw the apartment and the neighborhood, I started feeling anxious about

the day I'd have to leave my family in that place and go back on the road. But I knew I couldn't take them, so there was no other choice. When it finally came time, I had to go.

But living there for Mona and Charlotte turned out to be much better than I ever imagined. Once I was gone, the pimps and prostitutes in the building couldn't have been nicer to them. Every time one of the whores went out, she'd check with Mona to see if she needed anything for Charlotte. The pimps would carry the baby buggy up and down the stairs. Then while they were standing out on 8th Avenue checking that their ladies were working, they'd keep an eye on Mona and Charlotte, who were trying to get some sun in front of the building.

The two of them stayed in the apartment until Rodriquez got back from his road trip six months later. At that point, apartments were still tight, so they went out to Chicago and visited my family for a while. Then they took a train to Sandusky and stayed with Mona's folks.

I'd call Mona once or twice a day, and whenever we played within a couple of hundred miles of where they were staying, I'd figure out a way to see them. Without our own place, it was a pretty bad situation. We knew it and we talked about it constantly.

Our goal was to be back in New York, because that was the place the band spent most of its time. It's where the guys who had permanent places lived, and we figured it was the place I'd most likely get other work if I ever had to leave Cab. So no matter where we were, we always kept our eyes open for possibilities in New York.

I still remember the day I called Mona in Sandusky and how excited she was about an apartment she thought we could get in New York. She told me she'd spoken to J.C. Johnson, a guy we knew who was writing for the Inkspots. He owned a place in Queens, on Long Island, not far from Manhattan. Somebody on his block had a vacant four-room apartment in their two-family house and he thought he could get it for us.

I didn't know a thing about Long Island or Queens. They were just names I'd heard a couple of times. So I let Mona make the decision. I told her if she thought it would be all right, she should get it. The next night when I called again I found out that she'd gone ahead and made the deal.

I was on the road, traveling in the West, so Mona had to get things into the new place by herself. But there really wasn't too much to move. Aside from our clothes, Charlotte's things were about the only furniture we owned. In fact, before Mona moved in she had to go out and buy a bed. Of course, being as practical as she's always been, she bought a single size, figuring she'd put it in the living room and use it as a couch during the day.

But right from the start, there were problems. The guy who owned the place lived upstairs with his wife, but that didn't stop him from going after Mona. Just about every time he had the opportunity, he'd knock on the door and try to get himself invited in. I guess he figured there was no man around, so she'd be lonely.

Of course, Mona never told me anything about this until she saw me. She knew me well enough to know that if I found out, I'd come home immediately. She's never panicked about things, but this guy was making her pretty upset. It even got so that she was afraid she'd run into him if she went down the block to the grocery store. At one point, she talked to J.C. and he told her to hang on while he tried to find another place.

By the time our road trip ended, Mona had been in the Queens apartment for about six weeks. I'll never forget my first trip out to there. Our train pulled into Penn Station about midnight and I read over the instructions Mona had sent. I knew I had to take the Long Island Railroad to the Jamaica stop, and then take a bus or cab or do some walking from there to the house.

There weren't many commuter trains at that hour, and to make things worse, it was snowing hard. I finally got a train, but it ran so slow that by the time

it got to my stop, it was nearly four AM. The buses had stopped running and there wasn't a cab in sight. My only choice was to walk, and with the snow coming down so fast, it was difficult. I ended up in the street, walking in car tracks, and even then I felt like I was up to my ass in snow. As I walked I kept asking myself the same kind of questions: "Where did my wife move to? Why did I let her do this?"

It probably took thirty or forty minutes before I got to the right street, but it seemed like a couple of hours. As I walked down the block, I tried to see the address on each house. Some didn't have a sign and a lot of signs were completely buried in snow. I must've passed our place three times before I realized I'd found it.

Mona greeted me at the door and we both went in to see Charlotte, who was sleeping. It didn't take long for me to forget about my trip and celebrate the homecoming.

The band was booked in New York for the next four or five weeks and I commuted back and forth to Queens every day. It was easy. It took about forty-five minutes each way and it gave me a chance to read the newspaper. After I was home a couple of days, Mona told me about the guy upstairs, about needing to move again, and how J.C. had told her, "I got you into this, so I'll get you out."

Two or three weeks went by and then one day J.C. told us about a place in the neighborhood which was about to go up for sale. It was a two-family, semi-attached brick house on Ruscoe Street and it even had a two-car garage. According to J.C., a vet had bought it for only $9,500 a couple of years earlier and had gotten financing from the VA. He'd finished off the basement and was renting it, which was illegal. An inspector caught him and told him to evict the tenants, but when his wife tried, they assaulted her. She was the one who wanted to get out as soon as possible. We were told we could have it if we quickly came up with $5,000 cash and a $4,500 mortgage.

We wanted the house badly, and for the next week we did everything possible to get the money together.

We had about $2,000 in savings and we borrowed the rest from Mona's mother, her oldest sister, Henerine, and my mother. Getting a $4,500 mortgage from a bank was much more difficult. We were buying a house in a black neighborhood and back in those days, banks didn't consider that a good risk.

Most of the banks used the same reason to turn us down—the type of work I did. Even though I'd drawn a steady paycheck for ten or twelve years, they claimed I was in the kind of business where there was no guarantee I'd be working next week.

Just when we thought we'd exhausted all our possibilities, a loan association approved our application. They gave us the full $4,500 at 6 percent, which was high in those days, and we had to pay them five hundred in cash up front. It wasn't the best loan in the world, but the numbers worked out fine for us. Our mortgage payment was seventy dollars a month, but we rented out the five-room apartment upstairs for fifty-two dollars. Of course, there were real estate taxes and oil bills in the winter, but they turned out to be reasonable, even for those days.

For a while, we had to deal with the couple who were renting the basement and refusing to move out. But a few months after we took over, the woman tried to commit suicide by leaving the stove on and we were finally able to evict them. When they left, it cleared up the housing violation.

When I look back at it now, I realize what buying that Ruscoe Street house really meant to us. For the first time, we had something that was ours. It was our security and it also gave us a feeling of freedom. The monthly expenses were small enough so we'd be able to pay them unless there was a national disaster. Besides, every time we made a mortgage payment we knew we were building up our equity.

It wasn't long before we got to know some of the people in the neighborhood. One person who really became important in our lives was Elizabeth Smith, who everyone called Tootsie. She lived nearby with her mother, Emma, who was having a hard time raising her only child alone. Tootsie was thirteen when we

Charlotte in front of the Hintons' Ruscoe Street house, Queens, New York City, 1950

first started using her to babysit for Charlotte. But everyone in our family fell in love with her, and within a couple of months, she'd become one of us. She was like an older sister to Charlotte, and Mona helped her in every way she knew.

Tootsie married a boy named Tommy Price when she was young. Shortly after their son, Tommy Jr., was born, the marriage ended, and our family got very involved in helping Tootsie with her child. We made sure she had an opportunity to go to college, and later on we saw to it that Tommy Jr. was headed in the same direction. Neither one of them made it. More than twenty-five years ago they were both violently murdered by a maniac who little Tommy knew from the neighborhood. I still feel the pain. They were both our adopted children, and it was the most tragic thing I've ever experienced.

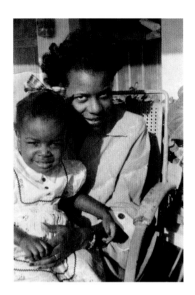

Charlotte and Mona, Queens, New York City, c. 1951

Cab's band broke up in 1950 in Jamaica, Queens, close to where we bought our first house. If I'd given it any real thought, I would've seen it coming. Even by the late '40s, the band business was bad. We were playing fewer and fewer theaters. In fact, when we worked a theater it was more likely to be a second-rate place. Even in New York City, we'd play out in Brooklyn or Queens instead of Manhattan.

I remember that night in Jamaica when we all got our two-weeks' notice. I was totally devastated. I'd been with the band longer than anyone else. In fact, after Foots left in the middle '40s, I'd become straw boss, handling the music when Cab wasn't on-stage. But that didn't matter. Everybody got the same slip. To this day, that was the only time in my life anybody's fired me. I'm still sensitive about it. After all we'd been through together, I figured the least Cab could've done was tell us face-to-face. But the way it happened was cold and calculating—all business—and I'd like to think his managers were responsible for that. I'll probably never know for sure.

I didn't hear from Cab until a week later. He phoned to say that from then on, he'd be working

regularly with a seven-piece band which included me. I told him I was burned up. I asked how he could've fired me a week earlier if he knew he had steady work. He didn't really answer. He talked about being forced to give everybody notice, and he kept repeating, "That slip wasn't for you." I swallowed my pride and I took the job, mainly because I had a family to support, and no other possibilities.

Our scaled-down band had a front line of Jonah on trumpet, Keg on trombone, and Jeff and Sam Taylor playing reeds. The rhythm section was me, Dave Rivera on piano and Panama Francis on drums. We pared down the old arrangements ourselves, and with the four horns playing harmony, we could still get the feeling of the big-band sound. But the chorus girls, the background singers, the dancers, the managers, and all the people who hung around Cab were gone.

We worked clubs most of the time—San Francisco, L.A., different parts of the country. I remember one gig we did in Milwaukee because of the trio they had as our warm-up act. I don't remember who played guitar, but Al Haig was on piano and Red Mitchell was playing bass. It was the first time I'd heard Red and I was amazed by his speed. Since Cab was the featured act, we really didn't have much to do. By the time those three finished the opening, none of us felt like playing at all.

About six months passed and then Cab got an offer to work in Cuba. He took a quartet—the three-piece rhythm section and Jonah on trumpet.

We worked at a big gambling casino in Havana called the Montmartre for about four weeks. They had a show which featured an act from Spain, a South American group, and us. A full orchestra played for all the acts, but when Cab performed we'd go out with him. The orchestra was well rehearsed, but our being there helped hold everything together. We could make them sound like they'd been playing Cab's music forever.

While we were working this gig, Cab got ahold of some promoters and booked us into a local theater. So when we finished at the Montmartre, we picked up five

or six local musicians, rehearsed Cab's material with them for a couple of days, and did another two weeks in Havana.

It may seem silly, but one of the things that really impressed me on this trip was the hotel I stayed in. Each of us had to make his own living arrangements, and I picked a middle-class place called the Inglaterra. It was on the Prado in the middle of Havana, next to everything.

This was the first time I stayed at a place which served black and white guests. And everyone was treated equally. I never got the slightest hint of any discrimination. It was amazing to me.

About the only racial tension I ever felt in Cuba was around the big hotel where we worked. These kinds of places were owned by Americans and catered to American tourists. That may be why they seemed to treat blacks more like hotels did in the States. I remember hearing a story about how Joe Louis had trouble staying in one, even at the time he was the champion.

It's no secret that before Castro, many of the large casino hotels had backing from American gangsters. These guys were out in the open. In fact, I'd see them in the audience almost every night.

The casino at the Montmartre was incredible. Every kind of illegal thing was available, the way it always seems to be whenever there's gambling. But in Cuba, these activities were more public than anyplace I've ever seen. There was prostitution, of course, but there were also a lot of drugs around.

Many of the guys who worked the tables in the casino—dealers and croupiers—carried little vials of cocaine. Every time they had a break, they'd go into a back room, take a few snorts, and get a rubdown. Our dressing rooms were close to theirs and after a few days some of them got friendly and invited us to share their coke. When I refused, the Cuban who offered it smiled at me and said, "I know what you Americans like." I saw him the next night between shows and he handed me four or five big joints.

After a couple of weeks, I became friendly with a Cuban who was always around the casino at the

Montmartre. He seemed to have an important position there, but at first I didn't know exactly what he did. All the casino workers wore tuxedos, but he always wore a regular coat and tie. The waiters, the dealers, even the maitre d's would bow whenever they spoke to him. The whole scene was strange to me because this guy was dark skinned and it was unusual to see a dark Cuban getting treated like he was royalty.

A few times between shows, he'd take me and a couple of the other musicians to a large office in the hotel and show some unbelievable Chinese porno films. Three or four times after we finished working, he invited me out or for a drink. We'd drive into the countryside and stop at some small local bar. Everything was outdoors and we'd sit with our beer listening to guitar players until it started getting light. Wherever we went, everyone greeted him and I began to feel I was with a celebrity.

On one of these late-night trips he took me to see his house. I couldn't believe the place. It was built on three or four different levels and it was huge. There was a sixty-foot swimming pool, servants' quarters, everything imaginable. I kept wondering how a black man could possibly own all of it.

That night he told me about his past. He had been a baseball superstar in the Cuban league. Even though he had a couple of offers to play in the Majors, he never wanted to go because of the race scene. He was a hero all over the island, and he was rewarded with a high-paying management job at the casino.

I only got involved in one racial situation during my stay. It started just like one of those incidents I'd been through a hundred times in the States, but thanks to my black Cuban friend, it had the kind of end I'd always dreamed about.

I was going to work at the Montmartre one night and I took an elevator from the lobby to the second floor, where we played. There were a couple of customers on the same elevator and when we stopped at the second floor, they walked out and I started to follow. A maitre d' standing right outside the elevator door greeted them, but raised his hand, signalling me to

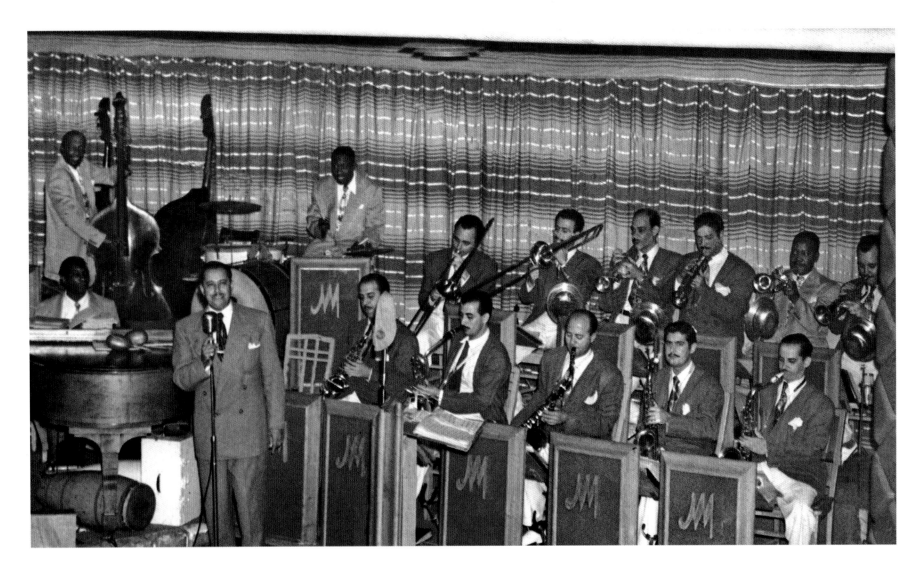

Dave Rivera (*at the piano*), Milt, Cab Calloway (*at the microphone*), Panama Francis (*at the drums*), and Jonah Jones (*with trumpet, second from right, top row*) and the Montmartre Orchestra, Havana, 1951

stay in the car. Then he took one step into the elevator and told me in broken English, "You can't come this way. You have to use the stage entrance."

I didn't have my bass and I was dressed in a tuxedo. He didn't have any good reason to stop me. But I didn't want to cause a scene, so I took the elevator back down to the lobby.

When I got off the back elevator on the second floor, my Cuban friend stopped me and asked, "Didn't

I see you come up here a few minutes ago?" As soon as I told him what had happened, he insisted it be straightened out immediately. The two of us walked across the ballroom to where the same maitre d' was standing and when we were about fifteen feet away, he signalled for the man to join us. When he had, my friend looked him in the eyes and said slowly, "You get on that elevator and don't come back here anymore."

The poverty in Cuba was about the worst I've ever

seen. Kids as young as eight or nine roamed the streets twenty-four hours a day. Evidently, they were homeless. You'd see them sleeping in doorways around town and you could always find a bunch of them washing up on one of the public beaches. The local people called them "gangsters," probably because they'd figured out all kinds of hustles.

Wherever I went, I always had three or four of these kids following along, asking for a handout. They'd be chased away from hotels and restaurants, but whenever I sat in an outdoor cafe they'd beg for something from the table. They were in rags and always filthy. Physically they were beautiful—every skin color imaginable—but they had the saddest faces I've ever seen.

There were many times when I'd spend the day with three or four Cuban musicians playing on radio stations in Havana. We'd go to one station, play for an hour, stop for a couple of beers, then move on to another station and do another hour. In those days, everything was broadcast live. We'd get paid three dollars an hour apiece as soon as we finished playing. It didn't take long before I got to know most of the songs and could get work whenever I wanted.

I also got hired to do a television show. It was a variety program like the ones in the States which were so popular in the early days of TV. It was sponsored by Bacardi Rum and paid eighteen dollars—six times better than Cuban radio.

Candido was on the show. It was the first time I ever heard him. He has dark skin and African features. He's what's known as Afro Cuban, the same as all the drummers I saw down there. He has huge hands, and the joints of his fingers are the size of doorknobs from playing congas and bongos for so long.

Cab saw him a few weeks later and liked him enough to offer him a permanent job. In fact, Candido was all set to go back to the States on our flight. I remember seeing him at the airport with all his drums and luggage, but they wouldn't let him leave Cuba because he didn't have the right papers.

One of the most memorable things about my trip was getting to meet and spend some time with a Cuban bass player named Orestes Urfé. He was one of the greatest symphony players I've ever heard. His father had been a bass player and had started training him when he was only seven or eight. His body looked like it had adapted itself to playing the bass. His left hand was twice the size of mine and he had enough power to handle the fingerboard like he was playing a violin.

I don't remember how we first met, but once Orestes saw my bass and played it, he never left me alone. We'd meet at my hotel or in the Montmartre and he'd take me to symphony rehearsals a couple of times a week.

After a while, I learned that at some earlier time he'd been a guest soloist with the Boston symphony. Evidently, something very unpleasant happened while he was in Boston and he returned sooner than expected. I never knew the details, but I always assumed it must've been a racial incident. Orestes was so bitter about the States, he said he wouldn't return under any circumstances and even pledged never to speak English again. In fact, he's the reason I tried learning Spanish. I wanted to get as much music as I could from him. I figured if it had to be done in his language, I'd struggle through it. And now I speak Spanish with a thick Mississippi accent.

A short time after we returned from Cuba, Cab got an offer to take a big band to Montevideo, Uruguay, and play the Carnival. He took Jonah and the rhythm section, but he also added a bunch of the guys from the old days like Hilton Jefferson, Paul Webster, Ike Quebec, Mario Bauza, and Doc Cheatham. The trip turned out to be a marvellous reunion for all of us.

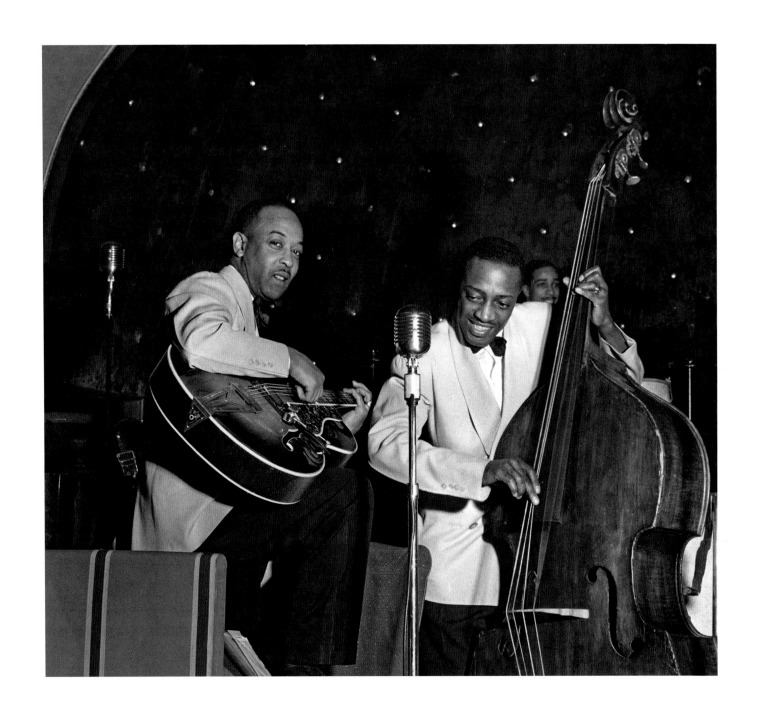

Danny Barker, Milt, and J.C. Heard (*in the background*), nightclub, New York City, c. 1943

4
In the Studios

After we returned from Uruguay, Cab reduced the band down to just four pieces again. We'd have some steady work for a while, then it would taper off to a weekend once or twice a month. We'd get paid by the job, but not much was coming in. This was the one period in my life when I was worried about earning a living. I owned a house in Queens, so my base was New York, but since I'd been working with Cab for sixteen years, I didn't think I had connections around the city.

Danny Barker, who'd also been with Cab, felt the same kind of financial pressure. In those days, he was a wisp of a guy who had a thin mustache and always wore a hat, just the way some of the big guys like Prez and Roy Eldridge used to. In fact, back in the old days there was a joke about that: People would say, "There's an easy way to know who's the star. He wears a hat all the time and always shows up late."

But Danny wasn't that way at all. He was always an enterprising guy and he worked out a good way to earn money using his musical talents. On Friday and Saturday nights, he'd pack up his guitar and take the ferry or the tubes over to the waterfront in Hoboken, where he'd work the bars. He asked me to go with him a couple of times and whenever I could, I'd get my bass and join him.

These bars were real small and there were always three or four hookers hanging around. I guess at some point, Danny realized that musicians could provide these women with a good excuse for being around a bar all night. It worked like this. At the beginning of the night we'd set up in a corner of the barroom and start playing. Then after a while, Danny would sing some of the popular new songs and a few of the old standards. If a guy walked in who looked like a cop, the hookers in the place would stroll over to us, line up, and take turns singing whatever we were playing. Most of them were way off-key and usually jumped four or five bars a chorus, but we managed to follow. Of course, they were pretending to be entertainers and we just went along with it.

The girls were always grateful for our help and they'd buy us drinks to show their appreciation. And since we'd also helped out the owner by making his place look legitimate, he'd usually feed us a good-sized meal.

Bars like these attracted sailors, which meant there was always plenty of booze flowing. As it got later, the customers got looser with their money and the plate we'd put out would start to fill. Each request we did usually brought in at least a fifty-cent tip. If things went well, by closing time we'd have twenty or twenty-

five dollars apiece in our pocket, and by then we were so loaded up with booze, we'd go home happy.

I guess being forced to scuffle in one way or another happens to most musicians at times. Perry Bradford told one of the best stories I ever heard about money when he and Eubie Blake were at my house one afternoon in the early '70s. Perry was a musician and songwriter, but he was also one of the first blacks in the record business. In fact, he was the one who first recorded Mamie Smith.

Perry's story was about a problem he experienced back in the '20s. It began with his getting up one Friday around noon. It was August, the weather was hot and humid, and to make matters worse, he was hung over and just about broke. He was living in a beautiful Harlem apartment but hadn't earned money for weeks, and he knew if something didn't come through soon, he'd be in real trouble. So he decided to go to his office downtown to see if he could hustle up a few dollars.

In those days, the heart of Tin Pan Alley was the Brill Building at 46th and Broadway, where some of the most successful people in the music business had offices. A block down the street was the Gaiety Building, also known as Uncle Tom's Cabin, where prominent black personalities including Perry, Eubie, and Noble Sissle had their offices.

On his way to the subway, Perry suddenly realized he didn't even have enough change for the fare. So he figured he'd walk to a couple of places in the neighborhood where his friends hung out and try to borrow some money. Within an hour he ran into Eubie, who lent him a quarter. The subway ride cost a nickel, and since he hadn't eaten, he went into the Automat on Broadway and spent his last twenty cents on food. He knew he was broke again, but figured he could always borrow more change from one of the other tenants in his office building.

Walking from the Automat to the office, he ran into a couple of guys he knew, and by the time he finally got upstairs, it was after three. He made a few phone calls, then opened his mail. And that's when he found a royalty check for $17,000.

By this time, the banks were closed and he realized that, even with all that newfound money, he still had absolutely nothing in his pockets.

Perry was really disgusted. He left the office, walked over to 47th Street, and sat down right in front of the statue of Father Duffy. A couple of minutes later, Eubie walked by, saw him and stopped. Perry showed him the check and explained his problem. Eubie told him, "Man, don't be sitting here like this. Somebody could come by and grab that check from you. Take

Perry Bradford, Eubie Blake and Noble Sissle, recording studio, New York City, c. 1958

Willie "The Lion" Smith and Eubie Blake, backstage, Newport Jazz Festival, Newport, Rhode Island, c. 1971

Eubie Blake, concert (25th Anniversary of the Newport Jazz Festival), the White House, Washington, D.C., 1978

it home for the weekend, then Monday you'll come downtown and get it cashed."

"Man, how the hell am I gonna get uptown and downtown and live until Monday?" Perry asked. Eubie reached in his pocket and handed him a dollar and a quarter.

Eubie and I had been listening closely while Perry told the story, and just as soon as Eubie heard the part about the second loan, he jumped in, saying, "It's been forty years, and you know he hasn't paid me that dollar and a quarter yet."

While I was hustling with Danny and still working with Cab occasionally, Tony Scott called me for a gig at Minton's. Minton's was at 117th and 7th in the Cecil Hotel—the same place where Mona and I were staying when we had the run-in with Ben and Maizie. It was a small club which probably held about seventy-five people. The bar was up front and in the back there were a couple of dozen tables crowded around a tiny bandstand. There was also a cabaret in the basement, but I never spent much time down there.

We had a quartet—Tony playing reeds, me, Dick Katz on piano, and Philly Joe Jones on drums. I don't remember exactly what the pay was, but I know it wasn't good. In fact, Tony knew how much Mona and I were struggling to make ends meet, so at the end of the week he insisted I take part of his money. Years later, when he was doing work for Harry Belafonte and would hire me for record dates, we'd laugh about being down-and-out at Minton's.

It was Jackie Gleason who really helped me get started in another part of the music business—studio work.

I first met Jackie sometime during my last years with Cab. Back in those days, he was a struggling comedian who got his best laughs—sometimes his only laughs—from the band. He loved jazz and always liked to hang out with musicians, who are known for their generosity, especially when it comes to buying drinks.

It was during my slow period that I ran into Jackie and his manager, Bullets Durgom, on a street corner downtown. I knew Bullets from the old days when he was a song plugger. Whenever we played New York, he'd bring Cab material and try to get it on the air. I hadn't seen Jackie for a while, and by this time he was a celebrity. He asked me the usual kinds of questions: "Whatta ya doing? What's going on?"

But instead of giving the standard show-business answer, I told the truth and said, "Nothing."

Hearing that, Jackie turned to Bullets and said, "We're doin' a record date tomorrow. Put Milt on it."

Bullets didn't know what to say. He tried to explain about contractors and hiring, but Jackie didn't want to know.

"I don't give a damn about the contractor. Call whoever's in charge and tell him I want Milt there tomorrow," Jackie said.

"But Jackie, we already have a bass player," Bullets argued.

And I'll never forget Jackie's answer, "Well, now we have two."

That night the contractor called to hire me for the date. Truthfully, I felt sorry for the guy. He'd never heard of me and had no idea if I could play.

The next morning I showed up at Capitol. There must've been fifty musicians in the studio and most of them were string players. I'd recorded before, but never anything this size. Besides, I knew from the minute I walked in, I was the only black.

As it turned out, the other bass player got to do all the bowing with the strings, and I played the pizzicato parts with the rhythm section. I guess the contractor figured I wouldn't be able to bow and didn't want to take any chances.

After the first few takes, we took a break and a couple of the musicians came over and introduced themselves. I learned that the date we were doing was for a Gleason album called *Music for Lovers Only*. About halfway through the session, Bobby Hackett, who was featured on all the tunes, came in to play the solos. We'd known each other for years and seeing

him put me more at ease. Bobby introduced me to Lou Stein, the piano player, and a couple of the horn and reed players.

By the time the date ended, I felt much more comfortable. To this day, I'm grateful to all the guys who extended their hospitality and helped me feel relaxed. The contractor came over, complimented me, and asked if I'd do the next session to finish the album. I didn't even wait to get the day and time—I just nodded yes.

A couple of days later, I ran into Chet Amsterdam on a street corner downtown. I guess he'd heard things weren't going well for me. After we talked for a few minutes, he asked if I'd do three nights for him at a club he was working on the East Side called La Vie en Rose.

The next night I arrived at the place about a half hour early. It was very small, but it was posh. I found the leader, Van Smith, a portly little well-dressed piano player, standing at the bar. I told him, "Chet can't make it and asked me to cover." I can still remember how shocked this guy looked. Evidently, in those days it wasn't too chic to have an integrated band playing society music in a fancy East Side club. At that point, I really wasn't familiar with that end of the business. Chet had to have known there could be some tension,

but he never mentioned it to me. Looking back, I think it's possible he did it deliberately. He understood that at times, if you really want to change things, it's better to take action without giving people a chance to say no.

About a month later, I got asked to go back into La Vie en Rose for a week with Peggy Lee. Her bass player, Joe Mondragon, couldn't make it and I filled in for him. Then someone from Gleason's office offered me a week with Jackie at the Paramount in New York, followed by another two with him at La Vie en Rose. I jumped at the opportunity.

Jackie wanted to hear the music from his albums played live, and the Paramount was a good place to do it. Unfortunately, things were different when we moved to La Vie en Rose. The room was so small that fifty of us couldn't fit on the bandstand. The piano, bass, and drums were the first to go because of their size and they put us on a small balcony in one corner, just large enough for the three instruments.

Gleason always conducted with a cigarette. Between numbers he'd make wisecracks about the size of the place and the size of the band. He'd say "There's more musicians in here than customers." Then he'd turn, look over at me in the corner, and ask, "Milt, is that your own private cave?" The jokes were really giving me some exposure. The place was packed every night and we seemed to be the hottest thing going in the city.

When I finished with Gleason, Phil Moore asked me to stay on at the club and work with his trio for three weeks. Dorothy Dandridge and Carl Ravassa were the featured vocalists and we'd accompany them and also play alone.

It turned out to be a smash. People jammed the place every night and we ended up doing thirteen weeks. It was a great job for me—the pay was a couple of hundred dollars a week and I could be with my family every day. But while I was there I had one bad experience, and unfortunately, it involved Cab.

About the fourth or fifth week of the engagement, Cab called to tell me he'd booked a couple of weeks

in the West Indies and would be taking the usual four pieces with him. I was glad to hear he was working again, but I told him I already had a job and wouldn't be able to make it. He flipped. "You're my bass player, you work for me," were his exact words. I tried to tell him about my commitments, but it didn't help.

I was so upset, I even went to Phil Moore to ask about leaving. Truthfully, I really didn't want to go, but since I'd been close to Cab for so many years, I figured the least I could do was go through the motions. I remember how relieved I was when Phil told me there was no way he could let me leave.

A couple of nights after I told Cab what Phil had said, he came into the club. We were in the middle of a number when I saw him across the room, sitting at the bar. After the years I'd spent with him, even at that distance, I knew how he moved well enough to know he was loaded. In fact, I didn't have to see him. He was so loud I could hear him between numbers. He'd point to me and tell everybody around, "That's my bass player. When he's finished here, he's going with me."

I was never too sure about the kind of people who owned the club, but I had my suspicions. There were always two or three tough-looking guys hanging around, and it didn't take long before one of them went over to Cab. I could see the two of them talking. Then somone blocked my view for a few minutes and by the time he moved out of the way, Cab was gone.

Looking back, I think this particular incident changed the relationship I had with Cab. From that point on, he'd really lost the control over me which he'd had for sixteen years. Of course, money-wise, I'd broken away from him months before, but at this point there was much more of a mental separation. I'd become my own person, and from then on he wasn't my boss anymore.

Naturally, we saw each other and even worked together after that. We played a couple of festivals which featured him along with some of the guys from the old days. In fact, about fifteen years ago, we did a

[Opposite page] Jo Jones, backstage, New York City, c. 1951

Cotton Club-type review in Iceland for IBM. But Eddie Barefield and I were the only original guys there.

Toward the end of the thirteen weeks with Phil, Joe Bushkin came by the club one night. At the time, he was the darling of the East Side society set. Evidently, Jonah Jones knew Joe was looking for a bass player and told him to check me out. He stayed for several shows, liked what he saw, and asked me to join his group at the Embers when I finished with Phil.

The Embers wasn't as posh as La Vie en Rose, but it was still a chic East Side place. It was long and fairly narrow. As you walked in, there was a bar along the left wall and farther back was a bandstand running in the same direction. The kitchen was downstairs next to the furnace room, and in between was a small area with a toilet and sink we used as a dressing room.

Joe's quartet was wonderful. Besides the two of us, we had Buck Clayton and Jo Jones, so together we represented three of the most popular big bands—Tommy Dorsey, Basie, and Cab. I think that's one reason we did good business for almost four months.

From a musical standpoint, the most valuable thing to me about working with that quartet was the chance to play with Jo Jones every night.

His full name was Jonathan Jones. He was born in 1912, so he was a couple of years younger than me. I knew him for fifty years and I played with him in his prime. At one time or another, I worked with just about all the great drummers of the '30s and '40s, but to me, Jo was the greatest. I can still hear his sound in my head. No one had his control and sensitivity. He was regal.

Jo's time was impeccable. He played drums like he was a violinist. He could control his sound and actually had the ability to change his pitch for soloists. Years later when I ran jazz workshops, I tried to teach drummers what Jo did, but soon I realized it can't be taught.

Jo would enhance any band. He'd listen to a soloist until he was able to identify the qualities which made that person unique. Then he'd experiment with his drums until he found the right way to be comple-

Unfortunately, Jo always wanted to be the leader both on and off the bandstand, and there were many times when he was overpowering and just plain arrogant. He'd assume he had control and he'd start giving out orders—"You set up over there," "Stand between the drums and the piano"—that sort of thing. He'd even continue after the gig ended. I remember times when he'd tell me who I should work with, where I should travel next, and how I should be living. If he hadn't been so serious, it would've been pretty funny.

The last time we worked together was at Carnegie Hall. He was partially paralyzed and had to be helped onto the stage. He was Papa Jo Jones, senior citizen, and everyone in the house was paying their respects. When he started playing, I could hear the same qualities I'd heard fifty years earlier, and he looked just as regal too.

Max Roach says, "Of every three beats a drummer plays, one of them belongs to Jo Jones." Buddy Rich said the same thing. And even though people will probably always argue about what made Basie great, everybody agrees that Jo's contributions to jazz are unforgettable.

mentary. Kirby tried to do something similar on bass. He'd change his line depending on who was playing. Truthfully, I took the idea from him very early in my career. If I was accompanying Ben, I'd play one and five, then walk a little. Ben always liked things open and usually just wanted to hear the tonic and the five. But if I was playing behind Chu, I'd walk constantly because he always played riffs.

I learned a tremendous amount about pitch and sound from Jo. He could drive a band harder, louder, and better than anyone, but he also knew about using the drums to speak softly. His brushwork was something to behold. He showed us that you don't have to be loud to be heard. If you're good enough, people make it their business to listen.

Getting back to the early '50s and the work I did with Joe Bushkin at the Embers—Gleason really enjoyed our group and I guess because of us, he became a regular customer. So when he had a chance to take a variety show to five cities, he asked Joe to bring the group along. Since it was a short trip and the money was right, I decided to go. Besides, I figured if the rest of the quartet went, I'd lose my gig at the Embers anyway.

Gleason had a big show—the actors from *The Honeymooners*, a singing group, dancers, and the four of us. We had a featured spot, but a local pit orchestra did all the accompaniment. The whole trip didn't last more than a month. We played Pittsburgh, Detroit, Chicago, Boston, and another city, and when I got back home to New York, I started freelancing again—taking anything I could get.

I began getting more calls to do studio work. The two record dates I'd done with Gleason turned out to be a break for me. Evidently, word spread, and it wasn't long before a couple of producers and contractors found out I could read and bow and seemed to be friendly and easy to get along with. But there was still no steady paycheck coming in and my earnings were unpredictable. One week I might work in a club, do a wedding or a party, and make a record date. But a week later I might only have one night's work. In fact, during this period I taught Mona how to transpose and copy music so she could make some money at home working for a couple of arrangers I knew.

Whenever you did a record session, you'd fill out a W-2 slip on the date, wait three or four weeks, and then pick up your paycheck at the union. Mona figured if we could live on what I earned from working clubs and club dates, we could leave the record money at the union for a couple of months. That way, if freelancing got bad, we'd always have a little cushion waiting for us.

I remember an experience I had the third or fourth time I went to the union to get my paychecks. They had one guy, Jules Aron, handling the record money. He was probably in his late fifties, with a delicate build and a devilish kind of smile.

He'd sit in a regular cashier's booth with a cigar in his mouth all the time, and people would form a line in front of his window waiting to be served. He kept all the checks in a shoebox and was very meticulous whenever he went through them. In a way, he looked like one of those old-time English bookkeepers who wore a green visor and bands around his shirt sleeves.

On this particular occasion, Mona had written down the names of the two or three sessions I'd done a couple of months earlier, and I was third or fourth in line. After a ten-minute wait, the guy in front of me stepped up to the window. He was short, bald, in his sixties, and very dignified looking. I didn't know it, but he was Tosha Samaroff, one of the busiest violinists in the studios. I watched him open his briefcase and take out a pad with a list of sessions almost two pages

Jackie Gleason tour, RKO
Keith's theatre marquee,
Queens, New York City,
c. 1952

long, like a stock listing from the newspaper. I must've waited twenty minutes more while he went over the list with Jules, date by date, to make sure everything was right.

When they finished, Samaroff turned to me, and with a thick Russian accent said something I'll never forget: "You are a good bass player. The same thing will happen to you one of these days." I was flattered that he knew who I was. Naturally, I had absolutely no idea his prediction would come true.

I continued working wherever and whenever I could and then I got a job offer I never expected—a chance to work with Basie.

Basie lived in our neighborhood and Mona had become friendly with his wife, Catherine. I don't remember where or when I first met Bill, but we'd known each other since the '30s. A lot of the guys who played in his band were good friends of mine, so we'd always traveled in the same circles.

After Catherine and Mona got to be close, Basie and I spent more time together. He was traveling most of the time, but whenever he was home, we'd make it a point to hang out at one of our houses.

He had a fabulous place. It was built on a corner but had an extra lot attached which was almost a block long. There was an Olympic-sized swimming

A studio string section, including: Tosha Samaroff, Jack Zayde, Sam Rand, Julie Brandt, Ralph Silverman, David Berkowitz, Harry Katzman, Alex Cores, Bernie Eichen, Felix Giglio, Harry Hoffman, and Max Hollander, recording studio, New York City, c. 1962

Freddie Greene and Jo Jones, television studio (*Sound of Jazz* rehearsal), New York City, 1957

I knew Basie well enough to tell him the truth. Even though he understood, he was desperate. Beginning the next night, the band had solid bookings. He'd already tried other bass players but couldn't find anyone who didn't need at least a couple of rehearsals. Then he came up with a solution: "Look, we're gonna be right around New York for the next month. Why don't you do it while we're here? That'll give me time to find a guy to take on the road and break in."

Basie was my friend and he was asking me to do him a favor, so I told him, "Okay, I'll do it, provided you take me back and forth to work every night."

"You got a deal," he said.

So for the only time in my life, I had a bandleader as my chauffeur. I used to kid him about it all the time. If we'd finish for the night and he was standing around talking to some ladies, I'd whisper to him, "Basie, either we leave now or you better get two of them. With the deal we got, if I come home without you, your wife's gonna know where you've been."

My joking didn't seem to matter. There were plenty of early mornings when I'd stand around for hours waiting for my driver to finish his business and take me home. The pay was terrible. I think I got seventy-five dollars a week. But the band was great. Gus Johnson was the drummer, and Lockjaw Davis, Marshall Royal, Frank Wess, Frank Foster, Johnny Mandel—the songwriter—and Joe Newman were also in the band. Of course, Freddie Greene was always there.

When you're a bass player in Basie's band, you spend your time walking. The rhythm section is responsible for a big part of the sound which is his trademark. I'd heard it for years, so playing it was enjoyable for a while.

Basie wouldn't let me get bored. Onstage we'd always be a couple of feet apart and he'd kid with me all night. If we were playing up-tempo and I was walking fast and starting to sweat, he'd tinkle a couple of notes, then lean over to me and say, "Go ahead, hog, you're gonna take it anyway." I always broke up.

pool surrounded by stone statues on the lawn, and a high wooden fence kept things private. Basie loved toys, and I can still see the model train set he had. You'd get in the center to run it, and the layout and scenery were better than the displays they have in department stores at Christmas.

When he came to my place, we'd have a ball—drinking, talking, listening to music. I had a piano and a couple of projectors in my basement, and he loved to watch silent movies. He'd sit down at my old upright, get himself into position to see the screen, then play just the way they did in the old theaters. He wouldn't stop, even when I got up to change reels.

After Walter Page, Basie changed bass players fairly often, and one day he called and asked if I'd go out with the band. By this time, I was busy freelancing and couldn't afford to leave town. Besides, I'd made the road scene for sixteen years and wasn't about to leave my family and start over again.

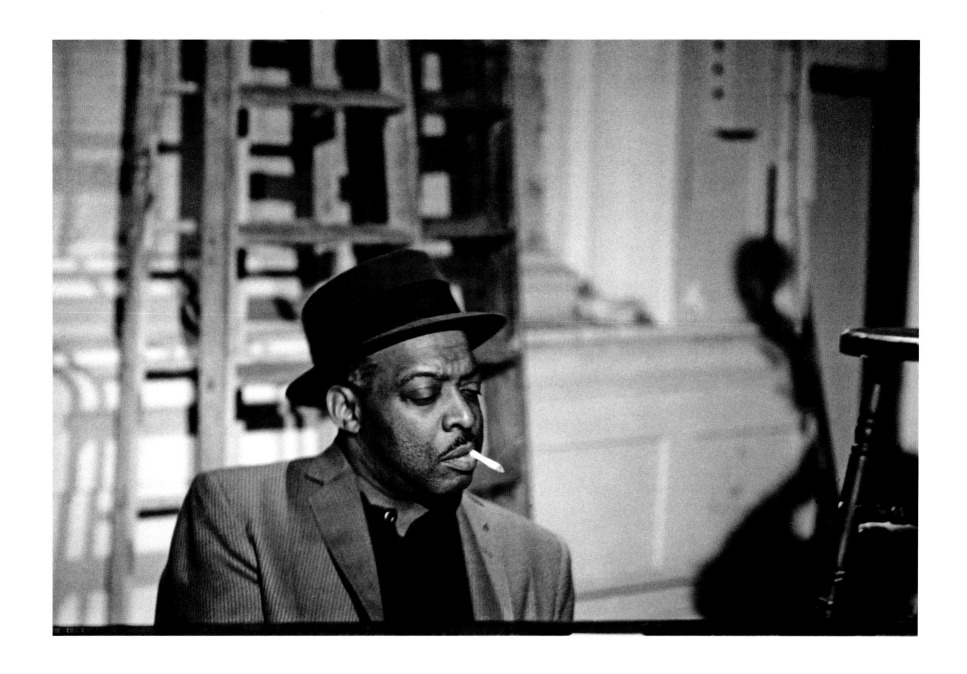

Count Basie, television studio (*Sound of Jazz* rehearsal), New York City, 1957

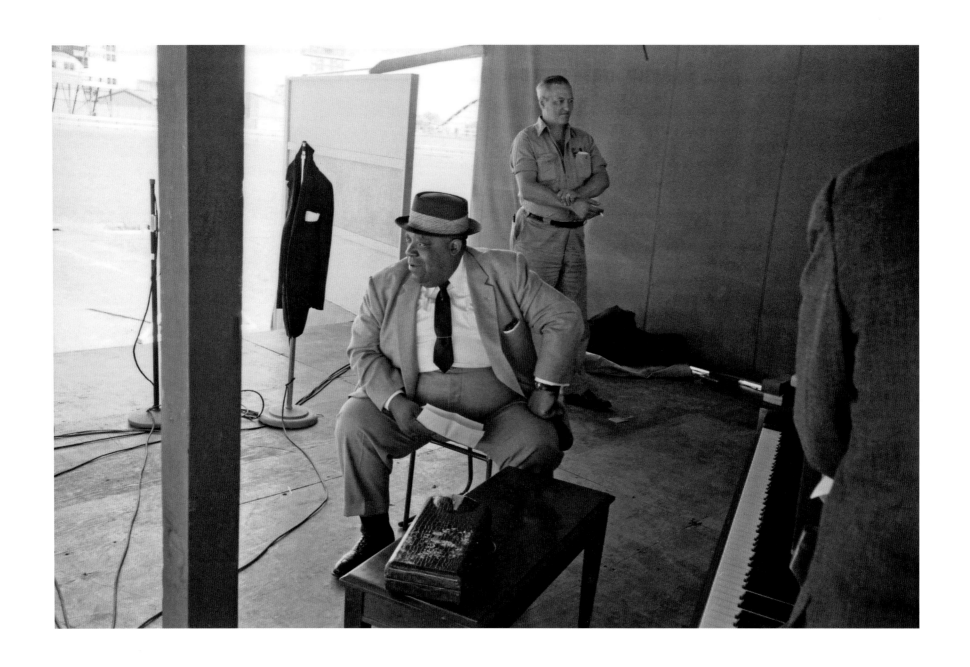

Jimmy Rushing, concert, Forest Hills, Queens, New York City, 1963

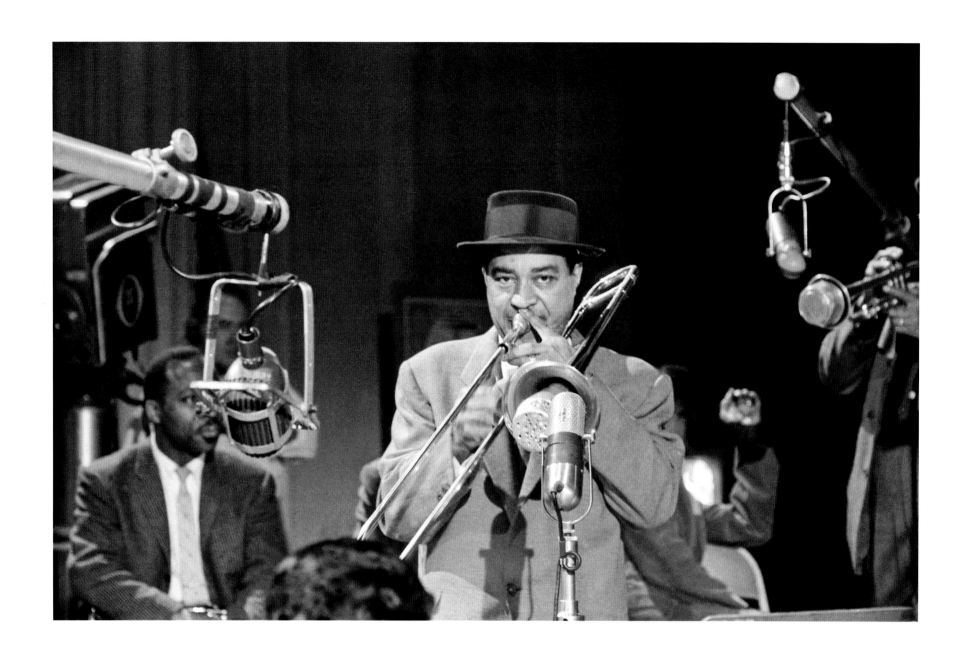

Joe Wilder and Dickie Wells, television **studio** (*Sound of Jazz* rehearsal), New York City, 1957

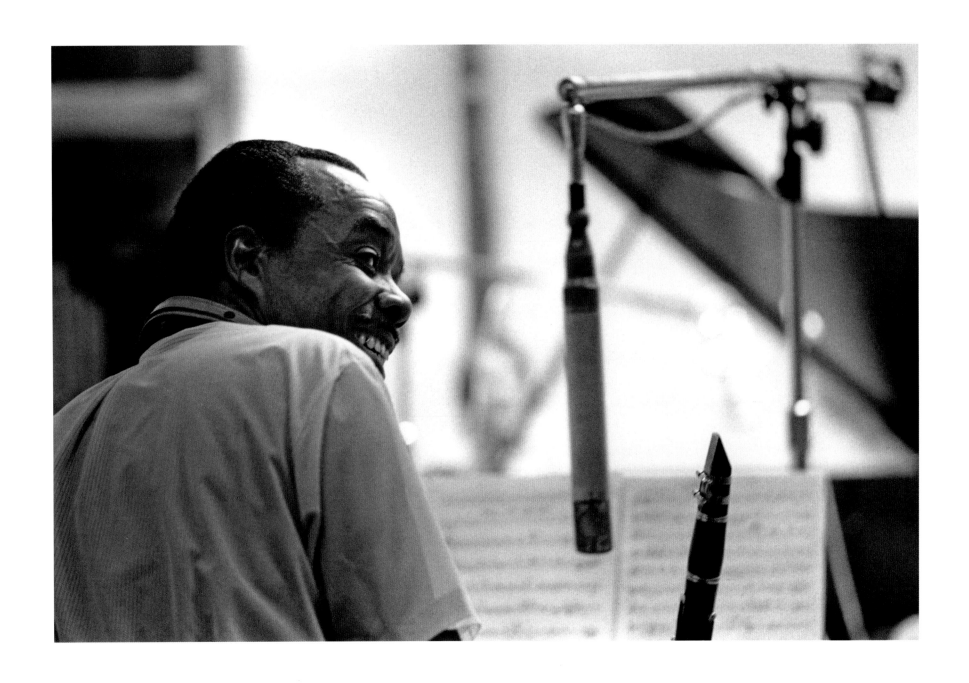

Buddy Tate, recording studio, New York City, c. 1975

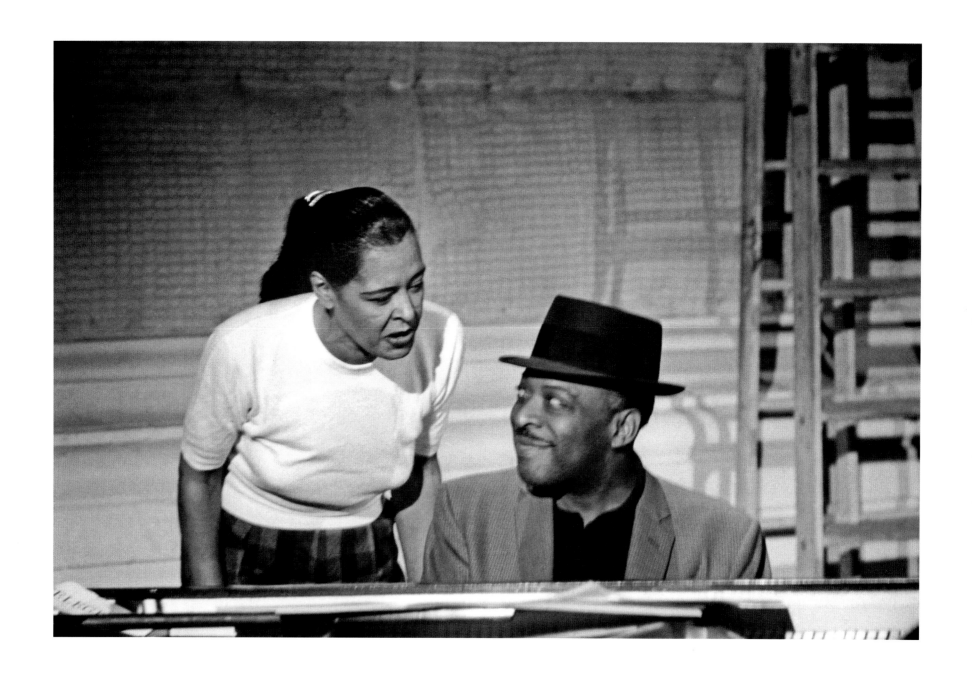

Billie Holiday and Count Basie, television studio (*Sound of Jazz* rehearsal), New York City, 1957

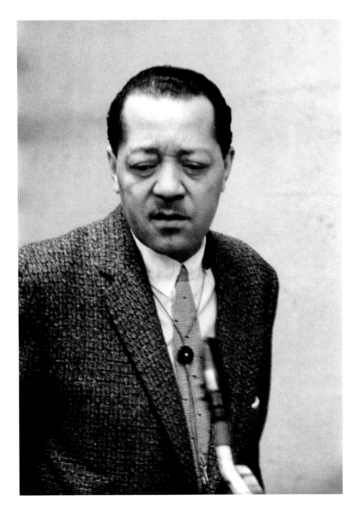

Lester Young, television studio
(*Sound of Jazz* rehearsal),
New York City, 1957

When Duke played, the place was quiet, and everyone sat back and listened to the great soloists, like a concert was taking place. Then when we'd come on, people would get up and dance.

From what I saw myself and what I was told by Ben and other guys who worked for him, Duke's band was always strange. His men never acted like family, the way we did with Cab. Most of them didn't hang out together. They'd finish work and go their separate ways.

Duke's philosophy was pretty straightforward. He believed if you let musicians have their way, they'd play their hearts out. Once you started making rules, it stifled creativity. He was the only leader I ever knew who had to call his band back to the stand after a break. He had a routine for doing it. When he was ready to begin the next set, he'd go to the bandstand and play the same phrase on the piano. It was dissonant, so it cut through the noise in the hall. All his guys would probably hear it, but only the most disciplined ones, like Harry Carney and Lawrence Brown, would go back to the stand immediately. The rest would ignore it and go on drinking and talking.

Duke would wait for a few minutes until a couple of guys got back to the stand, then he'd start playing something soft. He usually picked a tune based on who was there. In fact, I've heard he purposely wrote material for just these kinds of occasions. While the small group was playing, the rest of the guys would drift back, one by one. Johnny Hodges, Ben, and a couple of the other heavy drinkers were usually last. Then, just as soon as everyone had returned, Duke would end the quiet melody and call one of his loudest tunes. The contrast was unbelievable. The guys had gotten back on their own time. They were ready and wanted to be there. So when the full band hit, the earth shook.

In the old days, one of my favorite people in Duke's band was a bass player named Junior Raglin, who was quite a character. He loved gin mixed with cherry juice, which he called a Junior Flip. Since no

I played with Basie for a little over a month. The thing I remember most was the gig we did for a week with Duke at the Bandbox. It was a huge downstairs place, next to Birdland. It wasn't fancy at all. There were booths and tables all around a big dance floor and two large bandstands next to each other. The two bands alternated sets—Duke on the right side, Basie on the left—and the place was packed every night. All the guys had a chance to hang out together and there was a happy feeling in the air. It was one big, long reunion.

I was amazed at the way audiences reacted to the two bands. They seemed to understand the differences.

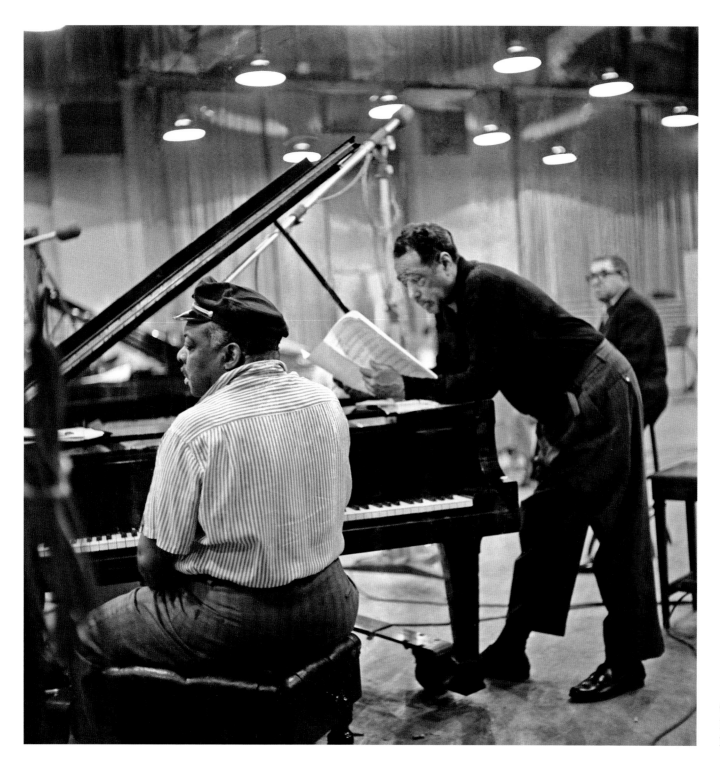

Count Basie and Duke
Ellington, recording studio,
New York City, 1961

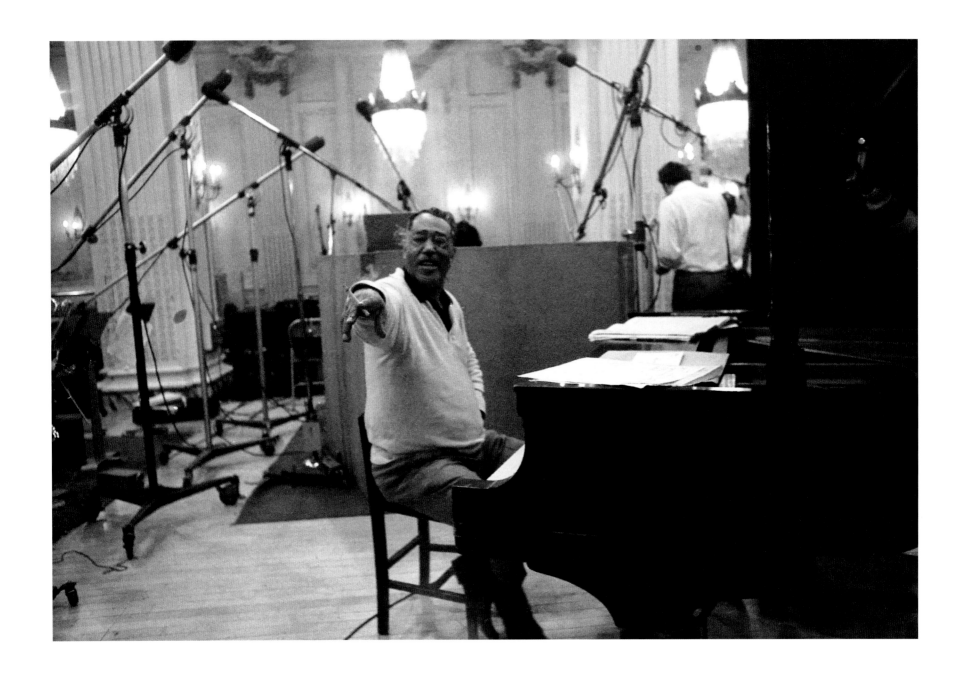

Duke Ellington, recording studio, New York City, 1959

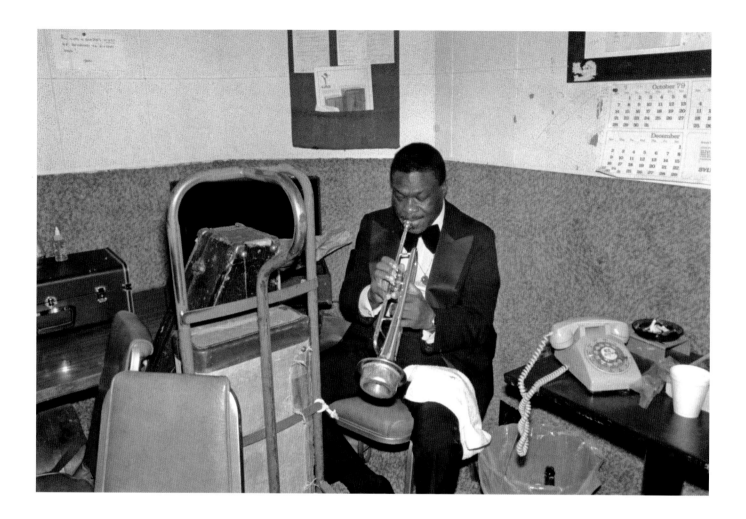

one in the band really cared, he'd bring pitchers of his concoction on the bandstand and get drunk almost every night.

One time in the early '40s we were playing the ballroom at the Park Sheraton on 57th Street and Duke was at the Zanzibar on 49th. For some reason, Junior decided to bring me a pitcher of his favorite drink. So he mixed it at the Zanzibar and walked eight or nine blocks to our hotel. This was a particularly hard trip for him because he had bad feet and always wore house slippers instead of shoes.

When he arrived, we were onstage and Cab was in the middle of one of his vocals. I noticed Junior moving slowly through the ballroom toward the stage. He had on a tux and his slippers and he was carrying a pitcher with a white towel draped across the top. A couple of seconds later I saw the maitre d' stop him. While they talked, Junior pointed toward the stage where I was playing. He was a big man who was hard to turn down, and it wasn't long before the two of them were in front of me.

Junior put the pitcher down at my feet and said, "I told this guy I was all right, I know Milt." Then he turned and left. Of course, Cab was always a disciplinarian and when he saw this, he just about went crazy.

I never recorded with Duke. What's worse is that

Cat Anderson, dressing room, Las Vegas, c. 1979

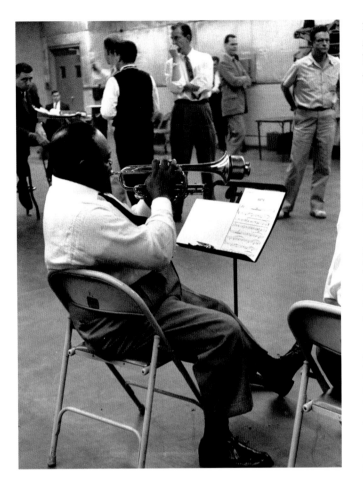

room we were playing, checked out the bandstand, and then tried to find bass parts. I was unsuccessful, but that wasn't unusual—Joe Benjamin had been with the band long enough to know the music.

I was on good terms with all the guys in the band. Some of them may not have been talking to each other, but when I went back to the dressing room, they all greeted me. Unfortunately, after I spent a few minutes asking questions about the music, it was clear they weren't going to give me help. That didn't surprise me. With all the stars, big egos, and conflicts in the band, these guys couldn't cooperate on anything.

I figured the only way I had a chance to get information was to talk to one or two guys individually. I saw Harry Carney first. I took him aside and asked about the first set. He told me, "Duke's been using an opening tune which starts out with a bass solo." He wasn't kidding, and suddenly I began to feel jittery.

A couple of minutes later I cornered Cat Anderson and he told me the same thing about the first tune. I asked about the key and he said, "Well, it starts out— You start out— I don't know the key offhand, but my first note is D." That's about all the information I could get.

About twenty minutes later we began to take our places on the bandstand. I still hadn't seen Duke and I didn't know what the hell I was supposed to play. I was really on edge.

As soon as I got on the stand, I spotted Duke sitting with some guests at one of the front tables. The band wasn't ready, so I put my bass down and walked over to him. He got up from the table, greeted me with his usual "Hello, baby," and kissed me on both cheeks, the way he always did. I must've seemed nervous when I asked about the first tune, but he was very calm. "You just cantor in F 'til I bring the band in."

I knew what he wanted immediately. Cantoring is a vamp which gets its name from Eddie Cantor's old radio show. His audience used to chant the same four notes over and over, saying, "We want Cantor." I felt more relaxed.

I went back to the stand, everyone took their

I once got called for a record date, but I was booked and had to turn it down. Fortunately, in the middle '50s, I did have a chance to play with the band for one night and it was an unforgettable experience.

Duke called me one afternoon and asked if I'd come down to the Rainbow Grill that night and sub for Joe Benjamin. I jumped at the opportunity.

The Rainbow Grill is a big place on the sixty-fifth floor of Rockefeller Center which probably seats two or three hundred. There are windows everywhere and the views of Manhattan are spectacular. Looking south, you can see where the island comes to a point—almost like the bow of a ship.

I got there fairly early. I took a good look at the

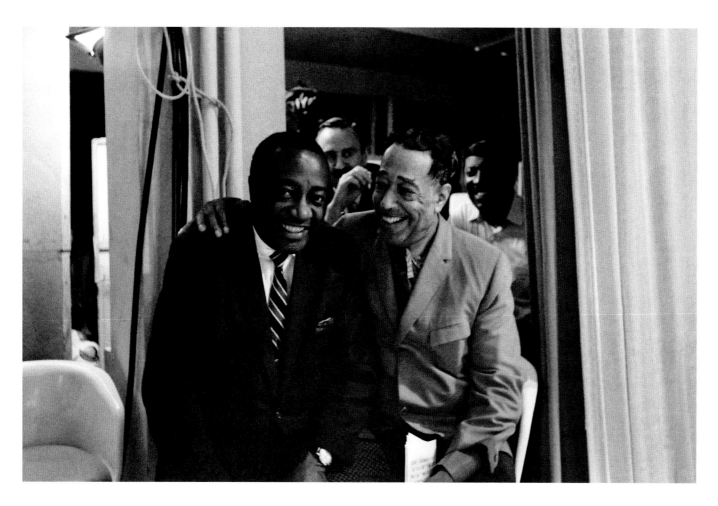

places, and a few minutes later Duke joined us. Then he counted off, pointed to me, and I began. About thirty seconds later the whole band hit and then I was totally confused. I didn't know the changes. There was no guitar, and since Duke wasn't seated at the piano, I couldn't watch his left hand to get my notes. Trying to find changes by listening to the brass and reeds is an uphill battle.

Duke could tell I was struggling. He looked in my direction until he was sure he'd caught my eye. Then he pointed one finger to his ear, as if to say, "Relax and listen, baby, you'll hear it." I did. I followed the best way I knew, and I survived.

Duke praised me all during the evening. He intro-duced me to the audience and told them how I'd come in at the last minute to help him out. But the greatest compliment came in a letter I got about a week later. It was from a Canadian priest. He'd been one of Duke's guests the night I played. He said that at one point during the evening, Duke talked to him about me and told him, "He looks like a king up there on the stand, doing all those miraculous things. He plays like he's been here all the time."

Duke worked miracles writing and orchestrating for his men. He was known for his ability to get the most out of the musicians who worked for him. I gave everything I had that night, and I know Duke was the force which made it happen.

Milt and Duke Ellington,
Yale University, New Haven,
Connecticut, 1972

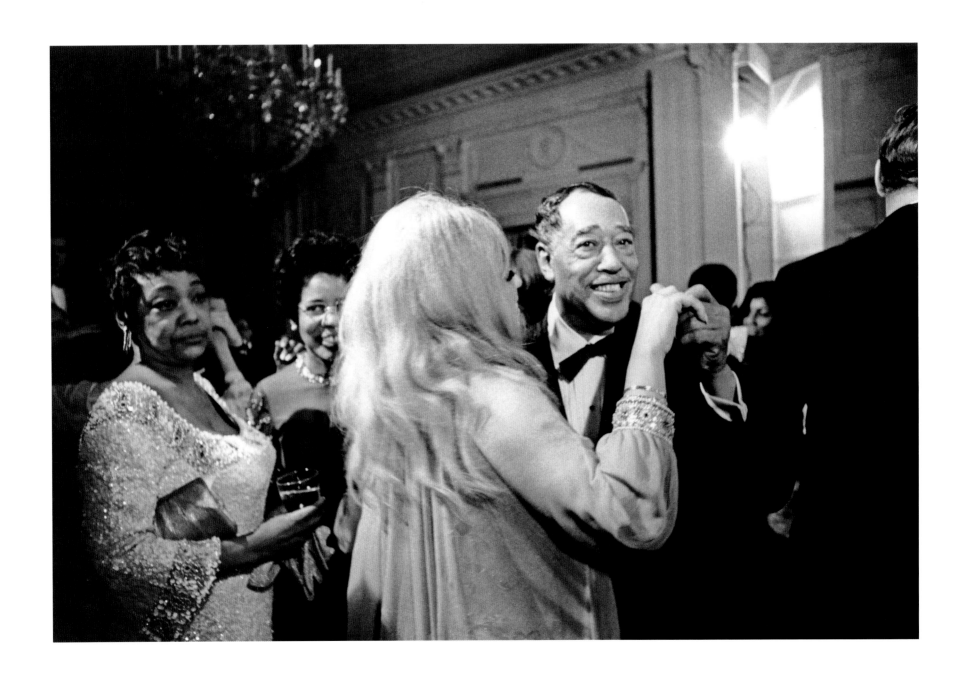

Pauline Terry, Mona Hinton, and Ruth and Duke Ellington (Duke's 70th birthday party),
the White House, Washington, D.C., 1969

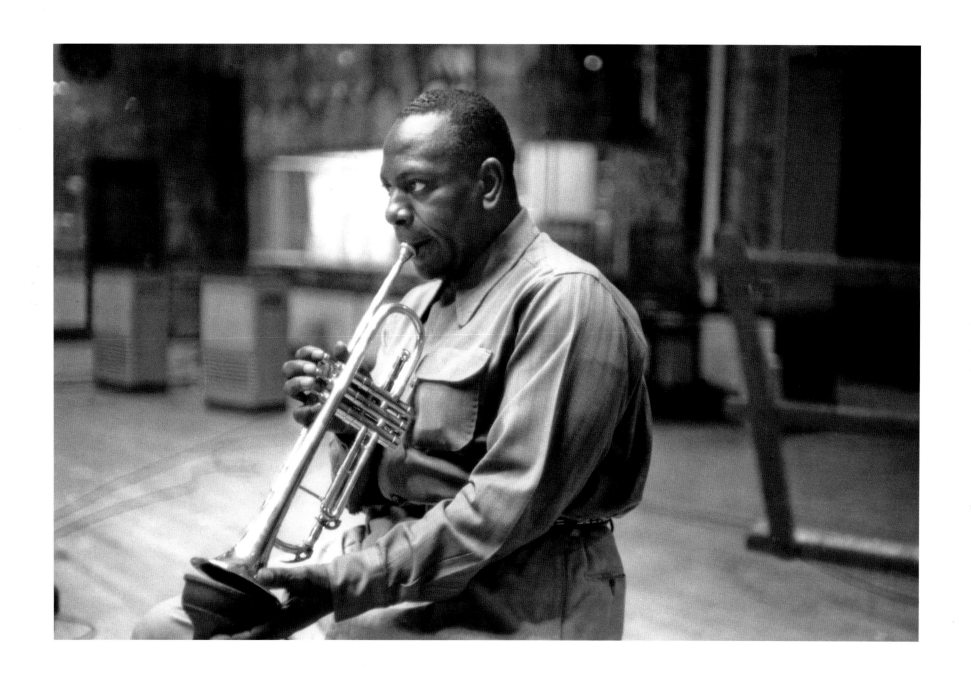

Cootie Williams, recording studio, New York City, c. 1958

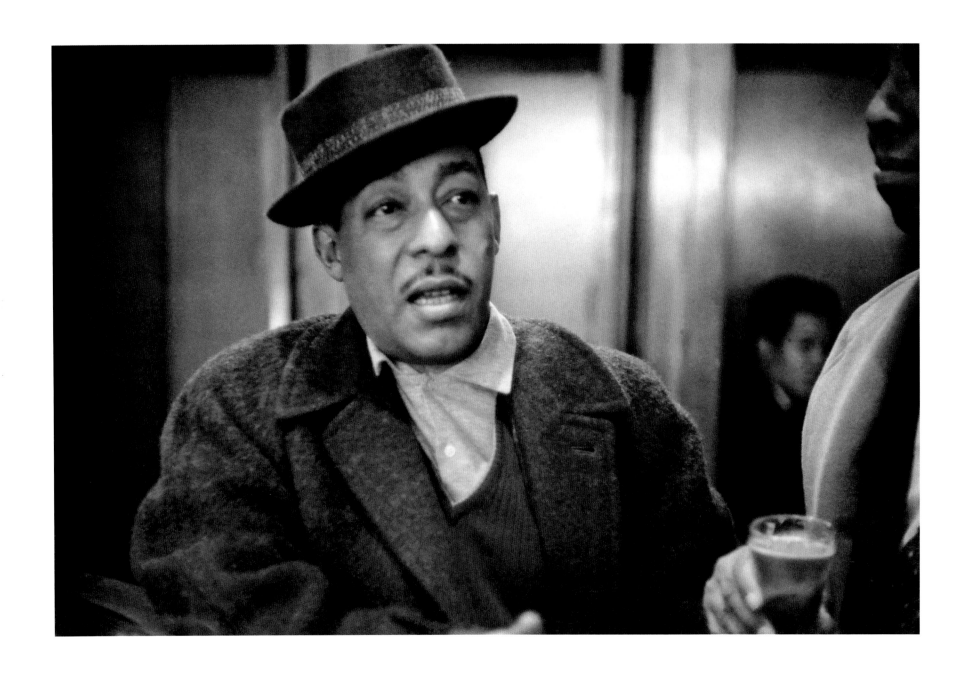

Johnny Hodges, Beefsteak Charlie's, New York City, c.1960

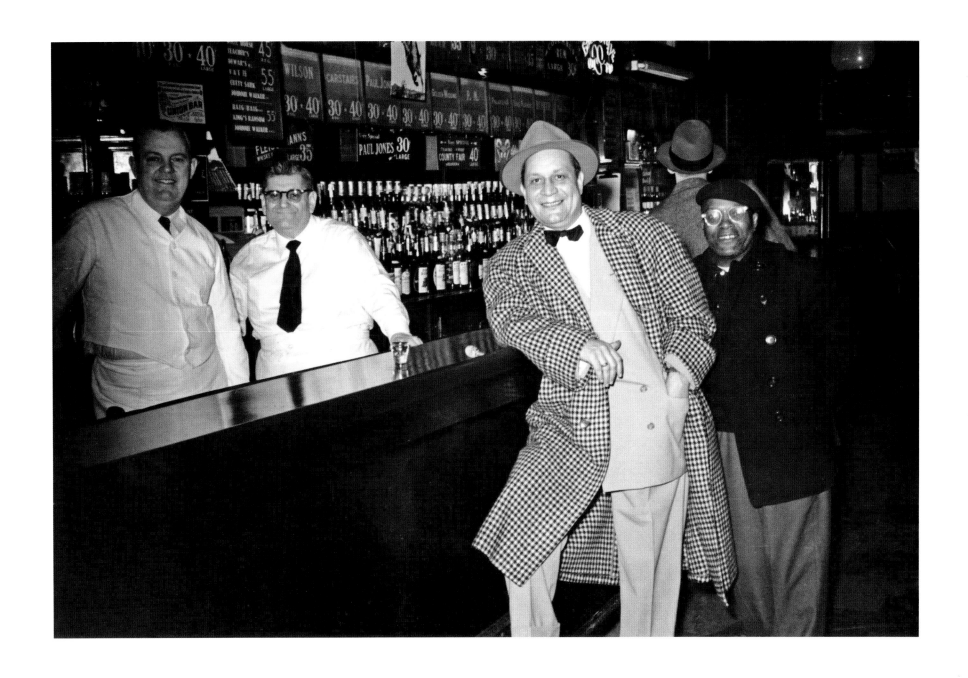

Barney Bigard with bartenders Jack and Herman, Beefsteak Charlie's, New York City, c. 1955

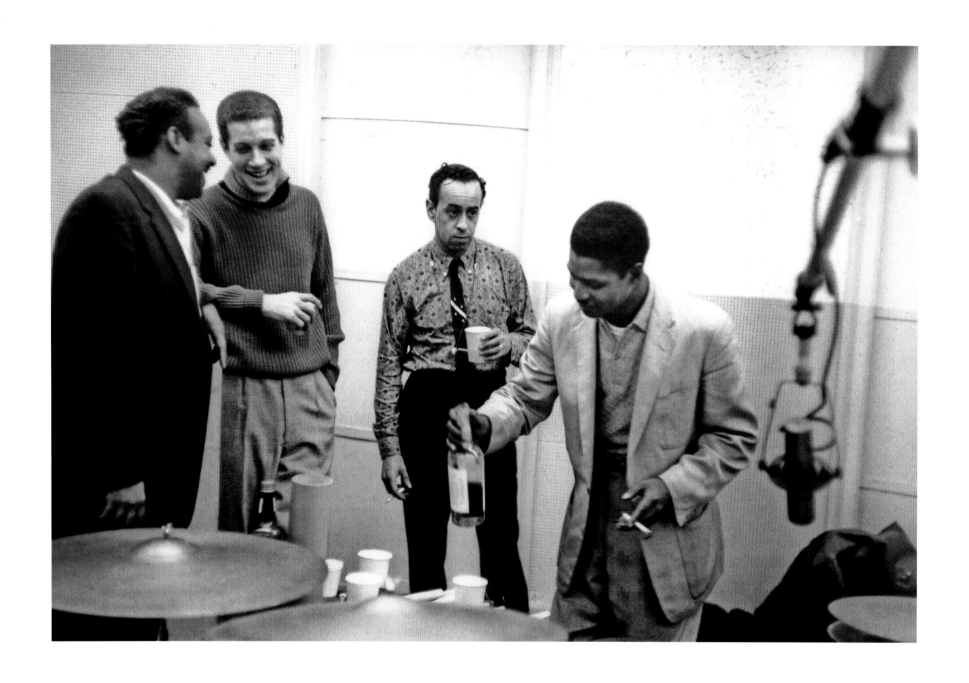

Jimmy Nottingham, Kenny Burrell, Paul Gonsalves, and Willie Cook, recording studio, New York City, c. 1959

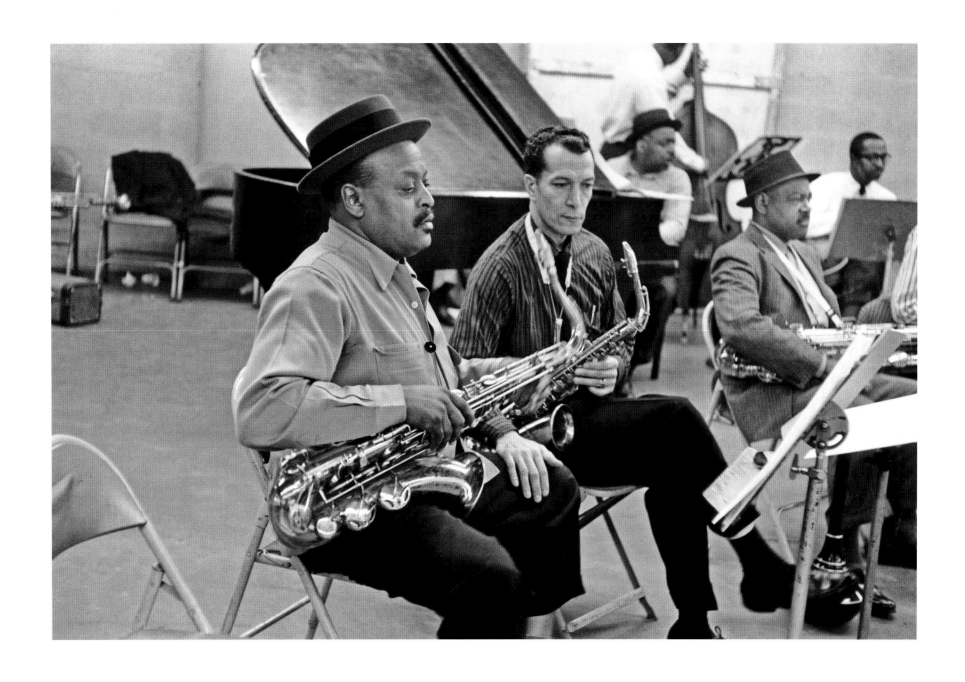

In foreground: Ben Webster, Earle Warren, and Coleman Hawkins; Count Basie (*piano*), Ed Jones (*bass*), and Freddie Greene (*guitar*), television studio (*Sound of Jazz* rehearsal), New York City, 1957

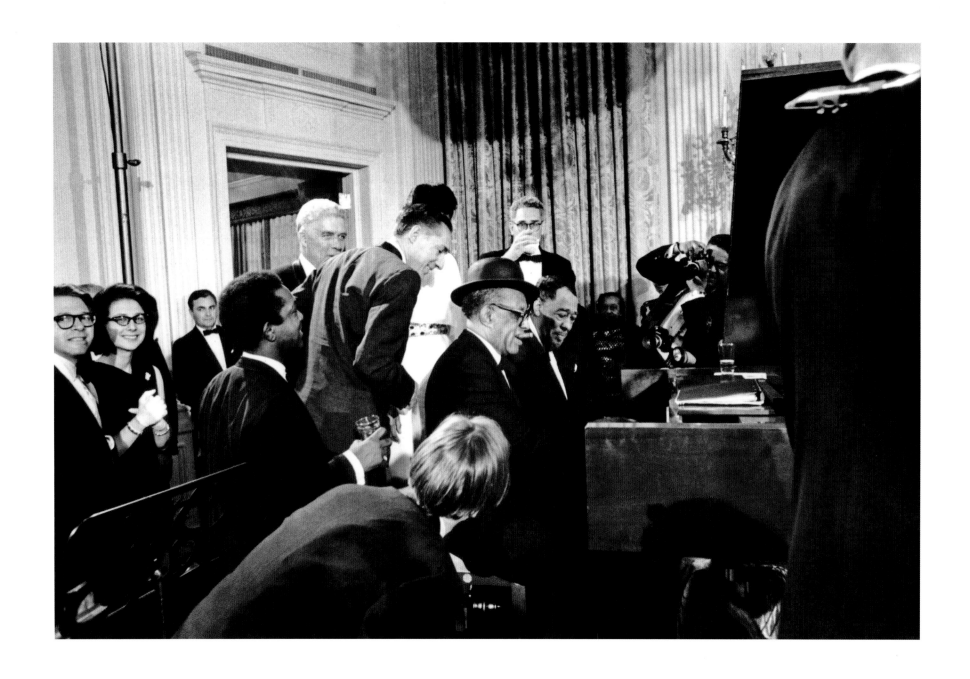

Willie "The Lion" Smith and Duke Ellington at the piano (Duke's 70th birthday party),
the White House, Washington, D.C., 1969

On our next-to-last night at the Bandbox with Basie, I got an offer to go out on the road with Louis Armstrong. Joe Glaser, who handled Louis, sent one of his people—a guy named Frenchy Tallerie—down to the club to ask if I wanted the job. It was as simple as that.

I was really taken by surprise. I told Frenchy I needed time to talk about it with my wife and that I'd call Joe in a couple of days.

In the old days around Chicago, Joe Glaser had a reputation for being a real tough guy. From what I heard, he came from a middle-class family but he was the black sheep. I think his mother owned the building on the Southside which the Sunset Cafe was in. That's the place a lot of famous entertainers, including Cab, got their start. Evidently, at one point after Joe had gotten in some kind of serious trouble with the law, she'd helped him become an agent and manager.

Louis and Glaser got together in 1935. As the story goes, for years there was never a written contract between them. They shook hands one time and that was it. Right from the start, they hit it off. Joe had the connections and got the bookings. Louis had that wonderful, friendly personality and, of course, the musicianship. Their careers just took off together.

Louis's name was well known around Chicago when I was growing up. Along with Eddie South, he was one of my two boyhood idols. As a kid I'd seen him perform in theaters, but as I got older and more involved playing music, I was around people who knew him personally. I remember watching him rehearse, and I can recall many times when I'd run into him talking with a group of guys on a street corner or in a bar. And later, when I worked with Zutty, Louis's close friend, I really got an opportunity to spend some time with him.

Deciding whether or not to go with Louis was very difficult. My month-long commitment to Basie was over, but I was getting good freelance jobs. And even though I couldn't be sure how much I'd be making from week to week, the pay was getting better. When I left Cab, I said I'd never go back on the road for

any length of time, but the thought of playing with a legend like Louis made the idea of traveling more acceptable.

I wanted to go, but with my family to support, money became a real issue. Mona and I figured I might earn a little less with Louis than freelancing, but it would be a steady salary. Besides, if I got paid expenses on the road, I'd be able to save much more. We decided if the money was right, I'd take the job.

Everyone knew Pops didn't discuss money. Joe dealt with those things. But before I called him, I figured I should try and get an idea about what other guys in the band were making.

I got ahold of Cozy, who'd been with Pops for a while. He told me he'd just given notice and was planning to form his own band. Of course, I was disappointed. We were close back in the Cab Calloway days and I'd been looking forward to spending time with him again. He filled me in on the personalities in the band and Joe's people. Then we talked about money.

When Frenchy had approached me at the Bandbox, he'd told me the pay would be seventy-five a night. But when I mentioned that figure to Cozy he said, "That may sound good to you, but I'm makin' one twenty-five and I don't see why you can't get that too."

A couple of days later, I sat down with Joe and Frenchy to talk about money. Joe was a thin, dapper-looking guy with pretty sharp features who walked pigeon-toed. Frenchy was just the opposite. He was sloppy and fat. He didn't like anyone and you couldn't believe a word he said. Everyone knew he hated Louis and Louis couldn't stand him. In fact, some people said that's why Joe made him road manager. He knew if Louis did something wrong, Frenchy would report him, and if Frenchy tried to steal, Louis would do exactly the same thing.

Just before the conversation began, Louis walked in. I started out real bold. "Look, I gotta have one twenty-five a night." At that point I wanted the job and I was hoping they wouldn't say no when I gave them my price.

"Get the hell out of here!" Joe screamed, "We don't even know your work."

I kept cool. "Louis's known me for years. He can tell you how I play," I said.

"I don't pay one twenty-five to nobody just startin' out. I'll give you a hundred. If you work out, I'll give you more," Joe answered.

I stood my ground. "No," I said. "I gotta get one twenty-five."

Joe shook his head, which was his way of saying, "Forget it."

There was dead silence for a couple of seconds and then Louis spoke. "I know this boy. Give it to him." It was settled, as simple as that.

A week later I went out with the band and for a while we mostly did one-nighters. Cozy was still there along with Trummy Young playing trombone, Barney Bigard on clarinet, and Marty Napoleon on piano. We also had Velma Middleton as a vocalist. At one of those early gigs something incredible happened.

It was at an outdoor concert in Washington, D.C., near one of the big malls, right on the Potomac. The stage and dressing rooms were set up on a big barge which was docked at the edge of the river, and the audience sat on the long, wide grass bank in front of it. We had to walk down a ramp to get on the barge so we could change clothes and get set up. But the facilities were very comfortable.

In addition to us, Lionel Hampton and Illinois Jacquet's bands were on the program. Jacquet was scheduled to play first, from six to seven, and Hamp was to follow from seven to eight. Then, after an intermission, Louis would come out and do the finale.

We had worked in New Jersey the night before and drove down from there in a private bus. We arrived at five-thirty, a half hour before show time. There were about a thousand people in the audience, but no sign of Jacquet's band.

We unloaded our suitcases and instruments and moved everything over to the barge. By the time we'd changed into our tuxedos, it was six-thirty. Jacquet

should have gone on at six, but he still hadn't arrived. To make matters worse, Hamp hadn't made it either.

Standing backstage, we could sense the audience was getting restless. Every couple of minutes they'd start applauding and chanting, "Start the show," and "We want music."

About fifteen minutes later one of the producers went to Frenchy and asked if Louis would go on first. Louis was a star, but he didn't care about billing or protocol. He was usually understanding and cooperative.

So we went out and started playing. After waiting so long, the audience gave us an unbelievable reception. They applauded every solo and when we finished a tune, they'd stand and cheer for a couple of minutes.

We played about an hour and then took our bows. But the people wouldn't let us off the stage. They screamed for encores and we kept doing them. Louis knew there was no act to follow us. And he was content to stay out there and keep everyone happy until help arrived.

Finally, during our fifth or sixth encore, we saw a bus pull up and unload. As soon as Louis knew it was Jacquet's band, he told us, "This time when we end, walk off and stay off."

As soon as we finished, we headed for the dressing rooms and changed. Then we packed up our instruments and hung around backstage talking to some of the guys from Jacquet's band.

Following a performer like Louis really put Jacquet in a difficult position. To make matters worse, the audience knew he'd been scheduled to play first and had kept them waiting. So when he came out onstage, he got a lukewarm reception.

Jacquet had eight or nine good musicians with him. They started with a couple of standards, but there was no response. They even featured the drummer, but that didn't seem to rouse the audience either. Then Jacquet must've figured he had nothing to lose, so he called "Flying Home," the tune he'd made famous with Hamp's band.

It took a couple of minutes before the audience rec-

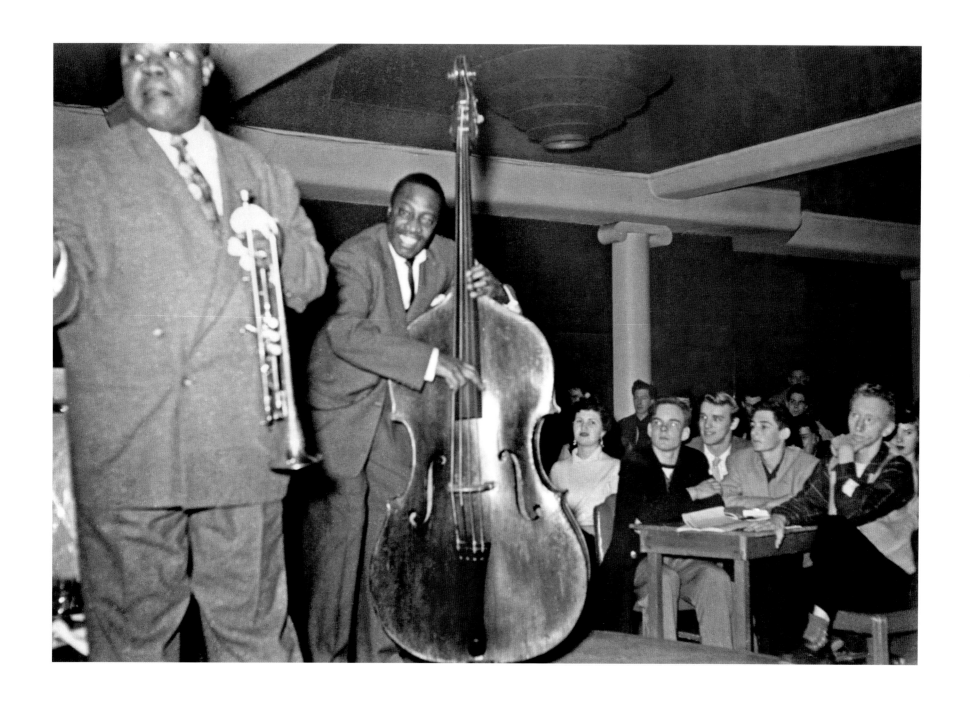

Louis Armstrong and Milt, Seattle, 1954

ognized the tune and started to react. By then Jacquet was soloing and he gave it everything he had—honking, screaming, and dancing. By the time he finished, he had the audience in the palm of his hand, the same way Louis had them an hour before.

The audience screamed for an encore and Jacquet did another couple of choruses of "Flying Home." But right in the middle, Hamp's bus pulled up. Hearing someone else play a tune he was known for and seeing the fantastic audience reaction must've made him furious. Everyone backstage saw what was going on and knew Hamp would want to somehow outdo Jacquet.

Louis was watching and he got interested too. We were set to get on the bus, but Louis turned to a couple of us and said, "Wait, we have to see this."

Jacquet finished and after the stage got set up, Hamp came out. He began with "Midnight Sun," one of his famous ballads. But after Louis's performance and Jacquet's finale, the audience was in no mood for it. He did "Hamp's Boogie Woogie," and a couple more numbers. He even played drums and sang, but he still didn't get much of a reaction.

I was standing in the wings with Louis and a couple of other guys and we could see how hard he was working. But time was running out. He looked frustrated and desperate and he finally called "Flying Home."

The band started playing but there wasn't much response from the audience. Hamp wouldn't give up. He put everything he had into his solo, starting out soft, then building to a crescendo. When he finished, sweat was dripping off every part of him, and a handful of people cheered.

I guess Hamp sensed he was making some headway with the crowd. So while the band continued, he went back to Monk Montgomery, who was playing Fender bass, and told him, "Gates, you jump in the river on the next chorus, I'll give you an extra ten."

Monk must've agreed because when the band got to the next crescendo and Hamp raised his mallets, Monk jumped over the railing. The audience went crazy.

The band kept playing, and a few minutes later Monk came out onstage soaking wet. Hamp walked over to him and said, "Another ten if you do it again."

Monk made it back to his bass and played another chorus. Then when the band came to the same crescendo and Hamp raised his hands, he went over the side again.

By this time the people were in a frenzy and Hamp knew he'd accomplished what he'd set out to do. Louis turned to us and said, "Start up the bus. We can go now."

When Cozy left the band, Kenny John took his place. He was a short, thin, pale, blond kid who'd been fairly successful as an actor in Hollywood and was also a good drummer. But he had some serious problems. He'd gotten his way most of his life and that's probably why he'd fallen into some bad habits which were destroying him.

Louis's schedule was unbelievable. We were on the move constantly. We never seemed to play any single place more than once or twice. In fact, there were many times when we'd do a night in a theater, then move across town or even a couple of blocks away and work the next day. There were always places for Pops to play.

After a while I got close with Barney Bigard and his wife, Dottie, who traveled with us. He was a fair-skinned guy from New Orleans and Dottie is about as white as any white person I've ever seen.

Even though we traveled outside the South, I was always sensitive to the racial scene, especially when it came to hotels. Barney shared my feelings, so whenever we thought there might be a problem, he'd tell me, "Let Dottie take care of our rooms."

The three of us worked out a scheme. Before we'd get to a town, Dottie would reserve a suite at a nice hotel using the name "Mr. and Mrs. Barney Bigard and brother." Then when we got to the town, the three of us would head for the hotel, but Barney and I would go to the bar while Dottie checked in. And a short

time later the two of us would go off to play our gig with Louis.

By the time we finished and got back to the hotel, it was usually one or two in the morning. Most times we didn't have problems going up to our rooms, but there were a few exceptions. Once I remember we were walking through a lobby toward the elevators, and when we passed the desk, one of the clerks asked very loudly, "Where do you think you're going?"

Barney cut the guy off immediately and answered just as loudly, "Is there some kind of problem? We have a suite here."

We walked right up to the desk and Barney told him, "You check Suite 17."

The clerk looked down at his book for a couple of seconds and then said, "Oh, yes, Suite 17, that's Mr. and Mrs. Barney Bigard and brother."

Barney snapped, "You see, I told you I had a suite here, I'm Mr. Bigard." Then he'd turn to me and say, "Okay, brother, let's go upstairs."

Somehow we controlled ourselves until we got into the elevator. But as soon as the doors closed we let it all out. We laughed so hard it hurt and the operator must've thought we were crazy.

Getting back to the financial aspect of the tour—everything was beautiful until we got ready to go over to Japan. I knew we'd be playing more concerts, radio, and TV over there, and I heard we could be doing two or three things in one day. So I went to Joe and told him I had to have a different contract. At first he was relaxed about it, but when I pushed him, we started to argue.

Eventually, we reached an agreement and signed a new contract. Joe would pay hotel and transportation and I'd get one twenty-five for every two shows I did

Unknown, Trummy Young, Billy Kyle, Dottie Bigard, and Barney Bigard, Seattle, 1954

in an eight-hour period. If there were more than two in the same eight hours, I'd get paid another one twenty-five for the next two, no matter where they were. TV and radio were separate, and I was to get an extra one twenty-five for each one I played.

All the personnel in the group stayed the same, except by this time, Billy Kyle had replaced Marty Napoleon. Everybody flew over together, including Joe and Frenchy, and the tour began almost the minute we landed in Tokyo.

We worked like crazy. We started off doing six shows a day, plus a couple of radio and TV programs each week. I was very careful about keeping good records. At the end of every day I'd sit down and figure out how much I'd earned. And it was adding up quickly.

Sometimes when things are going smoothly I begin to get a little nervous. So after about ten days, I decided to check in with Joe, just to make sure his records of the finances were the same as mine. We met in his hotel room one afternoon. He took one look at my calculations and went wild. I tried to stay real calm and rational.

"Look, Mr. Glaser, yesterday we did six shows. I get one twenty-five for every two, so that's three times one twenty-five."

He didn't answer.

I gave him some more examples. I mentioned other concerts and the radio and TV shows we'd done, but all he'd do was shake his head from side to side.

Then he finally spoke. "No, no, no. You don't like what's going on? Quit. You want money? I'll pay you in yen."

There was nothing else to say. There was no point in quitting. I figured the best thing to do was finish the tour and then try to settle up when we got back to the States. That way, whatever I got would be in dollars and I wouldn't lose on the exchange rate.

About a week later, I got a cable from Mona telling me that Lou Shoobe, a contractor at CBS, had a TV job for me in New York. Since things were bad with Joe, I thought about getting on the next plane. But I

didn't want to hurt Louis. I'd made a commitment and I knew I had to stay.

I wired Shoobe and asked if he'd hold the job for me until I finished with Louis. Two days later I got a wire saying he agreed.

Knowing I had a good steady job waiting back in States made everything easier. From then on, I enjoyed the trip much more. We spent most of the time working in Tokyo, but we also traveled to other cities, like Kyoto, Osaka, Sendai, Kobe, and Yokohama.

Louis was never a problem. He didn't have a big ego so he never wanted special treatment. He'd travel right along with us, in buses or planes—it didn't matter to him. He was quiet and didn't like to hang out a lot. If we worked at a club, he'd never go out into the audience. I heard this habit dated back to his early days in New Orleans when clubs were segregated and he wasn't allowed to socialize with customers.

Pops spent most of his free time in his dressing room and let the world come to him. He didn't care who or how many came, either. He'd just sit there in his undershirt with a handkerchief tied around his head, talking and fooling with his horn for hours. I never got the feeling he missed being home or wanted a break from all the traveling.

His life was pretty simple and he followed a regular routine practically every night. When he was through working and no one was left in his dressing room, he'd go back to his hotel, get undressed, and light up a joint. Then he'd usually write some letters. He loved doing that. He'd get so involved, no one could get his attention.

After about an hour, he'd send out for Chinese food. That was his big meal for the day and he'd always drink a beer while he ate. I never saw him drink hard liquor until he got older and started taking brandy, which might've been for medicinal purposes.

By the time he finished eating, it would be early morning. He'd be exhausted, but sleeping was always difficult for him. Years earlier, he'd worked out a special way to get some rest.

Wherever he traveled, he took three tape recorders

Kenny John, Barney Bigard, Billy Kyle, and Trummy Young, backstage, Tokyo, 1953

Milt (*left rear*), Louis
Armstrong (*right front*), and
Barney Bigard (*behind Louis*)
with fans, Tokyo, 1953

which were hooked together and stacked up on
shelves in a special trunk he'd had made. One of his
two valets would load all three machines and, as soon
as Pops got into bed, the first one would be turned
on. The music was always the same—his own or Guy
Lombardo's—and usually within a couple of minutes,
he was snoring.

The valets would take turns staying up and watch-
ing the machines. When a tape finished, they'd quickly
switch on the next recorder, then reload the empty.
They knew that if the music stopped, even for only a
few seconds, Louis would wake up.

When we left Japan, Joe flew to New York and
everyone else went to Honolulu, where we were sched-
uled to play a place called the Brown Derby. Barney
and I had made arrangements to get a cottage with a
kitchen at a big hotel called the Moana. But our plane
was late getting in, and since there were only a couple
of cottages at the hotel, Barney was worried they'd
give away our reservation and put us in regular rooms.
So he told me he'd wait for my luggage to be un-
loaded and take it through customs. That way I could
go through Immigration fast, grab a cab to the hotel,
and make sure we got our cottage.

Louis Armstrong, hotel room,
Seattle, 1954

I checked in an hour later and got the cottage. Then I sat around the lobby waiting for everyone. But after two or three hours passed and no one arrived, I began to worry.

I kept checking with the hotel people, but they had no information. After waiting a few more hours, I overheard some people talking in the lobby about Louis being arrested for drug possession. That made me even more anxious and I went back to the cottage to try to get some sleep. Finally, at about two AM, Barney walked in and gave me the details of what had happened.

When Louis's wife was going through Customs, one of the inspectors discovered a joint in her eye-glass case. Louis wasn't with her when they found it, but that didn't stop them from searching him and everyone else connected with the band. Even though Louis and the guys were clean, they got held for hours.

I saw Louis the next day and he was absolutely furious, ranting and raving about being stopped and how badly he'd been treated. "I spread goodwill for my country all over the world and they want to put me in jail," he yelled. Then he said, "If that theater's allowed to cancel us out without paying us our money, I'm gonna tear up my union card."

In fact, we were cancelled. When we went to the theater to get our instruments, we found them piled

Louis Armstrong, hotel room, Seattle, 1954

up out on the street and it took us hours to put things back in order.

A couple of days later we flew to San Francisco and checked into a hotel. Then I went to Frenchy's room and told him that since the tour was over, I'd be going on to New York the next day to start a job at CBS. He must've gotten on the phone to New York right after I left, because Joe called me within an hour. He was more than upset:

> I hear you're quittin'. Whatta ya mean, you're quittin', you little son of a bitch! You don't just pick up and walk out on the greatest name in the music business. Who the hell do you think you are? You can't leave Louis stranded out on the road. You do that and I'll see to it you never work for anyone again.

I knew about Joe's reputation from the old days in Chicago. It was the way he said those last words that made me do some quick thinking. I told him:

> Look, I got a good offer at CBS and they're waiting for me to get back. But I know it's not right to leave Louis stranded. I'll tell CBS to wait another two weeks. That way I can finish all the gigs Louis has out here and it'll give you a chance to pick up a good bass player.

"Good, I'm glad you're gonna stay," he said.

"Remember, I'm doing the things out here and that's all," I told him.

Before we hung up he told me, "Go see Frenchy. Give him your figures from Japan. He'll give you a check."

The next morning, Frenchy gave me a check for more than twelve thousand dollars. It was a hell of a lot more than I'd ever had at one time and I sent it home to Mona immediately.

Later that day I called Lou Shoobe to tell him about the two-week delay. He wasn't too happy, but he accepted it.

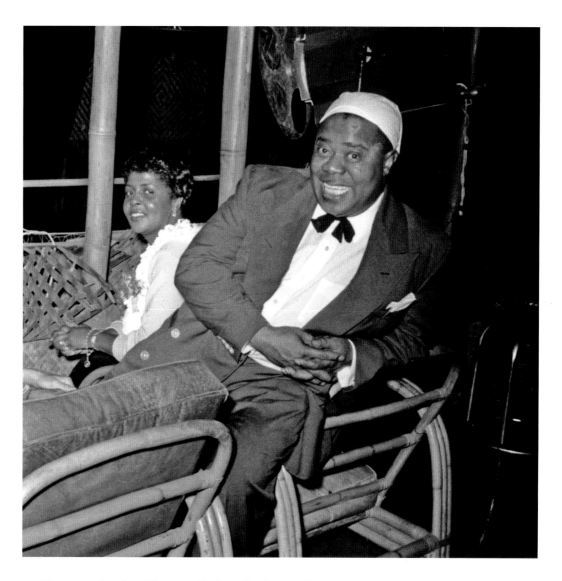

The next day Joe Glaser called me back to tell me about some new plans. "Look, after they finish in Seattle, they're gonna stop in Chicago for a couple of weeks. You got family in Chicago. You gonna make that?"

"No, Mr. Glaser," I said. "I'd love to, but I have to get back. They're waiting for me at CBS."

About two weeks later we finally finished playing the Coast. Louis went on to Chicago and I flew to New York.

Lucille Armstrong and Louis Armstrong, Honolulu, 1954

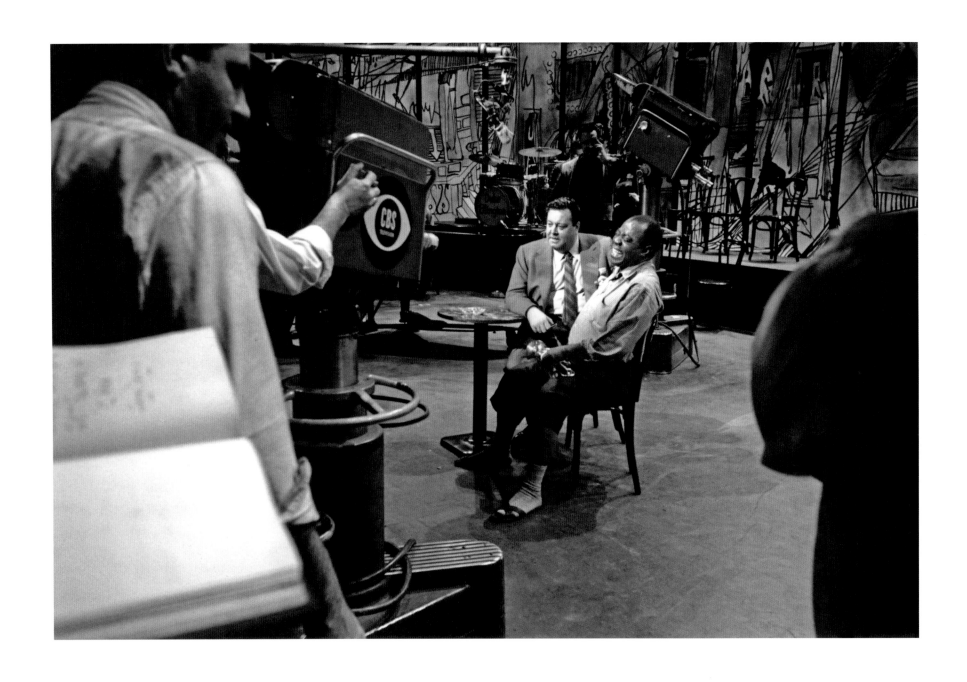

Jackie Gleason and Louis Armstrong, television studio (*Timex* rehearsal), New York City, 1959

Less than a week after I was home, Shoobe put me in the band on *The Robert Q. Lewis Show* on televison. Ray Bloch was the conductor, and that's when I found out he was really responsible for keeping the job open until I finished with Louis. Evidently, he kept telling CBS he had to have me in the band, and Shoobe had to go along with it.

Shoobe had been a bass player with CBS, but when I met him he wasn't playing anymore. He had an ordinary build, dark hair, and a mustache. He always had a cigarette in his mouth and, maybe because of that, his lower jaw looked a little turned. He had a reputation as a disciplinarian, especially when it came to punctuality. And he was also known as a person who didn't do favors for anyone. He never said much, but if he had a problem with somebody, he always let them know about it.

The show was on five mornings a week. It was a beautiful gig for me. I got a chance to work with a good conductor and some of the established studio guys. Shoobe hired me as a freelance musician. I wasn't on staff, which meant I got paid by the show and didn't have any other commitments to the network. So when we finished at noon every day, I was free to do other freelance work in the afternoons and take something steady at night.

That's exactly what happened. Almost immediately, I got a steady gig at the Metropole. Joe Glaser was booking it, and even though we'd had our problems a few weeks earlier, he hired me. The personnel changed all the time, but when I started I was with Jimmy McPartland and Bud Freeman, and we alternated with a group led by Cozy. The pay was good, and with the money from the TV job and a couple of other freelance gigs, I was in fine shape.

The Metropole was a pretty unusual place. The bandstand was behind the bar and elevated, so if you were sitting at the bar, you'd look up to see the guys. You got to the bandstand from one end, and it was so narrow that you had to be very careful when you crossed it. You could easily knock a drum into the bar well or trip and end up there yourself. I always wor-

Lou Shoobe, recording studio, New York City, c. 1958

ried about the big guys who had to squeeze by the larger instruments to get to their positions on stage. Posters with the names and pictures of the musicians who played the Metropole were used to decorate the wall behind the bandstand.

The audience seemed to be made up of tourists who were just passing through. They were usually loud, and people didn't seem to pay attention to the music. But over the years, many people told me they spent hours sitting in that place, just listening. And some said it was their first exposure to jazz. It was cheap and if you got close enough to the bar, you could hear almost everything.

About a month went by. Then one day Joe Glaser called and asked me to go into Basin Street West with Louis, who was coming back into town. He told me, "When you play in New York, everything's gotta be right. I want Louis to have the best guys around." I knew that wasn't all of it. Arvell Shaw had replaced me, and I knew he and Joe had some kind of falling out. I agreed to do it if I got the same one twenty-five a day I got in Japan.

We must've argued for ten minutes. Joe kept saying, "You're not on the road. You live in New York. I

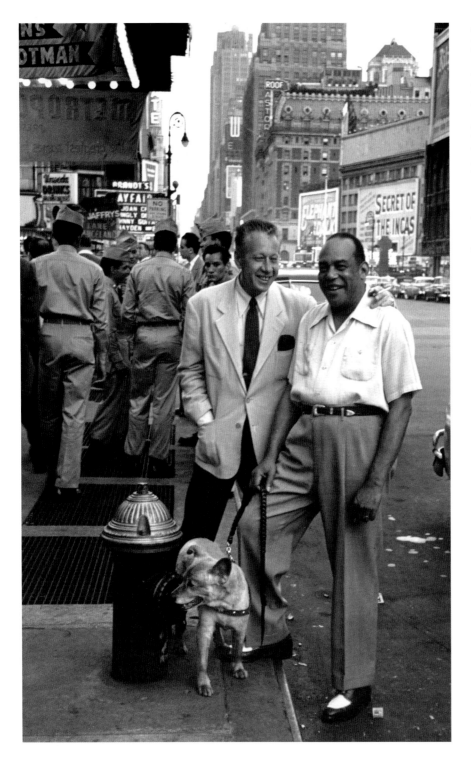

don't have to give you that kind of money when you're home."

I knew he was stuck. Not only was Arvell gone, but I figured Louis wanted me and was probably telling Joe that. So I held my price.

Finally he said, "Okay, if you do a good job for me, I'll give it to you and I'll look out for you." I wasn't sure what that meant, but I was so happy about the money, I didn't bother asking.

Basin Street West was a downstairs place at 51st and Seventh. There was no bar, only one big room filled with tables and a bandstand for six or seven guys. We did business like nobody could believe. The room was always packed, even for the midnight show on weeknights. There was no problem about the money either. I got paid what we'd agreed to.

When Louis closed, Joe asked me to go out on the road again. I had the steady TV job and plenty of freelance work and I enjoyed being home too much to consider it. I tried telling him how much my family and home meant, but he only wanted to know what kind of money it would take to get me, and he kept increasing the offer.

At one point I told him, "Look, I've been traveling so long my daughter doesn't even know me." When he heard that, he said I could take my family with me and he even offered to pay for a babysitter and tutor for Charlotte. But there was nothing that could get me to go.

I finally convinced him to give Arvell another chance. Joe was a strange man. He'd argue with you, threaten you, call you all kinds of names, but I think he really had some respect for people who stood up to him.

He'd said if things went well with Louis, he'd take care of me. He made good on that by giving me the relief band at Basin Street West. And for the first time in my life, I had my own group, the Milt Hinton Trio with Al Williams and Kelly Martin. We stayed for a month and there were even a couple of weekends when I got to add a guest horn player like Seldon Powell.

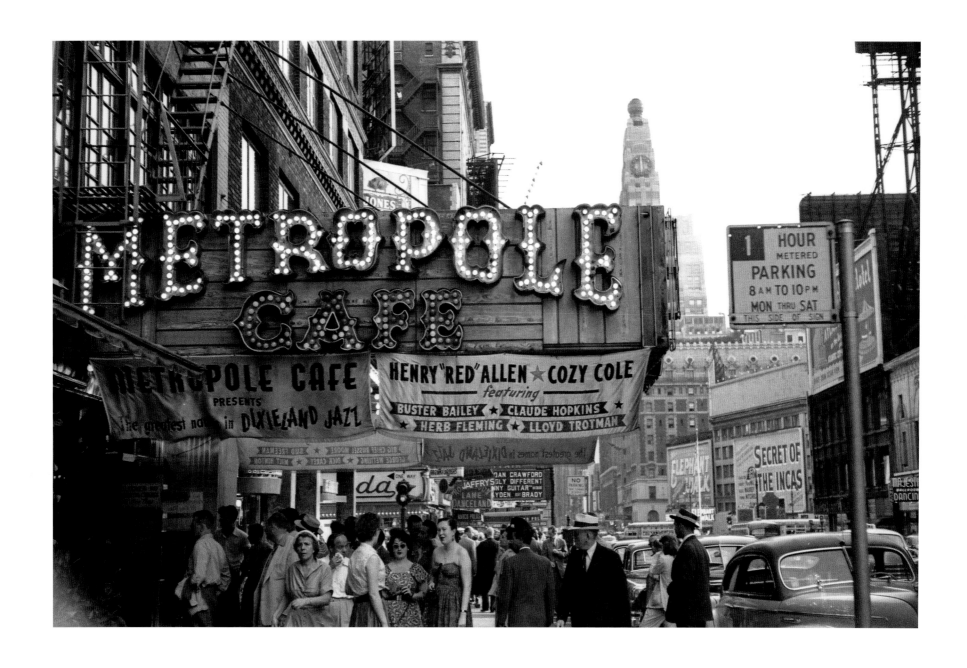

[Above] The Metropole Café, New York City, 1954

[Opposite page] George Wettling and Zutty Singleton with his dog, Bring Down, outside the Metropole Café, New York City, c. 1954

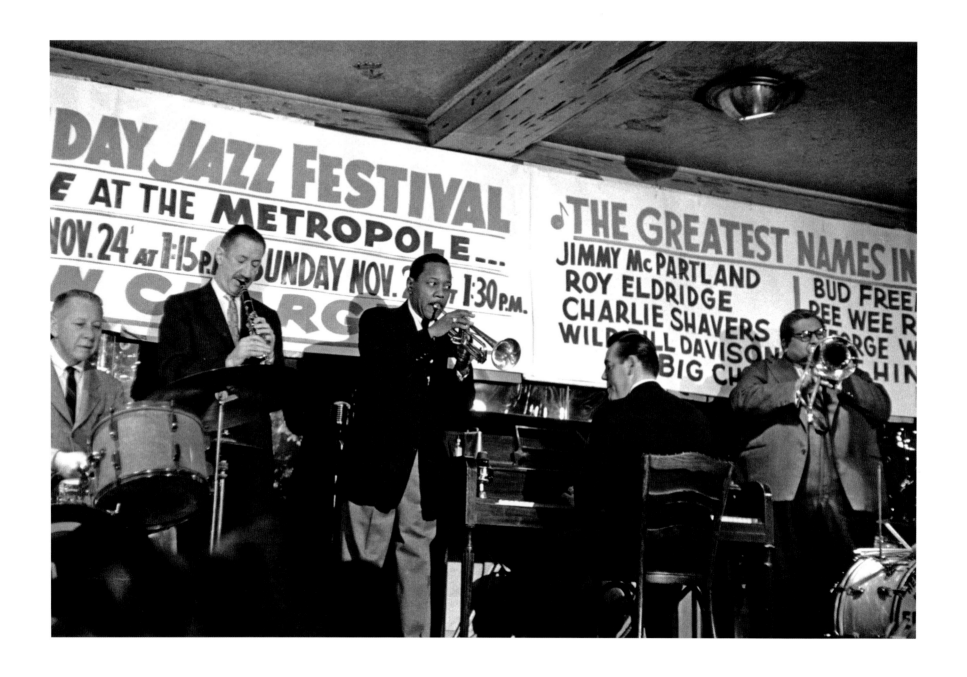

George Wettling, PeeWee Russell, Roy Eldridge, Marty Napoleon, and Big Chief Moore,
the Metropole Café, New York City, c. 1955

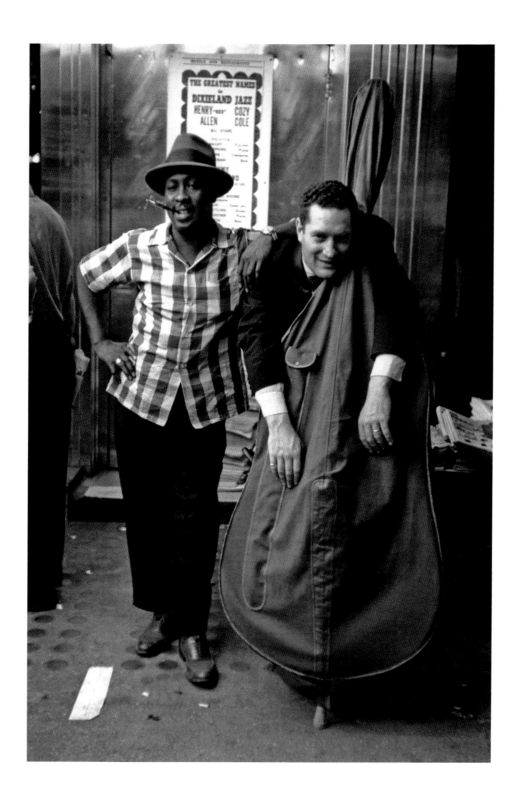

Panama Francis and Irv
Manning, the Metropole Café,
New York City, c. 1951

Benny Goodman was booked to follow my trio gig and a couple of days before we finished, he came by and asked me to play with his group. I agreed.

I most likely worked with Benny twenty or thirty different times after our Hull House days in Chicago back in the '20s. Sometimes it was for a week or two in a club. Other times we'd do a concert or a TV special.

Benny was a great clarinet player. For a jazz musician he was unusual, because he also had a big following in the world of classical music.

Some people say John Hammond was the man behind the scenes when Benny hired Teddy and Hamp, but I give Benny a tremendous amount of credit. He went out on a limb and did a very unpopular thing. I don't think he did it just to make a statement to the

world. He had a sincere desire to play with the best people he could, regardless of their color. For me, his reasons don't matter. What's important is that he was the first to open doors and create opportunities for black musicians.

I did a couple of gigs with Benny which were particularly memorable from a musical standpoint, and Basin Street West was one of them.

The personnel changed a few times over the four or five weeks we were there, but at one time or another we had Gerry Mulligan, Ruby Braff, Bobby Donaldson, Teddy Wilson, Zoot Sims, Paul Quinichette, and Urbie Green. It was one of the best-sounding gigs I've ever played, and for a long time I felt bad we'd never been recorded.

But then one day about fifteen years later, I got a

six-hundred-dollar check for some record sessions I couldn't remember playing. Mona decided to track it down. Evidently, without our knowing, Benny had been recording us at Basin Street West every night. Later he sold the tapes to a company which had to pay everyone what we'd get for a regular album. I was glad, because when I finally got to hear the record, it confirmed what I'd always remembered about how good we sounded.

There was another gig we did at the Rainbow Grill I'll never forget. It was a quintet with Benny, me, Bob Rosengarden, Bucky Pizzarelli, and John Bunch. The place was packed, night after night, and we really tore

it up. Looking back, I'd have to say Benny probably enjoyed that gig more than any other we did.

It's no secret that most musicians found Benny difficult to get along with. An incident which happened to George Duvivier is typical of what many other guys experienced.

George told me they were playing at a club one night and right in the middle of a chorus Benny turned to him and told him to lower his amp. George did what he was told. But that wasn't enough. When they finished the tune, Benny looked over at George and said, "Turn off your amp."

Fifteen or twenty seconds later, they began the next

Benny Goodman, concert rehearsal, New York City, c. 1956

tune and about two choruses into it Benny turned to George, shook his head from side to side, and said, "Don't do that. Don't do that. Take your bass and stand over there for a while."

George would never take that kind of thing from Benny Goodman or anyone else. On the next break he walked up to Benny and told him, "Look, man, I'm gone. Don't ever call me again for anything. As far as you're concerned, I'm booked forever."

After a while, word about Benny's behavior got around and a few inside jokes developed. If somebody was acting peculiar in a bar or on the bandstand, one of the guys might look at him, shake his head, and then, imitating Benny's tone of voice, tell him, "Don't do that. Don't do that." It also became common for us to tell each other, "You know you've made it when Benny Goodman's fired you at least once."

Like many other guys, I had a few strange experiences with him too.

One began when Benny asked me to do a television show with him. It involved rehearsing in New York in the afternoon, then flying up to Canada for the performance at night.

When I went down for the rehearsal, I couldn't believe my eyes. I saw Mel Torme and Red Norvo along with some other fabulous sidemen, but Slam Stewart was there too. At first I figured Benny had made some kind of mistake, but after listening to him for a couple of minutes, I knew he'd done it intentionally.

It's difficult for two basses to play together in one rhythm section. It's especially hard on the drummer, who hears different bass notes flying from all directions.

I tried telling this to Benny, but he just shrugged his shoulders and said, "Well, go ahead and try."

At first, Slam and I decided to take turns playing choruses, but that didn't work out too well. Then I suggested we take turns playing tunes. Slam played the first song, but when Benny saw me standing on the sidelines watching, he said, "Come on, both of you, play together." I took my bass over to where Slam was

[Above] Benny Goodman, television studio (Patti Page's *The Big Record* rehearsal), New York City, c. 1957

[Opposite page] Zoot Sims, New Orleans, c. 1979

standing and started playing, but a couple of choruses later Benny turned around, looked at me, and said, "Milt, would you mind laying out for a while. Just go over and stand on the side." To tell the truth, I felt a little hurt, but Benny was the leader, so I did it.

I stood about twenty feet away. Benny couldn't miss seeing me watching and waiting, but he let Slam play the next three or four tunes.

Finally, someone called for a five-minute break and I went over to talk to Benny. "If you don't need me for the rest of the day, is it okay if I go?" I asked.

Benny stood there fingering his clarinet for a few seconds. Then he said, "Okay, Pops."

I expected more of an answer, but that's all I got.

I went over to Beefsteak's, a local bar where I hung out. Then I wrote a note to Benny's secretary saying I wouldn't be going to Canada. I had the uniform they'd given me for the show in the back room. I pinned the note on it and had a messenger deliver it to Benny's office.

A couple of days later Benny called. "You mad at me, Milt?" he asked.

"No, Benny, I'm not mad. I love you. I don't have time for carrying a grudge," I told him.

Another experience had to do with a jazz festival on the West Coast about twenty years ago. Carl Jefferson called and asked me to get some of the older guys around New York to come out and do one night at the Concord Festival. He said he'd give everyone a thousand bucks and also pay transportation. I made a few calls and lined up Roy Eldridge, Benny Morton, Claude Hopkins, Budd Johnson, and Jo Jones.

As it turned out, Benny was scheduled to play at the same festival on a different night. Somehow he learned I'd be out there and he called me. "I hear we're going to be playing at Concord next month," he said. "Listen, I'd like it if you would play for me."

"Sure, Benny," I told him. "What's it like?"

"How's one fifty?" he answered.

I was speechless for a couple of seconds. I was going out there for a thousand and transportation, and he was offering me one fifty.

"Oh, Benny, for goodness' sake!"

"Well, look, I want you to be happy. What do you want?"

I thought for a moment, "Five hundred."

He hung up.

That particular incident, like so many others, didn't end our relationship. He called again and asked me to do something else, and whenever I was free and the price was right, I'd take it.

I never thought of Benny as being angry. He always seemed to be a loner. In fact, later in his life, I'd see him standing alone, playing pinball machines in one of the arcades on Broadway. To me, he seemed to be a man who just found it very hard to be comfortable with people.

Jack Lesberg, another bass player, was responsible for getting me my second job in broadcasting. But this time, instead of TV, it was a radio show.

For months he'd been doing *The Housewives' Protective League*, Galen Drake's Saturday morning radio show on CBS, and also playing the *Lucky Strike Hit Parade* on NBC-TV. Then the *Hit Parade* people changed their rehearsals and the new schedule conflicted with Galen Drake. Jack was forced to make a choice and decided on TV, where the future looked more promising. When he told Galen Drake's people he was leaving, he recommended me as his replacement.

Since the Drake show was at CBS, Lou Shoobe was contracting, but the final decision was up to Bernie Leighton, the leader and piano player. He agreed to hire me. In addition to Bernie, Al Caiola was on guitar and Romeo Penque played woodwinds. There was no drummer, and I was the only black in the group.

At this point things were really going well for me. I was doing *Robert Q. Lewis* on weekdays, Galen Drake's show on Saturday mornings, and playing in clubs almost every night. I was also getting more calls to do record sessions and even though it was freelance work, I was becoming a regular in the studios.

A couple of months passed and then I got offered another radio job. This time it was the *Woolworth Hour* on Sunday afternoons, with Percy Faith conducting. There were about sixty men in the orchestra, including some of the most established guys in New York. I was the only bass player, but there was a full-sized string section.

The guest stars who appeared on each show determined the kind of music we played that particular week. If it was someone like Robert Merrill or Roberta Peters, there would be opera, of course, but if it was Ella Fitzgerald or Erroll Garner, we'd play jazz.

Sam Shoobe, Lou's brother, who was a bass player on staff at CBS, did the show for a while. Evidently he got reassigned and I got the call because they wanted someone who was very flexible musically. People in the industry knew I played jazz, but by this time I guess the word had gotten around that I could read and bow too.

The first couple of times I did the show, I was pretty nervous. I didn't know what kind of music I'd have to play. Also, I felt a little uncomfortable in a situation where Specs Powell, a drummer on regular staff, and I were the only blacks. But it really didn't take long before I knew I could handle the music. The classical parts were always fairly simple, and naturally, whenever we played jazz, I felt right at home.

At first, just having Specs there helped ease my mind. In fact, he taught me some useful tricks about counting long musical rests. And by the third or fourth week, a lot of the other guys really went out of their way to be friendly toward me.

A few months later, Lou Shoobe put me on another radio show he contracted. It was a Sunday night celebrity talk program hosted by Mitch Miller which was broadcast from a restaurant in the Park Sheraton Hotel.

There were three of us—me, Bernie Leighton, and Jimmy Raney on guitar. We'd go in at about five and set up our instruments next to the bar. Then we'd have a couple of drinks before the program started.

The show always opened with a recording of

Mitch's theme song, which featured him on oboe. We'd follow with eight or ten bars of music, just to let the listeners know something live was happening in the place. Then Mitch would do his interviews and we'd eat dinner. Naturally, if one of his guests happened to be a musical performer, we'd do the accompaniment. We didn't even have to play at the end of the show. It was probably the easiest steady gig I ever worked.

For a while I did a Saturday afternoon program at CBS with Teddy Wilson and Jo Jones. I think it was simply called *The Teddy Wilson Show* and it was a half hour long. Every week there'd be a different guest artist, but it was so low-budget that many times the guest would be one of the staff guys at CBS.

At some point during this period, I did Vic Damone's TV show, Patti Page's show, the *Big Record*,

Jack Lesberg, recording studio, New York City, c. 1981

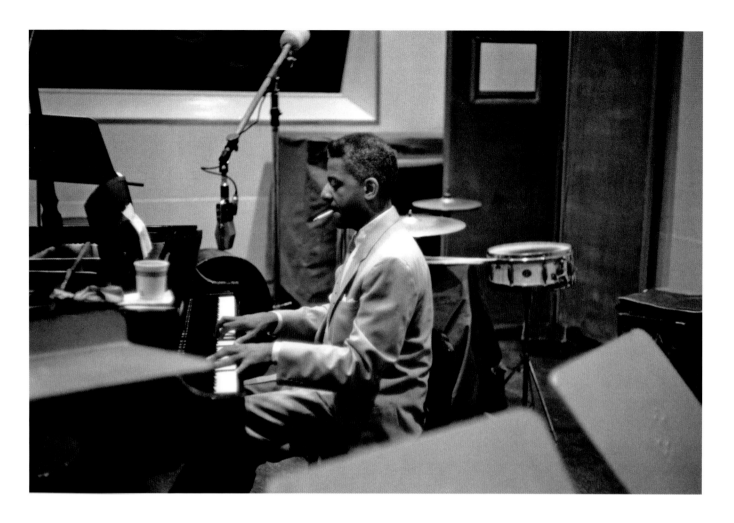

[Above] Teddy Wilson, recording studio, New York City, c. 1955

[Opposite page] Charlie Shavers, recording studio, New York City, c. 1956

and Gleason's *Honeymooners* series. For that show, we'd go down to a studio one morning a week and record the incidental music for the latest episode. Lines from the soundtrack would be played and we'd record a few bars which helped make transitions from scene to scene.

A couple of months later, Gleason's people had Shoobe ask me and Charlie Shavers to do his regular variety show. By this time I was too booked in the studios to take the job, but Charlie did. He was a great trumpet player who'd worked in Kirby's band, but like too many others of that era, he drank far more than he should. There's a funny story about him on the Gleason show.

Evidently, things went fine his first week, but there was a rapid decline after that. Even though Charlie came in for all the rehearsals the second week, he was nowhere in sight for the actual performance. Two days passed and then Shoobe saw him on the street and asked, "What happened to you Saturday night? Where were you?"

And Charlie answered with a straight face, "Wasn't I there?"

Over a seven- or eight-year period, I must've done a dozen different radio and TV shows, and probably averaged five or six hundred a week doing them. Regular staff musicians earned about half as much and worked

much longer—four hours a day, five days a week. I had a great situation because I was never on staff. That meant I'd get paid by the show. And since I never spent more than fifteen hours a week on rehearsals and shows, I always had free time to do record dates. Of course, Shoobe knew exactly what was going on, but we never discussed it.

It didn't last forever. Eventually CBS brought in some efficiency experts to look at their operation and they quickly figured out how much could be saved by using staff musicians instead of me. Shoobe called me in and was very apologetic. He offered me a regular staff job, but it was just a formality because he knew about the record work I was getting. When I turned him down, he told me he was forced to let me go.

Fortunately, in those days musicians couldn't be fired until a show ended, so I didn't have to drop everything immediately. I waited for each show to run its cycle and then left them, one by one. It also helped when I got a call to do the *Polly Bergen Show* for ABC. I took it because it didn't require much time, and I could continue freelancing in the studios.

The recording business was booming and a good part of it had to do with the growth of LPs and the sales of hi-fi and, later, stereo equipment. By the middle '50s I was doing a couple of dates a day and also making jingles and movie soundtracks.

When I broke into the record business, there was a small group of producers and contractors who were responsible for hiring musicians, and a few of them really seemed to like me. I did a lot of work for people like Mac Ceppos at RCA, Julie Held at Capitol, Milt Gabler at Decca, Clyde Otis at Mercury, and of course, Lou Shoobe who also contracted for Columbia, which was the CBS label.

Most of the time I played popular music, although occasionally I did get to do some jazz dates. The music changed from session to session. I might be on a date for Andre Kostelanetz in the morning, do one with Sam Cooke or Johnny Mathis in the afternoon, and then finish up the day with Paul Anka or Harry

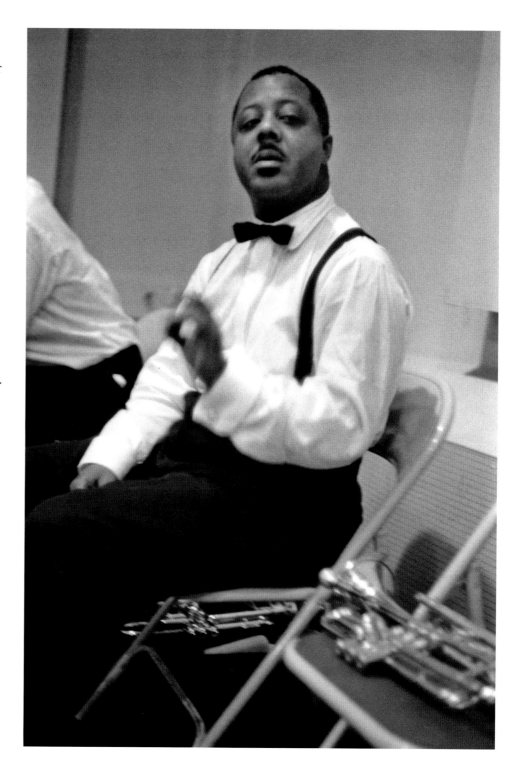

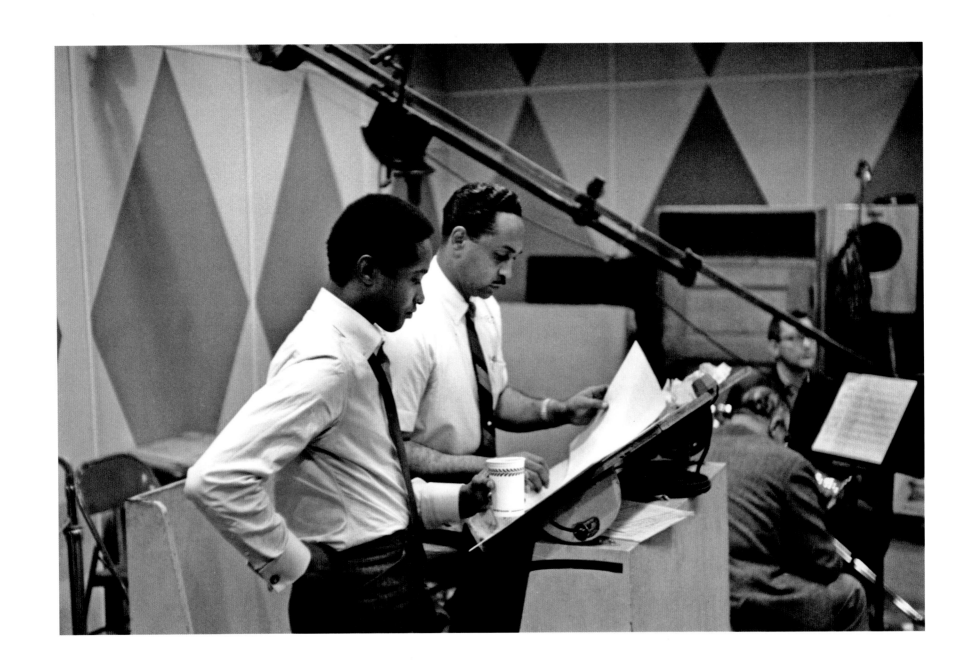

[Above] Sam Cooke and Ernie Wilkins, recording studio, New York City, 1960

[Opposite page] Aretha Franklin, recording studio, New York City, c. 1961

Belafonte. At one time or another, I probably played for just about every popular artist around in those days.

Many of the jazz dates involved big studio bands accompanying artists like Sarah Vaughan and Joe Williams, or playing arrangements and compositions by guys like Quincy Jones and George Russell. And I got to make some albums with small jazz groups, but that didn't happen very often.

When I first became a regular on the studio scene, scale for a three-hour date was about forty-one dollars, which was a lot of money back in those days. For a while, scale was the same no matter what day or what time you recorded. Studios were active around the clock. Some producers found it more convenient to have sessions late at night after an artist finished doing a Broadway show or a nightclub act, or when a few of the best sidemen would most likely be available. It was common to have midnight sessions go overtime and end at four in the morning. In fact, I can remember many times when I'd finish at daybreak, have a session start two or three hours later, and have a couple later the same day.

Needless to say, this kind of schedule really took its toll on musicians. Eventually the union increased the scale for Saturday and Sunday sessions—except for Broadway shows—and for dates beginning after one AM. After the change, the pace was still hectic, but there were many fewer early mornings and weekends involved.

When I really got busy, I found there were many days when it was practically impossible for me to get from one studio to another on time. Naturally, having to deal with a bass slowed me down considerably. The packing and unpacking wasn't the problem—it was the transportation. Dozens of times I'd have to stand on a corner for twenty minutes waiting for a Checker to come along because a regular cab wouldn't pick me up with the bass.

After a while, I learned about a group of studio musicians who'd had the same problem at one time, but had worked out a solution. They hired a guy

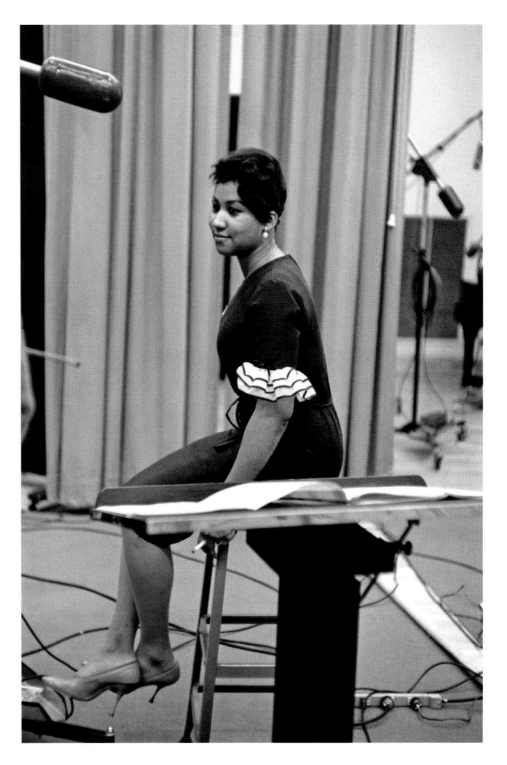

Big Joe Turner, backstage, Carnegie Hall (*From Spirituals to Swing*), New York City, c. 1967

Joe Williams and Jimmy Jones, recording studio, New York City, c. 1960

Gene Krupa, concert,
New York City, c. 1955

Cannonball Adderley, recording studio, New York City, c. 1958

Art Farmer, unknown, John Coltrane, Bill Evans, and Bob Brookmeyer, recording studio, New York City, 1958

Marion Evans and Tony Bennett, recording studio, New York City, 1967

J.J. Johnson, Osie Johnson and
Miles Davis, recording studio,
New York City, c. 1956

Sarah Vaughan and Bob James, recording studio, New York City, c. 1967

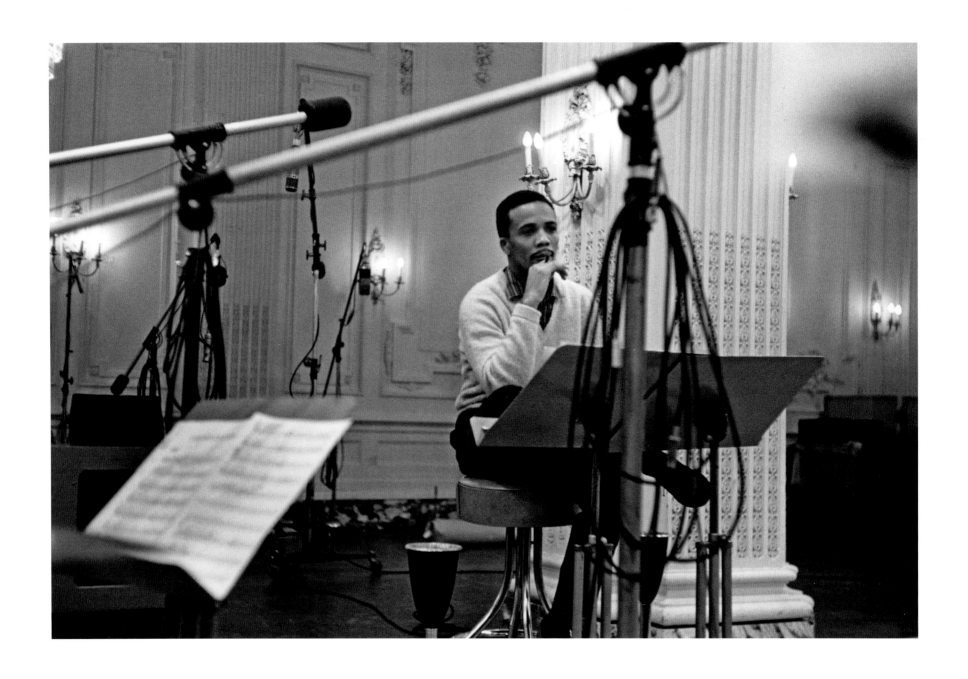

Quincy Jones, recording studio, New York City, c. 1959

named Ernesto Ricci, who'd been moving instruments and running errands for Ray Bloch for thirty-five years.

It was really simple. Each guy had a couple of his own instruments, and every few days he'd call Ernesto and give him an up-to-date list of sessions. Then Ernesto would move the instruments from studio to studio, making sure one always arrived long before the guy showed up to play a date.

Once I heard about Ernesto, I hired him too. What made things even better was the union rule saying guitarists with amplifiers, drummers, and bass players got an extra three dollars a job to pay for the cost of carting their instruments. The additional money almost covered his charges.

Ernesto had come over from Italy at a very young age and he spoke with a pretty thick accent. He's the only person who ever called me "Milty." And even though it's been years, I can still hear how he'd say it. He was a little man, but he was incredibly strong. He didn't drive, and even though he sometimes used the same cabdriver to help, you'd always see him walking around midtown carrying and pushing a couple of different instruments and amplifiers.

He had to be very well organized to keep up with the daily schedules of a dozen different guys and continue to work for Ray Bloch. You could call him at any hour of the night to give him a last-minute change, and he'd be right on top of things. He was one of the most responsible people I've ever known. And to the best of my knowledge, he never let anyone down.

But there were always a few great stories around the studios about Ernesto. Since he'd been with Ray for so long, some of the best ones were about that work.

Apparently, it was common for him to wander through the CBS studios searching for Ray. And since he always seemed to be totally unaware of what was happening around him, on more than one occasion he'd walked right onto the set of a live TV show and appeared in living rooms across America.

There was also a great story about banking. For years Ernesto would go to the bank a couple of times

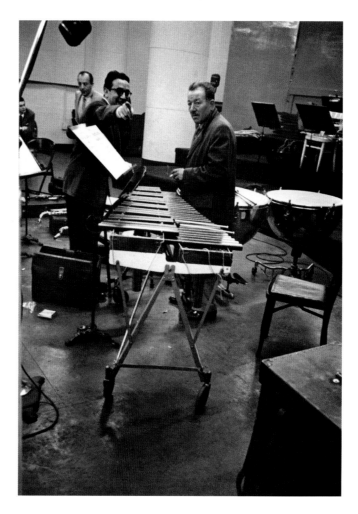

a week to do all Ray's banking. One day, he couldn't make it and Ray had to go himself. There was only one problem—the bank people had never seen Ray before and the only person they associated with his accounts was Ernesto. So when Ray went to the window to make his deposit, the teller accused him of being an imposter and called the guards over.

Ernesto's lifelong ambition was to save enough money to go back to Italy and retire. When the time finally came, he did go back, but within a few months he died.

After I had Ernesto to help out, I didn't have the

Toots Mondello, Bill Versaci, and Ernesto Ricci, recording studio, New York City, c.1955

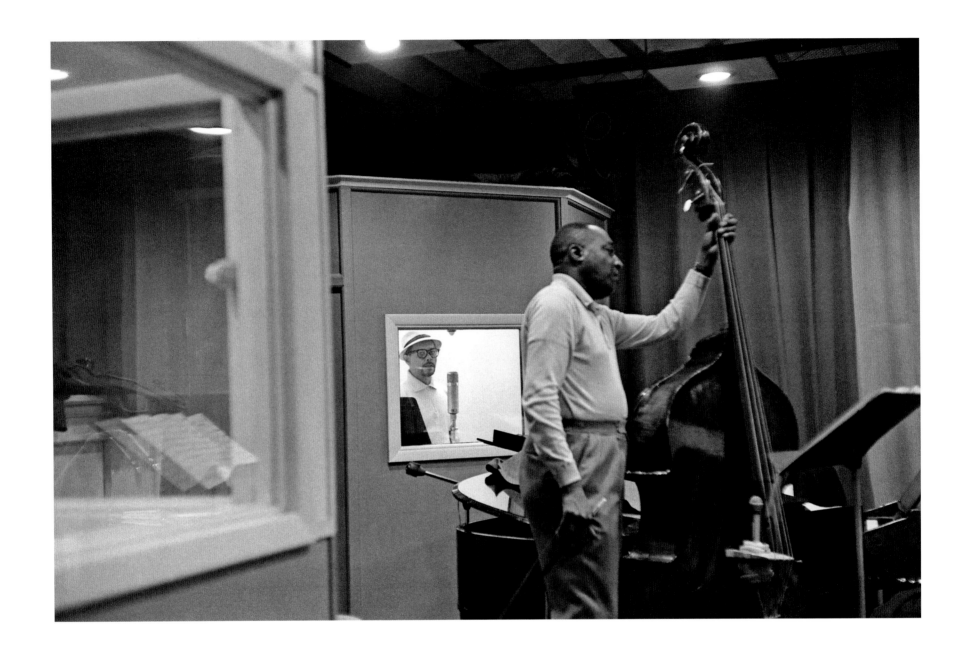

Milt and Billy Eckstine, recording studio, New York City, c. 1959

same problem making it from studio to studio, but there were still a few times I had close calls.

One incident involved Lou Shoobe and a *Honeymooners* session. The recording schedule for the show was so predictable you could set your watch by it. We'd start at ten in the morning and end no later than one. There was never overtime. Knowing this, I got into the habit of taking record dates which started at two, leaving me a full hour to get from one place to the other.

On this particular day, my luck ran out. We were recording, and at about noon, right in the middle of a take, a piece of equipment broke down. I had a two o'clock session and even though it wasn't scheduled to start for almost two hours, I began feeling nervous almost immediately. Cab had taught me the importance of punctuality and besides, there was a union rule that if a session went over because one guy was late, he could be asked to pay the overtime for everyone else on the date.

The first thing I did was talk to Shoobe, who was contracting. I figured I knew him well enough to be honest about the problem. We were up in the mid-40s and my date was downtown at Webster Hall. Ernesto already had a bass down there for me, so if I rushed out and grabbed a cab, I could make it in ten minutes.

We waited almost an hour while they fixed the machine, and it was after one when we started recording again. By one-thirty we'd made some progress, but I knew at that point I'd never get to Webster Hall on time. Panic set in. I wasn't thinking about what we were recording anymore, only the names of bass players who might cover for me. I watched the seconds tick off on the big studio clock and realized I wouldn't be able to reach anyone in time. Besides, we were in the middle of a take, so I couldn't drop everything and run to the phone.

Finally, at quarter of two we got a five-minute break. I put my bass down quickly, and just as I started toward the phone in the hallway, Shoobe appeared. He looked at the music on my stand and saw it was a very simple part. "Take off," he said. "I'll play it for you."

Shoobe had always been kind to me, which I figured had to do with us both being bass players. But what he did that day was beyond what anyone would've ever expected from a contractor, especially one who never did special favors. I've never forgotten him for it.

Something similar occurred when I was doing the *Woolworth Hour*. We always rehearsed the show at two on Fridays, but one day I had a session from ten to one at Decca, on the upper West Side, and it went overtime. When it finally ended, it was nearly two. I took a cab downtown to CBS, hoping things would start slowly and nobody would notice me slipping in twenty minutes late.

Unbelievably, everything turned out fine. Ernesto had brought over one of my basses earlier in the day. When I didn't show up, Marty Grupp, a white percussionists in the orchestra, uncovered my bass and stood with it in front of my stand looking like he was playing. When I arrived, I hung up my overcoat in the hallway. I figured if the guys in the booth said something when I walked into the studio, I'd tell them I was just coming back from the men's room. When I opened the studio door I saw Marty immediately. Just as soon as I got over to where he was standing with my bass, he told me with a straight face, "Don't worry, there's no problem. Everybody thought I was you."

A lot of the studio guys lived in the suburbs around Manhattan, forty-five minutes or an hour away. So it was hard to go back and forth, even when there were three or four hours between sessions. Of course, we always spent a good deal of this free time in a few of our favorite bars. But back in the days when sessions went around the clock, we'd usually spend early morning hours in an all-night coffee shop or catch a few hours' sleep in one of the twenty-four-hour movies on 42nd Street. Some of us even bought wristwatches with alarms, just to make sure we didn't sleep through a date.

In New York, bars have always seemed to play a

big part in the lives of musicians, and it's probably the same in other big cities. They've always been places where musicians can meet, socialize, and even find work.

When the downtown Cotton Club opened in 1936, a lot of us spent time between shows drinking down the street at McGinnis's Broadway Restaurant. It was a big place and had a few different rooms. One flight down was a dining room where they served seafood dinners. On the street level, they had a clam and oyster bar and another section for steak sandwiches and hamburgers. On the same floor was the long bar area where we hung out. It was unusual because right over the bar were dozens of Playboy-type cartoons attached to panels which slowly turned.

At first, we hesitated about going in because the patrons were all white. But it wasn't long before McGinnis's got integrated, and it was the chorus girls from our show who seemed to be responsible for that.

Some of the most beautiful girls I've ever seen were in the Cotton Club chorus. Louis married one. So did Duke and some of the other star musicians back in those days. These girls started going to McGinnis's between shows because it was so close to the stage door, they didn't have to worry about changing clothes, especially when the weather was bad. They were so good-looking, no one would dare chase them out. Word spread quickly about where they were spending intermissions, and pretty soon the white customers from the club began going to McGinnis's so they could meet them.

We took advantage of the opportunity the girls created and started going in there too. We figured if they didn't chase the girls out, they weren't going to chase us either. We were right. In fact, it always seemed to me that whenever a place got integrated, it was women who broke the color barrier first.

We even worked out a way to hustle drinks. We clued in some of the girls and they were very agreeable. If one of our guys saw a girl standing at the bar with a stranger, and there weren't drinks in front of them yet, he'd move over to them quickly, before the bartender took their order. Then the girl would introduce him to the guy as one of the musicians who worked at the club. When the bartender arrived to take the drink order, the stranger would have to offer the musician one too.

Beginning in the late '30s, and through the '40s and '50s, the bar where I hung out most was a place on 50th between Broadway and Eighth Avenue called Beefsteak Charlie's. Originally it had been a steak-house, but the ownership changed a couple of times and by 1936, the same year the downtown Cotton Club opened, it was just a bar.

The place was unique. There was a large room, maybe twenty by a hundred feet. The bar itself was built along a side wall and stretched out lengthwise, beginning about six feet from the front window and extending maybe forty feet into the room. There were at least thirty stools around the three sides and some wooden booths along one wall toward the front of the room. There were another thirty or forty booths in the back, but since I never a saw more than a few dozen people sitting in that section, they were probably left over from the days when the place was a restaurant. The floor was covered with sawdust, the lights were bright, day and night, and the place always smelled like beer.

The personality and color of Beefsteak's seemed to change once a day. During the daytime the customers were mostly white. Lunchtime was very popular with truck drivers and service guys from nearby office buildings and hotels. Like many other bars in those days, they'd set up a steam table and you could buy a beer and get a sandwich and condiments—pickles, macaroni salad, beets, sardines—free.

By late afternoon the customers were mostly black, which was somewhat unusual for a midtown bar at that time. I think I know why that happened. Right above Beefsteak's was a ballroom-dancing place where guys would go and pay ten cents a dance. The clientele was white but the band was black. Every intermission,

Herb Flemming and Sonny
Greer, Beefsteak Charlie's,
New York City, 1954

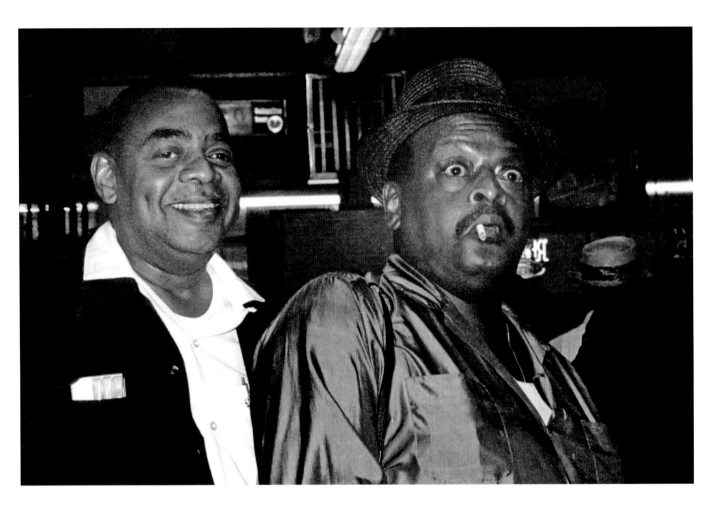

the musicians would go downstairs and drink in the front section of the bar near the big windows. It didn't take long before a couple of guys from our band who were on a break noticed them and went in for a drink. Word spread quickly and soon more and more black musicians were spending time in there.

It really didn't happen because other neighborhood bars refused to serve blacks. It's that we felt more comfortable in places where there was a good-sized group of people like us. Besides, Beefsteak's was really cheap. Even in the mid '50s, a glass of beer cost fifteen cents and a shot of scotch was half a dollar.

For a while Beefsteak's became a place where a few musician junkies hung out. It was safe because cops never seemed to look for them in bars and the bartenders never knew what was going on. I remember seeing a couple of well-known guys standing at one end of the bar or sitting in a booth sipping a Coke. They'd hang around for an hour, maybe more. I didn't know what was going on for a long time. Then somebody told me these guys were waiting for their connection. I became more observant, and it didn't take long before I was able to identify the dealer. He always carried a trombone case, but I never saw him on a gig. A couple of minutes after he'd arrive, his customers would go off to the bathroom, one by one, to make their buy.

I'll never forget the afternoon when one of the bar-

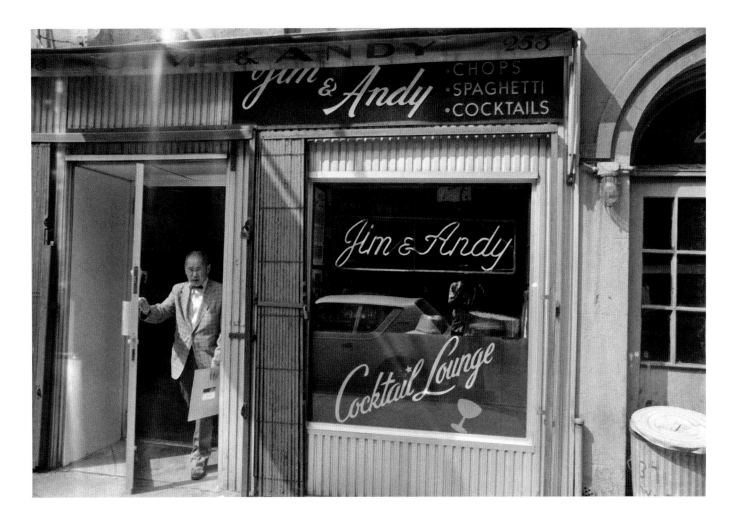

tenders asked if I'd help him pull out a guy who'd slid down onto the floor in one of the front booths. He told me he couldn't understand what had happened because, even though the guy had been in the bar a couple of hours, he'd only had one or two Cokes.

I crossed the aisle to the booth and when I looked down I saw it was Charlie Parker. He was conscious but slobbering all over himself and nodding the way junkies do. I told the bartender the guy was a friend of mine and was feeling sick. We walked him to a booth in the back and laid him across one of the benches so he'd be more comfortable.

There were a couple of midtown bars where studio musicians hung out. Some of the staff guys at CBS spent their free time at the Spotlight, a little place near what's now called the Ed Sullivan Theater. Many NBC musicians went to Hurley's on 48th Street, near Rockefeller Center, where they worked. But by far the most popular bar for studio guys in the '50s and '60s was Jim & Andy's.

Back in those days it was located on West 48th Street, which was known for music stores, instrument repair shops, and rehearsal studios. The place was owned by Jim Koulouvaris, a Greek who'd named it after himself and his cat, Andy. During the day it was mostly patronized by studio musicians and other

Harry Lim, Jim & Andy's bar, New York City, c. 1975

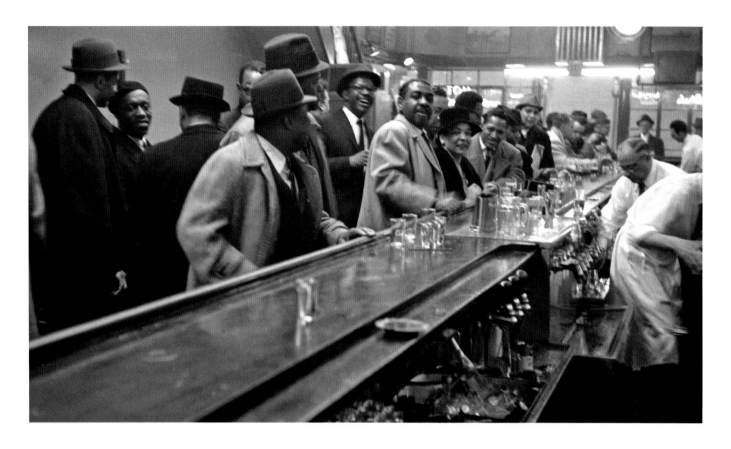

people from the record business—producers, arrangers, and copyists. Studio guys were also there at night, but some musicians from the Broadway shows were around too. I don't know why, but I never saw many string players in any of the bars. Maybe they had their own hangouts or spent time doing other things between dates.

Jim opened up the place in the morning and closed it down at night. He usually cooked lunch and dinner and left the drinks to Rocky, who was his bartender for years. The food was wholesome—meatballs, spaghetti, steaks, chops, and a couple of dishes like Shrimp Romeo, named after Romeo Penque, one of the studio guys who patronized the place. Most of the walls were covered with framed publicity photos of the patrons, and a lot of the records on the jukebox had

been made by regular customers like Quincy Jones, Zoot Sims, and Clark Terry.

Over the years, Jim & Andy's became more than just a place for studio guys to relax between sessions. There was a shelf in the back for storing small instruments and upstairs there was room for a couple of drum sets, basses, and guitar amplifiers. There was a coat rack where guys could hang a jacket or a tux for weeks at a time. In fact, I used to leave a topcoat back there from winter to spring and no one ever bothered it. We could also leave phone messages, letters, packages, even checks with Rocky or Jim. We always knew they'd be delivered to the right person.

At one point, Jim had a direct phone line put in to Radio Registry, which was an answering service many guys used to take their studio calls. It meant they

could check in every couple of hours without hassling with a pay phone. There were also times I was there when Jim or Rocky would announce a call from a musician working overtime who needed someone to cover his next date. Or from a contractor who'd been told to get another horn player for a session which was already in progress.

Jim was very sympathetic to musicians. He'd always let his regulars run up a tab that could be as high as two or three hundred dollars a week. He'd also loan money to guys who weren't good at budgeting and were always waiting for record checks to come through at the union.

About the only blacks you'd find in Jim & Andy's were the guys doing studio work. It had nothing to do with prejudice—it was purely economic. Compared to McGinnis's or Beefsteak's, Jim's was expensive. There was no beer on tap and a bottle cost seventy-five cents or a dollar, which was high even for those days.

In a way, the economic aspect of the bar scene represented a bigger conflict for me. I felt pulled between my old friends from the Cab Calloway days, who were less successful and hung out in places like Beefsteak's, and the Jim & Andy's crowd, who I was working with every day in the studios.

I'd go to Beefsteak's regularly and spend five or ten bucks buying drinks for my friends and their friends. I'd talk to anybody who'd listen about music and ways to improve musically. But I was resented for all of it. Many times I'd hear somebody say, "Man, he thinks he's great, making all that bread. He comes in and spends a few bucks, then he's gone." Guys hit me up for loans, and when I'd give a few bucks to a couple of them, I'd hear somebody mumble, "Look at him showing off." And at other times when I didn't have enough cash to go around, I'd see guys shaking their heads as if to say, "What a mean son of a bitch. Even with all that money he still can't share." No matter which way I turned, I couldn't win. I struggled with the problem for years. And in the end, the only way I got peace of mind was to know I was always doing my best.

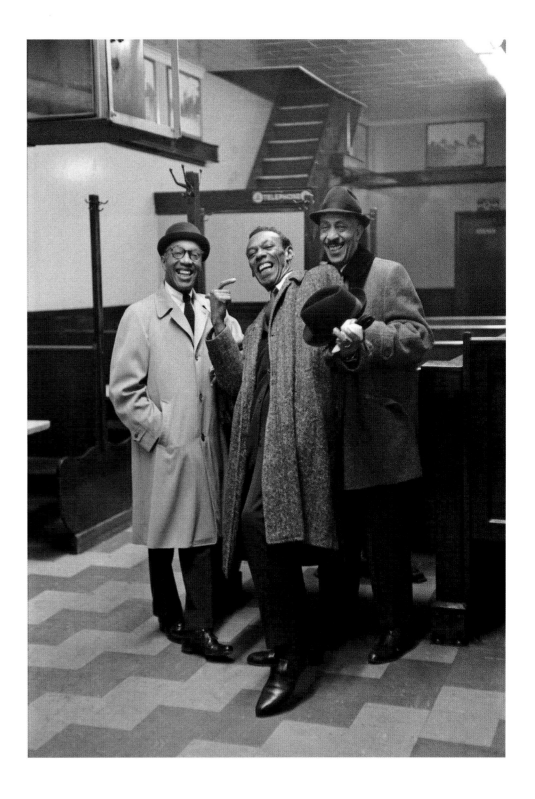

Stuff Smith, Beefsteak Charlie's, New York City, 1958

Danny Barker, Hot Lips Page (*foreground*) and other patrons including Barney Bigard,
Willie "The Lion" Smith, Claude Jones, and Wellman Braud, Beefsteak Charlie's, New York City, c. 1954

Barry Galbraith and Osie
Johnson, recording studio,
New York City, c. 1956

I'm convinced I got a lot of studio work because many producers and arrangers recognized that the rhythm section was the backbone of the music being done at the time. They also came to understand that there was a small group of rhythm section players who could easily adapt to different artists and really complement a performance. Eventually, Hank Jones, Barry Galbraith, Osie Johnson, and I got identified as part of the select group. And for a couple of years we worked together almost every day. We even got to be known as the New York rhythm section. It wasn't an official title, just an informal name people in the business gave us. And, of course, it wasn't an exclusive thing either. We all worked in plenty of other rhythm sections too.

Hank was always in demand because he's an unbelievable piano player. Back in those days he'd done a lot of records with Ella, and that seemed to make him even more popular, especially with female vocalists.

I guess they figured if Ella sounded so beautiful, how could they go wrong using her accompanist.

Hank's a good-looking, dark-complected guy who's always seemed to be concerned about his appearance. In all the years I've known him, I only saw him without a coat and tie once. That was when a couple of us played a party at Shoobe's house and it was so hot, Shoobe ordered him to take off his jacket.

Barry had been with Claude Thornhill's band. He was a very knowledgeable musician who was a great reader and could also write very well. He was a warm, small town-type guy—average height and weight, short hair, rugged but good-looking. He dressed like a woodsman. No matter how cold it got, he'd never wear an overcoat, just a plaid shirt with an open collar. He had a great sense of humor, but like a lot of guys who smoke too much, his laugh always turned into a cough.

Osie was a burly, dark-complected man. He was

very outgoing, affable, and had one of the most resonant voices I've ever heard. In fact, I was there when a funny incident involving his voice helped get him started in the studios.

Osie had come into New York with Earl Hines's band and run into Jo Jones, who invited him to a record session. I guess Jo wanted him to see how things worked and meet some of the studio regulars. We were doing a small date for a singing group called the Billy Williams Quartet. In those days they had a regular spot on one of the weekly TV shows and also a couple of good-selling records.

I don't remember what tune we were running down, but I can still see Osie sitting up on a high stool next to Jo with a big grin across his face, watching and listening to everything. After a while, we started to record, but before we could finish the tune, the guys in the booth cut us off. We tried another take, but the same thing happened. Finally, after seven or eight more attempts, we made it through to the end. But while the last note was resonating, and the recorders were still rolling, Osie boomed out, "Oh, yeah."

Everyone in the room turned toward him and for a second or two there was dead silence. Then someone said to Osie, "Man, in here you don't move 'til the red light goes out and the—"

But Billy Williams interrupted, "That's great, leave it in."

About a minute later, the playback started and when everyone heard Osie at the end, they flipped. In fact, they liked it so much they gave him a withholding slip and paid him for the date.

It didn't take long before people learned about Osie's true talents. He was a great drummer who could also arrange, sing, and play just about any kind of music. As it turned out, Jo Jones eventually lost studio work to Osie, who was a superb reader and didn't have as many personal quirks.

The four of us worked well together in all kinds of situations, and this had as much to do with our personalities as our musical talents. None of us was arrogant. In fact, we were exactly the opposite, congenial

and accommodating. Whenever we walked on a date we were really concerned about the featured artist. We wanted that person to be satisfied and we'd go to great lengths to accomplish it. If the music wasn't good and needed something extra, we'd fix it, right on the spot.

It even got to the point where some arrangers would hand us chords for a tune and expect immediate results. They'd say something like, "Your part is loose, have fun with it," which meant we should do a quick head arrangement without holding up the session. Sometimes our contributions really helped make a hit. For example, the four of us did Bobby Darin's record of "Mack the Knife." Osie or Hank had the idea of going up half steps, and as far as I'm concerned, that's what made this version a smash.

Of course, we never got arrangement credits on anything we did. Back in those days, it was rare for sidemen to get credits on an album, especially in the pop music field. But we got our forty-one dollars a session. And the fact that we knew how much we'd contributed seemed to give us enough satisfaction.

Hank Jones, Osie Johnson, and Milt, recording studio, New York City, c. 1957

Barry Galbraith, recording studio, New York City, c. 1959

Hank Jones, recording studio, New York City, c. 1962

Osie Johnson, recording studio, New York City, c. 1964

Billie Holiday and Hank Jones, recording studio (her last recording session), New York City, 1959

Ernie Wilkins, Kenny Drew
(*at the piano*), and Dinah
Washington, recording studio,
New York City, c. 1956

A couple of early-evening dates with Dinah always seemed to follow the same pattern. We'd all arrive on time to start at seven, but she was never around. A half hour would pass while the engineers worked on a balance and then we'd run down all the arrangements. There'd still be no sign of her.

Finally at about nine-thirty, she'd walk into the studio and ask us, "You got it?" Then a couple of minutes later she'd do a take on the first tune.

The instant she finished, while she was still in the studio, the producer would get on the intercom from the booth and say, "Great, Dinah, give me another one, please."

And we'd hear her answer, "Why? What's wrong with what I just did?"

Then he'd spend a couple of minutes trying to convince her, saying things like "I need a safety," and "I'm not sure we got all of it." But as far as she was concerned, she'd gotten exactly what she wanted the first time. Eventually, she'd give him a second or third take and still manage to record all the songs scheduled for her by ten. So we'd never go overtime.

I remember doing a big band date with her where Quincy was the arranger and conductor. Dinah was only about a half hour late, but this time she walked into the studio with a three-piece rhythm section who'd been out on the road with her. She looked at the guys in the studio rhythm section and told us in a real nasty tone of voice, "I don't need you. I got my own people." We could tell that everyone in the booth was completely taken by surprise.

After they talked among themselves for a couple of minutes, Julie Held, the contractor, asked the guys in the studio rhythm section, including me, to leave. But while we were standing around packing up, Quincy walked over and told us, "There's no way these guys can play my music. Do me a favor and hang out at the bar across the street for a while." We figured we were getting paid for the date anyway, so we did what he asked.

His prediction came true. About fifteen minutes later, Julie walked into the bar and asked us to come

I couldn't begin to list all the people I recorded with, and it would probably take years to describe just a fraction of the experiences I had. Of course, there were producers, arrangers, contractors, and artists who were easier to work with, just like it is in any other job.

Dinah Washington was one of the easiest. She rehearsed her material before she ever came into the studio, and she knew music well enough to tell everyone exactly what she wanted.

back to the studio. By the time we arrived, Dinah's guys had left. We unpacked, set up, got a balance again, and then went on to record all the tunes scheduled for the session. Dinah didn't say a word until the date ended. At that point she came over, winked, and said, "Look, you guys are the best. I just wanted to get my boys paid."

Back in the '50s, when he was a star, we all loved recording with Eddie Fisher because it was so lucrative. He was young, handsome, had a beautiful voice, and sold records by the millions. But there were always problems in the studio.

Eddie could never remember more than two or three words to a song—and he didn't seem to care. I recall sessions when he'd bring Debbie Reynolds along with two of their dogs. They'd hug and kiss, he'd sing a couple of bars and blow the lyrics. While the engineers reset the tape, they'd hug and kiss some more. In those days, other artists usually took one session to make both sides of a single, but with Eddie two tunes usually involved four or five sessions, and an album could take fifteen or sixteen dates. I remember times we'd work from two to five, break for dinner, then return and do back-to-back sessions from seven to ten and ten to one.

There was always a lot of overtime too. Eddie had a knack for almost finishing a song just when a session was about to end. I guess the producers figured it would be smarter to pay overtime and finish the tune instead of waiting for the next date, when they'd probably have to start from scratch. The company people never seemed to care. Eddie was so big they knew anything he recorded would sell millions. It got to the point where studio guys would joke and say, "If Mac Ceppos calls you for an Eddie Fisher date, you won't have to worry about work for the rest of the month."

Sinatra dates usually involved overtime too, but it had more to do with his generosity than anything else. I remember doing one session where Gordon Jenkins was conducting There were about seventy-five musicians and probably a dozen back-up singers crammed into a studio to do one tune, "Over and Over Again."

The date started at ten PM, but Sinatra wasn't around. We spent nearly two hours setting microphones, getting a balance, and running down the arrangement. Finally at midnight, Sinatra appeared. He walked into the studio followed by a couple of guys pushing carts filled with booze and cold cuts. We all got drinks and food and then sat around talking until one, when overtime began. We did our first run-through with Sinatra about two and finished the session at close to four in the morning.

One funny thing happened on a record date I did with Della Reese back in the '50s. She was young, just starting out, and had no reputation to speak of. In fact, before I did that date I'd never heard her sing.

Evidently, she really liked the way I played. One of the engineers told me later that during the session she'd asked her agent to see if I'd be interested in going on the road with her. The guy told her I was one of the busiest people on the studio scene and would never leave town with anyone. When the date ended, she came over and we talked while I was packing up. She told me how good I sounded and how she wished she could have someone like me on the road with her. I told her I enjoyed her singing and thanked her for including me on the session.

A couple of years passed, and by that time Della had two or three hits. One Sunday morning I got called at the last minute to sub on *The Ed Sullivan Show*. When I went to the studio and they handed out the music, I realized Della was one of the guests. I thought about that first session we'd done and how she'd become a star. So I decided to send her a note. All I wrote was "I'll go now!" I signed it and asked one of the stagehands to take it to her. I know she got a kick out of it because years later, when she was a guest on Dick Cavett's variety show and I was in the band, she told the whole story on national television.

Della Reese, recording studio, New York City, c. 1958

Gerry Sanfino, Hank Freeman, Fred Norman, and Dinah Washington, recording studio, New York City, c. 1963

Dinah Washington, recording studio, New York City, c. 1963

Three unknowns, Aaron
Rosand (*with pipe*), unknown,
Milt, George Duvivier, and
Marty Grupp, outside the
Roseland Ballroom,
New York City, 1962

Throughout the years I was active, there always seemed to be about three hundred guys who were regulars in the studios. When I first started there were only a handful of bass players—people like Doc Goldberg, Sandy Block, Jack Lesberg, and Frank Carroll. After I was involved for a while, George Duvivier began appearing on the scene and I was partially responsible for that.

During the years George was on the road with Lena Horne, he'd send me postcards giving me the dates he'd be in town. I knew Mac Ceppos and Julie Held liked his playing, so when I let them know his schedule, they'd line up sessions for him. I never felt competition with George or any of the other bass players because business was booming and we all got more work than we could handle.

Studio guys seemed to come from all different kinds of musical backgrounds. Some were out of the big bands. For example, Romeo Penque worked for Shep Fields, and Bernie Glow had played with Woody Herman. These were the guys who'd really been the backbone of those bands, not the flashy, loud-mouth types. Of course, many other studio musicians, including just about all the string players, were classically trained and came through conservatories and symphonies.

No matter what their background, all the studio guys were impeccable musically and shared the abil-

ity to discipline themselves in all aspects of life. They knew studio work wasn't art, but they were willing to use their skills to perform a service.

Some very talented guys never made it in the studios. Phil Woods and Gene Quill both played unbelievable alto, and Tony Scott was a great clarinet player, but none of them wanted to play all the woodwinds. Ben Webster couldn't bring himself to get to a morning date on time, and in the record business nobody ever bawled you out for being late—they just didn't call you again.

When I first came on the scene, there was only a handful of blacks who were heavily involved in studio work. It's true there were always a few black producers and arrangers around, and many black musicians were making records, but most of them were doing more specialized kinds of music like rhythm and blues, gospel, and jazz. Practically no blacks were recording regularly.

Naturally, just like other businesses, there were some bigoted people in recording. But most of the higher-ups seemed more concerned about sound than skin color. I never heard about kickbacks or payoffs in the studios. It was only ability that mattered.

Once producers, arrangers, and contractors saw blacks could qualify, they had no problem hiring more. Toward the end of the '50s, guys like Jimmy Nottingham, Joe Wilder, Clark Terry, Ernie Royal, Jerome Richardson, Thad Jones, Joe Newman, and, of course, Hank, Osie, and George had become a part of the studio group.

As one of the pioneers, I'd like to believe I showed some of the record people they had nothing to fear. Mona contributed to this effort too. Since she'd often pick me up at late-night sessions, she eventually got to know many different studio people, including musicians' wives. Everyone was taken with her personality and sociability, and as far as I'm concerned, this helped open doors for others.

I think the development of LPs and hi-fi helped blacks too. Music is an auditory art. People hear music on records; they don't see the performers.

Hi-fi made the sound clearer and listeners heard more. Some of the top executives probably recognized what was happening. They knew that when a star performed publicly, the visual aspect was most important and musicianship could be overlooked. But when the same person went into a studio to make a record, it was a different story. The visual was gone, so the sound had to be impeccable. That's why they'd hire the best—black or white, it didn't matter. As a result, throughout the '50s and into the '60s I made records with many people—singers and bandleaders—who I never could have played with publicly.

One funny exception was the time I got involved in a television appearance with Mitch Miller on the old Gleason variety show. It started when Mitch got invited on the show to do his big hit, "Yellow Rose of Texas." Frank Carroll was his contractor and also a bass player. He hired the musicians for Mitch's record dates and performances and whenever he couldn't make a gig, he referred it to me.

On this occasion, Frank was on vacation in Florida, so I got the Gleason gig. I remember taking the call myself. The person I spoke to asked for my hat and suit size, so I knew I'd be appearing on television wearing a costume.

The day before the show I went in for a morning rehearsal. A group of Mitch's singers were there along with three or four musicians I knew from the studios. The singers were good-looking white kids in their mid-twenties and all the musicians were white too. That made me the only black, but in those days it wasn't unusual in the studios.

During the rehearsal, we ran through "Yellow Rose" at least a dozen times while the technicians adjusted equipment and set our positions. Figuring out the precise camera angles and knowing exactly where to place each mike were very important in the days of live television, when there was only one chance to get things right.

Just before the lunch break, someone from the wardrobe department came around and told us where

Jimmy Crawford, Jack Jeffers, Milt (*with banjo*), Wally Richardson (*with Milt's bass*), Ernie Wilkins, and Clark Terry, television studio (Volkswagen commercial), New York City, c. 1964

to pick up our costumes for the dress rehearsal. Then I went out and got a sandwich and a beer.

When I went to the dressing room area to pick up my costume after lunch, some of the other performers already had shirts and pants on. I took one look at them and it suddenly hit me—the costume was the Confederate uniform, except the cap had a yellow rose stuck through the side.

I couldn't believe it. Neither could anyone else in the dressing room who saw me. We figured it was a gag and decided to play along. I put on the outfit, went out on the set, and got ready to rehearse.

I must've been a sight. Every time a technician walked by, he'd take a look at me and break up. Somebody had a camera and took a couple of posed shots. I became the center of attention and soon everyone in the place was rolling in the aisles.

All during the afternoon rehearsal I kept expecting one of the network people to tell me I had to be replaced. But it never happened. And the next night, I appeared in millions of homes across America—a black Confederate soldier from New York.

By the late '60s, the racial scene had changed a great deal. More blacks were appearing on television, and the idea of showing blacks and whites together was becoming more common. What particularly pleased me was the kind of blacks who started being shown. In the earlier days, light-skinned blacks with white features were about the only people the media used, but as soon as the "black is beautiful" idea got popular, dark-complected people began appearing more often.

I even appeared in a couple of commercials. In fact, I was involved in one incident which really shows

how things had turned around. For a while, they made two versions of TV commercials—one with black actors, one with white—and I got hired to do a spot for Volkswagen with about eight other musicians. Clark Terry was the leader and Jimmy Crawford, Ernie Wilkins, Jimmy Cleveland, and Everett Barksdale were also there.

When we finished recording the soundtrack, we were told to report to a different studio a week later to shoot the film. All of us were excited. The pay for making a jingle was good, but when you actually appeared in the commercial, the residuals were worth a few thousand dollars.

We showed up at the film studio to begin shooting. It was a simple sequence. It started out showing a small Volkswagen van with all of us stuffed in, looking like we were playing our instruments. I was right in the center with a blond bass sticking through the sunroof, and there was a banjo and a drum coming out the windows. The rest of it showed us getting out of the car carrying our instruments. It was all a takeoff on the old circus act where clowns keep coming out of a tiny car that can't possibly hold all of them.

We spent almost all of the first day waiting for the technicians to set up. Finally, in the late afternoon we got to shoot one or two scenes.

Before we started shooting the next morning, the producers told Barksdale they'd have to let him go. Evidently, when they saw what had been shot the day before, Barksdale looked more white than black.

They gave us a break for a couple of hours and we all went out for something to eat. Barksdale joined us, and he was furious. He said he was going to file a complaint with the union and see a lawyer about suing the advertising company. We tried to calm him down, but it was no use. When he finally left to get his car, he was still ranting and raving.

By the time we returned to the studio, Wally Richardson, a guitar player who's pretty dark, was on the set. Nobody said anything, but we knew he was Barksdale's replacement.

We began shooting again, but after a couple of hours a different problem arose. Barksdale had played a banjo solo on the soundtrack, but the breaks were a little tricky, and Wally was having trouble making it look like he was playing. After a couple of tries, they finally gave me the banjo and he took my bass. And that's the way it got released.

This incident really had special meaning for me. I'd known Barksdale from Chicago when we both worked for Eddie South. Back in those early days I'd watched him and a lot of other light-skinned guys play jobs I couldn't get near. But thirty years later, just the opposite thing had happened, and it was probably the first time Barksdale had ever experienced it. I didn't wish anything bad on him, but I remember thinking how this situation might help him appreciate what some of his darker brothers had gone through.

Everett Barksdale, recording studio, New York City, c. 1960

Kai Winding and Tony Scott, recording studio, New York City, c. 1954

Bernie Glow and Clark Terry, recording studio, New York City, c. 1956

Dick Berg, Bob Northern, Ray Alonge, Julius Watkins, Billy Costa,
and Warren Smith, recording studio, New York City, 1961

Bill Evans and Art Farmer, recording studio, New York City, c. 1959

Marlene VerPlanck, Stella Stevens Stalter, and Peggy Powers, recording studio, New York City, c. 1957

Billy Taylor, Nat Hentoff, and Eddie Bert, recording studio, New York City, c. 1954

Phil Ramone, Billy Eckstine, Billy Byers, Quincy Jones, and Harry Lookofsky, recording studio, New York City, c. 1959

Phil Bodner and Phil Woods, recording studio, New York City, c. 1963

Tommy Mitchell and Doc Severinsen, recording studio, New York City, c. 1958

The pace of studio work in the '50s and '60s put a great deal of pressure on all of us. A few guys just couldn't handle it and drank themselves to death—usually mixing booze with driving—but most of us found some kind of relief. Nobody took breaks as much as they should have. There was no such thing as a paid vacation, and most guys figured they couldn't afford to lose a week's worth of sessions.

For guys from jazz-oriented backgrounds, jamming was one means of relaxation. There wasn't much of a chance to play jazz during the week, and none of us was willing to give up sessions for a steady job in a club. So getting together and letting loose was a great way to unwind. It satisfied our creative urges and it was also a way to socialize and keep up with the latest innovations in jazz.

It didn't take long for my house on Ruscoe Street to become a regular weekend hangout. The basement was dry, I had a piano, and there was always plenty of food and booze. I couldn't possibly name everyone who came, but Barry Galbraith, Osie, Jimmy Jones, Art Farmer, Al Cohn, Doc Severinsen, Urbie Green, Zoot, Don Lamond, Eddie Costa, and Hal McKusick were some of the regulars.

After a while, some of us put thirty-five dollars apiece in a kitty so we could pay a couple of composers and arrangers we knew to write for us. We contacted people like Manny Albam and George Russell, and they were overjoyed. They already knew about our weekend sessions and probably would've showed up with music, free of charge, just so they could hear how it sounded.

For a short time we even started our own band, called the Natural Seven. We asked my old friend John Levy, the bass player from Chicago who'd become a booking agent, to check us out.

Eventually, he came to a rehearsal, and after we finished a couple of tunes he told us, "This is an unbelievable band. The only problem is, I can never get you what you're worth." He was right. We worked one thirty-five dollar gig and that was it.

At some point, Bernie Leighton discovered a decent piano in the basement room of a bar on 8th Avenue. For a couple of years, whenever he had a few hours off between sessions, he'd find guys around Jim & Andy's and go over to this place and jam.

From time to time, Bernie also managed to come up with high-paying gigs where we could play whatever we wanted. One of the most unusual was a wedding reception at the Museum of Modern Art back in

Manny Albam, recording studio, New York City, c. 1958

George Russell, recording
studio, New York City, c. 1958

the early '60s. We had a twelve-piece band with some of the best jazz players around—Clark Terry, Zoot, Bob Brookmeyer, Mel Lewis. I can still hear how the first tune sounded. We'd never worked together as a group and there was no music. But when Bernie called "A Train," somehow, as if by magic, we played Duke's arrangement note for note. And the same kind of thing went on all night.

Bernie would also call me to play small private parties. He'd made a couple of good contacts with some wealthy people, and when they'd have fifteen or twenty guests for dinner and want music, they'd call Bernie. It would always be just the two of us. The pay was good,

but the real reason we did it was the pleasure we got from playing together.

Back in those days, Bernie must've been in his late thirties. He had the looks of a model—good features, dark hair, well built. He'd done his master's at Yale. He always dressed Ivy League and looked more like a lawyer than a musician. He knew all kinds of music and he also wrote and arranged. But his real skills were at the piano. Not only was he an amazing technician who could sight-read anything, but he could also swing.

We'd do old standards mixed in with whatever songs were current. First there'd be cocktails for a

couple of hours, then they'd have a formal dinner. We were the background music for most of the evening. No one ever danced, but sometimes after dinner, a few guests would stand around the piano and listen to us play their requests. And one or two might even try to sing along with us.

It didn't take long before guests at one dinner began hiring us for their next party. We soon found ourselves playing in different places for the same group of people. We became part of a circle and by the early '60s we were doing two or three parties a month.

In 1961 we played for one dinner I'll never forget. We'd worked for the hostess a couple of times before. She lived in an enormous penthouse on Park Avenue and we were scheduled to start at eight.

I'd done a couple of sessions earlier in the day and when the last one ended, I'd gone over to Beefsteak's to hang out with some of my old friends. Around six-thirty I went back to the bathroom, washed up, and changed into my tux.

A few minutes later I was at the bar again, saying my goodbyes. I grabbed my bass and headed out to catch a cab. But just as I got to the door, one of the guys yelled to me from across the bar, "Hey, man, don't get a cab. I got my pickup outside. I'll take you."

"Great," I told him. "I'd rather give you the two bucks."

About fifteen minutes later, we pulled up in front of the apartment house on Park Avenue. We must've been a real sight—the old, beat-up truck with a bass in the back and two black guys inside, one in work clothes, the other in a tux.

I got out of the truck and started walking toward the back to get my bass. Just then, two guys wearing dark suits appeared out of nowhere. "What's the problem?" one of them asked me.

"Nothing," I answered. "I'm working at a party in the penthouse of this building."

One of them lifted my bass off the truck and carried it into the lobby while the other took a piece of paper out of his jacket pocket, looked at it, and asked, "Are you Milt Hinton?"

I nodded, "Uh huh."

"Good," he said. "Come inside with me."

We walked into the lobby and around to the service elevator. The door was open. I saw my bass leaning up in one corner of the car and I got on. A couple of seconds later, I was joined by two other guys in dark suits who rode me upstairs. I remember thinking, "There are an awful lot of waiters here tonight."

The elevator opened right into the apartment. It was a fabulous place. The large living room had a fireplace next to the piano and there was beautiful art wherever you looked. One side of the room opened out onto a long terrace which could be used when the weather was warm.

John Levy, recording studio, New York City, 1959

I walked my bass over to the piano and unpacked it. Then I spent some time making sure everything was set up so I could start playing as soon as Bernie arrived. As usual, I was early. When I finished, I still had a half hour to spare.

I got a drink and sat on the bench in front of the piano with my back to the entranceway. About fifteen minutes later, Bill Harbach, a guy I'd gotten to know from playing these parties, handed me a fresh drink and sat down right next to me on the bench. We began talking about the kinds of records I was making, but after a couple of minutes our conversation got interrupted when someone behind us tapped Bill's shoulder. He turned to see who it was, then immediately stood up and said, "Jack, how are you?"

A second later Bill touched my shoulder and said, "Milt, turn around. I'd like you to meet Jack." I turned, looked up, and almost fainted. Right there, standing in front of me, was the President of the United States.

I tried to get up, but I couldn't. I just sat there shaking my head from side to side. I couldn't believe it. He was very gentlemanly. He took a step forward, reached down, and shook my hand. After a minute or two, I gained enough composure to say a few words to him.

When Kennedy moved on to talk to some of the other guests, Bill explained how it was a policy not to tell anyone ahead of time the President was going to be someplace. The more people who knew, even waiters and musicians, the more dangerous it could be. That's when I realized the guys in the dark suits out front and in the elevators were Secret Service.

About ten minutes later, the elevator opened and out stepped Peter Lawford with Bobby and Teddy Kennedy. I couldn't wait to share all of this with Bernie. But he had trouble getting a cab and only arrived a few minutes before we were scheduled to start playing. So it wasn't until our second number that I had the chance to lean over and talk to him.

"Look around the room," I told him.

"What's happening?" he asked.

"You're not gonna believe this," I said, "but the President of the United States is sitting in a chair over there and his brothers are here too." Bernie spotted him immediately and almost flipped.

We kept playing while everyone drank and talked. Then about twenty minutes later, I saw the President get up and start walking toward the elevator. I figured he was leaving and I felt disappointed that Bernie wouldn't get a chance to meet him. I remember we were playing a bossa nova and when the President got about six or seven feet from us, he changed direction and walked over. "The music is beautiful," he said. "I love bossa nova."

I figured I'd better introduce Bernie before it was too late, so I said, "Mr. President, I'd like you to meet my friend Bernie Leighton."

Bernie jumped up immediately and turned away from the piano to shake hands. He was in shock the same way I'd been. He just stood there telling the President how much he enjoyed seeing him. And suddenly I was on my own—a bass player halfway through a chorus of bossa nova. I didn't know what to do except play rhythm and hope Bernie would sit down quickly. They probably were standing for only thirty seconds, but it seemed like much longer.

As it turned out, the President wasn't leaving—he was on his way to the bathroom—so the meeting with Bernie could have happened during our break. In fact, the whole clan stayed all evening and later we got a chance to meet Bobby and Teddy.

The President was at two other parties we played. At one, his brothers also came and Vaughn Meader, the comedian who did imitations of the Kennedy family, entertained. It was a small group and they all sat around the living room listening to him. At one point I heard the President tell someone, "He doesn't sound like me. He's much more like my brother."

Aside from jamming and occasionally taking outside gigs, there were other ways guys got relief from the pressures of studio work. Some took up sports like golf and joined country clubs out on the

Island and up in Westchester. For a couple of years, Jim & Andy's sponsored a musicians' softball league which played games every Sunday morning near my house in Queens.

For years, about a dozen guys—including me, Moe Wechsler, Barry Galbraith, Osie, Dominic Cortese, Jim Buffington, Eddie Costa, and Bernie Glow—had season tickets to the Giants football games. We'd get together for breakfast, then each take a bottle of brandy to the game and scream for a couple of hours.

Other guys had expensive hobbies, building or collecting things like cars, boats, instruments, and hi-fi equipment. A couple of people even bought bars or restaurants. I don't know of any who made money—it just gave them something to play with. Then there were always a few who liked gags and went to great lengths to have funny buttons and banners printed, so they could take them around the studios to show everyone.

Sol Gubin, one of the popular studio drummers in the '50s and '60s, once went to great extremes to be humorous. He hired Pat Williams, who was busy even in those days, to write four sweet Mantovani-type arrangements of standard tunes for a full string orchestra. Then he rented a studio, hired about thirty guys, got Pat to conduct, and recorded the tunes featuring himself at the piano. The arrangements sounded beautiful, but Sol purposely played everything slightly off. After the session, he had a few hundred records

Bernie Leighton, recording studio, New York City, 1974

Beginning about seventy-five years ago, St. Albans was about the only place outside of Harlem where successful black people could buy houses in New York. Musicians like Fats Waller and Basie lived in the neighborhood and some of the early black athletes who made it, like Roy Campanella, were there too.

Anyway, the thing I still like most about the new house is the basement. I'd had one when we lived on Ruscoe Street, and because it had once been an illegal apartment, it had its own kitchen and bathroom. But it was always too small to fit my basses and the photography and audio equipment I was accumulating.

Mona completely remodelled the basement of the new house and did a lot of the work herself. She replaced the toilet and sink in the powder room and she took the good-sized laundry room and turned it into a full kitchen. Then she put a big utility sink in a walk-in closet so I could set up a darkroom.

The main room was big enough to hold two or three basses, a piano, a couple of my movie projectors and tape recorders, a TV—all those kinds of things. Mona had it panelled, she put in a six-foot bar, and she had shelves and other storage units built in.

It became my space, where I could do all my entertaining and even put up a friend like Keg or Ben Webster who needed a place to stay for a few days. This is the same place where Basie and I would hang out when he'd accompany the silent movies.

Throughout the 50s, I kept working on my photography whenever I could, but I never seemed to have enough time to do anything more than develop my film and make contact prints. And when that happened, I'd usually have a friend in the darkroom with me who shared my interests.

Guys usually came by on the weekends when I was most likely to be around. It didn't matter if they dropped in without calling because I loved company and everyone knew it. I'd usually prepare food on a Friday night or Saturday morning and keep it warm all weekend. I'd cook a pot of beans and rice, greens, corn muffins, and a turkey or a couple of chickens,

pressed with a label reading "Medicinal Records Presents the Golden Gloves of Gilbert Gubin" and gave them away to friends. Of course, he made sure it got on the jukebox at Jim & Andy's so as many people as possible could share in his expensive joke.

In those days, I relaxed by spending whatever free time I had hanging out with friends in my area of the house—the basement.

We stayed in the first place we bought on Ruscoe Street for about ten years, until the late '50s, when Mona found a bigger house a couple of miles away in the St. Albans section of Queens. It's a corner house made of brick and stone with a beautiful yard. And right across the street is a large city park with a playground and plenty of grass, the size of three or four football fields.

and people would help themselves. There was always plenty to eat and drink.

This is about the time I started doing interviews with some of the people who came by. It was a very informal thing. I'd set one of my reel-to-reel tape decks at the slowest speed and leave it on all day. I got musicians like Perry Bradford, Eubie Blake, and Sam Wooding talking. And I was even able to record a few guys like Ben Webster playing piano and tenor. I recorded people who grew up with my family in Vicksburg and Chicago, reminiscing about the old days. This was really my way of relaxing. Of course, I also knew I was getting some pretty unique material about jazz history and black people generally.

I think Mona and I were able to do so much back in those days because we didn't follow a normal schedule. Neither one of us ever required much sleep, so we never had a routine for going to bed and getting up at certain hours.

In my case, it had to do with all those years on the road. Most times you couldn't predict when you'd be able to get a good night's sleep, so you learned to take catnaps. You'd close your eyes for ten or fifteen minutes and wake up refreshed. As a result, I never fell asleep on Cab's bandstand and I was always able to keep up with studio work, even though I 'd frequently be out of the house for fifteen hours straight. Mona was on the road enough to learn how to sleep this way too. And to this day, we both seem to follow the same kind of unusual schedule.

When I look back to my studio days, I realize that I got a great deal of satisfaction from the work itself. That's probably because, unlike many other guys, I figured out ways to make the work interesting. Fortunately, my abilities to read and improvise, and my reputation as a jazz musician got me on all kinds of sessions and the variety really kept me going.

It didn't take long to realize that no matter how bad the music was on a particular date, it wouldn't go much more than three hours. If it was really monotonous, I'd say to myself, "The next one's got to be better than this." And if I wasn't playing music I liked,

I'd look at what I was doing as performing a service, period. I was rarely challenged musically, but there was always something exciting about walking into a session cold, without rehearsals, running down an arrangement, and then recording it.

Of course, the calibre of musicians I worked with all those years in the studios and the close friendships I developed with many of them, made that period of my life even more satisfying.

[Above] Mona at home, St. Albans, Queens, New York City, c. 1957

[Below] Milt in his basement, St. Albans, Queens, New York City, c. 1957

By the late '60s I was doing much less studio work than I had before. Things didn't suddenly come to an end, they just slowly tapered off.

Part of it had to do with the younger, more modern producers and arrangers who'd come on the scene. These people wanted bass players like Richard Davis and Ron Carter, who fit their musical concepts better. Truthfully though, much less studio work was being done in New York, and all the other studio guys had lost work too. Looking back, I think there were a couple of reasons for the decline.

For one thing, by the mid '60s, many hit records were being made by self-contained groups like the Beatles. Since most of the group members not only sang but also played their own accompaniment, there was less demand for studio sidemen.

In addition, more music was being recorded in places like Detroit, Memphis, and especially Nashville. Nashville was always the center for country recording, but for years that kind of music was only a small part of the record industry. Beginning in the mid '60s, everything started changing. Country stars were getting on the popular music charts and Nashville producers realized that if they used strings and brass to soften their traditional sound, the music would appeal to a wider audience. And it wasn't long before popular music stars tried making albums down there.

By the '70s, the TV networks had moved whatever was left of their live music programs to the West Coast. Some New York staff guys moved to California and kept their jobs, but others got severance pay and stayed in New York.

Some of the top New York arrangers—Quincy, J. J. Johnson, Pat Williams, Ralph Burns, George Romanis, and Billy Byers—also moved out to California to work in TV and film. But things never really picked up for studio musicians out there either. In fact, film work dropped off because more movies were imported and soundtracks for many American films were being recorded overseas.

Studio work in New York never got back to where it was before. There's probably still a group of musicians who do jingles and some record dates, but it's much smaller than it once was because there's much less work.

Many of the guys who freelanced full-time in the old days took steady work in Broadway shows or at one of the big hotels. They used it as a base of operations, figuring if they got a studio call, they could always find a sub. A few others took teaching jobs at colleges in various parts of the country.

Of course, there were retirements right from the start of the decline. With income from investments, Social Security, and the recording pension fund, some musicians could live pretty well. I understand a group of retired guys live in Florida and socialize all the time. Some of them even play in rehearsal bands down there, just to keep in shape.

Having been around for so long, I witnessed significant changes inside the studios. Certainly by the '80s, except for jazz, live recordings had become a thing of the past. The technology got so advanced that in most cases, each musical part got recorded on a separate track.

The occasional sessions I played outside of jazz, from the '80s on, involved working with string sections. Sometimes I didn't even know who the featured artist was. I'd just go into the studio, put on a set of headphones, and bow whole notes—what studio guys used to call "footballs." There were times when I played without any other musician present. On most sessions, woodwinds didn't play with brass or strings anymore. Trumpets might not even play with trombones. Producers would double up on instruments. They'd bring in four violins, four violas, and four cellos and record the same arrangement again and again. When they finished, it sounded like a hundred strings.

As I see it, individual artistry has just about disappeared. Traditional acoustical instruments have been electrified and synthesizers are used more than

ever. There are keyboards around with built-in tape recorders and computers that can play what no human possibly could.

There's also been a revolution in bass playing. Before amplification, guys didn't have the kind of freedom with the instrument they do now. In the old days, when you played fast, you had to play up on the fingerboard, because sound from the higher-octave notes carries better. Back then we'd even pick the type of strings we used depending on the kind of sound we wanted to project.

But since the bass has been amplified, the old restrictions don't apply any more and you don't have to be concerned about projecting your sound. Today, people can play fast all over the instrument, and some even use three or four fingers to do it.

To my way of thinking, many of these changes have given a lot of today's popular music a clean, cold sound. But by now, a couple of generations have been raised on it and don't know anything else. The only live music most of them hear is also electrified and amplified, so they don't know what acoustical instruments truly sound like. I don't like most of what I hear, but I'm from another generation, and besides, it's not what I like that counts.

Barbra Streisand, recording studio, New York City, c. 1964

5
After the Studios

After freelance studio work slowed down for me in the late '60s, most of the recording I did for the next thirty years was in jazz. I'd get an occasional jingle or soundtrack through old friends in the business, but there weren't enough studio gigs to keep us going financially. So I started accepting other kinds of jobs.

I went back on the road, which is something I hadn't done for twenty years. I got involved in teaching, occasionally worked in clubs, and played jazz concerts and parties. And all of these activities happened at the same time over this period. So I might be on the road for a week, come back home to do a jazz session during the day, and work in a club the same night. The changeover happened gradually and our income was never really affected.

During my busiest years in the studios, a few of the performers I recorded with asked me to go on the road, just the way Della Reese had. I always turned them down in the past, because I couldn't afford to leave New York with all the studio work I was doing, But at this point I was more available, so when one of these people offered me a good salary to go out for a week or two, I accepted.

Paul Anka was the first. I figured he was an ideal person to try it with. I'd played on his records from the time he started out, and I knew how sympathetic he was to musicians. He'd always had excellent taste in music, he'd written beautiful songs, and he liked to surround himself with good arrangements and the best musicians.

Paul worked hard and expected everyone else to do the same. Once I showed him I could take care of business, he was very generous. I found the whole thing very enjoyable and, for a few years, I'd take a couple of week-long trips with him whenever it was possible.

Around the same time, I also went out to Las Vegas with Barbra Streisand for six weeks. As I recall, this engagement was for the opening of the International Hotel. There was a fifty-piece orchestra—five of us from New York and the rest were local musicians or guys from the West Coast.

Back then, Barbra was young and very opinionated. She had a strong sense of how the orchestra should sound and she'd always try to get exactly what she wanted from her arrangers. I remember how vicious she could be to these guys when they'd come to a rehearsal with a new chart. We'd try it, but halfway through she'd stop us and take it apart, section by section. She didn't play an instrument but she had

Paul Anka, San Juan, Puerto Rico, c. 1965

Bing was also very concerned about his sound. He once told me that when he was alone, he'd sometimes take song lyrics and work on diction and phrasing until he had things just right. That may be one reason I never heard him raise his voice to a musician or bandleader. He knew exactly how he was going to sing a tune, so all he had to do was calmly tell everyone else how to play it for him.

My experience on the road with Cab many years earlier had some negative aspects. It was exhausting, the living conditions were terrible, and of course, we also had to pay our own expenses. It was better when I traveled with Louis, but nothing matched the treatment I got with these celebrities. We always traveled by airplane and limousine, we stayed in luxury hotels, and we ate in the finest restaurants.

But there was even more to it. Often Mona was invited to join me and all her expenses were paid too. I remember one time when she was working on her master's and I was with Paul Anka in Puerto Rico. The day her Easter vacation started, Paul had a limousine pick her up and he flew her down to join me. In fact, both Mona and Charlotte went to Vegas with me for a part of the Streisand engagement, and there were nights when Barbra made sure they had a ringside table, so they could eat and watch the show.

Celebrities usually gave their featured musicians a gift at the end of an engagement—cuff links, a bar set, things like that. Bing was particularly generous. When we were playing Miami, he arranged to fly me back to New York for the day so I could teach my workshop. And when the tour ended, he gave everyone in the group a Rolex.

Whenever I think about Bing, I'm reminded of something that happened when I was teaching and he showed up one day.

In the early '70s, I had a jazz workshop at Hunter College, which is part of the City University of New York. Then a few years later, I moved it to Baruch College, which is another school in the same system. I stayed there well into the early '90s, and left only after I was sure a few of my former students would be allowed to take over.

a tremendous knowledge of music and as far as I'm concerned, the results she got always seemed to be an improvement.

In those days, Barbra never liked to hang out with show-business people and she went to great lengths to avoid the whole Hollywood scene. Dozens of celebrities were in the audience every night, but Joe Williams is the only person I can remember her introducing from the stage. She practically never let stars visit her dressing room. In fact, most nights when we finished, she'd change clothes and leave as quickly as possible.

In the mid '70s, I did a concert tour with Bing Crosby, who I'd known since the early '30s when we hung out at Ben Marden's club in New Jersey. He was a celebrity most of his life and also a fabulously wealthy man, but he was one of the most peaceful, down-to-earth people I've ever known. He was a great storyteller, and sometimes between shows, we'd hang out backstage talking about the old Paul Whiteman days.

In the beginning, I had some difficulties. I found myself teaching students who played different instruments and were on different levels in terms of their musical skills. It was a challenge and I worked it out.

When it came to playing, I evaluated each student's skills at the beginning of the term and then helped them decide on what they wanted to accomplish during the course. Sometimes I put together groups of compatible students and gave them a couple of musical assignments to complete.

I got whatever materials I could find and used trial and error to develop simple ways to explain chords and improvisation. I used tapes, films, and records, and I also tried to introduce personal experiences when I thought they could be relevant.

Both schools were always generous about allowing me to have substitute teachers whenever I had a conflict in my schedule, and I had qualified people to cover for me. The administration also supported my bringing in guests. In fact, when I see students from those days now, they always talk about the guests I'd have—Joe Bushkin, Benny Goodman, people of that stature. Not surprisingly, what every one of them seems to remember most is the day Bing Crosby came to class.

Bing Crosby, unknown, Joe Bushkin, and unknown, rehearsal, London Palladium, London, c. 1977

One night when I was coming home on the local bus, I noticed a billboard announcing a prayer meeting, and the special guest was Reverend Bill Bailey. I recognized Bill from his picture on the poster, and when I got home I told Mona about it. She, of course, also knew how Bill carried on in the old days and, for that reason alone, we decided to go and give him some encouragement.

We arrived early and got seats near the front. After a while the place filled up. Several other preachers spoke and then Bill came out on the stage. He started slowly, measuring every word, but after fifteen or twenty minutes, he picked up the pace and his voice got louder. Then, suddenly, he began to use his feet.

At first he'd do a light step every few seconds to accent a word, but soon he got to a point where he was preaching the gospel at the top of his lungs and stomping at the same time. He turned to one side of the stage and shouted, "If you don't . . ." He stomped, turned, and yelled, "change your ways. . . ." He stomped again, turned back, and screamed, "You're going straight to hell!" He came down on both feet to punctuate the last word. The audience was hypnotized.

We were sitting in the middle of the second row, but we hadn't made eye contact with him. That's the reason I was completely surprised when he ended with these words:

> I liken myself unto Paul. He was one of the worst sinners. Yes, Paul was a great sinner. And I was just like him. But Paul changed and so have I. I used to do everything. I drank whiskey, I smoked reefer, I took pills and other kinds of dope and I had prostitutes.

Then he paused, looked down, pointed at me, and shouted, "Didn't we, Hinton?"

Mona and I got up quickly, put a couple of dollars in a collection plate, and hurried out.

Getting back to Pearl Bailey, some of my fondest memories come from the first trip we made to the Middle East in the early '70s. Her husband Louie

Whenever I went out on the road with one of these stars, the music got repetitious. But I managed to overcome the boredom by keeping the engagements short and limiting my travel to places I thought would be interesting.

Some of my favorite foreign trips were with Pearl Bailey in the '70s and '80s. We'd known each other from the old days when she performed with Cab's band, and her brother Bill had been a dancer with one of the revues. He was quite a talent, just a notch below guys like Bill Robinson. He was handsome and always had a lady on each arm. In the old days, he was into everything and he was wild.

There's a funny story about what happened when I ran into Bill about twenty years after the Calloway days. At that point, he'd given up dancing and had become a traveling preacher. In fact, that's how I came to see him.

Bellson, was the drummer, and Don Abney was her pianist. This was a good will tour sponsored by the State Department. As I recall, we were about a week ahead of President Nixon, who was scheduled to make official visits to the same countries. We never played for the public, but we met a lot of foreign dignitaries and officials from our State Department.

It was an exciting trip. We began in Israel and then went on to Iran and played for the Shah. From there we went to Jordan. King Hussein greeted us and took us by helicopter to see five or six remote villages in the middle of the desert. Some of my best memories are from that part of the trip.

We spent a day visiting Amman. Then we drove to the border separating Jordan and Israel and spent time around a narrow little bridge which crosses the River Jordan and divides the two countries. Up on one bank, a big Israeli flag flew and ten or twelve soldiers sat around a couple of bunkers, talking and laughing. Right across from them, on the other bank, maybe fifty feet away, was a bunker with a Jordanian flag flying out front and a group of soldiers sitting around their bunkers doing the same kind of thing.

I watched Arabs with animals and carts cross the bridge in both directions, and after a while, I walked across to the Israeli side and took some pictures of the soldiers. Then I crossed back and got some shots around the Jordanian bunker.

Just as we were about to leave, Pearl came over and said to me, "Let's go down and get in the Jordan. We may never have a chance like this again."

I may not be a strong believer, but at that point my Baptist upbringing overpowered me. "Okay, let's do it," I told her, and off we went, down toward the river.

It wasn't that easy. There were thick weeds seven or eight feet tall and I was afraid the place might be infested with poisonous snakes. To make things worse, I was carrying a 35 mm camera and a home movie camera, which cut down on my maneuverability.

It took us about ten minutes to get to where there was actually water. When we finally made it, Pearl took my hand, stepped down, and immediately sank

in up to her waist. I can still see her gingham skirt floating to the top and opening around her like a parachute. She still had my hand, but we seemed to be sinking fast. I had to use my teeth to take the lens cap off my movie camera. Then I held it as far away as my arm would reach, pointed it at us, and squeezed the trigger.

A couple of seconds later, Pearl said, "Let's baptize ourselves." I didn't have a free hand, but she started putting water all over her face. I kept trying to aim the camera at her and hold it high enough so it wouldn't get wet.

Watching us that afternoon, the soldiers on both sides of the bridge must've had a good laugh.

Louie Bellson and Pearl Bailey, on tour in the Middle East, United Arab Emirates, 1979

Some of the most memorable travel experiences I ever had were during my two trips to what used to be called the Soviet Union. My first visit was in 1972, when I went over with Ara Oztemel, an American businessman who traded with the Russians for years. He'd decided to throw a party in Moscow to mark the twentieth anniversary of his business dealings. He played tenor saxophone and had always loved jazz, so he figured he'd take something to the party that was uniquely American—four musicians: Bob James, Toots Thielemans, Ben Riley, and me.

We spent ten days in Moscow at a hotel called the National, right across the street from the Kremlin. The place was beautiful. There were antiques everywhere and it gave you an idea of what luxury must've been like in the days of the czars. It was one of the easiest gigs I ever worked. During that ten-day period we only played once, and that was for forty minutes at the party.

I couldn't begin to describe all the incredible things that happened on this trip, but a couple of events really stand out in my mind.

There were places in Moscow they called dollar bars, which seemed to be located near the tourist hotels. The ones I visited all looked alike. They were small, there were practically no decorations on the walls or floors, and the atmosphere always felt cold. I was told these places only took foreign currency, which was the government's way of getting outside money into the country and also keeping Soviet citizens away.

One afternoon, I was sitting in the dollar bar at the Intourist Hotel having a drink and trying to identify all the languages being spoken around me. All of a sudden, a young guy about twenty-five came through the door and walked up to me. He leaned forward, put his face right up to mine, and, without saying a word, turned and ran out.

It was so strange that I immediately started to worry. I'd heard all kinds of stories about the secret police and I remember sitting there I trying to figure out what I'd tell them if they took me in for questioning. To the best of my knowledge, I hadn't done anything wrong.

About ten minutes passed. I ordered another drink, and just when the bartender put it in front of me, the same guy appeared in the doorway. This time he'd brought along a thin, pale guy about his age, with a beard and long hair. They came into the room and began walking toward me. I remember thinking, "Okay, this is it. I'm gonna' be arrested."

When they were four or five feet away, the thin guy spoke. He had a heavy Russian accent, but his English was easy to understand. "Milt Hinton, what are you doing here in Moscow?" He seemed to be pleased at discovering me, almost as if he'd found a fugitive he'd been chasing for years. I was trembling and my voice was shaky when I answered, "I'm playing at a party."

I couldn't believe what he told me next:

You know, when my friend here called me on the telephone a few minutes ago and said, "Milt

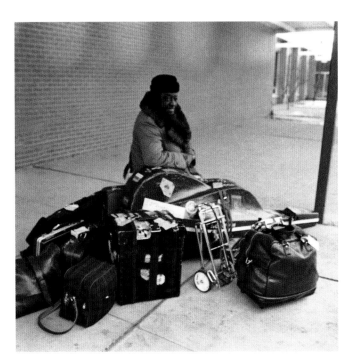

Milt, c. 1984

Hinton is in a bar in Moscow," I told him, "You are out of your mind." But he said, "No, no, I am a bass player. I have his albums with pictures on them. I have been admiring him all my life. I know it is Milt Hinton."

My friend wanted to talk to you, but he speaks no English. So he asked me to come down and see you right away. My name is Alexei Batashev and I can't believe you are here in Moscow. Welcome.

I breathed a sigh of relief. Truthfully, I was also flattered to be recognized in such a big city so far from home.

Over the next couple of days, Alexei, who asked me to call him Alex, and his friends showed me Russia from the inside. It was a real experience. Except for Alex, almost all the musicians I met were low-key and pretty shy. I don't know if these guys felt some kind of government pressure, but whatever it was, they just didn't seem to act very happy.

At that time, no Russian I ever met or heard about was making a living playing jazz. There were no jazz clubs, no jazz radio or television programs, and no jazz concerts. All the musicians I came in contact with had regular hotel or radio and television gigs or weren't earning a living from playing. The government seemed to control all the music. Some guys who worked in the hotels told me they'd have to submit a list of tunes they wanted to play and then wait for approval. Evidently, there was a great deal of concern about playing foreign music.

I still can recall a funny experience I had with censorship. I was in a restaurant with Bob, Toots, and Ben, and there was a balalaika band playing traditional music. Right in the middle of an old Russian tune, we began to hear a familiar melody. It was being played in the same traditional style, but within seconds we knew it was "Satin Doll." When the musicians finished the chorus, they nodded to us and, without missing a beat, slipped back into the original tune. We were probably the only ones in the place who knew what had happened.

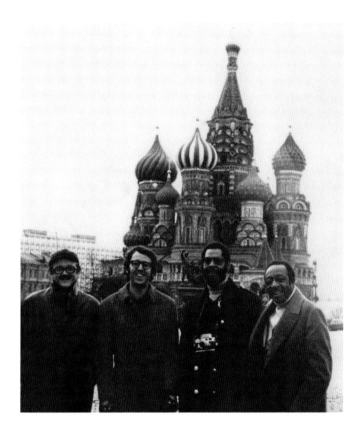

Alex acted different from the musicians I met. He seemed to have a much stronger character. He was a writer and an authority on the history of jazz, He told me stories about the Fisk Jubilee Singers, which was the first black group to go to Russia, the trip Sam Wooding's Orchestra made in 1927, and about Sidney Bechet's visit around the same time.

He also talked about the government's view of jazz. Back in those days, they didn't want any kind of culture that wasn't Soviet oriented. And, of course, jazz fell into that category. He told me he was trying to convince some officials that jazz is really a subculture involving people all over the world. His argument was that if Russia didn't get involved, they'd let something good slip by.

Somehow Alex managed to get around the government and put on a party for us. He got all his friends to contribute money so they could rent a big hall.

Toots Thielemans, Bob James, Ben Riley, and Milt, Moscow, 1972

Then everyone who came brought a bottle of vodka and a dish of food.

We felt like honored guests. Halfway through the party, they asked the four of us to play, and given the way we'd been treated, we were happy to oblige. We did a few tunes alone and then let some of the local guys sit in. Pretty soon musicians started appearing from everywhere. There were drummers who wanted to replace Ben so they could have a chance to play with me, Toots, and Bob. There were bass players who asked me to sit down, and there were singers and horn players who wanted to hear themselves with our rhythm section. One singer I remember was absolutely fabulous. She had a high voice like Ella's, and she could scat the same way.

A lot of the guests also brought good-sized tape recorders which didn't work on batteries and there was only one electrical outlet in the hall. So throughout the evening people took turns plugging in their machines and recording a few minutes of music. Things ended at daybreak, after we made sure everyone who wanted to play had a chance. Even though we were exhausted, I was glad we'd stayed.

On my last night in Russia, Alex and three guys came to my hotel to say goodbye. Each one had brought me a gift, which was customary whenever you visited someone. It was never anything big—maybe a couple of picture postcards, a photograph, things like that. For some reason, a lot of the musicians I'd met had given me pins. They looked like little medals, but each one seemed to have a different crest stamped on it. They might've had some special meaning, but no one ever explained it to me. Naturally, every time I was given something, I wanted to reciprocate, but being a visitor for such a short time, there was no way I could have carried around that many gifts.

It was different this particular night. I was leaving the country the next day, and I had a couple of things in my suitcase I knew these guys would probably appreciate. I'd brought about six sets of bass strings and I gave my last set to the young bass player. I also had two of my own albums and I gave one to Alex and

one to the guitar player. Alex didn't have to translate—I could see these guys were thrilled beyond belief.

While these exchanges were going on, I suddenly realized I didn't have anything for the trumpet player who'd just given me a pin. I looked through my bags hoping I'd come across something, but I didn't. Then I looked around my room and saw a copy of *Playboy* on the night table. Somebody had left it on the plane when we landed in Moscow and I'd walked off with it.

"Man, I'm sorry I don't have anything for you," I told him, using Alex to translate, "but maybe you'd like a copy of an American magazine as a souvenir."

I handed the *Playboy* to him. They spoke in Russian for a couple of seconds and then Alex told me, "He can't take it. It is considered pornography here and there is a big penalty if they catch you."

I didn't know what else I could give him and I felt embarrassed. I was running late for a dinner party, so I went in the bathroom to fix my hair.

When I came out a couple of minutes later, the four guys were huddled around the bed looking at the *Playboy* centerfold. The trumpet player lifted his eyes, looked over at me, and said, "I take, I take."

"Okay, you got it," I told him. Almost before I finished speaking he had the magazine pushed down inside the seat of his pants. I guess he knew it was the only way he'd get past the hotel people in the main lobby. The other guys hid their gifts too. The bass player had no problem with the package of strings, but Alex and the guitarist had to wrap their albums in a newspaper they found in the hall.

In 1984, I got another chance to go back to Russia and I jumped at it. This time Pearl hired me to go over for a week and play a couple of parties for some American diplomats. In addition to me, Pearl took Rozelle Claxton, the pianist; Remo Palmier played guitar; and of course Louie was the drummer.

We performed at the American Embassy in Moscow for about three hundred guests. Then a few days later, we took a night train to St. Petersburg, called Leningrad back then, and played at our consulate.

I saw Alex three or four times on this trip and we had plenty of opportunity to talk. He told me about some of the guys I'd met on my first trip and I learned that the young bass player had died in a fire in the hotel where he was working a couple of years earlier.

Alex organized a jam session and Louie, Remo, and I got a chance to play with some good young musicians. Just like the party on my first trip, bass players wanted to play with Louie, and about a dozen drummers waited around to have a turn with me. Remo was impressed with a few of the guitar players, and Louie and I liked what we heard too.

Alex told me how the Russian jazz scene had changed over the twelve years since I'd been there. He'd been able to get licenses and permissions from the government so he could publish his writings on jazz. Now it was legal for jazz musicians to have jam sessions in clubs, and jazz could even be taught in some Russian schools. He didn't take the credit, but I knew Alex had to be one of the people responsible for these changes. I figured it took him years, but he must've finally convinced the government that jazz could have positive value for his country.

Alex hadn't aged very much, but his appearance had changed. He'd shaved off his beard and cut his hair and it looked like he spent some time grooming each morning. The same thing was true about his clothes. In '72, he always wore an old sport shirt with a sweater and baggy unpressed pants, but whenever I saw him on this visit, he was dressed in a shirt and tie and business suit. Seeing all of this, I wondered if he'd changed his image so he'd have a better chance of being heard, or whether he started looking like an important person after the changes took place.

I got the sense that everything in Moscow had gotten more relaxed. The people I met, musicians and non-musicians, seemed to act much freer than they had before. In fact, I had an experience on the day I arrived which showed me there was less red tape than in the past.

When we landed, I discovered the bass I'd brought had gotten damaged and couldn't be used. But it didn't take more than an hour before an official arranged for me to borrow a bass from a Bolshoi musician and use it for as long as I needed. If the same kind of thing had happened on my first trip, it probably would have taken days to arrange for a replacement.

One of the nicest memories from this trip was an incident that happened a couple of days before we left. A young jazz musician walked up to me on the street and said, "I am a member of the Lester Young Jazz Club in Moscow." Then he handed me a button with a picture of Prez on it.

I happened to be carrying a loose-leaf portfolio with about thirty of my photographs. I knew I had a nice 11 x 14" portrait of Prez which I'd taken back in the late '50s. I opened the case, slipped the picture out of its plastic sleeve, and handed it to him—just like that. In a way, I startled myself because I almost never give away my prints.

This guy took one look at what I'd given him and flipped. He stared at the picture for ten or fifteen seconds, shaking his head from side to side. There were tears in his eyes. Then he grabbed me and gave me a bear hug.

I'd never heard of a Lester Young Club in the States, but there I was in the middle of Moscow, hearing about a group dedicated to Prez's music. The whole scene was absolutely beautiful.

In addition to traveling, beginning in the early '70s, I found myself working at a few jazz clubs around the city.

I worked fairly regularly at Michael's Pub, which was a club on the East Side. It was a big place with a long bar up front and three separate areas for eating. It was decorated like an English pub and it always attracted an upper-class crowd.

Actually, I began there with Teddy Wilson and Jo Jones, and the story of how that engagement turned into a permanent gig is interesting. When Teddy called me about doing it, he set a price and I accepted. But

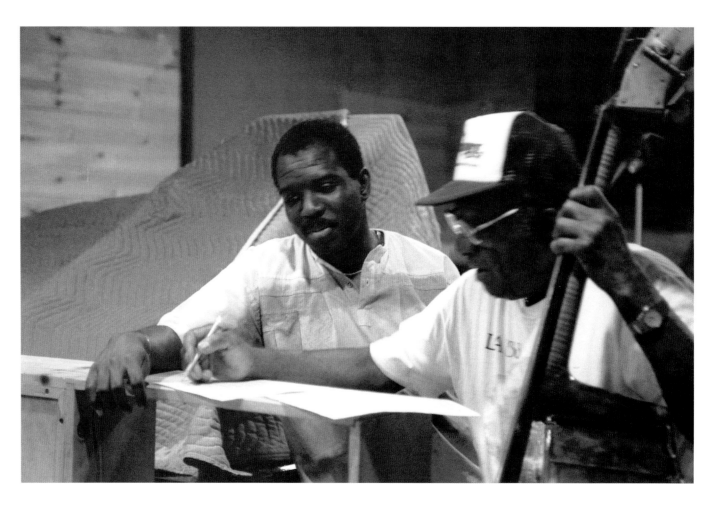

James Williams and Milt, recording studio, New York City, c. 1990

the night we opened, he told me there'd been a misunderstanding with the owner and he'd have to give me fifty a week less. I'd known Teddy for years, so I knew he wasn't trying to put something over on me, and since I'd already turned down other work to be available for this gig, I decided to do it.

I can't remember how long we worked, but I know we did fabulous business. A few months later, Teddy called to ask if I'd go back and do a couple more weeks with him. I told him I'd have to get my original price and when he said it couldn't be done, I turned him down. There was no hostility—everything was always very amicable between us.

A few days passed and then Gil Weist, the owner

of the place, called me. He said he'd asked Teddy why I wasn't coming back and when he learned about the money problem, he told Teddy he'd negotiate with me directly. That's exactly what he did and I got my price.

When Teddy finished his gig, Gil asked me to stay on and play with the next act he'd booked. He offered me a higher salary, almost double what most clubs were paying, and he said I'd get paid by him directly. The musicians he brought in were some of the best. I knew I'd only be working five nights a week, two shows a night, which meant I'd be finished by twelve-thirty. Compared to other jazz places, it was easy work, and much too good to turn down. In fact, I played there on and off for more than a decade,

working with people like Joe Venuti, Red Norvo, Johnny Hartman, Sylvia Syms, and Dick Hyman. I couldn't begin to list all the great sidemen who were there over the years. But I enjoyed playing with Bob Rosengarden and Derek Smith so much that we ended up forming a trio.

From the mid '70s until the mid '90s, once or twice a year I'd also take a gig with an all-star group and play at one of the major jazz clubs in the city. But, aside from Michael's Pub, the other places I worked were usually small and less known.

One of my favorites was an Italian spot called Zinno on West 13th Street in the Village. It was just piano and bass in a little section of the restaurant beyond the bar with seven or eight tables and maybe twenty-five seats. It was like playing in someone's living room. I was probably there with ten or twelve different piano players, but I remember Jane Jarvis and James Williams more than anyone else. Both of them were very kind to me and they let me call tunes and solo as much as I wanted.

I played there enough to develop a following. People found me in a newspaper or magazine listing and there'd be a bunch of them who came to hear me every night. Christmas was my favorite time at Zinno, because many old friends visited the city during that time of year. They'd stop by to listen to a set and say hello. The holiday spirit was always evident in that place. They didn't pay very much, but I never complained. In fact, I used to joke that between paying for cab fare and food and drinks for my friends, it probably cost me money to go to work.

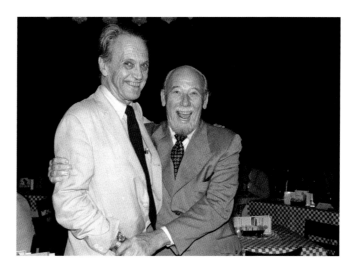

[Above] Alec Wilder and Red Norvo, Michael's Pub, New York City, c. 1975

[Below] Milt and Jane Jarvis, Zinno restaurant, New York City, 1986

Bobby Rosengarden and Derek Smith, recording studio, New York City, 1979

Toots Thielemans, Eddie Daniels, and Dick Hyman, concert rehearsal, New York City, c. 1986

Sarah Vaughan, Pearl Bailey, and Ella Fitzgerald, rehearsal, television studio, Pasadena, California, 1979

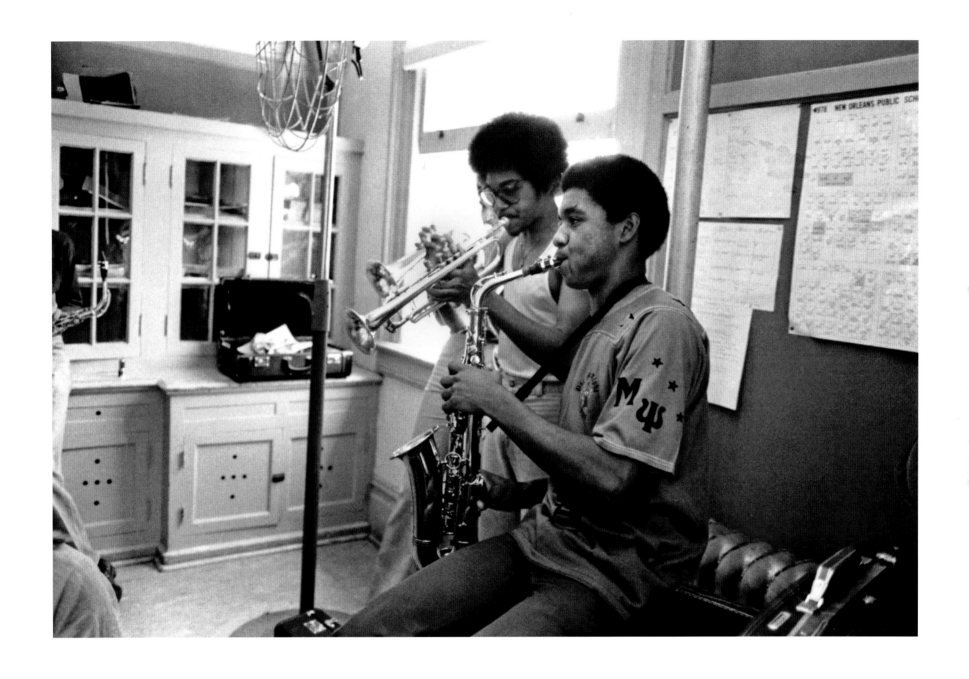

Wynton Marsalis and Branford Marsalis, classroom, New Orleans, c. 1978

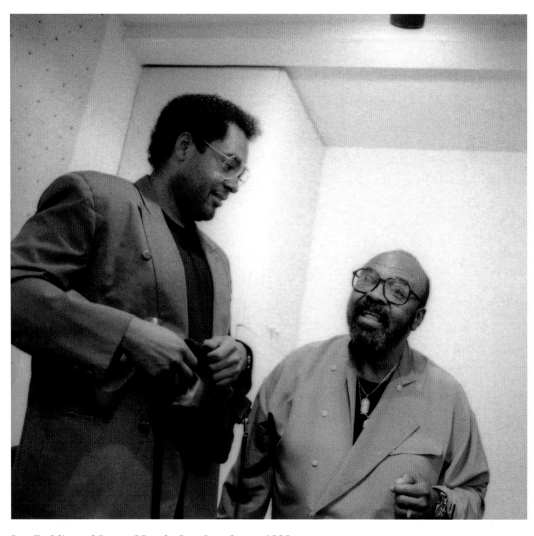

Jon Faddis and James Moody, Los Angeles, c. 1989

The first real jazz party I know about was started by Dick Gibson almost forty years ago. He and Maddie, his wife at the time, always loved jazz—not Dixieland, but the kind of playing that was popular in the '40s when they were in school. One Labor Day weekend in '63 or '64, they hired thirty or forty of the musicians they grew up hearing and brought them to Colorado where they lived. They invited their friends who loved the same music, and everyone shared in the expenses.

The earliest parties were in Aspen, but later they moved to Vail, Colorado Springs, and then Denver. Dick was always the organizer and it got much bigger as time went on. Eventually there were sixty or seventy musicians, and three or four hundred regular guests who paid a music fee and picked up their own tab for the hotel and meals.

There's no way I could possibly list all the musicians who were at the Gibsons' over the years, but some of the best jazz I've ever heard was played there. One year there were a couple of fabulous performances by Joe Williams and Maxine Sullivan. Another time, Dick got Joe Venuti out of retirement and had him play with Zoot. And at one party, Willie "The Lion" Smith and Teddy Wilson played piano duets.

Then there was the time Eubie Blake played a duet with Jon Faddis. Dick always prepared a lineup of musicians for each set and handed it out to the performers in advance. But on this particular occasion, he went even further and picked the tune he wanted—Eubie's "Memories of You." There was only one problem—Jon had never played it before. So a couple of guys spent some time teaching him the tune.

Before they performed, Dick introduced them, saying, "Eubie Blake was seventy when Jon Faddis was born." That line really impressed me, because it shows how jazz transcends age. When they played, it was clear that there was no generation gap. "Memories of You" had never sounded better.

The Gibsons paid pretty well and the accommodations were always first-class, but that's not why any of us went. The real reason was social. It was Colorado,

so musicians from both coasts were there and we all got to spend a long weekend together. What made it even better were the guests. They loved jazz, of course, but they also seemed to appreciate us outside of what we could do on the bandstand.

Over the years, the relationships some of us developed with these people were beautiful. There was never a wall between the performers and the audience. Everyone seemed to feel they were part of the same group.

Dick was originally from Alabama and, as I understand it, became a businessman who made a lot of money from the sale of Waterpik, the tooth-cleaning machine. His financial situation seemed to run in cycles—sometimes he had money, sometimes he didn't. But that didn't seem to stop him from always being extravagant.

At one point, he hired his favorite musicians and created the World's Greatest Jazz Band. He made sure everyone in the group got a high salary on a regular basis. And if a gig didn't pay enough, he'd personally make up the difference. The rumor was, that's how he lost his fortune. Eventually, the same thing happened with the parties. He could've hired half as many musicians, but he always got the guys he wanted regardless of the cost. Just like the World's Greatest Jazz Band, the parties came to an end when he couldn't cover the losses.

Dick and Maddie made a real contribution to jazz in a few different ways. They gave some underrated musicians more of the exposure they deserved and revived the careers of many guys who'd had big reputations years earlier. This happened because the Gibsons always made sure there were journalists at their parties who would write about what they'd heard and who they'd interviewed. I know many cases where that kind of exposure led to record contracts and work at clubs, concerts, and other jazz parties. And even though Gibson parties ended, some of their guests borrowed the idea and used it in their own hometowns. Today there are annual jazz parties across the country which employ quite a few jazz musicians.

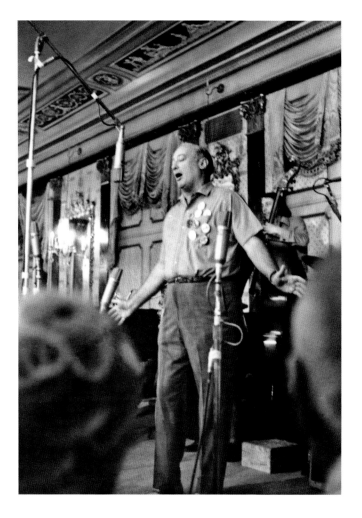

Jazz has come a long way during my career. Recognition and respect are just words until you actually experience a difference in the way you're treated. I often think back to that violent roadhouse episode in Longview, Texas, about sixty years ago. Then I compare it to the kinds of things that happened at the Texas parties in Midland and Odessa—being wined and dined by the town dignitaries, being made an honorary deputy sheriff, getting VIP treatment in one of the world's best eye clinics. It's a different scene. As far as I'm concerned, Dick and Maddie Gibson helped bring about those changes, and jazz musicians owe them a real debt of gratitude for doing it.

Dick Gibson, jazz party, Colorado, c. 1971

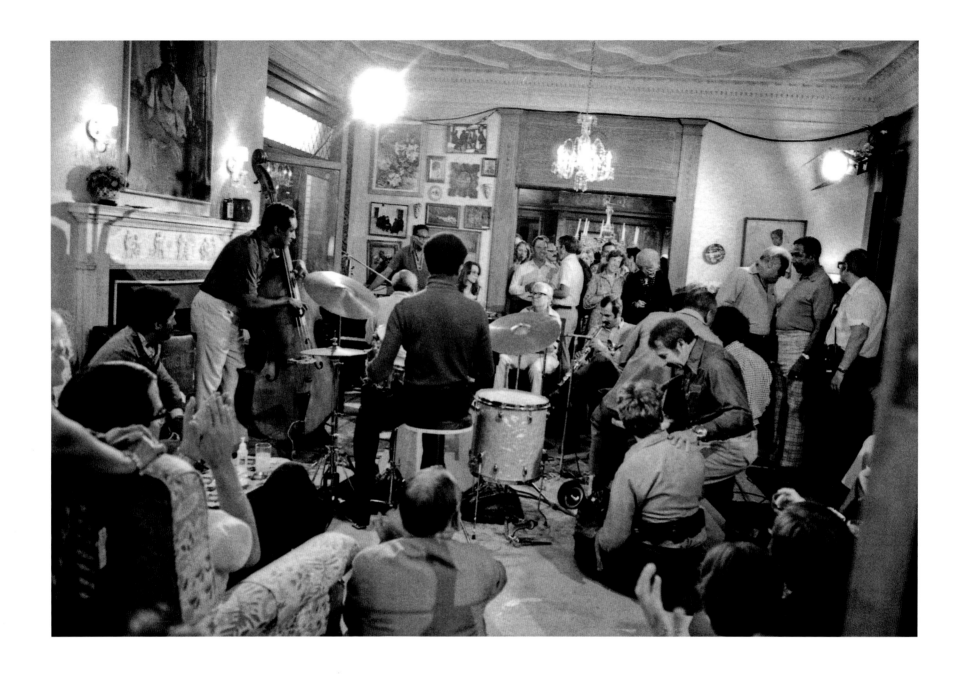

Dick Gibson and jazz party musicians, including Larry Ridley, Ray Brown, Alan Dawson, Butch Miles, Kenny Davern, Bucky Pizzarelli, and Gus Johnson, Denver, 1972

From the time I left Cab in the early '50s, I began playing jazz concerts and festivals as much as possible. Of course, I had to turn down a lot of this work during the period I was busy in the studios, but when things opened up in the late '60s, I took whatever looked good.

Over the years, I played concerts with hundreds of performers from just about every era of jazz. Truthfully, it really didn't matter who I was with or what the gig required, just as long as I could play the music I truly love.

As time went by and many of the guys from my generation passed, people in the jazz world began to see me as one the survivors. And that's probably why, by the early '80s, I was getting calls to play with all-star groups where I was one of the featured performers.

I played all the major European festivals pretty regularly and I also made a few concert tours to Japan. But as time went on, my favorite festival of them all was the one Hans Zurbruegg still puts on in Bern, Switzerland. He started in the early '80s and for about a week each spring, he had all the top jazz performers playing in different locations around the city.

Later, Hans and his wife, Marianne Gauer, renovated a small hotel called the Innere Enge at the top of a hill overlooking Bern. The view from their place is unbelievable. Standing outside, you can see the other hills surrounding the town, and every hour of the day and night there are trains running over trestles and through tunnels around all of them. The scene always reminded me of a gigantic model train set, the kind the Lionel people used to put on a card and send you at Christmas.

Their hotel is all about jazz. They built a club in the basement which is very cozy. It's got great acoustics and comfortable seats and there's a good view of the stage from anywhere you sit. Everyone who plays there comes back to the States raving about the club, the great food and the accommodations.

Hans and Marianne even named some of their hotel rooms after a few of their favorite musicians.

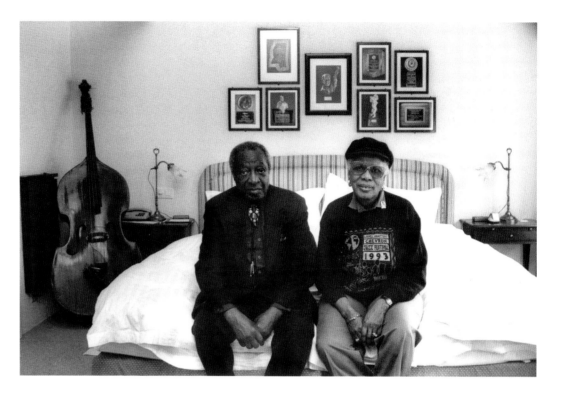

Then they decorated them with photos, awards, letters, and sometimes an instrument which belonged to the particular person. So each of these rooms is unique and reminds you of the musician they've honored. The last few times we were Bern, we stayed in the Milt Hinton Suite. It's got a big bathtub, a separate shower, and two sinks. And compared to what we used to have in the old days, half the guys from Cab's band could sleep in there and there'd still be room. It's no surprise Mona and I feel like royalty whenever we stay there.

Every year I've gone to Bern, I've worked with different groups. A few times Hans asked me to act as the MC for one of the concerts and that was a special thrill. Being a bass player, I might get to solo and have a spotlight on me once or twice a night, but this was the first time I got to be out front and actually speak to an audience at a concert.

Because we've been there so often, Mona and I have gotten to know a lot of people in Switzerland. Bern is in the middle of the country, so every time

Milt and Mona, the Milt Hinton Suite, Innere Enge Hotel, Bern, Switzerland, 1994 (© Hansueli Trachsel)

we visit, there's a steady stream of guests in our hotel room from all over Switzerland. And we're forever going to someone's house or going out to dinner with ten or twelve Swiss friends.

The only other place I've ever felt so comfortable was in Cuba when I was there in the early '50s. Spending a couple of weeks in Havana back then was the first time in my life I didn't think once about black or white, or what I was or wasn't supposed to do. It was a freedom I'd never known before. And it meant

so much to me that I went back whenever I could find the time.

I would have kept going back, but when Castro began to have problems with our government, it all ended. I'm sure there are other places in the world I could feel the same way, but I've never been in one spot long enough to know for sure. Bern is heaven for me and although Hans may not know it, the salary I get is icing on the cake. I would work there for nothing.

George and Joyce Wein have been our friends going back to the days when he had his Storyville jazz club in Boston and was starting the Newport Festival. Over the years, I was a regular at Newport, Kool, JVC, and many of the other festivals he put on.

In 1989, about a year before my 80th birthday, I ran into George in Bern. He asked if I'd be interested in having a concert the following year at the JVC Festival in New York to celebrate my birthday. We said we'd discuss it again and a few months later we agreed to have the concert at Town Hall.

Dick Hyman was the musical director and forty or fifty guys I'd known over the years were on the program. That included about fifteen bass players who performed a piece Dick arranged for me called "The Judge Meets the Section."

I really don't know the ins and outs of George's relationship with anyone else, musician or otherwise. Of course, I've heard rumors about him from the beginning—good and bad. I look at it this way—when someone controls so much of the business, there has to be plenty of gossip.

But George and I always got along very well. Whenever he hires me, he's fair. When travel is involved, it's always comfortable and smooth. Over the years, the people in his office—Marie St. Louis, Charlie Bourgeois, Bob Jones, Deborah Ross, every-

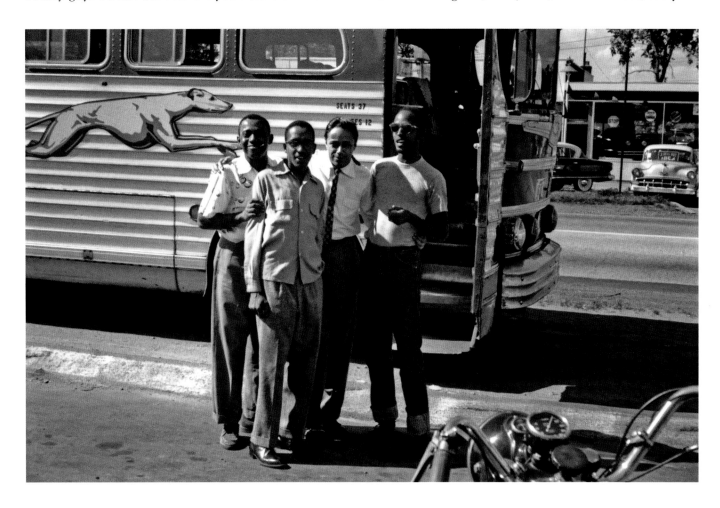

Charlie Persip, Milt Jackson, Horace Silver, and Percy Heath, Newport Jazz Festival, Newport, Rhode Island, c. 1956

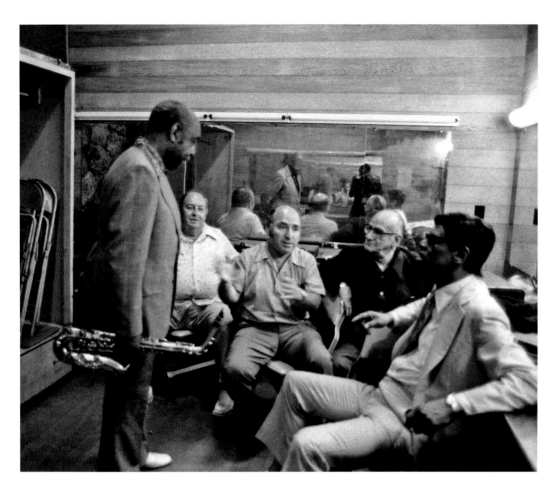

Benny Carter, Larry Wein, George Wein, Joe
Venuti, and Earl "Fatha" Hines, Kool Jazz
Festival, Honolulu, 1977

one—always treat me and Mona with great respect. A
big bouquet of flowers still arrives at the house on our
birthdays, and George and Joyce call every couple of
weeks to see how we're getting on.

Anyway, for this special birthday concert, George
showed me a kind of generosity I'd never seen from
him before. He arranged to have the proceeds from
the concert go to a bass scholarship fund which was
set up on my 70th birthday. Then he allowed the
members of the International Society of Bassists,
which was having its convention in the city, to come
to the concert for practically nothing. So although
Town Hall was packed, there were no profits for the
fund. It didn't matter, because George had given me
the best present possible—an audience of all kinds of
bass players from around the world hearing the music
I love.

There was another birthday concert to celebrate my
turning eighty-five. It was organized by Paul Weinstein
and David Berger. Paul's a good friend who's been
producing jazz concerts for decades and has always
been very supportive. David doesn't really need any
introduction, other than to say that for years we've
considered him to be our adopted son.

This concert was different because Mona and I sat
onstage through the whole event. Jon Faddis was the
MC and every time he introduced a musician, I'd say
something about that person. I'd tell a story about
how we first met or recall a funny incident which
happened on the road or in the studios or backstage
somewhere.

When a group finished playing, the performers
would walk over to where we were sitting and wish
me happy birthday. Some of them sat down with us to
hear the next few tunes and then left the stage when
the audience was applauding for another group. So at
any one time there were probably a dozen musicians
sitting up onstage with us. What a joy to be sur-
rounded by friends like that on your birthday! It was
perfect.

Lynn Seaton, Rufus Reid, John Clayton, Eddie Gomez, Milt, Richard Davis, Bill Crow, Major Holley, and Ron Carter, rehearsal (Milt's 80th birthday concert), JVC Jazz Festival, Town Hall, New York City, 1990

the ship and then later he'd release them as albums on his label. A few times, a filmmaker who was working on a documentary about one of the musicians would come on board and shoot interviews with the guy's friends. Arthur Elgort did that when he was making *Texas Tenor,* his film about Illinois Jacquet.

As far as I'm concerned, the best part of a cruise was getting the chance to hang out with my friends for a solid week. Better yet, I never had to feel guilty about going off with them, because there was always plenty for Mona to do on the ship.

There were usually a few guys on board from my years with Cab—Doc, Dizzy, Jonah—and there were people from my studio days, like Phil Woods, Urbie Green, and Clark Terry. Over the years I might run into these musicians backstage or at airports in between gigs, but in those situations, we really couldn't do more than exchange pleasantries.

So these cruises gave us all a chance to relax and get reacquainted. And wives and girlfriends could do the same thing. I think Hank recognized how unique these gatherings were because he'd frequently ask a couple of us to lead an afternoon discussion and share stories with the audience.

Quite naturally, there'd always be at least one of the younger generations represented on the ship and five or six other bass players, all younger than me, of course. All these guys are beautiful. Only a few are drinkers and most don't mess around with drugs. Some are health-food nuts and lead very clean and stable lives.

Unlike many of the old-timers, the new guys are well schooled in music and open to learning as much as possible about their instruments and about jazz history. They seem to want to spend time with me and they are always very respectful and courteous. They ask about the old days—"What was it like to travel during segregation?" "What kind of guy was Basie?" "What was Ben like when he was drinking?"—those sorts of questions.

Younger bass players I come in contact with want me to show them how I slap. And I obliged as long as

In the '80s and '90s I probably did about one jazz cruise a year. A cruise is something that's a combination of a jazz festival and a jazz party. Hank O'Neal, who owns Chiaroscuro Records, and his wife Shelley Shier, were the organizers. Maybe there were other people who booked cruises, but I don't remember anyone other than the two of them.

For years, they used a ship called *The Norway* and then later *The Majesty of the Sea.* These cruises lasted about a week. They were really floating festivals, with fifty or sixty musicians and about eighteen hundred passengers. No one seemed to care where the ship was going—it could have been sitting still. Everyone was there for only one reason—jazz.

Hank would record some of the performances on

I was physically able. I'd take my bass and play a chorus of something like "Indiana" at a pretty fast tempo. Then I'd do the same thing in slow motion. I'd break it down, beat by beat, to try and show them what was going on a bar at a time.

What these kids probably didn't know is that I wanted something from them too. I'd ask one of them to demonstrate his new pickup or I'd ask another one to show me how he was fingering his solo. So a give-and-take was going on continuously, the same way it was when I was coming up and a few guys around Chicago helped me. The best example of this kind of exchange happened to me years ago, when every bass player in the studios had to play a Fender-type bass, or a "sidewinder," as I used to call it.

Playing a sidewinder never came naturally to me. I wasn't used to having an instrument shaped like a guitar tucked up under my arm and I thought it sounded very artificial. But I practiced at home until I thought I could make it, and then I accepted a few record dates. The first two went all right, but on the third I ran into a problem. The engineer asked me to give him some "more lows." I wasn't aware you could adjust the tone, so I just turned down the volume. Of course, that only added to the confusion.

Luckily, the guitar player who was sitting on my left—Barry Galbraith, I think—quickly realized what was happening. He reached across my chest and turned a knob on my sidewinder which reduced the treble. Although things were fine for the moment, I realized I had to get some help fast.

I knew Bob Cranshaw when he first arrived in New York. In the early days, he'd ask me to take him on record dates so he could see how they were run. And by the middle of the '70s, he'd become quite proficient on a sidewinder, so he was the natural person to turn to for help.

There was nothing formal—we just arranged to get together at his place a few times. He familiarized me with the instrument and got me comfortable. I learned how to hold it a different way and how to position my body so it was easier to reach the notes I wanted

and to play in tune. Bob also showed me how to make electronic adjustments so I could get different kinds of sounds. Truthfully, I never really got used to the instrument, but I got good enough to use it in the studios without being embarrassed. To this day whenever I see Bob, he tells me how glad he was to be able to return the kindness I'd shown him.

Ron Carter and Bob Cranshaw, recording studio, New York City, c. 1971

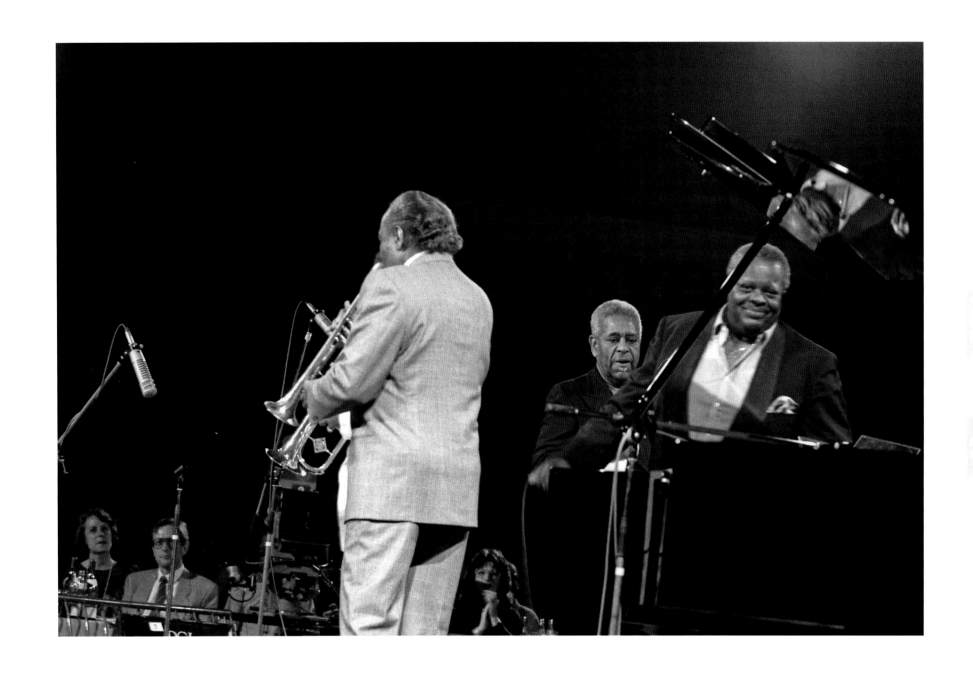

Harry "Sweets" Edison, Dizzy Gillespie, and Oscar Peterson, concert, Bern Jazz Festival, Switzerland, 1988

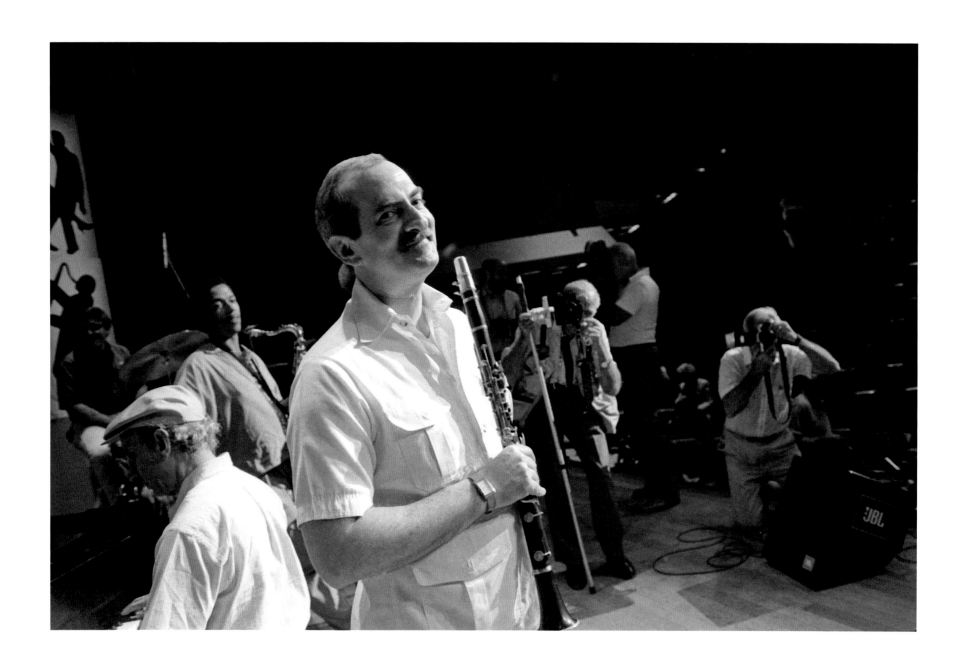

Dick Hyman (*at the piano*), Ricky Ford (*with saxophone*), and Kenny Davern (*with clarinet*), Sarasota, Florida, 1986

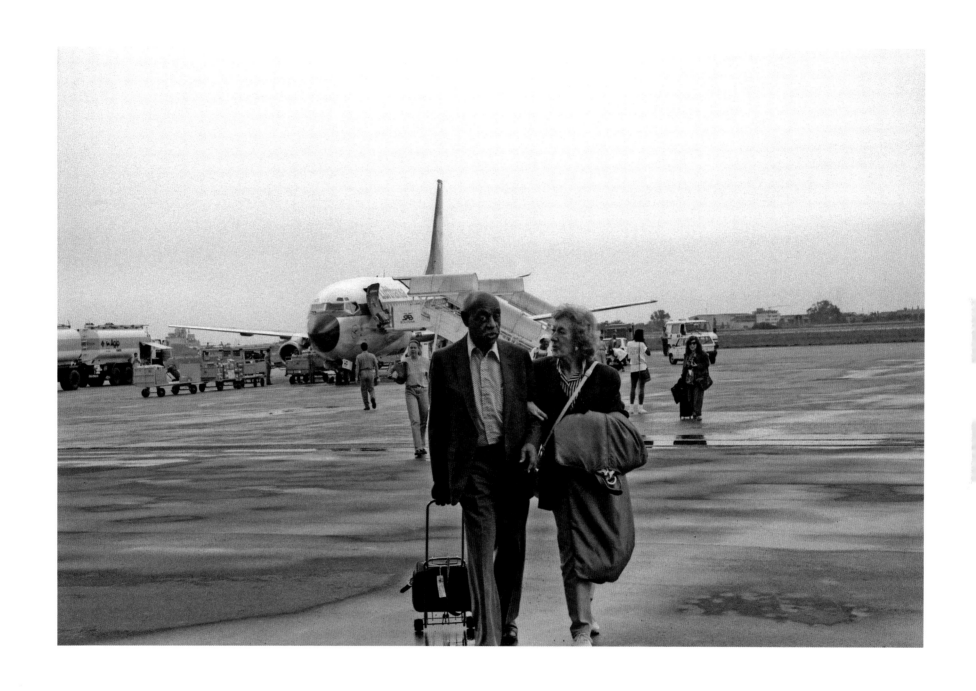

Benny Carter and Marian McPartland, on tour in Europe, 1991

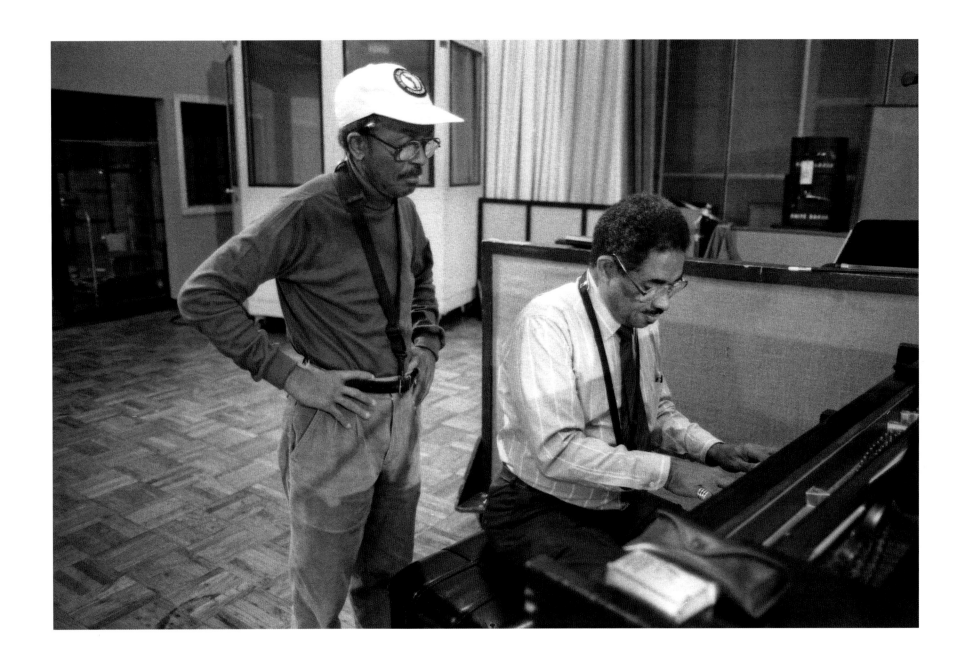

Jimmy Heath and Frank Wess, recording studio, New York City, 1989

Dizzy Gillespie, Grande Parade du Jazz, Nice, France, c. 1981

Howard Alden, Gibson jazz party, Colorado, c. 1987

Malone thought it would be good to have an old-timer on his date. And once or twice a year, an established star like Willie Nelson would call me to do something.

I also got to make a few albums under my own name. Hank O'Neal put out *Old Man Time* on his label. He combined some of the cruise performances he'd recorded with a couple of sessions we did in the studio later. A lot of the guys I knew over the years—Cab, Dizzy, Hamp, Danny Barker, Joe Williams—were on it. For me, the unique thing was that Hank had four or five of us sit down at one session and talk about the old days. He recorded and edited our conversation which became a long track on the album. I guess he got a good reaction, because he started doing the same thing on other CDs he made.

I also produced some recordings on my own in around 1989. I asked Mona if I could take some of the royalty money we got from our books and bring a few musicians into a studio. I really didn't have any plan; I just wanted to do it. When she agreed, I scheduled three or four sessions and got Howard Alden, Kenny Davern, Janice Friedman, Sylvia Syms, Warren Vaché, Kenny Washington, Frank Wess, and James Williams. We did ten or twelve beautiful tunes and I've made sure they're stored properly so they can be used in the future.

Then there was an album I made for Columbia called *Laughin' at Life* that featured me playing and also singing on a few tunes. One was "Old Man Harlem," a Hoagie Carmichael song I'd done with Eddie South when I was in my early twenties. Back then my voice was at least an octave higher. Jon Faddis was on the date and he worked with the engineer to get just the right kind of old-time trumpet sound. When Jon was just starting out, I'd hired him for a record I was making for an independent label. Over the years, I watched him develop into a trumpet virtuoso who's capable of doing it all. And I'm proud of him.

Many more of the jazz records I made between the late '60s and the mid '90s were done for independent labels. Sometimes they'd put together a group of recognized people, call them "all-stars", and make an album. I can't possibly name everyone I recorded with, but Joe Venuti and Mary Lou Williams are two who immediately come to mind, probably because I'd known them for so long and always wanted to record with them.

Other times I might be featured on an album with a regional group who'd met me at some small festival in the Midwest, or an Asian or European performer, or someone I taught at Baruch or Hunter College. Occasionally a rising star like Branford Marsalis—who I met when he was a kid—or Russell

Mary Lou Williams, Yale University, New Haven, c. 1972

Joe Venuti, Bucky Pizzarelli, and Bob Wilber's hands, rehearsal, Carnegie Hall, New York City, c. 1977

Branford Marsalis and Jeff "Tain" Watts, recording studio, New York City, 1988

Sweets Edison and Terence Blanchard, recording studio, New York City, 1991

Russell Malone, recording studio, New York City, 1991

Randy Sandke, Barry Manilow, and Joe Wilder, recording studio, New York City, 1994

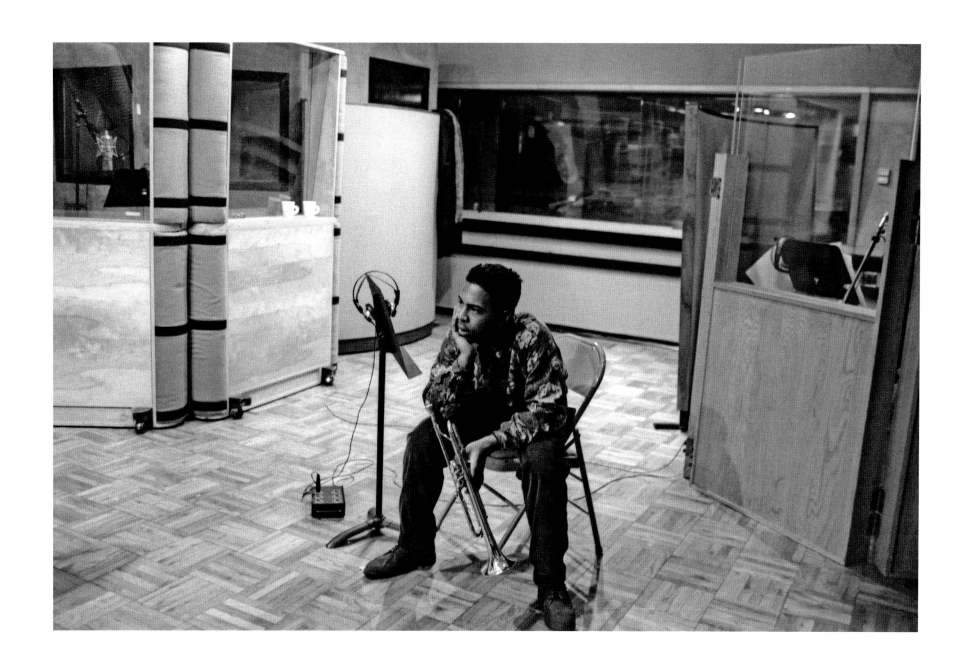

Roy Hargrove, recording studio, New York City, 1991

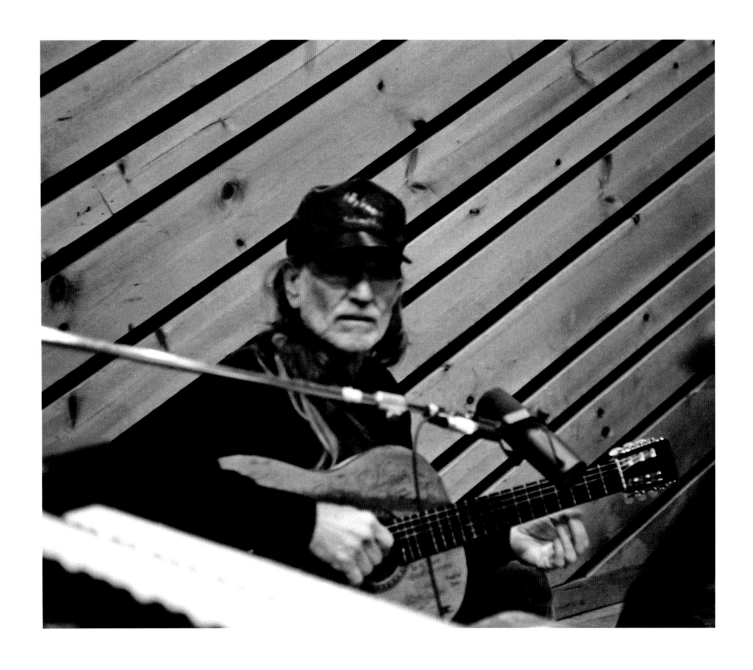

Willie Nelson, recording studio, New York City, 1992

After the two books with my photographs came out, people got more interested in them than ever before. I had shows at places like the Rhode Island School of Design and the Denver Art Museum, which I've been told are very prestigious. Truthfully, that kind of thing has never really mattered to me. My main concern has always been that people from all walks of life have a chance to see my pictures.

It's important to me that they get shown at places where jazz fans go, like Monterey. And I also like the idea that they were shown at community centers and libraries in smaller towns around the country. In fact, for three or four years, there was a show which traveled to different FNAC stores in France and Belgium. These are places that sell albums and electronics and each store has a gallery area so customers can see different exhibits. I've been told thousands of people got to see my photos in their stores, and that's exactly what I always wanted.

Of course, there've been a few exhibitions which were special. One was a show I had with the great artist Jacob Lawrence in Hartford, Connecticut. Then there were the shows at the Corcoran and the Smithsonian—both at the same time. When I went to Washington and saw my photos on the wall, I kept pinching myself, just to make sure it was really happening.

As people in the jazz world came to know about my photographs, musicians started asking me to take their pictures. And I also got plenty of comments and criticisms about why this or that person was included or left out of one of the books. I'd usually say that the people in charge of the books made the final selections. Of course, even if I'd taken good pictures of everyone I ever knew or worked with, it would have been impossible to include them all.

When my photos attracted so much attention, I began to question my abilities as a photographer. I went back and looked at my work and I asked myself why I started taking pictures, what my goals were, and whether I really deserved the kind of praise and recognition I was getting. I talked to a few knowledgeable

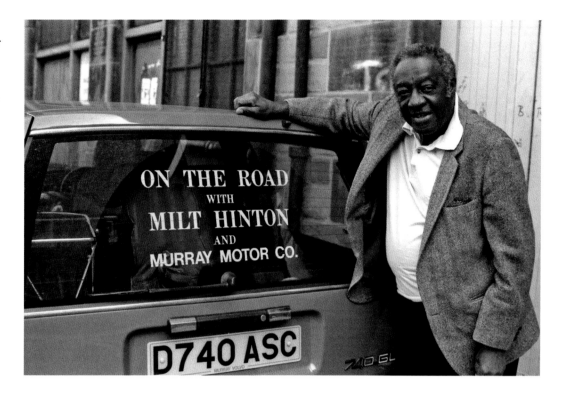

friends, but the thing that helped me most was reading over what I'd said on this subject in the past. So I've reworded a few things, but I'm repeating the main points because it still describes how I feel about myself and photography.

I got my first camera in 1935. It was a 35 mm Argus C3, and it was a present for my twenty-fifth birthday. I had the Argus with me when I started on the road with Cab in 1936. Although I took a few posed shots, I was never much for taking formal pictures. Everybody was shooting the band onstage in uniform, and if you went to a professional photographer for your own publicity shot, he'd ask you to smile and act like you were playing your instrument. I've never wanted to get those kinds of photos because I don't see musicians that way.

I always tried to capture something different. Whenever possible, I liked to shoot people when they

Milt, Edinburgh, Scotland, 1986

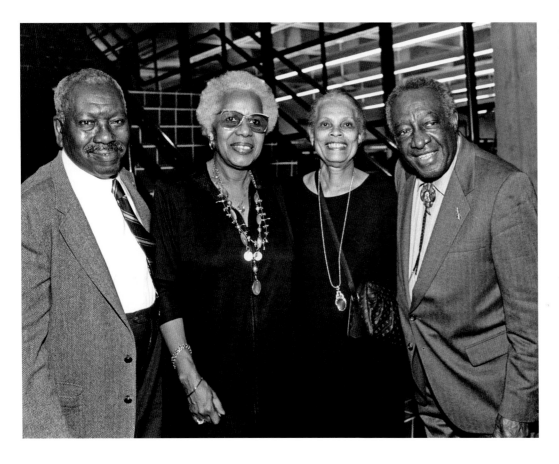

Jacob Lawrence, Mona, Gwen Knight Lawrence, and Milt, gallery opening for Lawrence and Hinton exhibition, Hartford, Connecticut, 1990 (© Whitey Jenkins)

amazed at the size of the locomotives and the machinery they used to switch tracks. So once again, whenever possible, I'd have one or two guys stand next to a locomotive so I could get them in my shots. I also realized that if I put a person in the picture, it would show just how big those locomotives really were.

I admit I've always been biased toward black-and-white photos. It's probably because when color film first came out, what you saw in a print didn't seem to match the colors you'd see in nature. And after a while, color prints would fade. Besides, a lot of color processing was done through the mail, and since I was on the road and didn't have a permanent address, it made it difficult to get prints back.

During my days in the studios, whenever I had time, I'd make a few black-and-white prints from what I'd shot a day or two earlier. Then I'd give them out to the guys the next time I saw them on a record date. Although it was unintentional, the prints I made of my white friends always came out looking very dark. And whenever someone teased me about it, I'd say the same thing: "I can't help it, that's just the way I see everybody."

I still get asked why I took some of the pictures I did, and it's hard to answer that question. When I took those early pictures of Dizzy, we were both in Cab's band. Even back in those days, I knew he was very innovative, but I never suspected he would turn out to be such a giant. The same thing was true for Chu and Cozy and the other guys. These were my friends, and I wanted pictures of them so that one day we could look back and remember the great times we'd shared.

When I shot those Jim Crow signs in the South like the ones at the entrance to the train station in Atlanta, I wasn't trying to make a statement. We all lived in the North, and one of the only ways we could deal with the stupidity of the segregation laws was to make fun of them.

At some point, probably in the late '40s, I saw that jazz was changing quickly and there were new faces coming on the scene all the time. Some of the pioneers

were off guard or unaware. Of course, I was limited in some ways. I didn't have a flash in the early days, and the film speed was so slow you couldn't take photographs indoors without using a long exposure. Even so, I did get some unusual shots inside, like pictures of the guys sleeping on the train. There were also times when the stage lights were on and I could use them to get a better indoor exposure.

Whenever I wanted a picture of a specific place, I'd always try to include one of the guys in the shot. For example, years ago when I was in Springfield, Illinois, with Cab, I wanted a shot of the Lincoln statue. But instead of taking a picture of the statue alone, I got Danny Barker to stand out in front of it. The same thing happened in the railroad yards where we'd always spend a lot of time waiting for trains. I was

like Chu and Jimmy Blanton were already gone, and some of the other greats were well on their way to early deaths. For some reason, I felt strongly about using my camera to capture the people and events from the jazz world that I was lucky enough to see. I guess I realized I was actually living through jazz history.

Keg Johnson had more influence on my photography than anyone else. He was diligent and precise with just about everything in his life. He didn't have many personal possessions, but whenever he bought something, it had to be the best. Consequently, a couple of years before the war when he decided to get a camera, he got the best Leica he could find. After that, he spent weeks reading up on photography in books and magazines. When I saw the kind of pictures he was getting, I couldn't believe it. Everything was absolutely needle sharp. It wasn't long before I bought a Leica too.

We decided to process our own film while we were traveling with Cab, and we bought some basic equipment. Whenever we were in a big city playing a theater and staying in a hotel for more than a couple of days, we set up our darkroom. We usually started late at night, after the last show. That way we didn't have to figure out a way to block off the light in our room. We bought a special box which allowed us to make a 4x5 print from a 35 mm negative. We'd work until daybreak when the room started getting light, and by the time we cleaned up it would be about seven in the morning. We'd get some breakfast and then sleep for a few hours before heading over to the theater to play the first show.

In the early '50s, a short time after Mona and I bought our first house, I set up a small darkroom in the basement. By this time, I wasn't out on the road anymore and I thought I'd be able to spend more time working on my photography. I got my first enlarger through a friend from Cab's band, Gene Mikell, who left music and was working at the United Nations. He told me they were replacing darkroom equipment and he could get me an Omega for a hundred dollars. I grabbed it.

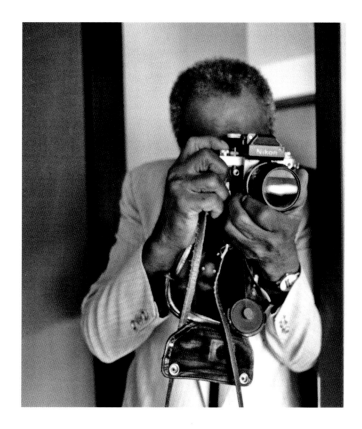

Milt, Hartford, Connecticut, 1990 (© Robert Appleton)

When I went to Japan with Louis Armstrong about the same time, I bought a Canon 35 mm range-finder camera. It had advantages over the Leica. It was easier to load film and it had a mechanical trigger for advancing frames. Also, when you changed lenses, you could reset the eyepiece to see what was included in your shot. Even though the Canon was easier to use, the pictures I got with the Leica were sharper. So I used them both. This went on for about ten years, until the early '60s when I bought a single-lens reflex—a Nikon F. At that point, I put away both the Leica and the Canon.

I get asked most often about the shots I took of Billie Holiday at what turned out to be her last recording session. I had the feeling she was close to the end. I think the record company people knew exactly what was going on and were trying to finish the album while she was still on her feet.

I took most of the pictures while Billie was listening to playbacks. Looking at her, I could see how disappointed she was about how she sounded. The quality of her voice had changed, and she knew that better than anyone. As she listened, her eyes would fill with tears, and I had the feeling she was imagining how much better she'd sounded twenty years before when she'd sung the same song. She was so wrapped up in listening that she was completely unaware of me and my camera.

I'm also pleased about some of the pictures I got at the *Sound of Jazz* television show. As far as I'm concerned, this was one of the best programs ever done on jazz. I got photos of Basie, Billie, Prez, Bean and many others. I know you can get the program on videotape and I've seen it a dozen times. But photos are different. You can study them. You can analyze the expressions on people's faces, and to my way of thinking, you can see what they're really all about. That's one thing which always attracted me to photography.

Of course, I got to shoot the rehearsals where performers are less formal and more relaxed. How often do you get a chance to shoot Basie watching Monk play?

In 1958, *Esquire* magazine invited practically every living jazz musician to pose for a picture up in Harlem. It was scheduled for ten in the morning. And even though there was no pay involved and the hour was early—especially for jazz musicians—the turnout was enormous. The minute I arrived, I knew it would be a big event. Some of these people might work together once in a while or see each other in a bar, but to have about seventy-five of them in one place at one time was truly amazing.

I don't think the *Esquire* people had any idea about the importance of the gathering. All they seemed to want was a perfect shot of the whole group posed on the stoop of a brownstone. It was funny to watch the musicians fraternizing while the magazine people shouted directions at them.

Jean Bach, who made *A Great Day in Harlem*, the film about that day, found out that a couple of people had brought cameras. But except for *Esquire*'s photographer, Art Kane, I don't remember seeing any of them. Fortunately, I had enough sense to bring three—my Leica and Canon and a little Keystone 8 mm movie camera. I gave Scoville Browne the Canon, which had color slide film in it. I used the Leica with black-and-white, and Mona took color movies which became a big part of Jean's film.

The shot I got that day of some of the greatest drummers in jazz is one of my favorites. Just being able to capture Jo Jones, Gene Krupa, George Wettling, Zutty Singleton, Sunny Greer, and Art Blakey all together was the chance of a lifetime. I also managed to take some photos of Prez looking upbeat—talking to J.C. Heard.

It was one of those times when I sensed there was going to be a major event and I prepared ahead of time to record it. I wanted future generations to be able to see some of the best representatives of the different eras of jazz all together in one place. Looking back, I can truly say that gathering marked the final days of what's now called the Golden Age of Jazz. A few years later, many of the guys who were there were gone.

By the time I was playing in the studios regularly, I had one or two cameras with me all the time. Record companies had great professional photographers come in and shoot sessions, but they kept a close watch on these guys. They'd usually let them in at the beginning and end of a date, or during five-minute breaks. Sometimes I'd see a makeup artist work on a performer for an hour and someone else setting up a background to stage a candid shot. Of course, as a musician hired to play, I could get pictures whenever I wanted. During all those years, I don't remember anyone ever trying to stop me.

From what I've said about my photography, a few things should be clear. I don't think of myself as a professional. I have no formal training and I never had enough time to develop my technique. I really don't know the giants in the field except for the people who've taken photos of jazz musicians.

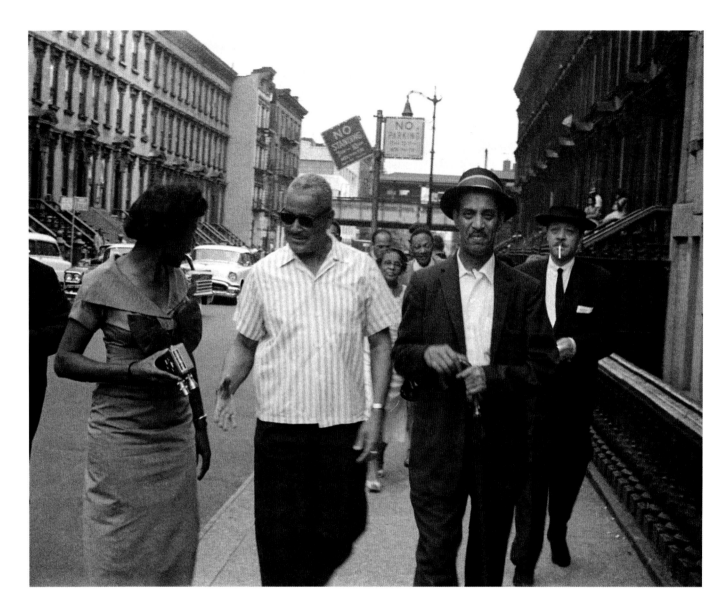

When I first started out in the '30s, I took pictures so I could show my family and friends that I'd really been to all those places and knew all those people. Several years later, the guys I was traveling with became my friends and I shot things we all experienced so we could share them later.

But as time went on, I realized the importance of the world I was living in, and I decided to try and make a record of it for future generations. Being a musician gave me access, and consequently some of the best photos I ever took were simply a matter of being in the right place at the right time. Of course, I had no idea that some of my shots would be used to document jazz history, but I'm glad I've lived to see it.

Mona, Buster Bailey, Vic Dickenson, and Lester Young, *Esquire* magazine photo shoot, Harlem, New York City, 1958

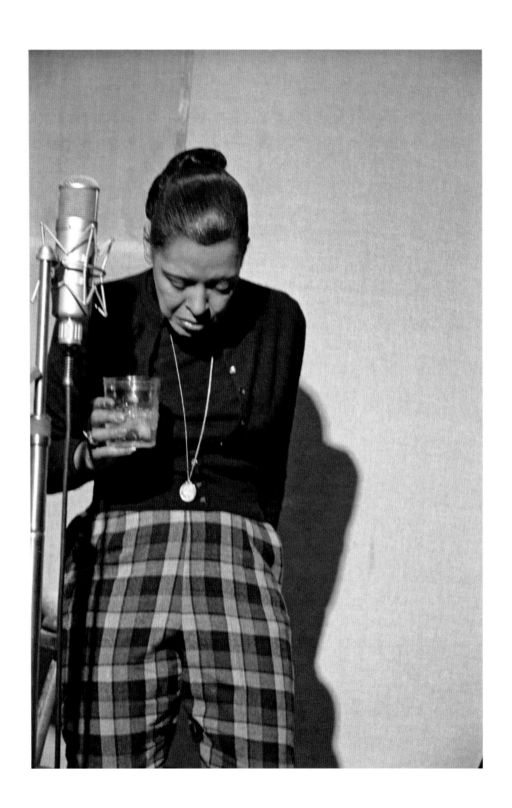

Billie Holiday, recording
studio (her last recording
session), New York City, 1959

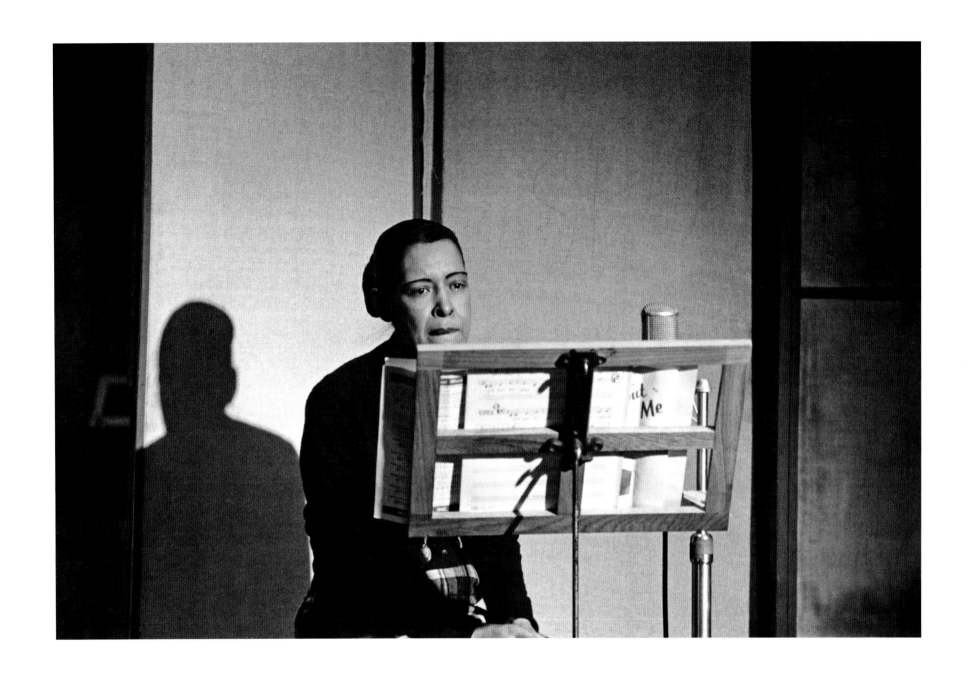

Billie Holiday, recording studio (her last recording session), New York City, 1959

Thelonious Monk, Ahmed
Abdul-Malik, and Count
Basie, television studio
(*Sound of Jazz* rehearsal),
New York City, 1957

Lester Young and J.C. Heard,
Esquire magazine photo
shoot, Harlem, New York City,
1958

Front row: George Wettling and Bud Freeman; *Second row:* Jo Jones, Gene Krupa, Sonny Greer; *Third row:* Miff Mole, Zutty Singleton, and Red Allen; *Fourth row:* Dickie Wells, Art Blakey and Taft Jordan; *Top row:* Buck Clayton, Benny Golson, Art Farmer, and Hilton Jefferson, *Esquire* magazine photo shoot, Harlem, New York City, 1958

Epilogue: Making It to Ninety

In early January of 1996, I took a weekend gig in Atlantic City with an all-star group. It was at the Resorts International Hotel and Flip Phillips, Scott Hamilton, Howard Alden, and Jack Sheldon were in the band. Mona was with me and we also took a close family friend, Donya Kato, who everyone calls Dee.

During the second set, I was doing my vocal on "Old Man Time" and right in the middle of the chorus, I froze up. Everything stopped working. I'd already had problems with my nervous system—I'd had trouble lifting my feet when I walked and my speech wasn't as clear as it once had been. But those things were nothing compared to what happened that night. Mona and Dee were sitting in the first row and when Dee saw I was in trouble, she got to the stage quickly and walked me off.

That night a terrible storm hit the East Coast and we got snowed in for two or three days. I didn't see a doctor until I got back home. But I didn't need someone to tell me what I already could sense—at eighty-six, my career as a bass player was over.

During the next couple of months, I experimented with different ways of playing. Several bass players came to the house and gave me suggestions. I tried to use a stool, but I 'd never been able to move around on a bass when I was sitting down. I even tried lean-ing against a wall to get some added support, but that didn't work either. No matter what I did, my balance was still off and my arms and fingers were too weak to play.

I took one more gig. It was with James Williams at Zinno. He insisted, and I finally agreed to try it, but only if there was another bass player standing by at the job, just in case. It didn't work out. I couldn't make it. I was too far away from the standard I'd set for myself when I first started out.

In addition to the physical problems I already had, I developed some new ailments over the next few years. I was diagnosed with Parkinson's, prostate cancer, and a few other choice conditions which seem to catch up with all of us eventually. The details are pretty boring, even to me, so I won't spend any more time on the subject.

What's important is that I struggled and continue to struggle to accept everything that's happening. Obviously, I couldn't play bass any longer, which was something I'd been doing for seventy years. But I also found myself spending more time at home than ever before and I know that continues to have an effect on my relationship with Mona, who's developed her own physical problems.

These days, although many people visit, I spend

less time hanging out with musicians. Fortunately for me, I've always had good friends in the neighborhood and I'm making new ones every day.

For some years, even before I stopped playing, I'd spend the spring and summer months growing vegetables on a small plot of land at a community center a few blocks from our house. Other than a couple of flowers in the backyard, I'd never grown anything before. I guess I was exposed to farming as a child in Vicksburg and forgot all about it. Or maybe these kinds of things are passed on through your genes. Wherever it comes from, I know I've always had the urge.

Anyway, when I stopped playing, I got friendlier with ten or twelve guys who each had a garden plot at the local Roy Wilkins Center. They'd already taught me about hoeing and planting, but now, with fewer obligations, I'd spend much more time sitting around and talking about gardening with them.

I got excited just watching a cucumber or zucchini grow from a seed, to a flower, to a foot-long vegetable. All summer long, I harvested more produce than we could possibly eat, so I gave it out to everyone in the neighborhood who'd take it.

I also took up swimming at the same community center. I didn't know how to swim when I started, but I was told it was great exercise and decided to learn. I've made some good friends at the pool. Until recently, two guys named Al and Leon would pick me up almost every day and drive me there. The two of them are beautiful, just regular guys who aren't trying to prove anything. All of us are in the same situation—we have our ailments that are wearing us down and we do everything possible to slow up the process.

I've become much more active in a club I belong to called the Friendly Fifty. It's based in Harlem and made up of a bunch of senior citizen musicians. Some members like Jonah Jones, Beverly Peer, and Percy Bryce had pretty successful careers in jazz. Others may have played a little jazz, but mostly worked club dates.

We meet once a month at a community center uptown. The purpose is purely social—sharing stories about the old days in New York, discussing a medical condition or a doctor, those kinds of things. We have a formal dinner dance once a year at a catering hall in the Bronx and some of the guys perform. But it's really an opportunity for friends and family to meet other club members and to see what we're all about. I enjoy the club because we're all in the same position and we do a good job of supporting each other.

Even though I can't play music anymore, I still go to jazz events. Hank O'Neal invited me and Mona as guests on one or two of his jazz cruises. I'd sing a chorus or two during the week or participate in a discussion about jazz, but most of my time was spent socializing with old friends.

The same kind of thing happened with the Bern Festival. Hans and Marianne flew us over and it was like a big family reunion. Of course, all our expenses were covered, but there wasn't a paycheck in it for me. That didn't matter, because I realized that staying close to the music I love is what keeps me vital.

I haven't been concerned about money for many years. I have a nice Social Security check coming in every month and a pension from the union, and Mona made solid investments that earn good dividends.

Besides, our expenses are pretty low. Our house was paid off a long time ago. Our daughter, Charlotte, married Bill Morgan in the early '80s and they've been living in Atlanta with their child—our only grandchild—Inez Mona.

Even after I stopped playing, until recently, I continued going to schools and talking to students. I'd show my photographs and talk about my life. It became a new career. David Berger and his wife, Holly Maxson, usually made the arrangements and went with me. Holly's a photographer and also archives photographs. She's worked with my pictures for more than twenty years, so she knows them as well as anybody, including me. And when she and David got married, she became one of our adopted children too.

Milt at home, St. Albans, Queens, New York, 1986

Anyway, two of the most memorable gigs were the trips we made to Phillips-Andover Academy in Massachusetts and the Providence–St. Mel School in Chicago.

We spent about three days at Phillips-Andover. They had a gallery with my pictures displayed and they arranged for me to do slide talks in several different classes and tell stories about some of the shots I'd taken. I also got to hear their student jazz band and I tried to give them some tips about improving their overall sound.

The school reminded me of the small colleges where I'd performed and done clinics. I was excited to see such interested and motivated students, especially in high school.

Then a couple of weeks later, we flew out to Chicago together and spent three days doing the same kind of things at Providence–St. Mel. Evidently, the person responsible for getting us to Phillips-Andover thought I should also visit Chicago.

Providence–St. Mel is an all-black school in a poor neighborhood on the West Side. It's private, so parents have to be concerned enough to have their children apply and to pay tuition. I learned that there were

rules for students about how they could dress, how they should speak, punctuality, manners– those sorts of things. And there was a school philosophy about the importance of getting the skills needed for college and beyond.

We stayed with Paul Adams, who still runs the place. He'd just moved into a brand-new house they built for him right beside the school. He talked about plans to renovate houses in the neighborhood so teachers could live where they worked.

Paul's philosophy about education made a great deal of sense to me. For the first time in a long time, I felt pretty optimistic about the future of children living in the ghetto. To this day, I still talk about the great work that's going on there.

In 1998, there was a show of my work at a beautiful gallery in Flushing, Queens, a few miles from where we've lived for the past fifty years. Marc Miller, the person who put it together, included memorabilia along with my photographs. It was the first time that had ever been done. He'd searched our attic and found things I hadn't seen for decades—pay stubs from Cab's band, pocket calendars from my studio days, old letters, and other souvenirs. Looking at them triggered so many memories that for months I'd recall the exact details of experiences I'd had when I was in my twenties.

I still receive all kinds of accolades and awards, probably because I'm old, and until very recently, I could manage to go to the ceremonies to accept them. The two which mean the most to me are worth describing because they involve Mississippi.

The first one was getting the key to the City of Vicksburg where I was born, and the best part was having it presented by the mayor, who just happened to be black. The second was when the State of Mississippi officially recognized me for my lifetime achievements. And the unusual part about it was that the ceremony took place in the old legislative building in Jackson, which up until the '60s only allowed black

people to sit in the balcony. So at least on the surface, it seems a few things have changed in Mississippi during my lifetime.

I continue to work on my pictures as much as possible with David and Holly. We go through old contact sheets making identifications and deciding which shots should be enlarged. Every day I see things I've never seen before, probably because I made contact sheets years ago but never took a second look. Seeing these photos jogs my memory the same way the memorabilia in the Flushing show did.

Two neighborhood friends are still unbelievably supportive. One is Dee, who's always around to take care of our everyday needs. She takes us to doctors and runs all kinds of errands. She also puts on barbeques in our backyard just about every time one of us has a birthday or there's a holiday. She invites musicians and neighbors, then cooks more food than anyone can possibly eat.

The other friend is Hal Squires. He's from Barbados but has lived here for decades. Squires is the guy who got me all my electronic equipment and set it up. We're both Masons and although we often talk about that, we spend much more time having friendly arguments about politics and race. Our perspectives are at odds because we were raised in different places, but I think we really have learned something from each other over the years.

Anyway, Squires got very concerned about our eating correctly, and he makes sure to bring fresh fruit and vitamins to the house and mixes up special shakes for us. Without people like these two, I don't know where we'd be right now.

Mona and I have had a very strong marriage for almost sixty years. But like many marriages, it's hard to explain what's made it work. Our basic approach to life and our ways of relating to people are different. It's not that one is better than the other. I just think it's a difference which has a great deal to do with the way we were brought up.

We really seem to have been able to complement

each other. That may be the reason we've made it for so long. Anyone who's ever come in contact with me knows that I wouldn't know which end was up if it wasn't for Mona. I'm gratified about what I've been able to accomplish, and Mona is more responsible for that than anyone can possibly know.

People still ask me to do interviews for articles, films, and TV programs. I participate because I think it's important for everyone to know about the past. For the last five years David and Holly have been working on a film about me and Mona and I've seen parts of it. I sincerely hope it gives future generations a chance to see what I saw and experienced in my lifetime.

Milt with students,
Providence–St. Mel School,
Chicago, 1996

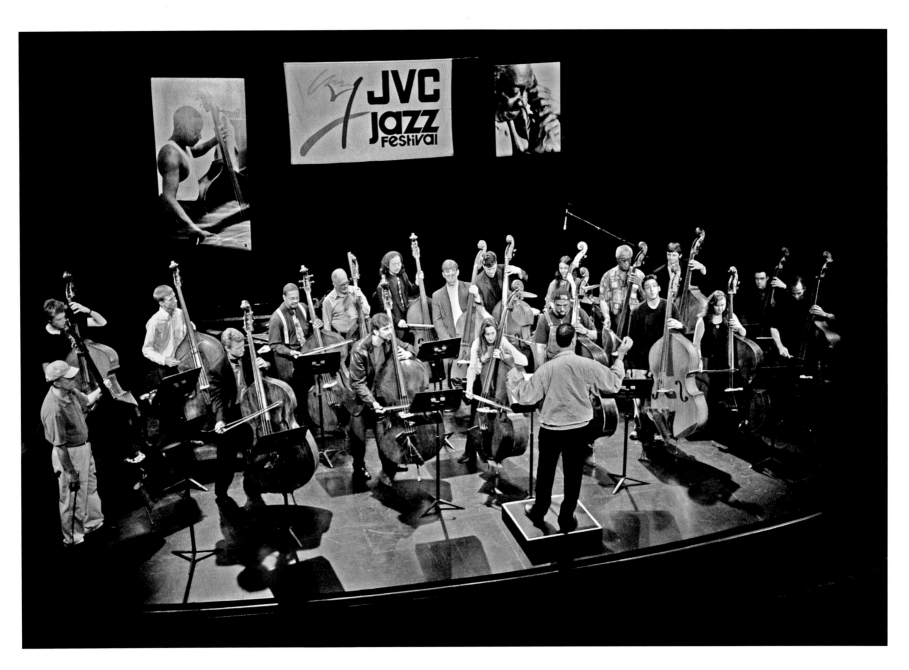

John Clayton (*center, back to camera*); *Front row:* Jay Leonhart, Martin Wind, Brian Torff, Mary Ann McSweeney, Christian McBride, David Wong, and Nicky Parrot; *Back row:* Kyle Eastwood, Tom Jensen, Fred Hunter, Bill Crow, Fumio Tashiro, Elias Bailey, Doug Weiss, Jennifer Vincent, Richard Davis, David Ruffels, Paul Beaudry, and Darryl Hall, rehearsal (Milt's 90th birthday concert), JVC Jazz Festival, Danny Kaye Playouse, New York City, June 2000 (© Ed Berger)

Well, I made it to my 90th birthday, June 23rd, 2000. David produced a birthday concert that was beyond belief. George Wein agreed to make it a part of the JVC Festival in New York and John Clayton was the musical director.

Musicians from all generations performed and for the finale, John conducted a group of bass players made up of both sexes, all ages, and all colors. To see that kind of rainbow, and to hear so many bass players making such beautiful music, truly fulfilled one of my goals in life. Although I couldn't put the words together to thank everyone out loud, the gratitude I felt was in my mind and in my heart.

Bass playing has come a long way since I've been on the scene, and the idea that some people appreciate my contribution and have given me a place in its evolution is very gratifying. But there's more to it than that.

I was pretty young when I realized that music involves more than just playing an instrument. It's really about cohesiveness and sharing. All my life, I've felt obliged to try and teach anyone who would listen. I've always believed you don't truly know something yourself until you can take it from your mind and put it in someone else's. I also know that the only way we continue to live on this earth is by giving our talents to the future generations.

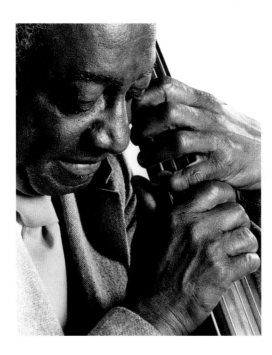

Milt Hinton, 1979 (© Chuck Stewart)

Postscript

Milt died on December 19, 2000, nearly six months after his 90th birthday. On June 24, 2001, the day after what would have been his ninety-first birthday, a memorial was held at Riverside Church in New York City. More than twenty-five hundred people attended. The event opened with "A Child Is Born," which Jon Faddis played alone on trumpet from the highest rafter in the chapel. Other musical performances and speeches followed, and the memorial closed with Rufus Reid conducting a group of fifty-seven bass players who honored Milt with a magnificent tribute.

Acknowledgments

By David G. Berger and Holly Maxson

Milt Hinton had a major influence on David's life. He was a teacher, parent, and lifelong friend, and that only begins to describe their relationship. David sees and experiences the world the way he does largely because of Milt.

Holly first met Milt in 1979 when she began printing and archiving his photographs. This work brought her into the Hinton extended family, and she and Milt regularly looked at and talked about his photographs for more than two decades.

A part of this book draws from *Bass Line: The Stories and Photographs of Milt Hinton* that Milt and David completed in 1987 and published in 1988. *Playing the Changes* goes beyond the earlier book in several significant ways. Milt's life story is continued from 1987 until his death in 2000. Although some of the photographs in this book were published in *Bass Line* and in *OverTime: The Jazz Photographs of Milt Hinton*, there are almost ninety new images, many previously unpublished, and approximately sixty pictures of Milt at various stages of his career. In addition, there is an extensive discography and solography compiled by Ed Berger at the Institute of Jazz Studies, Rutgers University as well as a selected bibliography and filmography. Lastly, there is a CD accompanying this book in which Milt reminisces about his life, plays bass, and sings.

Obviously, Milt is largely responsible for this book, but there are many others whose contributions we must acknowledge.

We are indebted to Dan Morgenstern for his insightful introduction, to Ed Berger for spending weeks listening to Milt's solos, and to Clint Eastwood for his love of jazz and for understanding how Milt is a significant part of its history.

We are thankful to Bil Keane for allowing us to reprint his illustration from *Family Circus*, and to Bob Appleton, Robert Asman, Ed Berger, Don Peterson (on behalf of Charles Peterson), Chuck Stewart, and Hansueli Trachsel, for permitting us to use their photographs in this book.

Since the early 1980s, Milt's pictures have been superbly printed by Robert Asman, and more recently, printed and scanned by Ken Wahl. Both are fine photographers, and we are grateful to them for bringing Milt's pictures to light.

Fred Landerl and Phran Novelli first met Milt in the late 1980s when we worked on a radio series about his life that was recorded at WRTI-FM in Philadelphia and is the foundation for the CD in this book. Fred

and Phran's ongoing support and incisive criticism have helped shape this book. The CD was enhanced by the contributions of Colin J. Bray, Anthony Barnett and John Wilby (*www.JazzOracle.com*); the George H. Buck Jr. Jazz Foundation (*www.Jazzology.com*); Hank O'Neal (*www.ChiaroscuroJazz.com*); and Hans Zurbruegg, who allowed us to use their master recordings. Special thanks are due to Jeffrey Stern and Milo Berger, who lent their ears and technical expertise to the CD editing and production process.

We are exceedingly grateful to Sally Steffen and Ed Townsend for their legal expertise, their concern for Milt's legacy, and their steadfast friendship. We are indebted to Hank O'Neal and Bruce Ricker for giving so much to this project and for knowing the right thing to do—most of the time.

Patricia Willard and John Clayton generously shared their knowledge about music, musicians, and jazz history. And the comments and clarifications offered by Konrad Nowakowski over the years were extremely valuable. They jogged Milt's memory about past events and helped to correct the chronology, particularly concerning his early days in music.

Other friends and colleagues offered intellectual stimulation, emotional support, and sound advice during the evolution of this book, including Dennis and Marge Akin, Jean Bach, Anita Becker, Tony Bellamy, Steve Bishop, Richard Bocchini, Lisa Bocchini, Jerry Borod, Tom and Katie Burke, Walter Carlyle, Ian Clifford, Brian Cogan, Michael Cogswell, Gretchen Condran, Phillips Cutright, Jay D'Amico, Marianne deTrey, Anne Miller, Jon Faddis, Steve Fortgang, Kate Gill, Deborah Gillaspie, Michael Gordon, Nat Hentoff, Geoffrey Herrera, Larry Hilton, Kate Hirson, Douglas and Karen Holmes, Sandy Jackson, George W. Johnson, Barrie Kolstein, Shelly and Barbara Kurland, Diane Levy, Jimmy Lew, Russell Malone, Jerry and Barbara Marwell, Judy Maxwell, Deborah Mayer, Christian McBride, Connie McCabe, N. David Milder, Debora Hess Norris, Richard A. Peterson, Arthur Phillips, Robert and Sophia Phillipson, C. Claiborne Ray, Rufus Reid, Charles and Marcene Rogovin, Deborah Ross, Menchi Sabat, Shelley Shier, Rick Smolan, Harold Squires, Walter Sterrchi, Fumio Tashiro, Franco and Vittoria Tayar, Brian Q. Torff, Marilyn Kemp Weidner, George and Joyce Wein, Paul Weinstein, Bill Wishner, and Mayer Zald.

Michael Ames, the director of Vanderbilt University Press, worked with us closely at every stage of this project. He was calm, reasoned, and pragmatic – in short, a pleasure. The same can be said for Dariel Mayer and Sue Havlish. They pushed us when it was necessary, but we never felt close to the edge.

David's parents, Rosalind and Alfred Berger, provided emotional as well as financial support beyond our expectations. Holly's parents, Ruth and Bill Maxson have always been ardent fans of whatever creative impulses she pursued. We are also grateful to David's aunt, Florence Taub; and Holly's four brothers, Wayne, Peter, Glen and Craig, for their continued nurturing.

Mona, our adopted mother, was always receptive to our questions and gave us ready access to anything we needed for this project. Although Milt and Mona's daughter Charlotte lost her husband Bill Morgan several years ago, she continues to live in Atlanta with her daughter Inez Mona and a new grandson Kamyron —Milt and Mona's first great grandchild. Mona still lives in the Hinton home on 113th Avenue (officially renamed Milt Hinton Place) where she is well cared for by Donya Kato, a long-time family friend, and Carmen Francois. Approaching ninety, she remains "the developer and the fixer."

Finally, loving thanks to our children, Samantha and Milo, who knew Milt all their lives and now have something more of him to pass on to future generations.

New York City
July 2007

The Photographic Collection

The black-and-white photographs taken by Milt Hinton between 1935 and 1999 comprise the major part of the Milton J. Hinton Photographic Collection, which is housed in New York City. The collection, co-directed by David G. Berger and Holly Maxson, contains approximately sixty thousand 35 mm negatives, thousands of reference and exhibition-quality prints, and photographs given to and collected by Milt throughout his life.

Photographs from the collection have appeared in books, periodicals, newspapers, jazz calendars, postcards, CD art, films, in videos, and on the internet.

The collection has curated exhibitions at venues ranging from neighborhood community centers to museums, including the Corcoran Gallery of Art, the Denver Art Museum, and the Smithsonian Institution.

Until Milt's death in 2000, the management of the collection—selecting negatives for reference and exhibition prints, monitoring print quality, and choosing exhibition sites—involved a close collaborative effort between Milt, David, and Holly. In their continuing administration of the collection, David and Holly are always mindful of Milt's point of view as a documentarian, his aesthetic, and his "voice."

Milt was never a professional photographer, and he readily acknowledged that many of his pictures are of dubious quality. He rarely used a flash in low-light situations, and to be less obtrusive, he often preset the camera's focus so he could literally shoot from the hip. Many rolls of film remained undeveloped for twenty years, and because Milt was seldom in the darkroom, at times he inadvertently used stale chemicals to process his film. Negatives remained paper-clipped to contact sheets for years, which resulted in rust problems, and several basement floods caused many to adhere to one another and to their paper sleeves.

A current and major goal of the collection is to complete a database of Milt's photographs. This ongoing project, begun in the late 1990s, in recent years has benefited from advances in digital photography. Scanning has become faster and more accurate, and digital storage is less expensive. Computer software allows a trained user to restore a damaged negative or print and to retrieve elusive details from poor-quality images while maintaining the integrity of the photographs. The success of digital processing is clearly visible in the 2002 Berger and Maxson documentary film, *Keeping Time: The Life, Music & Photographs of Milt Hinton,* and in some of the photographs that appear in this book as well. (Additional information and a current listing of shows can be found at *www. MiltHinton.com.*)

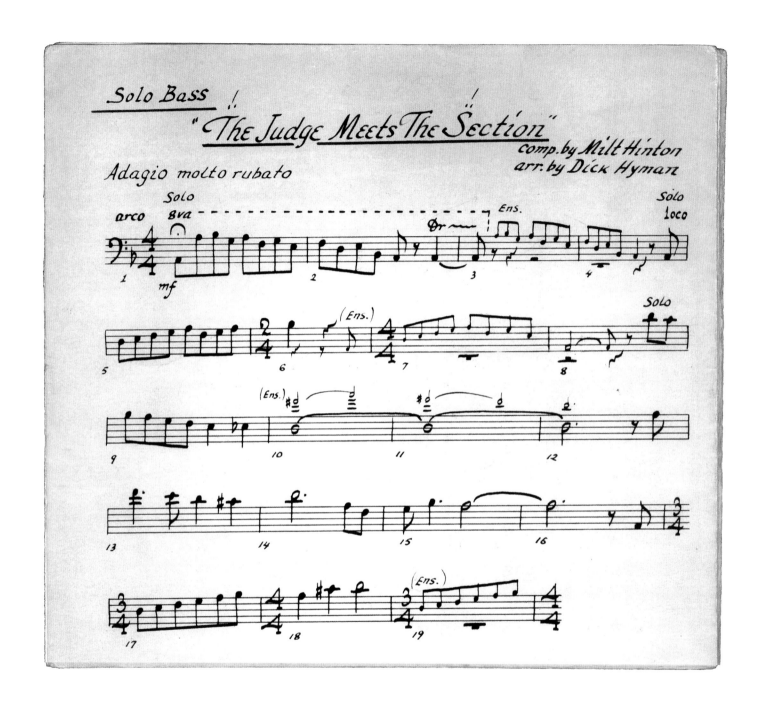

Milt's solo bass part from "The Judge Meets the Section," composed by him and arranged by Dick Hyman.

List of Illustrations and Credits

Unless otherwise noted, all photographs were taken by Milt Hinton and are copyrighted by the Milton J. Hinton Photographic Collection. Other photographers are credited in the caption accompanying their photograph.

For photographs that were not taken by Milt Hinton and where the photographer is unknown, the following credit abbreviations are used:

[HFC] photograph from the
 Hinton Family Collection
[w/MHC] photograph taken with Milt Hinton's
 camera and copyrighted by the Milton J.
 Hinton Photographic Collection

Photo subjects are identified in the captions from left to right, unless otherwise noted.

5 After the Studios

Epilogue: Making It to Ninety

Ephemera

Selected Discography

Compiled by Ed Berger, Institute of Jazz Studies, Rutgers University

It is estimated that between 1930 and 1995, Milt Hinton performed on more than nine hundred jazz record sessions. He made at least as many records, especially during the '50s and '60s, that featured hundreds of non-jazz performers, as well as countless jingles and film and television soundtracks.

Specific and comprehensive information about Hinton's recordings outside of jazz is nearly impossible to obtain. A partial list of non-jazz performers with whom he recorded includes: Paul Anka, Pearl Bailey, Harry Belafonte, Tony Bennett, Brook Benton, Archie Blyer, Teresa Brewer, Diahann Carroll, the Clancy Brothers, Nat King Cole, Perry Como, Sam Cooke, Bing Crosby, Vic Damone, Bobby Darin, Sammy Davis Jr., the Drifters, Percy Faith, Eddie Fisher, Connie Francis, Judy Garland, Jackie Gleason, Arthur Godfrey, Eydie Gormé, Skitch Henderson, John Lee Hooker, Lena Horne, Langston Hughes, Mahalia Jackson, Jack Jones, Frankie Laine, Steve Lawrence, Guy Lombardo, Johnny Mathis, Paul McCartney, Bette Midler, the Mills Brothers, Mantovani, Willie Nelson, Patti Page, Leontyne Price, Leon Redbone, Della Reese, Debbie Reynolds, Frank Sinatra, Kate Smith, Barbra Streisand, Sonny Terry and Brownie McGhee, Bobby Vinton, Dionne Warwick, Roger Williams, Jackie Wilson, and Hugo Winterhalter.

1. Milt Hinton as Leader or Co-leader

The recording location is the New York City area unless otherwise noted. CDs have the same title as the LPs unless otherwise noted. [MH comp] indicates that Hinton was the composer or co-composer of a piece.

July 6, 1945
Milt Hinton (with Tyree Glenn, Jonah Jones, and others)
 "Broadway Holdover"
 (78: Unissued) [MH comp]
 "Bass Pandemonium"
 (78: Unissued) [MH comp]
 "Everywhere" (78: Keynote 639)
 "Beefsteak Charlie" (78: Keynote 639)
 [MH comp]
CD: Mercury 830925 (*The Essential Keynote Collection, Vol. 4: Roy Eldridge and the Swing Trumpets, 1944–1946*)

October 28, 1947, Detroit
Milt Hinton (with Hilton Jefferson, Keg Johnson, Jonah Jones, and others)
"Oo-La-Fee"
"And Say It Again" (78: Staff 604)
"Cle-hops"
"Just Plain Blues" (78: Staff 605)
"If I Should Lose You"
"If You Believed in Me" (78: Staff 606)
"Humba Rhumba"
"Meditation Jeffonese" (78: Staff 608)

January 20, 1955
Milt Hinton (with Dick Katz, Osie Johnson, and Tony Scott)
"Milt to the Hilt"
"Ebony Silhouette" [MH comp]
"Cantus Firmus"
"Don't Blame Me"
"Upstairs with Milt" [MH comp]
"These Foolish Things"
"Pick 'n Pat [MH comp]"
"Over the Rainbow"
"Mean to Me"
"Katz Meow"
LP: Bethlehem BCP10 (*Milt Hinton: East Coast Jazz 5*)
CD: Rhino 74325; Lone Hill Jazz 10178 (*Tony Scott and the Three Dicks*)

February 1, 1955
Milt Hinton (with Danny Bank, Billy Byers, Al Cohn, Joe Newman, and others)
"Prelude to a Kiss"
"Fump"
"I Hear a Rhapsody"
"Moon over Miami"
LP: RCA LPM1107 (*Milt Hinton, Wendell Marshal, Bull Ruther: Basses Loaded*)

April 25, 1956
The Rhythm Section (Barry Galbraith, Milt Hinton, Hank Jones, and Osie Johnson)
"Hallelujah"
"Mona's Feeling Lonely" [MH comp]
"Out of Braith"
"The Legal Nod"
"Polka Dots and Moonbeams"
"Minor's Club" [MH comp]
"They Look Alike"
"Do Nothing Till You Hear from Me"
"Kookin' in the Kitchen"
"Walk, Chicken, Walk" [MH comp]
"Ruby, My Dear"
"Koolin' on the Settee"
LP: Epic LN3271 (*The Rhythm Section*); 3 titles from this session
"Milt's on Stilts" [MH comp]
"He Was Too Good to Me,"
"Mambosies")
LP: Epic LN3339 (*After Hours Jazz*).
All titles on CD: Columbia 477402 (*After Hours Jazz: The Rhythm Section*); Fresh Sound FSRCD371 (*Hank Jones: The New York Rhythm Section*)

May 11, 1960
Jo Jones and Milt Hinton
"Tam"
"Me and You" [MH comp]
"Coffee Dan" [MH comp]
"Love Nest"
"H.O.T."
"Shoes on the Ruff"
"The Walls Fall" [MH comp]
"Blue Skies'
"Late in the Evenin'" [MH comp]
"Ocho Puertas"
"Tin Top Alley Blues" [MH comp]
"Little Honey"
LP: Everest BR5110 (*Jo Jones, Milt Hinton: Percussion and Bass*)
CD: Fresh Sound FSRCD 204

1964
Milt Hinton and Ben Webster
"Sophisticated Lady"
"Stridin' with Ben I" [MH out]
"Stridin' with Ben II" [MH out]
"All the Things You Are"
LP: Famous Door HL104 (*Here Swings the Judge: Milt Hinton and Friends*) (See March 1975 entry for the rest of this LP.)
CD: Progressive 7120

March 1975
Milt Hinton (with John Bunch, Jon Faddis, Budd Johnson, Jo Jones, and Frank Wess)
"Blue Skies"
"Blues for the Judge" [MH comp]
"It Had to Be You"
LP: Famous Door HL104 (*Here Swings the Judge: Milt Hinton and Friends*) (See 1964 entry for the rest of this LP.)
CD: Progressive 7120

July 17, 1976, Nice, France
Milt Hinton (with Cliff Smalls and Sam Woodyard)
"Look Out, Jack"
"Joshua Fit the Battle"
"Mean to Me"
"Prelude to a Kiss"
"Undecided"
"How High the Moon"
"Laughing at Life"
"Mona's Feeling Lonely" [MH comp]
"Indiana"
"Toning Down"
"Me and You"
LP: Black and Blue 33096 (*Basically with Blue*)
CD: Black and Blue 890

October 17, 1977
The Trio (Milt Hinton, Hank Jones, and Bob Rosengarden)
 " 'S Wonderful"
 "Queen of Hearts" [MH co-comp]
 "Mona's Feeling Lonely" [MH com]
 "Right Here, Right Now" [MH co-comp]
 "I'll Remember April"
 "Oh, What a Beautiful Morning" [piano
 solo—MH out]
 "Lullaby of the Leaves"
 "Re-Union" [MH co-comp]
 "Hank You, Thank" [MH co-comp]
LP: Chiaroscuro CR188 (*The Trio*)
CD: Chiaroscuro CRD188

August 26, 1981
Milt Hinton and Art Hodes
 "Willow Weep for Me"
 "Winin'"
 "I Would Do Most Anything"
 "Low Down 'n' Below"
 "Bye and Bye"
 "Down Home Blues"
 "Randolph Street Blues"
 "Here Comes Cow Cow"
 "Miss Otis Regrets"
 "Milt Jumps"
LP: Muse 5279 (*Just the Two of Us*)

June 1984
Milt Hinton (with Jay D'Amico Sam Furnace, Kevin Norton, and Mike Walters)
 "The Judge's Decision"
 "When Jen"
 "Mona's Feeling Lonely" [MH comp]
 "Diga Diga Doo"
 "Indiana"
 "How High the Moon"
 "Tricotism"
 "In a Minute"
LP: Exposure 6231910 (*The Judge's Decision*)

September 3, 1984
Milt Hinton (with Louie Bellson and Jane Jarvis)
 "Undecided"
 "Satin Doll"
 "Prelude to a Kiss"
 "Cut Glass" [MH comp.]
 "Brush String Key" [MH comp]
 "Fascinating Rhythm"
 "My One and Only Love"
 "Everywhere You Go"
 "Windy City Blues"
 "Joshua Fit de Battle of Jericho"
CD: Progressive PCD7084 (*Back to Bass-ics*)

March 1987
Lance Hayward and Milt Hinton
 "Mean to Me"
 "Exactly Like You"
 "I Didn't Know about You"
 "Willow Weep for Me"
CD: Town Crier TCD514 (*Hayward & Hinton*)

June 23, 1989, September 27, 1989, September 7, 1990, October 10, 1990
Milt Hinton (with Howard Alden, Kenny Davern, Janice Friedman, Sylvia Syms, Warren Vaché, Kenny Washington, Frank Wess, Jackie Williams, and James Williams)
 "Raincheck"
 "A Time for Love"
 "Johnny Come Lately"
 "Fascinating Rhythm"
 "Blessed Assurance"
 "Mona's Feeling Lonely" [MH comp]
 "Order in the Court"
 "Wade in the Water"
 "Night and Day"
 "As Long as I Live"
 "Love Me or Leave Me"
 "Old Man Time"
 "Summertime"
 "Travelin' All Alone"
CD: Chiaroscuro CRD222 (*The Basement Tapes*)

Milt's payroll tax-deduction slip for a Cab Calloway engagement at the Apollo Theater, New York City, for the period ending September 18, 1947

October 1989, February–March 1990

Milt Hinton (with Eddie Barefield, Cab Calloway, Doc Cheatham, Dizzy Gillespie, Al Grey, Lionel Hampton, Buddy Tate, Clark Terry, Joe Williams, and others)

 "Old Man Time"
 "Time after Time"
 "Sometimes I'm Happy"
 "A Hot Time in the Old Town Tonight"
 "Four or Five Times"
 "Now's the Time"
 "Time on My Hands"
 "Heart of My Heart"
 "I Ain't Gonna Give Nobody None of This Jelly Roll"
 "Mama Don't Allow It"
 "Girl of My Dreams"
 "This Time It's Us" [MH comp]
 "Good Time Charlie"
 "Jazzspeak #1" (interview)
 "It Don't Mean a Thing"
 "Blue Skies"
 "Slap Happy" [MH comp]
 "The Yellow Front"
 "Bloody Mary"
 "Milt's Rap"
 "Jazzspeak #2" (interview)
CD: Chiaroscuro CRD310 (*Old Man Time*) (double CD)

August 15, 1991

Marian McPartland with Milt Hinton
(*Piano Jazz*) Radio interview interspersed with performances.
 "Milt's Rap"
 "All the Things You Are"
 "My One and Only Love"
 "Joshua"
 "Willow Weep for Me"
 "Old Man Time"
 "These Foolish Things"
 "Stranger in a Dream" [McPartland solo]
 "How High the Moon"
CD: Jazz Alliance 12016 (*Marian McPartland's Piano Jazz with Guest Milt Hinton*)

January 14, 1994

The Trio (Milt Hinton, Bobby Rosengarden, and Derek Smith)

 "No Greater Love"
 "Sweet Lorraine"
 "Just a Closer Walk with Thee"
 Brazilian Medley:
 "Manha de Carnaval"
 "Garota de Ipanema"
 "Samba de Orpheo"
 "Bluesette"
 "Fascinating Rhythm"
 "Cute"
 Ellington Medley:
 "Don't Get Around Much Anymore"
 "What Am I Here For"
 "Caravan"
 "Shiny Stockings"
 "Someday My Prince Will Come"
 "Love for Sale"
 "Jazzspeak" (interview)
CD: Chiaroscuro CRD322 (*The Trio 1994*)

May–July 1994

Milt Hinton (with Harold Ashby, Terry Clarke, Alan Dawson, Santi Debriano, Jon Faddis, Rufus Reid, Lynn Seaton, Brian Torff, and others)

 "A Child Is Born"
 "Laughing at Life"
 "Indiana"
 "Jon John" [MH comp]
 "Old Man Harlem"
 "Just Friends"
 "Sweet Georgia Brown"
 "How High the Moon"
 "Prelude to a Kiss"
 "Mona's Feeling Lonely" [MH comp]
 "The Judge and the Jury" [MH comp]
CD: Columbia CK66454 (*Laughing at Life*)

1973–1995

Milt Hinton

This anthology highlights Hinton's previous releases for the label as both leader and sideman; the exception, "Joshua," is a previously unissued bass solo recorded aboard the *S.S. Norway*, October 26, 1990.

 "Joshua" [1990]
 "I Know That You Know" [1973]
 "Russian Lullaby" [1975]
 "Deep Night" [1975]
 "Shine" [1975]
 "Mona's Feeling Lonely" [1977]
 "Right Here, Right Now" [1977]
 "Rosetta" [1979]
 "Mama Don't Allow It" [1989]
 "Slap Happy" [1990]
 "Milt's Rap" [1990]
 "Honey" [1989]
 "New Orleans" [1992]
 "Jumping at the Woodside" [1993]
 "Just a Closer Walk with Thee" [1994]
 "What Am I Here For" [1994]
 "Hindustan" [1995]
 "Old Man Time" [1989]
CD: Chiaroscuro CRD219 (*The Judge at His Best: The Legendary Chiaroscuro Sessions, 1973–1995*)

2. Selected Solography

This list of representative solos by Hinton as a sideman in a variety of settings throughout his career is not definitive. He was such a consistent soloist that one could cite many other equally accomplished performances. In some cases, particularly from the 1930s when bass solos were relatively rare, the recordings listed contain prominent bass accompaniment.

November 4, 1930, Chicago
Tiny Parham
 "Squeeze Me" (first Hinton recording, on tuba)
78: Recorded for Victor, unissued
CD: Timeless CBC1022 (*Tiny Parham, 1928–1930*)

January–March 1933, Hollywood
Eddie South
 "Throw a Little Salt on the Bluebird's Tail" (vocal)
 "Goofus"
CD: Jazz Oracle BDW8054 (*Eddie South and His International Orchestra: The Cheloni Broadcast Transcriptions*)

May 3, 1933, Chicago
Eddie South
 "Old Man Harlem" (vocal)
78: Victor 24324
CD: Classics 707 (*Eddie South, 1923–1937*)

June 12, 1933, Chicago
Eddie South
 "My, Oh My" (slap bass)
78: Victor 24343
CD: Classics 707 (*Eddie South, 1923–1937*)

March 3, 1937
Cab Calloway
 "Congo"
78: Variety 593
CD: Classics 554 (*Cab Calloway, 1934–1937*)

January 26, 1938
Cab Calloway
 "I Like Music" (brief solo, slap bass)
78: Vocalion 3995
CD: Classics 568 (*Cab Calloway, 1937–1938*)

August 30, 1939
Cab Calloway
 "Pluckin' the Bass" (solo feature —slap bass)
78: Vocalion 5406
CD: Classics 595 (*Cab Calloway, 1939–1940*)

March 8, 1940, Chicago
Cab Calloway
 "Pickin' the Cabbage" (intro)
78: Vocalion 5467
CD: Classics 595 (*Cab Calloway, 1939–1940*)

June 27, 1940, Chicago
Cab Calloway
 "Bye Bye Blues" (intro and solo)
78: Okeh 6084
CD: Classics 614 (*Cab Calloway, 1940*)

January 16, 1941, Chicago
Cab Calloway
 "Ebony Silhouette" (solo feature, arco and pizzicato)
78: Okeh 6192
 "Willow Weep for Me"
78: Okeh 6109
CD: Classics 629 (*Cab Calloway, 1940–1941*) (includes both)

November 3, 1941
Cab Calloway
 "Tappin' Off"
78: Vocalion 6547
CD: Classics 682 (*Cab Calloway, 1941–1942*)

July 19, 1944
Pete Brown
 "That's My Weakness Now"
78: Unissued
CD: Classics 1029 (*Pete Brown, 1942–1945*)

October 11, 1944
Walter Thomas
 "Every Man for Himself"
78: Joe Davis 8128
CD: Classics 863 (*Coleman Hawkins, 1944–1945*)
Alternate takes from this session are on
LP: Harlequin 2032 (*Hot Jazz by Walter Thomas and His All Stars*)

September 4, 1946
Jonah Jones
 "Jonah's Wail"
78: Swing 243
CD: Jazz Time 251273 (*Swing in America: The Charles Delaunay Sessions*)

September 23, 1946
Ike Quebec
 "Bassically Blue" (MH comp and solo)
78: Blue Note 539
CD: Mosaic MR3–107 (*The Complete Blue Note Forties Recordings of Ike Quebec and John Hardee*)

September 1946 [aircheck]
Cab Calloway
 "Bassically Blue" (MH comp and solo feature)
CD: Magic 52 (*Cruisin' with Cab*)

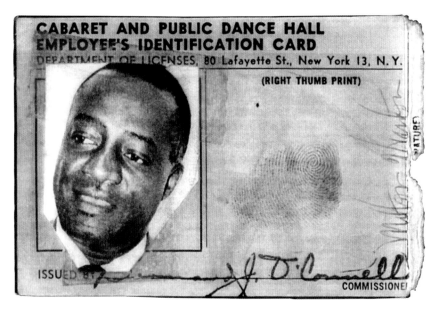

CABARET AND PUBLIC DANCE HALL EMPLOYEE'S IDENTIFICATION CARD

DEPARTMENT OF LICENSES, 80 Lafayette St., New York 13, N.Y.

(RIGHT THUMB PRINT)

ISSUED BY

COMMISSIONER

Milt's cabaret card, issued in 1964. The card was required for all employees in New York City nightclubs.

April 15, 1953
Buddy DeFranco
"Bass on Balls"
LP: Norgran MGN1026 (*Mr. Clarinet*)
CD: Jazz Factory 22865 (*Complete Mr. Clarinet Sessions*)

August 27, 1953
Tony Scott
"Milt to the Hilt" (solo feature)
LP: Brunswick BL58057 (*Jazz for G.I.s*)

January 16, 1954, San Francisco (Club Hanover)
Louis Armstrong
"12th Street Rag" (includes slap)
CD: Storyville STCD4095 (*Louis Armstrong and His All Stars*)

November 8, 1954
Coleman Hawkins
"Get Happy"
"Stompin' at the Savoy"
"Just You, Just Me"
LP: Jazztone J1002 (Timeless Jazz)
CD: Fresh Sound FSRCD347 (*Coleman Hawkins: The Complete Jazztone Recordings 1954*)

October 1954
Jack Teagarden
"After You've Gone"
LP: Urania 1002 (*The New Jack Teagarden, Vol. 2*)
CD: Lone Hill Jazz 10113 (*Accent on Trombones*)

January 1, 1955
Teddy Wilson
"Hallelujah"
LP: Norgran MGN1019 (*The Creative Teddy Wilson*)
CD: Mosaic MD5–173 (*The Complete Verve Recordings of the Teddy Wilson Trio*)

February 1955
Osie Johnson
"Cat Walk"
LP: Period SLP1108 (*Osie's Oasis*)
CD: OJC 1916

February 17, 1955
Hal McKusick
"Give 'Em Hell"
"Minor Matters"
LP: Bethlehem BCP16 (*East Coast Jazz 8*)
CD: Lone Hill Jazz 10176 (*Hal McKusick Quartet: The Complete Barry Galbraith, Milt Hinton, and Osie Johnson Recordings*)

September 14–15, 1955
Hal McKusick
"My Inspiration"
"Step Lively, Osie"
"Minor Seventh Heaven"
LP: RCA LPM1164 (*In a Twentieth Century Drawing Room*)
CD: Lone Hill Jazz 10176 (*Hal McKusick Quartet: The Complete Barry Galbraith, Milt Hinton, and Osie Johnson Recordings*)

March 31, 1956
George Russell
"Livingstone, I Presume"
LP: RCA LPM1372 (*The Jazz Workshop*)
CD: Bluebird 6467–2-RB

March 7, 1957
Bud Freeman
"Sugar"
RCA LPM1508 (*Chicago Austin High Jazz in Hi-Fi*)
CD: Mosaic MCD1002

October 10–11, 1957
Manny Albam
"Tonight"
LP: Coral CRL57207 (*West Side Story*)

March 17, 1958
Langston Hughes
Hinton is prominent throughout this LP behind the recitation by Hughes.
LP: MGM E3697 (*Weary Blues*)
CD: Verve 841660

July 1958
Ben Webster
"Ev's Mad"
"Ash"
LP: Verve MGV8359 (*The Soul of Ben Webster*)
CD: Verve 527475

July–August 1958
John Benson Brooks
 Hinton has short solo passages throughout, especially in the first and second movements.
LP: Riverside RLP12–276 (*Alabama Concerto*)
CD: OJC 1779

August 21, 1958
Cannonball Adderley
 "Two Left Feet"
LP: EmArcy MG36146 (*Jump for Joy*)
CD: Verve 528699 (*Cannonball Adderley and Strings / Jump for Joy*)

December 1958
Edmond Hall
 "Off the Road"
LP: United Artists UAL4038 (*Petite Fleur*)
CD: Mighty Quinn 1106

1958
Eubie Blake
 "Our Director"
LP: 20th Century Fox 3039 (*Marches I Played on the Old Piano*)

1958
Hank Jones
 "I Can't Sit Down"
LP: Capitol T1175 (*Porgy and Bess: Swingin' Impressions*)
CD: Okra-Tone 4972 (*Talented Touch / Porgy and Bess*)

January 3, 1959
Benny Goodman
 "Diga Diga Doo"
CD: Musicmasters CIJ60142 (*Benny Goodman: Yale University Music Library, Vol. 1*)

1960
Jackie Gleason
 "I'm Gonna Sit Right Down and Write Myself a Letter"
LP: Capitol SW1439 (*Lazy, Lively Love*)

February 23, 1961
Pee Wee Russell, Coleman Hawkins
 "Mariooch" (MH co-comp and solo)
LP: Candid CM8020 (*Jazz Reunion*)
CD: Candid 79020

1961, Chicago
Tyree Glenn
 "Stompin' at the Savoy"
 "Blue Lou"
LP: Roulette R25138 (*At the London House*)
CD: Lone Hill Jazz 10138 (*Hank Jones and Tyree Glenn Quintet/Sextet: Complete Recordings*)

September 5, 1963
Sonny Stitt, Paul Gonsalves
 "Sposin' "
LP: Impulse A(S)52 (*Salt and Pepper*)
CD: Impulse 210

March 13, 1964
Clark Terry
 "Jazz Conversations"
LP: Impulse A(S)64 (*The Happy Horns of Clark Terry*)
CD: Impulse 148

March 23, 1964
Stuff Smith, Ray Nance
 "Play" [aka "Timme's Blues"] (short duet with George Duvivier)
CD: Mosaic MD4–186 (*The Complete Verve Stuff Smith Sessions*)

February 28, 1968, Aspen, Colorado (Sunnie's Rendezvous)
Ralph Sutton, Ruby Braff
 "Limehouse Blues"
CD: Storyville STCD8243 (*Ralph Sutton Quartet with Ruby Braff, Vol. 1*)

June 1969, New Orleans Jazz Festival
Sarah Vaughan
 "Sometimes I'm Happy" (duet section)
CD: Scotti Bros. 75244 (*Sarah Vaughan: Jazzfest Masters*)

May 1970
Julian Dash
 "Don't Blame Me" (duet, arco solo)
LP: Master Jazz 8106 (*A Portrait of Julian Dash*)

June 1971
Maxine Sullivan and Dick Hyman
 "Under the Greenwood Tree"
LP: Monmouth-Evergreen MES7038 (*Sullivan, Shakespeare, Hyman*)
CD: Audiophile ACD250

May–August 1973
Zoot Sims
 "Do Nothing till You Hear from Me"
LP: Famous Door 2000 (*Zoot At Ease*)
CD: Progressive 7110

March 1974
Buck Clayton
 "Boss Blues"
 "Case Closed"
LP: Chiaroscuro CR132 (*A Buck Clayton Jam Session*)
CD: Chiaroscuro CRD132

May 1974
Joe Venuti
 "Tea for Three" (duet)
 "I Got Rhythm" (slap)
LP: Chiaroscuro 134 (*Blue Four*)
CD: Chiaroscuro CRD142 (*Joe Venuti and Zoot Sims*)

June 18–19, 1974
Danny Stiles
 "It Had to Be You"
 "In a Mellotone"
LP: Famous Door HL103 (*In Tandem*)

November 8, 1974 (Carnegie Hall)
New York Jazz Repertory Company
 "Someday, You'll Be Sorry"
 "S.O.L. Blues" (slap)
LP: Atlantic SD1671 (*Satchmo Remembered*)

May 1975
Joe Venuti and Zoot Sims
 "Russian Lullaby" (arco)
 "Shine"
LP: Chiaroscuro CR142 (*Joe Venuti and Zoot Sims*)
CD: Chiaroscuro CRD142

August 1975
Flip Phillips
 "Nature Boy" (duet)
LP: Choice 1013 (*Phillips' Head*)
CD: Candid 71013 (*Spanish Eyes*)

1975
John Bunch
 "Love You Madly"
LP: Famous Door HL1007 (*John's Bunch*)
CD: Progressive 7113

July 14, 1976, Nice
Teddy Wilson
 "Three Little Words"
 "Don't Be That Way"
 "Basin St. Blues"
 "Flyin' Home"
 "Undecided"
LP: Black and Blue 233094 (*Three Little Words*)
CD: Black and Blue 233094

September 8, 1980, Yokohama, Japan
Gentlemen of Swing (Benny Carter, Harry Edison, Milt Hinton, Shelly Manne, Teddy Wilson)
 "Idaho" (slap)
LP: East World EWJ80188 (*Gentlemen of Swing: Aurex Jazz Festival '80*)
CD: Toshiba TOCJ8012

January 3–4, 1988
Branford Marsalis
 "Three Little Words" (duet, slap)
 "Gutbucket Steepy"
LP: Columbia CX244199 (*Trio Jeepy*)
CD: Columbia CK44199

October 1988
Benny Carter
 "Blues for Lucky Lovers"
 "Ain't Misbehavin'"
CD: Musicmasters CIJD60196 (*Over the Rainbow*)

March 4, 1989
Ricky Ford
 "Ode to Crispus Attucks"
 "Portrait of Mingus"
 "Manhattan Blues"
CD: Candid 79036 (*Manhattan Blues*)

March 27–28, 1989
Ralph Sutton and Jay McShann
 "Old Fashioned Love"
 "Cherry"
CD: Chiaroscuro CRD306 (*Last of the Whorehouse Piano Players*)

February 6–7, 1990
John Pizzarelli
 "I'm an Errand Boy for Rhythm" (slap)
 "Oh Me, Oh My, Oh Gosh"
CD: Chesky JD38 (*My Blue Heaven*)

May 30–31, 1990
Bob Wilber and Kenny Davern
 "Lover Come Back to Me"
 "St. Louis Blues"
CD: Chiaroscuro CRD311 (*Summit Reunion*)

June 2, 1990, New York City (Birdland)
Ricky Ford
 "Ebony Rhapsody" (slap)
 "In a Sentimental Mood" (duet)
CD: Candid 79053 (*Ebony Rhapsody*)

August–December 1991, March 1992
Russell Malone
 "St. Louis Blues" (duet)
 "Close Your Eyes" (slap)
CD: Columbia CK52825 (*Russell Malone*)
 Includes liner notes by Hinton

October 27–28, 1992, *S.S. Norway*
Kenny Davern and Bob Wilber
 "Apex Blues"
 "Love Me or Leave Me"
 "Chinatown" (slap)
CD: Chiaroscuro CRD324 (*Summit Reunion 1992*)

August 3, 1993
Joe Wilder
 "Harry Lulu" (slap)
CD: Evening Star 103 (*No Greater Love*)

ca. 1993
Jay D'Amico
 "Alfreda"
CD: Consolidated Artists Productions CAP
940 (*Ponte Novello*)

May 24–25, 1994, Purchase, New York
(SUNY)
Dick Hyman
 "Dooji Wooji"
 "Soft Winds"
CD: Reference Recordings RR59 (*From the
Age of Swing*)

August 30–September 1, 1994
Christian McBride
 "Splanky" (features McBride, Ray
 Brown, and Milt Hinton)
CD: Verve 523989 (*Gettin' to It*)

December 20, 1994
Statesmen of Jazz
 "Moten Swing"
 "No Bridge" (slap)
CD: American Federation of Jazz Societies
201 (*Statesmen of Jazz*)

March 24–26, 1995, Deerfield Beach,
Florida (March of Jazz)
Flip Phillips
 "Poor Butterfly"
 "The Claw"
 "Hashimoto's Blues" (slap)
CD: Arbors 19281 (*Flip Phillips Celebrates
His Eightieth Birthday*)

Saxophone part from "Ebony
Silhouette," #112 in the Calloway
band book. This tune featured
Milt playing arco and pizzicato.

THE FAMILY CIRCUS® By Bil Keane

6-9
© 1990 Bil Keane, Inc.
Dist. by Cowles Synd., Inc.

"You can tell he loves his bass
because of the way he hugs it."

"Family Circus" cartoon reprinted
with permission of Bil Keane

3. Other Milt Hinton Favorites

Using the Walter Bruyninckx discography *Sixty Years of Recorded Jazz* as the basic source, Milt Hinton selected the following sessions as favorites on which he performed (listed alphabetically by leader).

Manny Albam
December 11, 1955
LP: RCA LPM1211 (*The Jazz Workshop*)
CD: Lone Hill Jazz 10250

Chu Berry
September 10, 1937
 "Chuberry Jam"
 "Maelstrom"
 "My Secret Love Affair"
 "Ebb Tide"
78s: Columbia, Variety
CD: Classics 784 (*Chu Berry, 1937–1941*)

Emmett Berry
August 31, 1944
 "Sweet and Lovely"
 "White Rose Kick"
 "My Deep Blue Dream"
 "Byas'd Opinion"
78s: National
CD: Savoy 268 (*Don Byas: Savoy Jazz Party*)

Andy Bey
February 26, 1965
LP: Prestige 7411 (*Andy Bey and the Bey Sisters*)
CD: Prestige 24245

Eubie Blake
1958
LP: 20th Century Fox 3003 (*The Wizard of Ragtime Piano, Vol. 1*)

Teresa Brewer
July 24–25, 1978
LP: Doctor Jazz 60008 (*We Love You Fats*)

Ralph Burns
September 29, 1955
LP: Decca DL8235 (*Jazz Studio 5*)
CD: Fresh Sound 2216

Kenny Burrell and Jimmy Smith
July 23, 1963
LP: Verve V6–8553 (*Blue Bash*)
CD: Verve 557–453

Joe Bushkin
March 20, 1964, New York City (Town Hall)
LP: Reprise 6119 (*In Concert*)
CD: Collectables 6157

Billy Butterfield
October–November 1955
LP: RCA LPM1212 (*New York Land Dixie*)
CD: Fresh Sound 316 (*Soft Strut*)

Jackie Cain and Roy Kral
March 1957
ABC-Paramount 163 (*Bits and Pieces*)

Cab Calloway
July 17, 1939
 "Crescendo in Drums"
78: Vocalion 5062
CD: Classics 595 (*Cab Calloway, 1939–1940*)

Cab Calloway
June 27, 1940, Chicago
 "Ghost of a Chance"
78: Okeh 5887
CD: Classics 614 (*Cab Calloway, 1940*)

Benny Carter
November 30, 1976
LP: Pablo 3210–922 (*Wonderland*)
CD: OJC 967

Buck Clayton
August 1955
LP: Columbia CL778 (*Cat Meets Chick*)
CD: Collectables 7496; Mosaic MD228 (*Columbia Small Group Swing Sessions, 1953–1962*)

Al Cohn
February 1955
LP: RCA LPM1116 (*The Natural Seven*)
CD: RCA (Spain) 60992

Chris Connor
April 1955
LP: Bethlehem BCP20 (*This Is Chris*)
CD: Rhino 76684

Ida Cox
April 1961
LP: Riverside RLP373 (*Blues for Rampart Street*)
CD: OJC 1758

Vic Dickenson
March 31, 1976
LP: Sonet SNTF720 (*Trombone Cholly: Vic Dickenson Plays Bessie Smith*)
CD: Gazell GJ611

Pee Wee Erwin
1959
LP: United Artists UAL3010 (*Pee Wee Erwin and the Dixie Strutters*)

Aretha Franklin
January 10, 1961
LP: Columbia CL1612 (*Aretha*)
CD: Columbia Legacy 65375 (*The Great Aretha Franklin: The First Twelve Sides— Sweet Bitter Love; Aretha Sings the Blues*)

Big Mama Thornton and Joe Turner
January 15, 1967, New York City (Carnegie Hall)
LP: Columbia G30776 (*From Spirituals to Swing: 30th Anniversary Concert*)
CD: Vanguard 47, 48

Erroll Garner
April, November 1966
LP: MGM E4463 (*That's My Kick*)
CD: Telarchive 83332

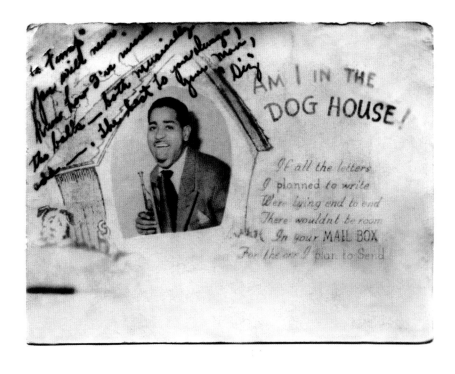

Novelty photo postcard inscribed to Milt from Dizzy Gillespie, c. 1943. It reads:

To Fump — You will never know how much I missed the balls—both musically and ——. The best to you always, your man, 'Diz.'

Benny Goodman
March 25–26, 1955
LP: Phillips 6379001
LP: Phillips 6379002
LP: Phillips 6379003 (*Live at Basin Street West*)
CD: Many of these performances and alternates on Musicmasters CIJ60156 (*Benny Goodman: Yale University Music Library, Vol. 2*)

Gigi Gryce
1958
LP: Metrojazz E1006 (*Gigi Gryce Quartet*)

Lionel Hampton
October 1964
LP: Impulse A(S)78 (*You Better Know It*)
CD: Impulse 140

Johnny Hartman
October 1963
LP: Impulse A(S)57 (*I Just Dropped in to Say Hello*)
CD: Impulse 176

Johnny Hodges
January 9, 1967
LP: RCA LSP 3867 (*Triple Play*)
CD: Bluebird 5903

Billie Holiday
October 21, 1936
 "Easy to Love"
 "With Thee I Swing"
 "The Way You Look Tonight"
Recorded for Brunswick.
CDs: Columbia Legacy 85470 (*Lady Day: The Complete Billie Holiday on Columbia, 1933–1944*); Classics 521 (*Teddy Wilson, 1936–1937*)

Billie Holiday
November 28, 1938
 "You're So Desirable"
 "You're Gonna See a Lot of Me"
 "Hello My Darling"
 "Let's Dream in the Moonlight"
Recorded for Brunswick.
CD: Columbia Legacy 85470 (*Lady Day: The Complete Billie Holiday on Columbia, 1933–1944*); Classics 556 (*Teddy Wilson, 1938*)

Billie Holiday
January 30, 1939
 "What Shall I Say"
 "It's Easy to Blame the Weather"
 "More Than You Know"
 "Sugar"
Recorded for Brunswick.
CD: Columbia Legacy 85470 (*Lady Day: The Complete Billie Holiday on Columbia, 1933–1944*); Classics 571 (*Teddy Wilson, 1939*)

Billie Holiday
March 4, 1959
LP: MGM E3764 (*Billie Holiday with Ray Ellis and His Orchestra*)
CD: Verve 835370 (*Last Recording*)

Claude Hopkins
1958
LP: 20th Century Fox 3009 (*Early Jazz Dances*)

Dick Hyman
December 11, 1973
LP: Columbia M32587 (*Some Rags, Some Stomps, and a Little Blues*)
CD: Columbia Masterworks MDK52552

Bobby Jaspar
November 20, 1956
LP: Columbia (France) FPX123 (*Clarinescapade*)
CD: Swing 8413 (*Bobby Jaspar: Recorded in New York, 1956*)

J.J. Johnson and Kai Winding
November 17, 1955
LP: Columbia CL973 (*Jay and Kai*)

Osie Johnson
April 1956
RCA LPM1369 (*A Bit of the Blues*)
CD: RCA (Spain) 74321–60983

Elvin Jones
1977
Vanguard VSD79389 (*Time Capsule*)
CD: Universe 38

Hank Jones
October 19, 1963
LP: Argo Cadet 728 (*Here's Love*)
CD: Gambit 69231 (*Hank Jones Quintet: Complete Recordings*)

Hank Jones
April 1964
ABC Paramount 496 (*This Is Ragtime Now*)

Jonah Jones
October 3, 1944 (World Transcriptions)
LP: Circle CLP83 (*Butterflies in the Rain*)
CD: Circle 18

Morgana King
1964
LP: Mainstream M56015 (*A Taste of Honey*)
CD: Some tracks on Mainstream CD0707

Michel Legrand
June 30, 1958
LP: Columbia CL1250 (*Legrand Jazz*)
CD: Verve 830074

Bernie Leighton
May 19, 1974
LP: Monmouth-Evergreen MES7068 (*Bernie Leighton Quartet Plays Duke Ellington*)

Bernie Leighton and Moe Wechsler
ca. 1965
LP: Westminster WST17108 (*Puccini, Rossini, Verdi, Bellini, and Blitzstein*)

Harry Lookofsky
June 2, 1959
LP: Atlantic SD1319 (*Stringsville*)
CD: Collectables 7792

Hal McKusick
March–April 1956
LP: RCA LPM1366 (*Jazz Workshop*)
CD: Lone Hill Jazz 10176 (*Complete Barry Galbraith, Milt Hinton, and Osie Johnson Recordings*)

Hal McKusick
April 7, 1958
LP: Decca DL 9209 (*Cross Section Saxes*)
CD: Lone Hill Jazz 10176 (*Complete Barry Galbraith, Milt Hinton, and Osie Johnson Recordings*)

Helen Merrill
1959
LP: Metrojazz E1010 (*You've Got a Date with the Blues*)
CD: Verve 837936

Charles Mingus
February 4, 1972, New York City (Philharmonic Hall)
LP: Columbia KG31614 (*Charles Mingus and Friends in Concert*)
CD: Columbia Legacy C2K64975

Wes Montgomery
April 18, 1963
LP: Riverside RLP12–472 (*Fusion! Wes Montgomery with Strings*)
CD: OJC 368

Joe Mooney
February 3–4, 1963
LP: Columbia CL2345 (*The Happiness of Joe Mooney*)
CD: Koch Jazz 7886

Phil Moore
1962
LP: Mercury MG20763 (*New York Sweet*)

Music Minus One
(Barry Galbraith, Milt Hinton, Osie Johnson, and Nat PierceL
1955
LP: Music Minus One J7 (*Music Minus One Bass*)

New York Bass Violin Choir (Lisle Atkinson, Ron Carter, Richard Davis, Michael Fleming, Milt Hinton, Sam Jones, Bill Lee)
1975
LP: Strata East 8003 (*New York Bass Violin Choir*)

Bill Potts
1963
LP: Colpix 451 (*Bye Bye Birdie*)
CD: Lone Hill Jazz 10170 (*Porgy and Bess and Bye Bye Birdie*)

Sammy Price
March 20, 1955
LP: Jazztone J1207 (*Barrelhouse and Blues*)

Ike Quebec
November 26, 1961
LP: Blue Note BLP4093 (*Heavy Soul*)
CD: Blue Note 64472

Ike Quebec
December 9, 1961
LP: Blue Note BLP4105 (*It Might as Well Be Spring*)
CD: Blue Note 62652

Jimmy Rushing
April 29–30, 1971
LP: RCA LSP4566 (*The You and Me That Used to Be*)
CD: Bluebird 6460

George Russell
March 25, 1959
LP: Decca DL9216 (*New York, N.Y.*)
CD: Impulse 78

Sauter-Finegan Orchestra
March, April, May 1957
LP: RCA LPM1497 (*Straight Down the Middle*)
CD: Three tracks on Collectors' Choice Music 078 (*Best of Sauter-Finegan*)

Tony Scott
February 5, 1953
LP: Brunswick BL58050 (*Music after Midnight*)

Tony Scott
December 28, 1954
EP: RCA EPA596
CD: Fresh Sound 415 (*Fingerpoppin': Complete Recordings, 1954–1955*)

Tony Scott
July 1956
LP: RCA LPM1353 (*The Touch of Tony Scott*)

Tony Scott
November 1967
LP: Verve V(6)8788 (*Tony Scott*)
CD: Verve 145902

Sound of Jazz (Red Allen, Vic Dickenson, Roy Eldridge, Coleman Hawkins, Billie Holiday, Jo Jones, Pee Wee Russell, Ben Webster, and Lester Young and others)
December 5, 1957
LP: Columbia CL1098 (*The Sound of Jazz*)
CD: Columbia Legacy 66082

Soprano Summit (Bob Wilber and Kenny Davern)
May 5, 1974
LP: World Jazz WJLPSL5 (*Soprano Summit*)
CD: World Jazz WJCD513

Rex Stewart
1955
LP: Grand Award 33–315 (*Plays Duke Ellington*)
CD: Jazz & Jazz 621 (*Rex Meets Horn*)

Sylvia Syms
August 11, 1965
LP: Prestige 7439 (*Sylvia Is!*)
CD: OJC 775

Buddy Tate
June 1, 1973
LP: Chiaroscuro CR123 (*Buddy Tate and His Buddies*)
CD: Chiaroscuro CRD123

Marlene VerPlanck
September 1978
LP: Audiophile AP138 (*Marlene VerPlanck Loves Johnny Mercer*)
CD: Audiophile APCD138

Dinah Washington
February 19, 1959
LP: Mercury MG20479 (*What a Diff'rence a Day Makes*)
CD: Verve 543300

Dinah Washington
November 1962
LP: Roulette R25189 (*Back to the Blues*)
CD: Roulette 54334

Ethel Waters
August 15, 1939
78s: Bluebird B10415, 11028, 11248
CD: Classics 755 (*Ethel Waters, 1935–1940*)

Bill Watrous
December 1972, January 1973
LP: Famous Door HL101 (*Bone Straight Ahead*)
CD: Progressive 7115

Lee Wiley
September 1956
LP: RCA LPM1408 (*West of the Moon*)
CD: Bluebird 3138 (*As Time Goes By*)

Joe Williams
July 14 and 16, 1959
LP: Roulette R52030 (*Sings about You*)
CD: EMI 866900

Joe Williams
February 1963
LP: RCA LPM2879 (*Me and the Blues*)
LPM 2713 (*Jump for Joy*)
CD: Collectables 40 (*The Legend at His Best*) (contains both LPs)

Pages from Milt Hinton's pocket calendar for October 26–29, 1954.

The October 26th entry shows a 1:00 PM Al Cohn recording session produced by Jack Lewis with musicians Sanford Gold, Joe Newman, Eddie Bert, Osie Johnson, and Billie Bauer at the RCA 24th St. recording studio, which Milt calls "Victors."

During the session, Milt noted that two Al Cohn originals were recorded and sometime after that, he itemized the money he earned on the session. The entry for October 28th, indicates that Milt hired Roy Francis to substitute for him at the Embers because he had a record date at 9:15 the same evening.

Selected Filmography

Compiled by David G. Berger

Films and videos are listed in chronological order, using *Jazz on the Screen: A Jazz and Blues Filmography* by David Meeker (Library of Congress, http://lcweb2.loc.gov/diglib/ihas/html/jots/jazzscreen-home.html).

Abbreviations:
- I contains a Hinton interview
- P contains a Hinton performance
- Ph contains Hinton photographs.

Distributors for the films and videos listed are not identified because they change frequently. Current information is available on the internet.

1937 *Hi De Ho*. Directed by Roy Mack. Hinton performs with Cab Calloway and His Orchestra. (P)

1942 *Soundies, with Cab Calloway and His Orchestra*. Includes "Virginia, Georgia and Caroline," "Blues in the Night," "Minnie the Moocher," and "The Skunk Song". (P)

1943 *Stormy Weather*. Directed by Andrew Stone. Hinton performs with Cab Calloway and His Orchestra. (P)

1945 *Soundies, with Cab Calloway and His Orchestra*. Directed by William Forest Crouch. Includes "Blowtop Blues," "Foo, A Little Bally-Hoo," "I Was Here When You Left Me," "Walking With My Honey," and "We, the Cats, Shall Hep Ya". (P)

1947 *Hi-De-Ho*. Directed by Josh Binney. Hinton performs with Cab Calloway and His Orchestra and also conducts the Orchestra on several songs. (P)

1950. *Cab Calloway and His Cabaliers Telescriptions*. Directed by Duke Goldstone. Hinton performs with a small band including Panama Francis and Jonah Jones. Songs include "I Can't Give You Anything But Love Baby," "Minnie the Moocher," "One for My Baby," and "St. James Infirmary". (P)

1957 *The Sound of Jazz*. Directed by Jack Smight. PBS *Seven Lively Arts* series. Hinton performs with all-star bands that include Red Allen, Vic Dickenson, Roy Eldridge, Coleman Hawkins, Billie Holiday, Jo Jones, Pee Wee Russell, Ben Webster, and Lester Young. (P)

1959 *The Timex All Star Jazz Show No. 4*. Directed by David Geisel. (P)

1961 *After Hours*. Directed by Shepard Traube. Hinton is featured with Cozy Cole, Roy Eldridge, Coleman Hawkins, and others. (P)

Chicago and All That Jazz, Directed by James Elson. *Dupont Show of the Week*. (P)

1969 *Duke Ellington at the White House*. Directed by Sidney J. Stiber. (P)

L'Aventure Du Jazz. Directed by Louis and Claudine Pannasie. (P)

1971 *One Night Stand with Lionel Hampton*. Directed by Sidney Smith. Hinton performs with Joe Bushkin, Lionel Hampton, Mel Tormé and others. (P)

1977 *The Great Rocky Mountain Jazz Party*. Directed by Vilis Lapenieks. Hinton plays and sings with all-star bands. (P)

1984 *Billie Holiday: The Long Night of Lady Day*. Directed by John Jeremy. (I, Ph)

1985 *The Apollo Story, Part 1*. Directed by Cathe Neukum. BBC *Arena* series. (I)

Milt and Honi. Directed by Louise Tiranoff. The lives of Hinton and tap dancer Honi Coles are explored through interviews, photographs, and a Hinton-Coles performance created for the production. (I, P, Ph.)

1988 *Art Tatum: The Art of Jazz Piano*. Directed by Howard Johnson. (I)

1989 *Benny Carter: Symphony in Riffs*. Directed by Harrison Engle. (P)

Performance at the White House. Hinton performs with Benny Carter and Dick Hyman. (P)

Ben Webster: The Brute and the Beautiful. Directed by John Jeremy. (I, Ph)

1990 *John Hammond: From Bessie Smith to Bruce Springsteen*. Directed by Hart Perry. (I)

Chester Zardis: The Spirit of New Orleans. Directed by Preston McClanahan. (I, P)

Satchmo: The Life of Louis Armstrong. Directed by Kendrick Simmons and Gary Giddins. PBS *American Masters* series. (I)

1991 *Texas Tenor*. Directed by Arthur Elgort. (I)

Golden Jazz Concert: Modern Jazz All Stars Tribute to Benny Goodman. Hinton performs with Buddy DeFranco, Terry Gibbs and others. (P)

1992 *Festival de Jazz de Montreux*. Hinton performs with Louie Bellson, Harry "Sweets" Edison and others. (P)

1993 *Benny Goodman: Adventures in the Kingdom of Swing*. Directed by Oren Jacoby. (I)

A Tribute to Dizzy Gillespie. Directed by Debbie Geller. BBC *Arena* series. (I, Ph)

1994 *A Great Day in Harlem*. Directed by Jean Bach. Contains archival home movies taken by Mona Hinton. (I, P, Ph)

1995 *Flip Phillips' 80th Birthday Party*. Hinton performs with all-stars including Kenny Davern, Scott Hamilton, Peanuts Hucko, Dick Hyman, Flip Phillips and others. (P)

The Long Island Jazz Festival, 1993. Directed by Bruce Ricker. (I, P)

1997 *The Spitball Story*. Directed by Jean Bach. (I, P, Ph)

2000 *Jazz*. Directed by Ken Burns. "Episode 2: The Gift;" "Episode 4: The True Welcome;" "Episode 5: Swing Pure Pleasure;" "Episode 7: Dedicated to Chaos;" "Episode 9: The Adventure" (I, Ph)

2002 *Keeping Time: The Life, Music, & Photographs of Milt Hinton*. Directed by David G. Berger, Holly Maxson, and Kate Hirson. Hinton's life story is told using interviews (with Hinton, Nat Hentoff, Gregory Hines, Quincy Jones, Branford Marsalis, and others), archival footage, and several hundred Hinton photographs. (I, P, Ph)

Selected Bibliography

Compiled by Ed Berger, Institute of Jazz Studies, Rutgers University

Oral histories of Milt Hinton may be found in the collection of the Rutgers Institute of Jazz Studies, the Smithsonian Institution Archives Center, the New York Public Library's Schomburg Center for Research in Black Culture, and the Hamilton College Jazz Archive.

Birnbaum, Larry. "Milt Hinton: The Judge Holds Court." *Down Beat*, January 25, 1979, pp. 14–16+.

Bourne, Michael. "Jazz Artists, Jazz Chroniclers: Arthur Taylor and Milt Hinton." *Down Beat*, December 1993, pp. 32–35.

Coolman, Todd. *The Bass Tradition*. New Albany, Ind.: Jamey Aebersold, 1985. Includes a transcription of Hinton's solo on "Flyin' Home," recorded July 14, 1976, with Teddy Wilson.

Feather, Leonard. "Celebrating Milt Hinton: Honoring the Great Bassist." *Jazz Times*, May 1985, pp. 12–13+.

Goldsby, John. *The Jazz Bass Book: Technique and Tradition*. San Francisco: Backbeat, 2002, pp. 43–47.

Graham, Charles, and Dan Morgenstern. *The Great Jazz Day*. Emeryville, Calif.: Woodford, 2000, pp. 28–31. Includes photos by Hinton.

Hentoff, Nat. "No Style or Idiom Fazes the Versatile Milt Hinton." *Down Beat*, August 11, 1954, p. 16.

Hinton, Milt. "Milt Hinton's Advice to Bassists." *Music and Rhythm*, August 1941, p. 38.

Hinton, Milt, and David G. Berger: *Bass Line: The Stories and Photographs of Milt Hinton*. Philadelphia: Temple University Press, 1988

Hinton, Milt, and David G. Berger: "Milt Hinton on Photography." *Mississippi Rag*, November 1988, pp. 1–3.

Hinton, Milt, David G. Berger, and Holly Maxson. *Overtime: The Jazz Photographs of Milt Hinton*. San Francisco: Pomegranate, 1991.

Jisi, Chris. "Slap Summit: 'The Munch' Meets 'The Judge.'" *Bass Player*, March/April 1991, pp. 34–39.

Jisi, Chris, and Richard Johnston: "Milt Hinton, 1910–2000: Big Sound, Big Heart: Remembering a Life in Jazz." *Bass Player*, March 2001, pp. 54–58+. Issue includes transcription by John Goldsby of Hinton's solo on "Three Little Words" from Trio Jeepy CD with Branford Marsalis, recorded January 1988.

Jones, Max. "Milt Hinton." *Jazz Journal*, April 17, 1968, pp. 16–17.

Lees, Gene. *You Can't Steal a Gift: Dizzy, Clark, Milt, and Nat*. New Haven: Yale University Press, 2001.

———. "The ISB [International Society of Bassists] Remembers Milt Hinton, 1910–2000." *Bass World*, June–September 2001, pp. 5–10.

Lieberman, Julie Lyonn. "'The Judge': Fortitude and Creativity." *Strings*, May/June, 1992, pp. 55–59.

Mandel, Howard. "Judge for Yourselves!" *Down Beat*, May 1990, pp. 30–31.

Morgenstern, Dan. "The Judge: Milt Hinton." *Jazz Times*, April 2000, pp. 52–55+. (Reprinted in Dan Morgenstern, *Living with Jazz* [New York: Pantheon, 2004], pp. 185–190.)

Robinson, Greg. "Milt Hinton: For the Long Haul." *Jazz Times*, April 1995, pp. 35–36.

Rusch, Bob. "Milt Hinton." *Cadence*, December 1978, p. 14+.

Schuller, Gunther. *The Swing Era: The Development of Jazz, 1930–1945*. New York: Oxford, 1989. Includes a discussion of Hinton's recordings with Calloway of "Ebony Silhouette" and "Pluckin' the Bass" with a transcription of the bass solo on the latter, pp. 344–345.

Shapiro, Nat, and Nat Hentoff: *Hear Me Talkin' to Ya: The Story of Jazz as Told by the Men Who Made It*. New York: Rhinehart, 1955.

Torff, Brian. "Milt Hinton: From Mississippi to the White House." *Jazz Research Papers* [IAJE] 20 (2000), pp. 76–80.

Voce, Steve. "A Bass for All Seasons." *Jazz Journal*, November 1981, pp. 8–10.

Watrous, Peter. "Milt Hinton at Eighty: A Celebration." *New York Times*, June 23, 1990.

Wong, Herb. "Milt Hinton: Grandmaster of Jazz." *Jazz Educators Journal*, Winter 1993, pp. 28–32.

Index

Page numbers in bold refer to illustration locations.

Track List for Companion CD

Telling Stories and Playing Music

Producer: David G. Berger • Editor: Jeffrey Stern • Additional Editing: Milo J. Berger

Track Credits for Companion CD

Tracks 1 and 14: "Milt's Rap" (D. G. Berger, A. Phillips, M. Hinton), Milt Hinton (bass & vocal), Gus Johnson (drums). From *Old Man Time*, Chiaroscuro CRD 310. Recorded 1989. Courtesy of Chiaroscuro Records.

Tracks 2-4, 6-13, 15, 17-18, 20-25, 27-28, 30: From interviews with Milt Hinton that were conducted in Philadelphia in 1989 by David G. Berger. Fred Landerl used these interviews to produce a radio series *Bass Lines*, for WRTI-FM, Temple University, that was written by Phran Novelli and broadcast on more than 140 National Public Radio stations nationwide.

Track 5: "Just a Closer Walk with Thee" (Traditional), Milt Hinton (bass), Derek Smith (piano), Bob Rosengarden (drums). From *The Trio 1994*, Chiaroscuro CRD 322. Recorded 1989. Courtesy of Chiaroscuro Records.

Track 16: "Throw a Little Salt on the Bluebird's Tail" (L. Robin, R. A. Whiting), Milt Hinton (bass and vocal), Clifford King (clarinet), Eddie South (violin), Antonio Spalding (piano), Everett Barksdale (guitar), Jimmy Bertrand (drums). From *Eddie South and His International Orchestra: The Cheloni Broadcast Transcriptions*" Jazz Oracle, BDW 8054. Recorded 1933. Courtesy of Jazz Oracle.

Track 19: "Joshua" (Traditional, arr. by M. Hinton), Milt Hinton (bass). From *The Judge at His Best*, Chiaroscuro CRD 219. Recorded 1990. Courtesy of Chiaroscuro Records.

Track 22: Excerpt from "Blues for the Judge," (M. Hinton), Milt Hinton (bass), Jon Faddis (trumpet), Budd Johnson and Frank Wess (reeds), John Bunch (piano), Jo Jones (drums). From *Here Swings the Judge: Milt Hinton and Friends*, Progressive 7120. Recorded 1975. Courtesy of George H. Buck, Jr., Jazz Foundation.

Track 26: "Slap Happy" (M. Hinton), Milt Hinton (bass), Lionel Hampton (vibes), Jimmy Ford (drums). From *Old Man Time*, Chiaroscuro CRD 310. Recorded 1990. Courtesy of Chiaroscuro Records.

Track 29: "Pull 'em Off," (M. Hinton), Milt Hinton (bass), Clark Terry (vocal). From a live performance at the Bern Jazz Festival, 1989. Courtesy of Hans Zurbruegg.

Track 31: "Old Man Time" (C. Friend, J. Reynolds), Milt Hinton (bass and vocal), Derek Smith (piano), Bob Rosengarden (drums). From *Old Man Time*, Chiaroscuro CRD 310. Recorded 1989. Courtesy of Chiaroscuro Records.